RENAISSANCE PERSPECTIVES
in Literature and the Visual Arts

RENAISSANCE PERSPECTIVES

in Literature and the Visual Arts

MURRAY ROSTON

PRINCETON UNIVERSITY PRESS

LIBRARY OF CONGRESS CATALOGING IN PUBLICATION DATA WILL
BE FOUND ON THE LAST PRINTED PAGE OF THIS BOOK

ISBN 0-691-06683-3
THIS BOOK HAS BEEN COMPOSED IN LINOTRON BEMBO

CLOTHBOUND EDITIONS OF PRINCETON UNIVERSITY PRESS
BOOKS ARE PRINTED ON ACID-FREE PAPER, AND BINDING
MATERIALS ARE CHOSEN FOR STRENGTH AND DURABILITY

PRINTED IN THE UNITED STATES OF AMERICA BY
PRINCETON UNIVERSITY PRESS
PRINCETON, NEW JERSEY

CONTENTS

EARLY RENAISSANCE

HIGH RENAISSANCE

MANNERISM AND CLASSICISM

ACKNOWLEDGMENTS

I SHOULD LIKE TO EXPRESS MY APPRECIATION OF THE WARM hospitality extended to me over the past few years by the English departments of the University of Virginia and (once again) of Stanford University. The periods I spent there as a visitor, apart from the personal pleasure they gave me, enabled me to combine teaching with access to library facilities not available to me in Israel. More recently, a fellowship at the National Humanities Center in North Carolina has provided me with ideal surroundings for seeing the book through the press, while at the same time researching its sequel. I wish to record here my sincerest thanks to the Center's ever-helpful staff, and especially to its chief librarian, Mr. Alan Tuttle, for kindnesses extending beyond bibliographical assistance.

Some of the material in chapter 7 appeared in an earlier form as an essay in *Approaches to Sir Thomas Browne: the Ann Arbor Tercentenary Lectures and Essays*, edited by C. A. Patrides (University of Missouri Press, 1982), and I am grateful to the publishers for permission to make use of the material here. The Research Committee of Bar-Ilan University generously covered the cost of preparing the typescript of this book.

In finalizing the text, I have benefited from valuable suggestions offered by Professors Roland M. Frye and James V. Mirollo who served as the readers for Princeton University Press, and also from the helpful advice of various friends, V. A. Kolve, Robert R. Edwards, and Ellen Spolsky, who were kind enough to read and comment on the earlier chapters, and Richard S. Peterson who made suggestions for the final chapter. I should like to record my gratitude for the valuable assistance received from Mrs. Elizabeth Powers at the Press, who so ably supervised the final preparation of text and illustrations.

Lastly, as always, a very special tribute of thanks to my wife Faith, whose artistic perceptiveness and delightful company so enriched our tours of the art centres of Europe.

Bar Ilan University,
Ramat Gan, Israel

LIST OF ILLUSTRATIONS

ix

(Illustrations 7, 12-15, 17, 18, 23, 25, 26, 28, 29, 32, 33, 35-37, 41-44, 47, 49, 51, 54, 57, 58-60, 65, 66, 68, 69, 71, 72, 74, 77, 78, 80, 81 were provided by Art Resource, New York.)

RENAISSANCE PERSPECTIVES
in Literature and the Visual Arts

INTRODUCTION

THE APPEARANCE IN RECENT YEARS OF SUCH IMPRESSIVE INTER-disciplinary studies as Roland M. Frye's *Milton's Imagery and the Visual Arts* and Ronald Paulson's *Book and Painting* has bestowed legitimacy upon that originally suspect area of scholarship, the relating of literature to the visual arts. It has done so in no small part because of their authors' rigorous insistence upon the established criteria of orthodox scholarship.[1] The methodology of Frye's work needs no defence, for it rests upon the accepted norms of chronological sequence. It examines the iconographic traditions which had accumulated in the generations preceding Milton's writings and which were therefore available for him to draw upon as part of the cultural heritage of Europe during the years when he was forming his own body of poetic images. Paulson too, exploring the reverse process—the use by painters of themes drawn from literary works—again preserves a traditional respect for chronological sequence as he investigates the depiction by eighteenth-century English graphic artists of scenes from earlier literature, from the Bible, Shakespeare, and Milton, in their hope that those august texts would lend dignity to their own painting until such time as English art became recognized as autonomously worthy of regard.

It is, however, the unfortunate sibling of such orthodox interart study whose legitimacy has remained under suspicion—that waif of literary scholarship, the "synchronic" approach, whose credentials are still frowned upon by much of the academic community. The theory there is admittedly less securely based, for it rests on the assumption that in each era literature and the visual arts, as aesthetic expressions of the cultural patterns dominant at that time, are likely to share certain thematic and stylistic qualities.

The objection of those unsympathetic to such enquiry has arisen not so much from the claim that every work of art is essentially the product of an individual and not of an age; for even the individual, however idiosyncratic or innovative he may be, is still organically part of his time, responding to contem-

porary stimuli even in his most rebellious moods. The reservation is rather that the disparities, both in conception and technique, between verbal and visual forms of expression, as well as the different limitations which each medium must strive to overcome, are too wide to allow for the drawing of any ultimately valid comparisons.

On this point the structuralists have, tangentially, come to the aid of synchronist research. The separation of *langue* from *parole* in the semiotic studies of Ferdinand de Saussure has revealed the extent to which language communication, both written and spoken, relies even in its most primitive forms upon a matrix of social norms. That matrix, it is argued, endows the reader or listener with a competence for deciphering patterns of meaning which the words in isolation would otherwise possess in only a restricted sense. The cultural setting of texts becomes by this linguistic approach not merely an interesting background to the works but intrinsic to their comprehension, making literary criticism isolated from that context no longer fully persuasive. Furthermore, the seminal studies of Lévi-Strauss and his followers, exposing in literature a concealed level of systematized mythic relationships bearing universal significance, have furthered the recognition that any segregation of literature from other forms of artistic expression (which by their nature share such mythic elements) is both arbitrary and artificial.[2] The result has been a new impetus for interart studies which, with the added momentum of Julia Kristeva's concept of intertextuality, developed by Harold Bloom, takes us outside the bare text to consider those philosophical, literary, or social traditions which impose preconditions on our reading, as they do on our responses to other arts. Critics such as Mary Ann Caws can now posit the existence of an "architexture" in each era, an intertextual overstructure created with the reader's collaboration, which transcends the barriers between the media. Structuralist interpretation has, for example, made possible, as in her own work *The Eye in the Text*, the application to literature too of psychologically analyzed principles of "perception" or creative illusionism which had previously been the exclusive preserve of such art historians as Gombrich and Arnheim; and by that cross-application has demonstrated as outmoded the claim that each art form must be judged solely by its own rules.[3]

Such critical developments have, then, confirmed, at least theoretically, the

legitimacy of the waif, offering linguistic, mythological, and sociological justi-
fication for interdisciplinary studies even in the absence of demonstrable histor-
ical sequence. What remains questionable, however, is the youngster's right to
acceptance into academic society on the grounds of his performance hitherto.
For on the basis of the work which has appeared, there exists considerable scep-
ticism whether the study of such an amorphous entity as periodized interart re-
lationships can be responsibly pursued. It is, for example, a firm principle of
such enquiry that no direct contact need be established between the writer and
the contemporary painter or architect, nor even any knowledge of each other's
works evidenced for stylistic affinities to be perceived; for it is assumed that each
may independently be fulfilling the task of the creative artist as it was defined by
Shakespeare—to show ". . . the very age and body of the time its form and pres-
sure," with that shared age or time producing stylistically comparable results.
Such a principle, however, offering a justifiable release of the critic from one
scholarly requirement, has proved a temptation for the synchronist to relax
other requirements too, encouraging him to rely only too often on an allusive
juxtapositioning of contemporaneous works of art and literature in place of the
detailed critical scrutiny necessitous in other branches of literary history and
analysis.

In an article which should be required reading for all aspiring students in the
field, Alastair Fowler, in the wake of a similar attack by Rosemund Tuve,
pointed a few years ago to the dangers inherent in the very idea of literary peri-
odization. On that point he does, despite his reservations, conclude with a will-
ingness to acknowledge the existence of synchronic patterns in history and the
consequent necessity, with all requisite circumspection, for the use of periodi-
zation as part of our critical apparatus. His main target is elsewhere. What he
does castigate is the methodology adopted by the leading exponents of the syn-
chronic approach who have, he suggests, fallen into the very trap which Wellek
foresaw as early as the 1940s, ". . . the tendency to impressionistic comparisons
and easily elastic formulas" which can be stretched to fit almost any precon-
ceived theory.[4] Mario Praz and Wylie Sypher have indeed stimulated much
thought and have often proved truly valuable in opening up new lines of inves-
tigation; but Fowler was surely voicing an exasperation felt by many readers

when he complained that they leave the hypotheses of their analysis substantially untested and, as such, must be regarded as academically unacceptable. They rely for the most part on a vague gesturing towards supposed parallels or, what is worse, on subjective assertions unsupported by evidence. He quotes in this regard a characteristic passage from Sypher's best-known work: "We can believe that mannerism is an art of bad conscience when we see the helpless gesture of El Greco's Laocoön, who seems destined to his serpent beneath a torn sky that is like a wound in the mind. The restlessness in Michelangelo's figures, the wilful David-frown, the writhing Night, and the unfinished marbles he left in their stony anguish provoke us to ask psychoanalytic questions—the questions we are tempted to ask about El Greco's enraptured saints, Saint Teresa, the puzzled Hamlet, and the strange people in Ford's evasive play *'Tis Pity She's a Whore.*"[5] Why the helpless gesture of Laocoön should be interpreted as a sign of "bad conscience" (whatever that may mean here) is left unexplained, as is the putative connexion between the stony anguish of Michelangelo's unfinished sculpture and Hamlet's puzzlement. Since such indeterminate comparisons form the basis for his broader interpretation of the mannerist temperament in art and literature, there can be little wonder that the edifice he erects upon that foundation may to many appear unstable, and that the synchronic method itself has, at least in that form, as yet failed to win the confidence of scholars.

There is, however, an area of synchronic research which can, I believe, prove rewarding and entirely legitimate. It aims not at period definitions *per se*, nor at analogue-hunting, but at something both more specific and more constructive, employing what may be termed a process of inferential contextualization. Instead of establishing initially some broad premiss defining the spirit of the age and demonstrating how various works of art and literature may be seen to conform to it, a reverse direction is followed. The research begins from a literary text and, even more specifically, often from a particular problem related to it, which has (perhaps for lack of further evidence obtainable from that era) remained in dispute. On such occasions, a knowledge of contemporary stylistic changes in the plastic or visual arts and, even more so, of the historical reasons which motivated painters, sculptors, or architects of that time to desert one technique in favour of another may offer a fresh approach to the literary work

by assuming that a writer living in that era and experiencing the same historical pressures may well have shared those impulses too. The supposed weakness in Milton's portrayal of an at times attractive and even heroic Satan, or the suggestion that his War in Heaven is ultimately comic can take on a different colouring when seen in terms of the baroque artist's desire to portray with deep seriousness the clash of immense forces, as part of his imaginative response to the innovative cosmic theories of his day.[6]

One requirement is, however, indispensable to such research if it is to achieve credibility. Any theory arising from these inter-art comparisons must be empirically tested by a rigorous and detailed analysis both of the art works and the literary text in place of the impressionistic responses and vague gesturing which have given synchronic enquiry its doubtful reputation. Due caution is needed to ensure that a theory is not being read into the literary work but genuinely arises out of it once the principle has been perceived, with the imagery, diction, and thematic treatment confirming the interpretation. Ideally, the reading offered of that work should emerge at the final stage as totally independent of the art parallels, resting instead upon substantiation adduced from the text; but the use of the art context will have been retrospectively justified since it served as the source of the original insight, suggesting an approach without which the subsequent analytical investigation could not have been conducted. If at certain times the argument may still fail to convince—and the reader's freedom to judge is, mercifully, a precondition for all criticism—at least the evidence on which it was based will have been made fully available, and on that evidence the theory, again as in all criticism, must finally stand or fall. Indeed, for those denying in principle either the existence of a *Zeitgeist* or the validity of interart parallels, the textual analysis may be judged independently on its own merits; but for those who do acknowledge, however hesitantly, some degree of interrelationship among the arts, there will be the added satisfaction, where the theory does seem convincing, that it is corroborated by the broader aesthetic context within which the literary work was produced.

This present volume offers a series of essays applying that technique to the works of leading English authors during what is still broadly known, despite its various artistic subdivisions, as the Renaissance; that is, the period from the

fourteenth century to the mid-seventeenth. Since so much of English art was destroyed at the Reformation and England, for reasons which have never been satisfactorily explained, took so long to develop its own national style in the visual arts, relying for the most part upon the importation of foreign artists, the contemporary aesthetic movements from which contrasts and parallels are derived are those belonging to the developing continental tradition, with which England was in constant contact. Each essay here is a self-contained unit devoted to a single author, work, or literary topic, but by offering them in chronological order I have hoped that a further aspect will emerge as a unifying theme, the subtle changes in "perspective" within that lengthy period—perspective not in its narrower sense of mimetic fidelity, as in the attempt to transfer a three-dimensional scene on to a two-dimensional canvas or page, but in its original meaning of "seeing through" one scene into another scene beyond. It may be helpful to elaborate.

There has in the past few years been a renewal of interest in the concept of spatial form whether in the illusionist sense of volumetric verisimilitude or as a metaphor applied to the morphology of language and to narrative sequence in literature. The *Critical Inquiry* has been particularly active in that area, with Earl Miner suggesting there the connexion of spatial metaphor to physiological factors in the brain, others examining the assumption of measurable linear or circular movement for chronological progression as in the use of *long* and *short* to describe intervals of time (with Wayne Booth musing whether the introduction of the digital clock will affect that usage) and the editor of that journal, W.J.T. Mitchell, offering a helpful overview of the debate.[7] My own interest, however, goes further than concern with the spatial measurement of actuality, whether in its literal or metaphorical forms, and even than the illusionism implicit in attempts to capture the concrete world realistically. For I would argue that the artist's and writer's view of the tactile world in which he lived was itself profoundly affected at all times by his conception of the imagined world beyond, whether that was the Christian eternity of afterlife, the semi-pagan Neoplatonic heaven of idealized forms, the redemptive dream world of the Loyolan meditator, distorted by the intensity of his religious fervour, or the physically conceived and rationalized infinity of the baroque cosmos. In each instance, the entity beyond

8

constituted a projection of dissatisfactions and assertions, aspirations and fears, implicit in man's mortal condition as it was conceived in that generation. It both reflected and retroactively modulated areas of human experience outside the religious sphere as well as within, including the preference he accorded to rational proof as opposed to transcendental paradox, to social conformity as opposed to a cultivation of the inner life, to self-indulgence in contrast to asceticism and, above all, the degree of authenticity which he afforded to the tangible reality about him. Volumetric fidelity in painting and verisimilitude in drama or narrative are not skills to be evaluated on their own terms, with the highest marks awarded for the depiction most faithful to nature, but (as the deliberate stylization of Egyptian portraiture and of modern expressionist drama suggest) are functions of the way in which the creative artist used his earthly setting as a frame through which man's hope of future, eternal existence could be asserted, implied, and at times bitterly denied. Such "perspective," in this specific meaning of the term, forms the coordinating theme of the following chapters.

EARLY RENAISSANCE

I

THE PILGRIMAGE TO
CANTERBURY

THE ANCIENT GREEKS, IT HAS BEEN REMARKED, LABOURED UN-
der a peculiar misapprehension—a failure to realize that they were ancient.
Those categories and periods to which we assign past writers are for our own
convenience, an indulgence of the historian's proclivity for schematic tidiness
for the most part imposed retrospectively and only rarely acknowledged by the
authors themselves. Chaucer, we may suspect, would have viewed with wry
amusement ("Men may divine and glosen up and down") the modern dispute
among scholars concerning his historical affinities, the problem whether he
should be classified as culturally indigenous to the Middle Ages or as an early
exponent of Renaissance sensibilities. Yet in this instance the determining of his
milieu does carry implications beyond mere period-labelling, and is of major
relevance in the interpretation of his texts. For a poet so elusive in the ambigui-
ties of his moral stance, whose pervasive use of unresolved irony is a hallmark
of his verse, a knowledge of the author's cultural setting, of the contemporary
moral and religious assumptions upon which he would have drawn as a writer
and relied for audience response could prove invaluable for modern assessment
of the intent behind the irony and of the meanings which his work would have
conveyed to a fourteenth-century reader.

In the recent controversy over Chaucer's cultural allegiance, the proponents
of the "allegorical" reading of *The Canterbury Tales*, insisting on the essentially
medieval character of the work, have posited it as fraught with the theological
and literary conceptions of the schoolmen, and to be read within the context of

the iconological principles prevailing in the Church-dominated literature of that time. In a provocative study, modestly termed a preface to Chaucer but in fact constituting a brilliant and wide-ranging exploration of the cultural lineaments of the period in which Chaucer wrote, D. W. Robertson, Jr., has argued against the popular belief that in the later Middle Ages a conflict or tension existed between the religious asceticism advocated by the Church and a growing desire among the people, pagan in tendency and often folkloristic in source, to celebrate worldly pleasures. Those lively scenes of music-making, of courtly amorousness, or even of frank carnality which found their way into the moralistic literature of the time did so, he maintains, not as an intrusive secularism which ecclesiastical authority was powerless to exclude as a new generation began to delight in a faithful mirroring of human activity. He sees them rather as part of an integrated and ordered didactic system, in which such scenes would have been immediately comprehended by the reader in condemnatory terms, as warnings against waywardness and the evil consequences of immorality.

The practical effects of such an approach for an evaluation of the poem are potentially far-reaching. The seemingly casual comment with which Chaucer concludes his description of the burly Miller:

> A baggepipe wel koude he blowe and sowne,
> And therwithal he broghte us out of towne.
> (*Gen. Prol.*, 565-66)

had traditionally been seen as exemplifying Chaucer's graphic realism, conveying the conviviality of the pilgrims as they joyfully set out on their way. However, in the light of the code of religious allegory which the Church had disseminated throughout the media, it has been argued that, since the wrestler was in the manuscript illustrations of the day an acknowledged "type" of moral disorder and discord and since the bagpipes signified (partly by their shape) the Old Dance of carnality as opposed to the New Dance of Christian harmony,[1] that scene would have evoked from a contemporary audience a response contrary to that of the modern reader, a sad recognition of the ill-omened start to the pilgrimage and Chaucer's disapproval (as author, if not as narrator) of the frivolous direction it had taken.[2]

Others, in extending this symbolic reading, have suggested a more solemn intent for the overarching pattern of the work as a whole. On the principle of fourfold scriptural exegesis, in which the surface meaning was a husk concealing a kernel of truth, the *Tales* have been seen, notably by Ralph Baldwin, as an emblem of the spiritual journey of mankind, with the opening description of the springtime engendering of flowers symbolizing the Creation, the pilgrimage itself representing man's movement through this temporal world on his way to heavenly judgment, the Parson's treatise redirecting the pilgrims after they have strayed from the true path, and Chaucer's own retraction at the conclusion marking a momentary pause at the threshold of eternity.[3]

As critics were quick to point out, some of the assumptions behind this theory need to be examined with caution. To regard the allegorical view, the interpreting of this world in symbolic terms as the "medieval" context from which Chaucer wrote, is to attribute to the Middle Ages a homogeneity, an unchanging, monolithic structure which they did not possess, and thereby to underplay the numerous theological variations and shifting emphases occurring during the long period included within that term. Morton Bloomfield has expressed doubts whether the principle of multilevel exegesis employed for reading the scriptures, as simultaneously conveying a literal, allegorical, moral, and anagogical meaning, was regarded at that time as applicable to literature in general, since it seems to have been recognized as specific to the divinity of the biblical text. It was a sacred quality which no human author was presumed to possess. R. E. Kaske similarly questions the denial of tension or complexity of response in medieval literature on the grounds that, as in all times, both society and human nature were many-faceted. Augustine's condemnation of *cupiditas* or interest in worldly objects for their own sake, while it may have been the ideal for living enunciated by theologians, was in practice not a firm principle adhered to by all men. Secular texts from that era should therefore not be forced by the interpreter into a preconceived pattern which they probably were not intended to possess.[4] Nevertheless, most literary historians have recognized the potentiality of this symbolic reading as a valuable tool for exegesis, not least as a corrective to the popular view of Chaucer as chafing at the aesthetic restrictions of the Church and basically sympathizing with the sensuality of his more earthy char-

acters. If the Wife of Bath is not entirely, as the allegorist school has asked us to believe, an iconographic figure of carnality intended to be duly condemned by the reader for her misinterpretation of patristic sources, it is certainly illuminating to recognize, within Chaucer's description of her, echoes of medieval symbolism which add a richness and subtlety to her depiction. Her being "somdel deef" is seen no longer as a casual descriptive detail, but as evoking for contemporary audiences the long-eared ass seated before a harp in many illuminated manuscripts to signify those who have ears but cannot hear the word of God.

As that last instance indicates, the argument for the allegorical reading of Chaucer has relied for much of its evidence on a close analysis of medieval art. While historians have responded and continue to respond to the theological and literary implications of Robertson's argument, his discussion of the visual arts of the period, of the illuminated manuscripts and medieval misericords, has been generally accepted as valid. Such approval is certainly justified in part. His perceptive comments on the many illustrations he brings before the reader prove beyond doubt that the animal figures and fantastic hybrid creatures to be found within the foliage ornamenting the text of a sacred manuscript were frequently not the idle invention of some irreverent or inattentive scribe, as many historians had believed, but in fact possessed a symbolic significance directly related to the text itself, the connexion having been apparent to any alert medieval reader. Thus a page from the fourteenth-century Ormesby Psalter (*fig. 1*) is shown by him to depict the contrast between the heavenly harmonies, represented within the decorated initial where King David plays on a harp accompanied by his musicians, and the human discord depicted within the borders of the page. Below the text, two men wrestle, urged on by a snarling ass-eared monster; above, a goat-footed (lecherous) husband clashes with his leonine (irascible) wife as she heraldically wields her cooking-pot and spoon; and to the right a warrior, lacking the courage inspired by such celestial music, drops his sword in terror at the appearance of a mere snail. So too, the scenes of hunting decorating the margins of many such illuminations were not secular encroachments, it is argued, a mundane realism distracting from the sacredness of the religious work, but rather allegorical depictions of the love-chase, with the rabbit (perhaps through a pun on *cony* and the French *con*) representing the pursued female. The scene as a

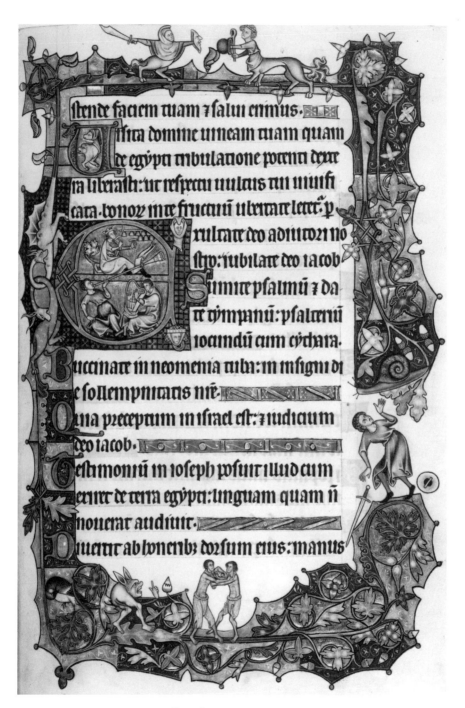

1. Page from Ormesby Psalter

whole is thus intended to contrast the depravity of sexual licence with the divine love advocated within the text.

The problem lies not in the argument itself, with its persuasive evidence that there was often a much greater integrity in such illuminations than had previously been believed, but in its extrapolation into a general theory, the assumption that all art of the period was therefore similarly subordinated to the solemn moral message of the Church. Any instances of realism in such art, it is asserted, were included only to exemplify the relevance of the moral lesson to the reader's own world, as in the depiction of a contemporary alehouse in the Taymouth Hours to localize a scene of lechery, and they do not indicate any growing interest in the actuality of this world. The question remains whether the evidence adduced is sufficient to warrant such a conclusion.

It is surprising, for example, that of over one hundred instances from art of that period selected and reproduced for analysis in Robertson's book, there appears not one from the famed Luttrell Psalter of about 1340, which is so rich in lively marginal scenes drawn from everyday life that it has served, and continues to serve, as a major source for illustration in countless history books. It contains the vivid drawing of a bear-baiting scene (*fig. 2*) presented with a cool, uncritical observation which would seem to deny any didactic or symbolic overtones. There are some less sophisticated sketches of assorted activities within a contemporary kitchen (*fig. 3*) again free from moral associations, of a physician treating a patient, of a travelling coach so detailed that it has improved our knowledge of transportation in that era, and numerous depictions of seasonal agricultural tasks being performed with the simple implements then in current use. All of these, we should recall, appeared as illustrations in a sacred Book of Psalms. Any theory denying that the later Middle Ages developed a growing interest in the physical world would need to explain the existence of such drawings and their intrusion into a holy text. Indeed, it has long been recognized by historians that the attractiveness of English art in the fourteenth century is to be found less in the monumental achievements of that period than in the incidental.[5] There are the numerous carvings beneath misericords, as well as the marginal illuminations of texts with mimetic scenes that display not only an eye for precise detail and accuracy of form but often a puckish humour which clearly places the work

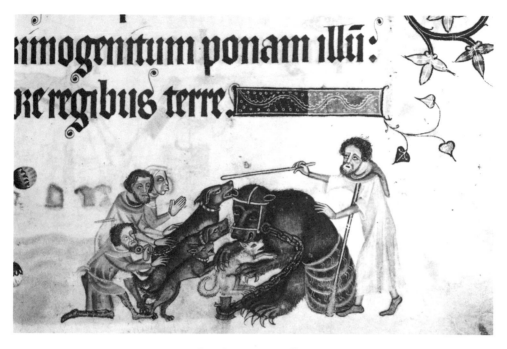

2. *Bear Baiting*, Luttrell Psalter

outside the solemn religious symbolism now being claimed for all art of the period.

In the Gorleston Psalter from Norfolk, dating from about 1305, the artist playfully sketches a funeral in which rabbits are the officiants wearing the robes of clerical office and solemnly carrying the cross, candles, and incense-burner, while two dogs, also walking on their hind legs like humans, carry the bier between them (*fig. 4*). In the Luttrell Psalter, one of the many "babwyneries" or monkey-pictures abounding in this period whimsically replaces the human figure by that animal in an otherwise sharply realistic drawing (see *fig. 5* with its careful shading of the horses' haunches).[6] And in a misericord from Winchester, a shepherd embracing two sheep (*fig. 6*) is mischievously viewed from above in a manner which ludicrously foreshortens him, enlarging the upper portion of his body at the expense of the lower. These might be thought minor instances, the *marginalia* of art in a figurative as well as a literal sense; but in the broader

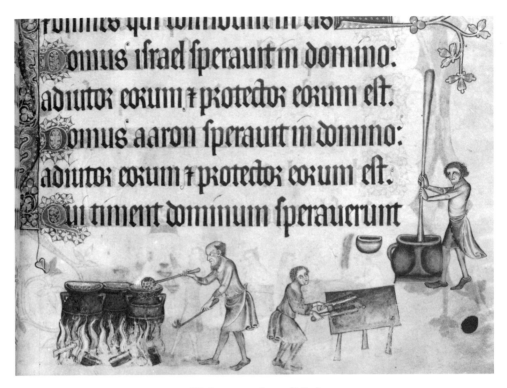

3. *Kitchen scenes*, Luttrell Psalter

range of European painting at this time, there are firm indications that the long-established distrust of sensory experience advocated by the schoolmen was being weakened not only in the popular mind but also in the attitudes of those engaged more directly upon religious tasks and upon disseminating the moral messages of the Church.

The exploration of contemporary painting in search of evidence helpful for literary analysis has, in connexion with Chaucer, a twofold justification. Most obviously, the claim for a medieval reading of *The Canterbury Tales*, by having rested much of its own case upon the manuscript illuminations of that time, invites further such evidence from anyone contending with the view. Yet for negative reasons too, that claim, by the nature of its argument, diverts the critic to non-literary sources; for the theory employs a process of reasoning which

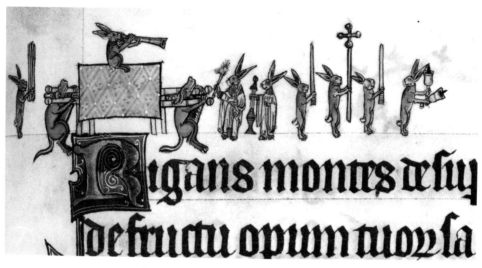

igans montes de sup

de fructu opium tuoz sa

4. *Funeral Conducted by Rabbits*, Gorleston Psalter

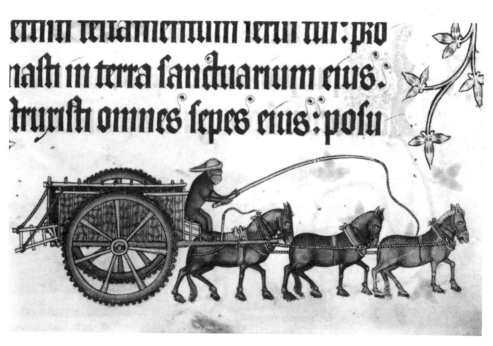

ettitit tettametttum tetut tut: pro

nasti in terra sanctuarium eius.

truristi omnes sepes eius: posu

5. *Monkey Waggoner*, Luttrell Psalter

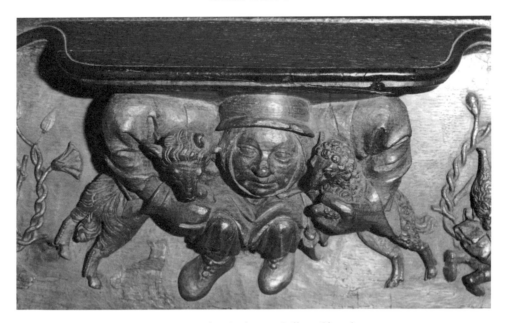

6. Misericord, Winchester College Chapel

strangely allows no exit from its assumptions, an inbuilt defence mechanism which not only discourages attempts to question or even modify its conclusions by recourse to the text, but disconcertingly places such reservations outside the bounds of literary controversy. The interpretive principle it insists upon for that era is, indeed, made automatically to disqualify in advance any contrary evidence drawn from Chaucer's writings. The fourteenth-century reader, we are authoritatively informed, belonged to a world knowing nothing of tensions, only of morally directed synthesis. It was a period continuing uninterruptedly the tradition of Peter Abelard's *Sic et Non* which posited dialectic polarities only in order to conclude by reconciling them. On that assumption, it is claimed, any interpretation of Chaucer's work which appears to contradict this principle must *ipso facto* be the result of a modern misreading, a projection upon the text of our post-romantic propensities towards pluralism, class struggle, conflict and ambivalence, of which the fourteenth-century reader was innocent.

The axiom thus dictates the reading, and where the evidence of a counter-

thrust in the text is so explicit as to be undeniable—when Chaucer's narrator states openly his sympathy with a rebel against Church doctrine ("And I seyde his opinion was good. / What sholde he studie and make hymselven wood / Upon a book in cloystre alwaye to poure")—the passage, we are told, must, by reason of that overarching didactic intent, be an instance of *antiphrasis*, or what Isidore of Seville called *alieniloquium*, arguing ironically for the reverse.[7] Such a reading may or may not be true for the specific instance adduced, but as a principle it closes the door on flexibility in interpretation and by such anticipatory invalidation of alternate readings precludes the normal recourse of the critic to search for counter-evidence within the text itself. Under such circumstances, the general axiom must be examined first. More broadly, we shall need to question the hypothesis that no basic change in outlook had occurred between the period of the medieval schoolmen and Chaucer's composition of the *Tales*, and in such matters of broader cultural significance an examination of the visual arts is certainly relevant.

An especially valuable tool for gauging shifts in philosophical, ethical, or religious patterns of thought is what may be termed the principle of "thematic convergence"—the identification of any sudden prominence or popularity of a theme, topic, or scene to which writers, painters, novelists, poets, and musicians are attracted, often quite independently, presumably because it answers in some way to the specific concerns of their time. Those vignettes of the eighteenth-century aristocracy at play in the works of Pope, Watteau, and Lancret, the recurrent deathbed scenes in the Victorian novel, the cluster of animal fantasies in nineteenth-century music and ballet, may reveal more of the deeper preoccupations of each age than was consciously intended by the artist individually drawn to the subject. When, as in the Middle Ages, the Bible prevailed as thematic source, fluctuations in the popularity of its variegated themes is particularly significant, together with the refocussing of emphasis in the artistic treatment accorded to them.

A remarkable instance of such thematic convergence in this period, which seems to have remained unnoticed by historians, may prove suggestive of a larger development in contemporary attitudes closely relevant to Chaucer's work. In Christian art, the scene of the Adoration of the Magi had received little

independent attention prior to this time, generally appearing as a subordinate component of the Nativity and only rarely depicted in isolation. From as early as the third century, the custom had arisen at Bethlehem of decorating the Grotto during each Christmas season with a model of the manger, lavishly executed in gold, silver, and precious stones; and as the practice spread from the Holy Land across Europe, each church or chapel would, at the Christmas season, have its own model *praesepe* celebrating the Birth. Present at that scene and forming an adjunct to it knelt the majestically robed Magi whose glittering gifts contributed to the jewel-like splendour, their homage as earthly kings symbolizing the reverence that was to be experienced by the spectator. That icon-like, static presentation of the scene was reworked in painting and sculpture throughout the Middle Ages, as in the brightly coloured enamel of 1190 from Limoges (*fig. 7*), where the kings seem timelessly present at an eternal moment of Christian history, cut off from the world as in some Byzantine mosaic. The miniature from an English psalter of 1210 (*fig. 8*) and the relief sculpture on the pulpit at Pisa by Nicholas Pisano dating from 1259, like so many other works of the time, demonstrate how this immobile quality in the presentation of the scene as a reverend and holy tableau was preserved. On rare occasions, as in the twelfth-century Albani Psalter from England, the Magi may be placed on horseback to indicate heraldically that they have come from afar, but they exist there motionless, isolated from any identifiable location.[8]

The irrelevance of spatial and temporal distinctions in a world viewed *sub specie aeternitatis*, which had in the early mystery plays allowed Joseph in Egypt to stand on the stage only a few feet away from his brethren in Palestine, lies behind this older iconography, with the principle of Christian typology encouraging in painting the telescoping of historically disparate events into a single framework. The prefigurative reading of the scriptures, by assuming not only a foretelling within the patriarchal stories of later Christian history but also a reverse process, a retrospective validation and re-enactment of the earlier prophecy at the time of its fulfillment, created a sense of chronological interchange, a merger of past and present into a transcendental moment embracing all time. In its more sophisticated form, medieval art could leave an often complex task of decoding to the reader, relying on his familiarity with medieval exegesis, so that

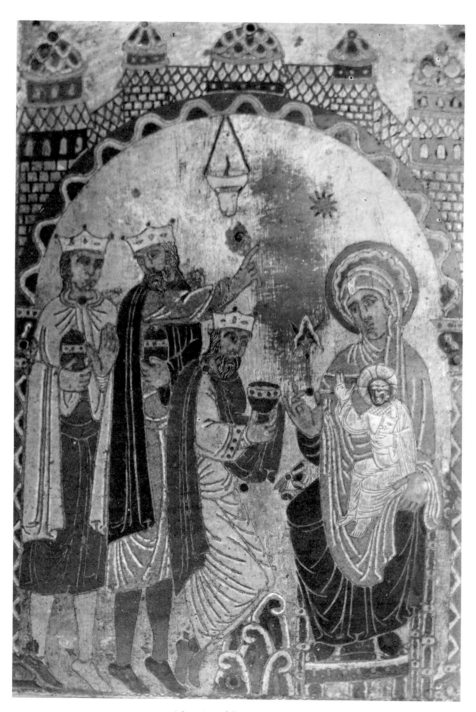

7. *Adoration of the Magi*, Limoges

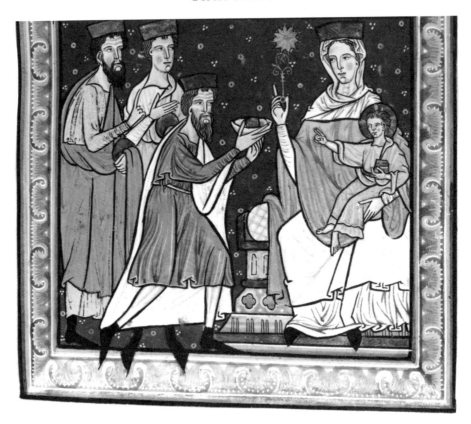

8. *Adoration of the Magi*, English Psalter

an apparently disconnected jumble of Old Testament scenes would emerge as
meaningfully unified. In a miniature from the twelfth-century Lambeth Bible
(*fig. 9*), the hospitality extended by Abraham to the angels in the twofold scene
above, the Binding of Isaac to the right, and Jacob's dream and subsequent li-
bation at Beth-el become, if read in this clockwise direction, dramatically con-
nected by the central image of Jesus, for whom they adumbrate respectively the
Annunciation, Crucifixion, Resurrection, and Eucharist. Implicit in such tem-
poral transcendence was the creation of a spatial montage too, with Mount Mor-
iah blending into Calvary, Beth-el into Jerusalem, in complete disregard of ge-
ographical location.

9. Illustration from Lambeth Bible

In the final decades of the fourteenth century, during the very years when Chaucer chose as the narrative frame of his work the description of a pilgrimage to Canterbury, the treatment and interpretation of the Magi scene underwent a notable metamorphosis, suggesting the artists' dissatisfaction with the traditional typological disdain for spatial rationality. A surge in the frequency of its depiction at this time—the prerequisite for applying the principle of thematic convergence—confirms that the topic in its new form had a peculiar relevance lacking in earlier periods, and the explanation of that new attraction is, as always, indicated by the change in the treatment of the theme. For the focus has now shifted from the homage of the Magi before the Virgin and Child, and been deflected to the *journey* which they have just completed, the lively movement from their fixed and distant locations to their moment of arrival at the specific place and time in Bethlehem where the Nativity has just occurred. Bartolo di Fredi's *Adoration of the Magi* dating from the 1380s (*fig. 10*), the earliest example I have discovered of this new reading of the scene, deserts the traditional depiction of an eternalized immobility detached from this world. Instead, there is an innovative dynamic quality, a jostling against spatial constrictiveness, a temporal immediacy as the horses crowd into the manger together with the Magi and their retinues, all of them thrust forward, as it were, by the momentum of their travel, the animals whinnying as they are drawn forcibly to a halt.

Introduced into the background of the painting in a manner which was to become standard practice in the new versions in order to underscore their fascination with travelling through this tactile world, is a lengthy procession of pilgrims still wending their way to the manger, winding through the variegated valleys and hills of the landscape, entering the gates of the town and being redirected onwards with their assorted accompaniment of camels and dogs inserted to enliven the scene. Even the town takes on a more local and topical aspect. The architecture of the main building, with its alternating bands of black and white stone, is in the Italian-Gothic style, familiar to the artist from his home cathedral at Siena only recently completed in 1380, and by being proudly reproduced here is clearly intended to lend a sense of contemporaneity to the scene. And finally, we may note a change in the structural design of the painting echoing the new interest, as the Madonna and Child are dislodged from their traditional position

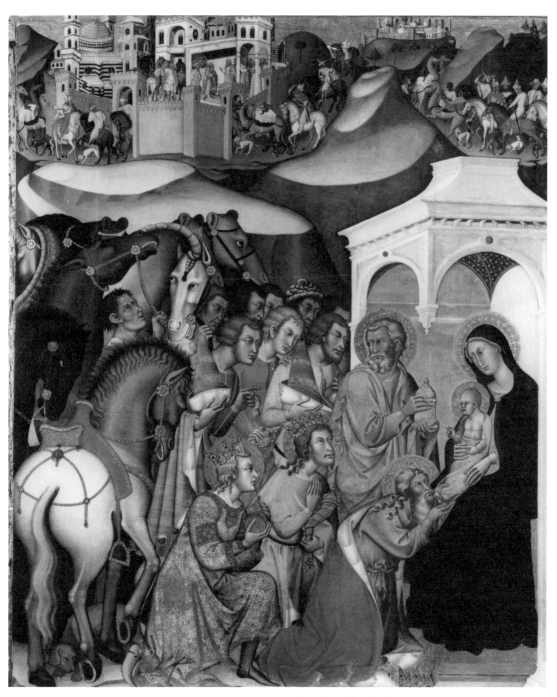

10. BARTOLO DI FREDI, *Adoration of the Magi*

of centrality to the bottom right-hand corner of the painting, still the venerated object of the journeying but no longer occupying a focal position to which the eye is first drawn.[9]

As an isolated instance, this painting would in any case have been remarkable for its break with earlier iconographical traditions, as well as for the lively movement of its figures and the artistic attention to detail; but, as has been indicated, it was the harbinger of a reading of the scene which was to displace the old abstracted eternalizations. That same preoccupation with physical motion is captured in the Magi scene from the anonymous Bargello altarpiece of 1390, which introduces into an upper corner a retrospective glimpse of the meeting of the wise men, conceived in forceful, even violent terms, as three galloping horsemen, pulling at their steeds' heads and bridles, strive to avoid collision. A similarly restless Magi painting was produced around 1400 by the so-called Brussels Master of the Initials, who preceded the Limbourg brothers at the court of Jean de Berry (*fig. 11*). There the procession of travellers led by the Magi pours into the narrow space of the stable from a pathway leading through a landscape picturesquely endowed with turreted castle, walled city, trees, and a windmill, elements now to become characteristic of such scenes.

A few years later, the Limbourg brothers advanced this interest by a further significant innovation, inserting before the traditional Nativity scene in their *Très Riches Heures* (ca. 1413-1416) an exquisitely worked painting devoted not to the Adoration at all but solely to an incident in their journey, to *The Meeting of the Magi (fig. 12)* before that event, with the three kings depicted as still in the course of their travel as they reach the crossroads near Calvary on their way to Bethlehem.[10] It is noteworthy as part of this developing sense of locality that despite the New Testament's specific statement that the Magi came from the east (Matt. 2:1), as had been the artistic tradition throughout the early part of the Middle Ages, it was in this period, in response to the new geographical awareness and increased exploration as navigational horizons were being expanded by the more effective use of the magnetic compass, that they began to be represented instead as coming respectively from the three major continents of the then-known world—Europe, Africa, and Asia—to demonstrate a more universal homage. Accordingly, one of the Magi, Balthazar, was often portrayed from

II. BRUSSELS MASTER OF THE INITIALS(?), *Adoration of the Magi*

this time as a black African king. In this miniature, the kings, as in the Bargello altarpiece, approach from their different directions, but here in addition they are distinguished by their exotic garb, associated with their respective and distant countries.

The introduction into a sacred work of this kind of a separate illumination devoted to the Magi's journey rather than to their homage at the Nativity was an innovation more unusual than might at first appear, since it was extraneous to the subject-matter of the volume. The books of Hours, originating from the desire of religious laymen and laywomen to preserve in their secular lives a pattern of monastic devotion and liturgy in which the periods of the day would be marked for them too by prayer and contemplation, at times took as their theme the Passion of Christ; but among women especially, the monastic "Little Office of Our Lady" (*Officium parvum beatae Mariae Virginis*), which had been added to the liturgy in the tenth century, was often felt to be more appropriate and became the model for a series of such books intended for meditation on the Life of the Virgin. The Office itself, preceded by a Calendar conveniently listing saints' days in red and gold (the so-called red-letter days), was followed by the Hours, each of which concentrated upon an event in the life of Mary herself in the order of the Annunciation (Matins), Visitation (Lauds), Nativity (Prime), Annunciation to the Shepherds (Tierce), Adoration of the Magi (Sext), Presentation in the Temple (Nones), Flight to Egypt (Vespers), and Coronation (Compline). From this liturgical sequence it is evident that the only grounds for including an Adoration of the Magi in the series was its relevance to the Virgin, namely their humble veneration of her and the infant Jesus.[11]

In the superbly executed *Meeting of the Magi* which the Limbourg brothers inserted, no manger is visible. There is, therefore, no theological justification for the inclusion of the painting in a devotional book of Hours sacred to the Virgin's life, only the artist's fascination with the journey, with the flamboyant dress of the turbanned travellers, their gorgeous equipage, and the variety of their escorts (to whose animals there is now added a pair of tame cheetahs, presumably modelled from life on the three cheetahs which we know to have been presented to the court as a gift by the Duke of Milan). Typology did not, of course, cease to be employed in such miniatures and paintings, but it operated

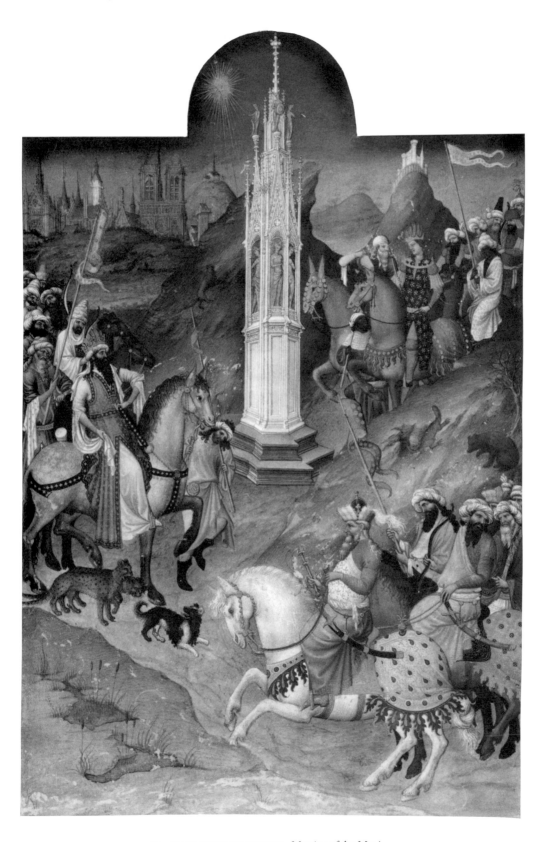

12. LIMBOURG BROTHERS, *Meeting of the Magi*

henceforth with a greater sensitivity to mimetic realism, reproducing the phys-
ical world familiar to the artist. In this painting, if the town in the background
is intended to represent Jerusalem, the artist, as in Bartolo di Fredi's version,
turned for his models to the churches he and his readers knew first-hand in Paris,
to Sainte Chapelle and Notre Dame de Paris so easily identifiable in their faithful
representation here.

By the time of the sumptuous *Adoration* of 1423 by Gentile da Fabriano (*fig.
13*), the exploitation of the event to depict the bustle of travel has become a staple
ingredient. Apart from the splendid cavalcade behind, with its menagerie of pet
monkeys, camels, leopards, and hunting hawks, there is in the crowded main
scene the engaging detail of a servant crouching to remove the stirrups from his
master, as an indication that the latter has only just dismounted. Yet even more
striking here is the impression that, despite the ostensible devotionalism of the
painting intended as an altarpiece and framed in a manner evocative of a trip-
tych, it is ultimately a celebration of worldly wealth and aristocratic magnifi-
cence. Beside the brilliant golden elegance of the younger Magus's robes, posi-
tioned as he is beneath the central arch of the painting, the monotone cloak of
the Madonna seated to one side appears almost drab. Theologically the holiness
of the scene is preserved, for the monarchs have come here to pay respect to their
eternal King. But from the semiotics of the presentation there can be little doubt
where the artist's interest lies, as the eye is drawn away from the holy tableau to
the splendour of the royal visitors, as well as to the circumstantial details accom-
panying human activity—not least in the homely detail of a muzzled dog in the
foreground, turning its head away from the main scene to gaze up a trifle anx-
iously at a horse whose hoof is coming dangerously close.

Gentile's introduction into this painting of figures reminiscent of the Flor-
entine noblemen of his day viewed in their ceremonial splendour marks an in-
terest which reaches its culmination in Benozzo Gozzoli's version of the *Journey
of the Magi* (again, we may note, not an Adoration but a Journey) in the chapel
of the Medici-Riccardi palace in Florence (*fig. 14*), for there the Magi are not
merely evocative of but represented by the Medici princes themselves. The
procession, while still biblical in theme, was, it is clear, intended primarily to
reflect the glory of the noble family in having recently achieved the transfer of

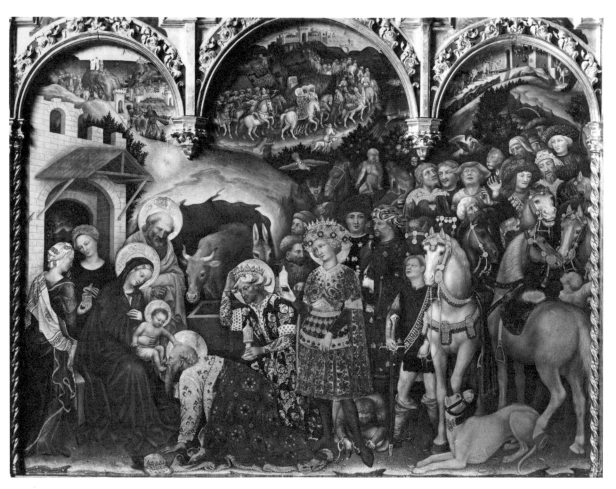

13. GENTILE DA FABRIANO, *Adoration of the Magi*

the Grand Council from Ferrara to Florence; and they appear here in recognizable portraits riding in splendid apparel through the hills of their local Tuscany, while members of their retinue are engaged behind in hunting a stag.

The Magi theme was not alone in displaying the new interest. In secular painting too the artist's imagination was drawn in a manner unprecedented in art to scenes of movement and travel within a naturalistic setting, localized by recognizable castles, chateaux, or churches. Simone Martini's *Guidoriccio da Fogliano*, commissioned in 1328 as a tribute to the general's victories on behalf of Siena, points the way to the new fashion by depicting him in motion, cantering on an elaborately caparisoned charger from the small Sienese hill-town he has already recaptured, its own flag proudly flying once again, towards the second town which he is about to relieve, its main building carefully reproduced for the benefit of the local inhabitants coming to view the painting. Ambrogio Lorenzetti's *Good Government* fresco from 1339 and Francesco Traini's *Triumph of Death* from about 1350 again depict scenes of people on the move in city and country, and towards the turn of the century that theme is well established. *The Duke and his Party Arriving at the Chateau* painted in 1409 by the Limbourg brothers, as well as their "Cavalcade" illuminations for May and August in their most famous book of Hours, all testify to the popularity of the motif of itinerary. So prevalent does the artistic fashion become that even the funeral of Charles VI of France in 1422 is recorded in movement by an artist as the procession emerges from the portals of the city against a detailed panorama of contemporary Paris, its two great churches prominent on the horizon. Religious art outside the Magi scenes displays a similar interest at this time in scriptural travel themes suitable for indulging the new taste, including *The Way to Calvary* and *The Flight from Egypt*—one particularly fine example of the latter, completed in 1399 by Melchior Broederlam, portraying a peasant-like Joseph leading the holy family along a rocky path through a tree-covered landscape towards a distant castle set atop a craggy hill.[12]

The Magi theme, however, has an especial relevance for the present study, since in addition to its sudden prominence in the art of the time, it underwent a major transformation, a deflection of focus from the eternal to the temporal, from a mood of holy veneration to one of lively observation. Moreover, the

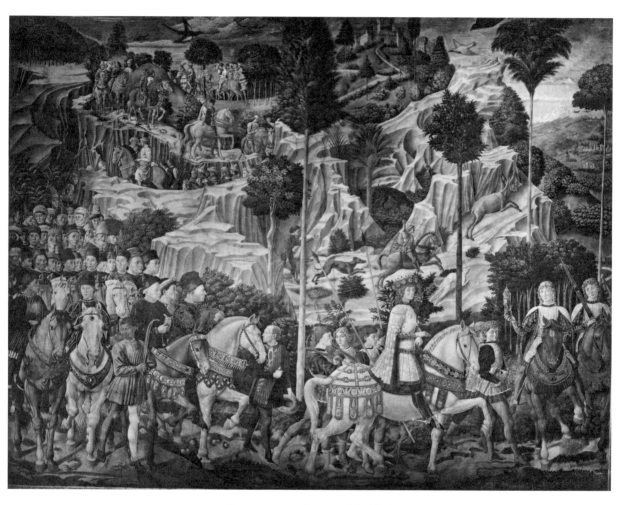

14. GOZZOLI, *Journey of the Magi*

change occurred in a scene at the very centre of Christian narrative. Versions of it, to be placed on the high altar of S. Trinita church, in fresco on the walls of a family chapel, or as an illustration in a devotional book of Hours, were being informed by a fresh responsiveness to the everyday world, the journeys offering not only a sharper sense of fixed location and measured time, but also the opportunity in art as in contemporary poetry for social discrimination, for perceptive depiction of the "sondry folk" participating in such travel as a cross-section of humanity, from the gorgeously clad Magus to the liveried servant leading his horse. It was, despite the religious purpose of that journey, a portrayal of:

> al the condicioun
> Of ech of hem, so as it semed me,
> And whiche they weren, and of what degree,
> And eek in what array they were inne.
> (*Gen. Prol.*, 38-41)

Such immediacy of depiction, or *haecitas*, suggests that the medieval sin of curiosity, for long castigated by the Church, was indeed beginning to lose its pejorative associations even within ecclesiastical art. Patristic sources, in their encouragement of the ascetic life, had ensured that the sin of *curiositas* should be firmly anchored in scriptural texts in order to augment its gravity. The warning against excessive worldliness in I John 2:15, "Love not the world, neither the things that are in the world," had been read back into the story of the Fall, with the forbidden fruit signifying the things of this world. On an analogy with the three temptations resisted by Jesus in the wilderness, the three human weaknesses which led to the Fall were identified as "the lust of the flesh, the lust of the eyes, and the pride of life." Of these, the central temptation, the lust of the eyes, became recognized by the schoolmen in a term sounding strangely as a sin to modern ears, the crime of *scientia*. The knowledge of the visible which had so treacherously led Eve to the forbidden tree had, it was argued, been preceded by its usual antecedent, *curiositas*, and in Book X of the *Confessions*, Augustine had listed among his own grievous failings that of *concupiscentia oculorum*, the sin of inquisitiveness regarding the things of this world. It may well be, as Donald Howard has argued, that the three vows of chastity, poverty, and obedience

which served as the underpinning of the monastic orders had originally been intended as a means of strengthening the monk against these three specific temptations, with the vow of poverty representing a renunciation of all worldly things and therefore serving to protect him against the lust of the eyes.[13]

The outcrop of treatises on the theme of *contemptus mundi* was, of course, a phenomenon not of that early period, when it could be taken for granted, but of the twelfth century onwards, when the impetus towards monastic renunciation of the temporal had weakened, and a fresh impulse to move out into the world seemed to animate society. The newly founded Franciscan and Dominican orders encouraged a desertion of the cloister in favour of ministration to the needy on their home ground; the quests of knights in search of the holy grail captivated the imagination; and the hunt, with or without moral connotations, became a favoured subject in art.[14] Bernard of Clairvaux might in his *Steps of Humility* exhort the more conservative monk to remain entrenched within the monastery and enjoin him to walk there with head bowed and eyes fixed on the ground lest he succumb to the curiosity which had corrupted the despised *gyrovagi* now wandering beyond its walls, but he could not stem among those outside the sense of spatial reality developing throughout the thirteenth and fourteen centuries, nor the informed interest in the daily affairs of human existence.[15] By the time of the Magi paintings we have been examining, Mandeville's *Travels* was being eagerly read, with its account of a pilgrimage to the Holy Land seen through the eyes of a sharply observant traveller, perhaps fictional but displaying the same kind of shrewd observation of people, places, and dress as inspired these imaginative recreations of the Magi scene.

Such acute perception was not always secular in the sense of distracting from the religious life, at times being regarded as a natural concomitant of it. The story of Petrarch's ascent to the summit of Mount Ventoux and the realization that, as his copy of Augustine's *Confessions* informed him, admiration of natural wonders merely causes the viewer to lose his own sense of selfhood, did, it is true, end with his descending in a chastened mood. Yet as a counterweight to this incident, so often quoted to illustrate the guilt which assailed men when they responded to the wonders of travel, it should be recorded that Petrarch's friend Giovanni Doni dell'Orgolio appears to have experienced no qualms at us-

ing his pilgrimage to Rome in 1375 as a means of enlarging his secular knowledge of archeology by examining ruins and buildings at first hand. On that journey, as Roberto Weiss has indicated, he imperturbably took copious notes of the classical ruins he managed to visit *en route*, including the bridge built by Tiberius at Rimini, and, while in Rome itself, devoted so long to examining the numerous classical sites there that he could have had little time for attending the churches.[16] Petrarch himself had written to friends in 1358 urging them on their pilgrimage to the Holy Land to ensure that they passed through Italy in order to enjoy its treasures.

Sometimes such visual awareness could be exploited as a means of reinforcing religious faith, particularly when scriptural scenes could be presented in a more contemporary form and thereby made relevant to the daily life of the believer. The meditative practices which St. Anselm and others advocated at this time as a method of intensifying the sense of identity between the worshipper and the saint contemplated, and which might have been expected to turn thoughts away from this world, could produce a contrary result. It encouraged Giovanni de San Gimignano to produce in the first years of the fourteenth century his enormously popular *Meditationes Vitae Christi*, which presented a charmingly domestic view of Jesus. The Virgin there takes up sewing to help with the family budget; and in a contemporary painting in that genre, the young Jesus is depicted as toddling about in a child's walking-frame (identical in construction to those used today), while Joseph and Mary are engaged in their respective tasks of carpentry and weaving.[17] However indebted we may be, then, to those who have sensitized us to the symbolic and iconological code of an earlier era still functioning at certain levels in Chaucer's work, they are, as contemporary painting amply demonstrates, less justified in either denying outright or at the very least seriously underplaying the new mimetic responsiveness to the tactile world which was emerging in this period. At a climactic moment in his argument, Professor Robertson declares that we must visualize Chaucer's folk "not winding through the soft intricacies of a landscape by Constable, but outlined against a background of gold leaf."[18] Gold leaf, it is true, was still occasionally retained in Chaucer's time as a background for holy pictures, notably in the Wilton diptych of 1377; but such usage marked the tail end of a style, of which

the Sienese painters had been the last great exponents. The choice in visualizing the setting for Chaucer's folk is not between gold leaf and a Constable painting, but between the older gold-leaf tradition then dying out and the new delight in accurate depiction of landscape or other framings of human activities which appear in art at the very time when Chaucer was writing, and which his own poetic narrative so obviously shares.

The Tower of Babel (ca. 1423) from a French book of Hours belonging to the Duke of Bedford (*fig. 15*), like such Magi scenes as Bartolo di Fredi's which originated in traditional Siena itself and was immediately contemporary to Chaucer, has no gold-leaf background. It is a miniature to delight the eye in its graphic depiction of the biblical scene. No tension is felt here between sacred and secular, for the didactic message is firmly proclaimed above as the angels in that upper section begin to destroy the tower and send its presumptuous builders crashing to their deaths or falling to blows as their language is confused. But the artist's primary interest has been transferred to the area below, where no hint of the coming cataclysm has yet been felt. The masons and their assistants continue unperturbed to be busily engaged in their quotidian tasks of mixing the cement, shaping and engraving the stones, and winching them up into position on hoists lovingly depicted in precise mechanical detail. Behind them, so far from gold leaf, there is, as in di Fredi's version, a crisply delineated landscape with castles, houses, and a windmill set atop a hill towards which a horseman and workman are climbing laboriously, a scene reminiscent of the particularized landscapes in Chaucer's world, such as that which opens the Reeve's tale:

> At Trumpyngtoun, nat fer fro Cantebrigge,
> Ther gooth a brook, and over that a brigge,
> Upon the whiche brook there stant a melle.

This is scarcely the eternal world seen through a glass darkly, with the tangible serving only for its symbolic significance, as we have been asked to believe, and the connexion between such continental painting and the innovations in English poetry was close.

The frequent intercourse between England and the papal court at Avignon ensured the infiltration into England of the International Style in painting, sup-

planting the previous dominance of the East Anglian forms; and many elements distinguishing on the continent the new pictorial representation of biblical and secular scenes came with that style. Even though little painting from this period survived the lamentable thoroughness of Puritan iconoclasm, what does remain is sufficient to confirm England's artistic participation in the European fashions. A crowding of figures and a restlessness of movement enter even the Crucifixion scenes of the time, as in the miniature from the Lytlington Missal of 1383-84 or that by Johannes Siferwas in the Sherborne Missal from Dorset dating from between 1396 and 1407.[19] The well-known miniature of Chaucer himself reading his poetry to an audience, which appeared as a frontispiece to the *Troilus and Criseyde* in Corpus Christi College, Cambridge, while less skilfully executed than those of the Limbourg brothers, reveals the same interest in the details of courtly dress, in the meticulously reproduced castle behind (apparently an imaginative English variation of one of the Duc de Berry's chateaux), in the trees dotting the countryside round about and, above all, in the relaxed movement of the courtiers in the background, strolling along the path or engaging in polite conversation.

Even before the placing of Chaucer within the medieval tradition of allegory had made it unfashionable to speak of his supposed realism, any connexion between his poetry and the manuscript illuminations by the Limbourg brothers had been offered only tentatively. The latter might be used for students as general illustrations of the period, but the fact that these magnificent contributions to *Les Très Riches Heures* date from 1413-16, when Chaucer had already been dead for over a decade, created a discrepancy which, for all the chronological flexibility permissible in discerning changing cultural patterns, might seem to suggest that the new movement in art arose too late to be related to his poetry. If, however, as I have argued here, the Limbourg miniatures did not mark the inception of a new fifteenth-century aesthetic awareness but rather the culmination of a trend in art developing throughout the latter part of the fourteenth century, at the very least from the time of di Fredi's *Adoration* dating from about 1380, then that interest in human beings in movement through a natural landscape becomes compellingly relevant to Chaucer's poetic world, and, indeed, to the Ricardian poets at large.[20]

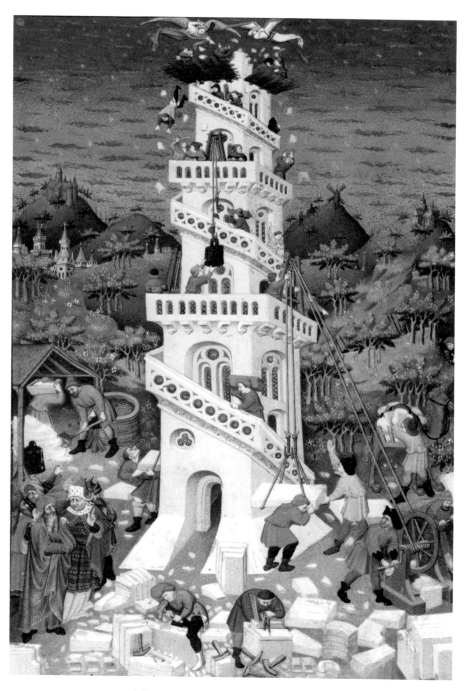

15. *The Tower of Babel*, Bedford Book of Hours

It is surely not chance that Langland's *Piers Plowman* opens not with an allegorical tableau like *Le Roman de La Rose* but with a narrator prompted by curiosity to make his way "wyde in the world" in search of wonders and, as he falls asleep on the Malvern hills, seeing in vision a fair field full of folk, people of all ranks, poor and rich, working and wandering as the world requires, some ploughing or sowing, some wearing costly garments, some travelling as merchants, and some as pilgrims. *Sir Gawain* is a poem of quest, and in it we are offered an account faithfully mirroring human affairs, with visitors preparing for the hunt in all the bustle of activity that it entails:

> And they set about briskly to bind on saddles,
> Tend to their tackle, tie up trunks.
> The proud lords appear, appareled to ride,
> Leap lightly astride, lay hold of their bridles.
> ...
> By the dawn of that day over the dim earth
> Master and men were mounted and ready.
> Then they harnessed in couples the keen-scented hounds,
> Cast wide the kennel-door and called them forth.[21]

Within the context of this new aesthetic pleasure in human movement through the temporal world, Chaucer's choice of a pilgrimage as the setting for *The Canterbury Tales* has a particular significance, and the opening passage takes on a vitality of which no possible symbolic associations can rob it. To begin the poem from line 19 with the narrative itself, "Bifel that in that season on a day . . . ," is to see how severely the ambience of the poem would be damaged by its omission. The season chosen by the poet for his account of the pilgrimage is the springtime rebirth of nature and, as the juxtaposition suggests, the period of man's reawakening to the soul-restoring beauties of the English countryside after the bleakness of winter:

> Whan that Aprille with his shoures soote
> The droghte of March hath perced to the roote,
> And bathed every veyne in swich licour
> Of which vertu engendred is the flour;

Whan Zephirus eek with his sweete breeth
Inspired hath in every holt and heeth
The tendre croppes, and the yonge sonne
Hath in the Ram his halve cours yronne,
And smale foweles maken melodye,
That slepen al the nyght with open ye
(So priketh hem nature in hir corages),
Thanne longen folk to goon on pilgrimages,
And palmeres for to seken straunge strondes,
To ferne halwes, kowthe in sondry londes.

Nature, Chaucer points out, prompts the "smale foweles" to burst into song at the dawn of a day and of a new season. In the same way, he drolly reminds us, it is only *when* April with its sweet showers has infused new life into the dry roots, engendered the flowers, and with Zephyr's assistance inspired every field and meadow with tender crops that *then* men suddenly long to go on pilgrimage and to seek out strange lands. The religious impulse of such pilgrimage is neither excluded nor denied. The knight and the parson may, if in a minority, indeed be dedicated to visiting the blissful martyr's shrine; but for others, and perhaps partly even for them too, one major impulse is, like those small birds, their hearts' desire ("so priketh hem nature in hir corages") to respond to the joyful freshness of the season, to leave the city and wend their way, like the Magi of contemporary painting also participating in the beginning of a new season for mankind, through the loveliness of open field and forest on their journey towards a holy site.[22] The focus of attention, both in a literal and in a larger metaphorical sense, is being diverted from the goal of man's journey to the process of his progression towards it.

Whatever moral lessons Chaucer may wish to convey in the course of these *Tales*, a warning against medieval *curiositas* or responsiveness to this world is certainly not one of them, and his sympathy towards those attracted by the springtime glories of nature even under the guise of a holy pilgrimage is reinforced throughout the work, as nature is called upon time after time as a rich and pleasing source of imagery. The attractive young Alison of *The Miller's Tale* has, we are told, a body softer than a wether's wool, as gentle and slim as a weasel's; her

mouth is as sweet as "a hoord of apples layd in hey or heeth," her brows curved and black like a sloe's; she sings with the grace of a swallow perched on a barn and, as she dances, her steps call to mind the skipping of a kid or calf as it follows behind its mother. On the one hand, such description places Alison within the world of nature where she no more invites moral condemnation for her actions than does a kid gambolling in a meadow,[23] while on the other it validates the attractiveness of that natural world to which she belongs. Sound, taste, sight, touch, and smell are evoked here with a delight never encountered in quite that way before, as the author deserts the allegorical convention of the medieval bestiary in favour of a sensuous immediacy which invites the audience or reader to participate in his own enjoyment of the variety and plenitude of the natural world.

Should we be tempted to see in these opening lines any moral condemnation of those who time their pilgrimage to coincide with the satisfaction of their wanderlust, we are not only provided with a narrator who himself cheerfully forms part of that well-timed pilgrimage but have evidence to confirm the author's sympathies from his *Legend of Good Women*, written just before he began work on the *Tales*. There, in a well-known passage, he readily confesses that the one attraction which can draw him away from his books and religious studies is that same irresistible call of the springtime freshness of nature:

> . . . whan that the month of May
> Is comen, and that I here the foules synge,
> And that the floures gynnen for to sprynge,
> Farewel my bok, and my devocioun!
> (lines 36-39)

And he concludes with his exquisite description of the daisy as typifying that natural beauty, a flower which he loves and "evere shal, til that myn herte dye."

The new responsiveness to the visible and tactile has often been described as a proto-Renaissance quality, anticipating changes which were to reach their fulfilment in the High Renaissance itself; but there is a danger in such terminology. Not only will no self-respecting artist or writer regard his own best work as a mere halfway house, aiming at something complete within itself, but even more

important, he cannot know the direction that a subsequent generation will take. History has shown as many reactions against the tendencies of a previous generation as continuations, and to read such "progress" into history retrospectively is a dangerous practice. For such nineteenth-century artists as the Pre-Raphaelite Millais, scrupulously attentive to accuracy of detail as part of his innovative aesthetic code, there was no hint that Impressionism would soon sweep away his concerns as outmoded. The same might, hypothetically, have occurred in the fifteenth century and this interest in the natural world would have remained without progeny. Accordingly, the literature and art of the late fourteenth and early fifteenth centuries must, like those of all other eras, be seen solely on their own terms and not as embryonic anticipations of later phenomena.

This principle holds particularly true for the limited spatial rationality that enters the art of the time. The old notion that artists of the Middle Ages were incapable of employing three-dimensional perspective because they lacked the technique has been discredited by historians. Sarcophogal portraits from the late Roman period testify to an accomplished control of depth-illusion on a flat surface; and its disappearance from Byzantine art would suggest a deliberate desertion of that technique.[24] It may be argued, therefore, that the Middle Ages had only "lost" the art of physical perspective in the sense that modern artists have lost it, as no longer serving their needs. In much the same way that the discipline of history in the sense of an accurate recording of past events, so highly developed in classical times by Thucydides and Livy, had proved unsuited to a subsequent Christian age immersed in thoughts of the world to come, and was replaced there by legends of the saints in which the moral lessons to be derived from their lives were more highly valued than fidelity to chronological or factual detail, so the allegorical and typological interests of the Middle Ages were served best by the hieratic tableaux and icon-like images to which the Lambeth Bible illumination and the older Magi scenes belong.

The change apparent in Chaucer's writing and in the art forms emerging in his era was not, therefore, as has so often been implied both by art critics and literary historians, a naturalism which he did not manage to effect completely because he had been born before the necessary techniques had been perfected.

On the contrary, the limitations to his *haecitas* or vivid depiction of this world must be seen as intrinsic to his profoundest convictions. The symbolic view of the world which had dominated the Christian response to nature from patristic times had not been ousted by the emerging delight in actuality, but modified, remaining integral to Chaucer's conception and that of his artistic contemporaries too. If there was now an enhanced awareness of the attractions of the husk, the inner truth of the kernel was not to be denied.

How deeply embedded the symbolic reading of the world was in this period, even when external reality was being more acutely observed, is suggested by one of the paintings most frequently cited to exemplify the new concern with optical accuracy. The convex mirror hanging on the wall behind *Giovanni Arnolfini and his Bride* in Van Eyck's famous painting of 1434 not only reflects with scrupulous fidelity even an orange left to ripen on the window ledge; it also encircles with its frame the newly wedded couple and thereby surrounds them with scenes of the Passion, allegorically extending, as Erwin Panofsky has shown, a Christian blessing for their future.[25] And the painting, for all its realism, is fraught with further symbols—the shoes discarded to indicate that this is holy ground, the dog a traditional emblem of fidelity, the broom at the head of the bed to represent domesticity.

Allegory and realism may coexist compatibly within the same frame in Chaucer too, and evidence of symbolism in his poetry does not exclude the validity of *haecitas*. His eulogy to the daisy in *The Legend of Good Women* acknowledges fully the genuineness of his sentiments towards the loveliness and grace of the delicate flower itself. Although he may echo phrases from earlier literary works, the distinctive quality he adds is an immediacy of response and a sense of the deep joy he experiences. Yet for all the sharp actuality of that experience transmitted so faithfully by his poetry, the daisy retains for him the symbolic aspects too as an emblem of Christian death and rebirth. Having witnessed with melancholy the closing of its petals at night, he rises early next morning to visit it again:

> With dredful hert and glad devocioun,
> For to ben at the resureccioun

Of this flour, whan that yt shulde unclose
Agayn the sonne.

<div align="center">(lines 109-12)</div>

The conviction that nature, however attractive it may be, remains only an
outward truth may well explain the two-dimensional quality of much painting
at this time. Those miniaturists working under the patronage of the Duke of
Berry, particularly the Limbourg brothers, have justly been praised for their ver-
isimilitude, as in the accuracy with which the duke's chateaux are depicted in the
background of certain paintings; but the flatness in the execution of the paintings
themselves must not be ignored, as it is an intrinsic component of these illumi-
nations. Such miniatures display, as in the scene for *April (fig. 16)*, a close atten-
tion to the intricate ornamention on the luxurious robes, and the elaborate head-
gear worn fashionably by both men and women. Yet for all the accuracy of detail
in a scene probably depicting an actual event (the betrothal of the duke's daugh-
ter in the grounds of his castle at Dourdan), the painting is nevertheless intended
primarily to represent a month within the Calendar section of a book of Hours.
That moment becomes an emblem in which we are directed to be less interested
in the emotions of the engaged couple than in the formal act of exchanging rings
as a symbol of the rites of spring. The magnificent robes are to indicate superior
social class in the same way as the delicately extended fingers of the young lady
holding the ring suggest the refinement of her careful upbringing. Where in later
art and literature outer details of costume, such as Hamlet's sable garb of woe,
generally function only to corroborate or at other times to conceal the inner
truth of the characters, here they act as the primary source of information be-
yond which the artist is not prepared to take us.

In a world still conscious of the distinction between husk and kernel, it is
what meets the eye which forms the legitimate prerogative of the artist, and its
relevance to the inner being is left for the viewer to determine, not for the artist
to explore. Fourteenth-century painting and that at the turn of the century adopt
a fixed, frontal viewpoint with no dramatic or disturbing foreshortening such as
was later to appear in Mantegna's *Dead Christ* or Titian's *Sacrifice of Isaac*. The
artist's aim was to present the scene as it appeared to a detached observer. The

<div align="center">49</div>

outer husk depicted, namely the physical reality of everyday existence, is presented in flat perspective, as lacking the depth or ultimate validity belonging to the eternal spiritual verities. In later years, those unchanging verities were to be dislodged by a new kind of inner truth, the mystery of man's longings and frustrations which were to become the legitimate and primary domain of writer and artist. The Renaissance discovery of the inner self of the individual as a complex, enriching subject of study inevitably gave to the outer self a lessened importance, and, what is more significant, created a profound distrust of that outer self. For Shakespeare, the contrast between appearance and reality, between the "honest" Iago as he appears to others and the villain concealed within or, conversely, between Cordelia's loving heart and her inability to articulate her love in externalized verbal terms, created the need for a new type of vision, an "insight" which should see with the true blank of the eye through the deceptive outer robes to the heart and soul of man.

In Chaucer's time that distinction had not been made. The characters in the contemporary morality plays are immediately identifiable both by name and apparel. Envy, Beauty, Knowledge, and Sloth act consistently within the bounds of their defined roles with no hint of discrepancy between the internal and external realities of their being. In that tradition, Chaucer can assume on the part of his reader a trust that the details of outward appearance will provide valid clues to the characters portrayed, and from that assumption arises the remarkable effect of mingled naiveté and sophistication which forms a major charm of his work. On the one hand there is the simplistic belief that anyone unfortunate enough to have repulsive boils and suppurating sores on his face must, like the Summoner, be inwardly corrupt and repulsive too; that a white neck must, as with the Friar, be an inevitable mark of sensuality. Yet on the other hand, that reliance upon outward appearance and the validity of the two-dimensional portrayal forms also a major ingredient of Chaucer's irony. For without it he could not create the subtle discrepancies between his narrator's approving description of a character and the reader's correction of that approval as the negative implications of the outward details hitherto misunderstood by the narrator are correctly perceived.

The portrait of the Prioress within the *General Prologue* is ostensibly fulsome

16. LIMBOURG BROTHERS, *April*

in its praise, moving appreciatively from detail to detail in her external appearance. She has a fine forehead, a charmingly gentle smile, sings the liturgy beautifully, speaks French fluently if with an English accent, has excellent table manners, displays compassion to animals, is elegantly dressed, wears a string of coral beads upon her arm,

> And theron heng a brooch of gold ful sheene,
> On which ther was first write a crowned A,
> And after *Amor vincit omnia.*
> (*Gen. Prol.*, 160-62)

As we well know, this apparently admiring description is in fact an inventory of conventual abuses typical of fourteenth-century nuns—petty abuses, it is true, but abuses nonetheless. Her compassion is misdirected from humans to animals, she reveals a concern with clothing and upper-class social graces incompatible with the vows of poverty and humility enjoined on members of a convent, and the incongruity of the motto at her wrist, like so many of the details, militates, although never explicitly, against the dominant tone of approval.[26] All this is achieved with an economy and sharp perception of *minutiae* ("in hir coppe ther was no ferthyng sene / Of grece, whan she dronken hadde hir draughte") which create an irresistible verisimilitude of portraiture.

On the basis of this discrepancy, E. Talbot Donaldson has argued that the fictitious narrator, Chaucer the pilgrim, is meant to be seen by us as a fallible observer representing the myopia of humanity, only too often misled by outward form and missing in general the moral or, more often, immoral implications of what he sees.[27] Yet Donaldson's admission that this is an artistic strategy widely employed in Chaucer's time should warn us that it may be less a trick of Chaucer's personal style, however skilfully that writer may use it, than a symptom of certain basic concepts shared by the literature and the painting of the era. The fallible narrator, whose obtuseness prevents him from making the necessary deductions and who leaves the reader to pass judgment, appears as the protagonist of *The Pearl*; Langland's Will in *Piers Plowman* is accused of being dull-witted, and the very same term is used apologetically by the lover in Gower's *Confessio Amantis*:

I am so rude in my degree
And ek mi wittes ben so dulle.
(iv, 946-47)

We may add, moreover, that within *The Canterbury Tales* that descriptive technique is by no means restricted to the passages when Chaucer the pilgrim is speaking, but is all-pervasive, adopted equally by his fellow pilgrims when they take over from him to relate their own tales. They employ the same shallow perspective as in the *April* illumination, focussing upon the outward details and allowing those details to speak for themselves without comment from the narrator.

Even the Reeve, whose declared purpose is to revenge himself upon the Miller by depicting a villainous exemplar of the trade, carefully offers a predominantly neutral portrait, a series of facts from which each member of the audience or each reader is to draw his own conclusions. Except for the statement at the end of the description that the miller of this tale was a thief (information which is essential for the subsequent story), all else is offered in a tone of cool detachment with no hint of the angry animosity which has prompted the tale. The miller, we are told, is proud as a peacock, wrestles and shoots well, carries a "joly" dagger in his pouch, and is well able to look after himself in a fight. But there is nothing which specifically brands him as a coarse, pugnacious ruffian. The clues are all there—the sharp sword, knife, and dagger always at the ready, the over-sensitive pride, the drinking; but they are left unelaborated, with no in-depth exploration of character such as we would expect from a later writer:

A millere was ther dwellynge many a day;
As any pecok he was proud and gay.
Pipen he koude and fisshe, and nettes beete,
And turne coppes, and wel wrastle and sheete.
Ay by his belt he baar a long panade,
And of a swerd ful trenchant was the blade.
A joly poppere baar he in his pouche;
Ther was no man, for peril, dorste hym touche.
(lines 3925-32)

53

The reader's perception within these details of what is concealed, as it were, from the narrator creates a humorous bond with the author. In the generally laudatory portrait of the Doctor, for example, at the line justifying the latter's love of gold—"For gold in phisik is a cordial"—we wonder momentarily whether the rather obtuse narrator has perceived the humour of his own remark, only to realize with amusement that, whatever the answer, Chaucer the author certainly has. Through the device of a double identity, he preserves the neutrality of an objective, factual description, while yet enjoying to the full the opportunity for manipulative comment.

The introduction into poetry in this period of a narrator who is at least partially an extension of the author himself marks also the growing self-awareness of the artist. There is as yet no sense of his being a divinely inspired creator, such as was to enter the consciousness of the High Renaissance painter, and he appears in a distinctly humbler and self-deprecatory form. Lorenzo Ghiberti may have justifiably prided himself upon his artistic success, but the self-portrait he introduced on the doors of the Florentine Baptistery (*fig. 17*) is remarkably free from any self-aggrandizement. He appears there as a bald man with head bowed, not unlike the rather ineffective figure Chaucer creates of himself, and a far cry, for example, from the dramatically ennobling self-portrait to be produced later by Leonardo da Vinci. The cool, unexaggerated depiction of actuality was a principle applied to self-portraiture too, and contributes greatly to the effectiveness of Chaucer's irony.

Indeed, the similarity in technique between the artist and writer in this period is at times striking. While I would certainly not argue for identity of character between, on the one hand, the young Medici prince in Gozzoli's portrait of him as a Magus on the way to Bethlehem (*fig. 18*) and, on the other, the Squire in Chaucer's *General Prologue*, the amused depiction achieved by a buildup of visual detail is remarkably close. Gozzoli's commissioned fresco was, no doubt, required to be complimentary to the members of his patron's family, and there is nothing specific of which a father could complain; yet the overall effect on the viewer, perhaps not consciously intended by the artist, is of a gently satirical portrait, as the young man gazes down a trifle disdainfully at us, confident that he is the very height of fashion.[28] He has hair, like the Squire's, just a

17. GHIBERTI, *Self-portrait*

little too carefully arranged, "lokkes crulle as they were leyd in presse," he wears a cloak of the very latest cut "with sleves longe and wyde" and a doublet (just visible) richly embroidered "as it were a meede / Al ful of fresshe floures, whyte and reede." The media techniques are different. The poet in a literary work can introduce verbal images such as the curling-press and the meadow to reinforce the hints, while the artist must rely on visual elements, his sitter's proud stance and the sparkling gold of the cloak and stirrups; but the final effect is basically the same—no deep perceptions on the part of artist or writer but an accumulation of observed external details which allow us, without explicit aid, to perceive the harmless pretentiousness of the young man portrayed. And the gap between what is directly described and what we are encouraged to discern creates the gentle satire which distinguishes so much of Chaucer's poetry.

The use of external detail as a primary means of conveying information created the need for a code similar to that employed in Christian iconology; but where the latter aimed at evoking more abstract associations—purity by the presence of a lily or eternity by a peacock whose flesh was believed never to decay—here the message is more worldly and more specific. Subtle variations in the social rank of aristocrat, churchman, professional, tradesman, and labourer, and the finer gradations within each group or guild had gained a new importance as society grew more urbanized and more complex. Dress served as a major distinguishing mark, and it is not difficult in *The Tower of Babel* (*fig. 15*, p. 43) to identify the noblemen responsible for the work in the lower left-hand corner, or in Gozzoli's painting (*fig. 14*, p. 37) to mark off the armed footmen from the rest of the retinue by the bows or spears borne in their hands.

Similarly, Chaucer is fascinated by the diversity of social levels about him, ranging from rich to poor, and in his *House of Fame* perceives around him

A ryght gret companye withall
And that of sondry regiouns,
Of alleskyns condiciouns
That dwelle in erthe under the mone,
Pore and ryche.
 (lines 1528-32)

56

18. Detail from GOZZOLI, *Journey of the Magi* (fig. 14)

In *The Canterbury Tales* he feels a necessity at the very opening to identify all the pilgrims according to their degree and "array," once again concerned less with eternal symbols than with earthly rank and status as observable to the human eye.

His interest in classifying the social cross section brought together by the pilgrimage, the "sondry folk, by aventure yfalle" assembled in the specific location of Southwark at the Tabard Inn, prompts him, as has often been noted, to produce a contrary effect—types of his pilgrims rather than individuals, each a model of the category he or she represents, for good or ill, a "verray parfit, gentil knyght" or a Shipman who has no peer "from Hulle to Cartage" in the art of navigation and knowledge of tides. Chaucer's compartmentalizing into social groups goes beyond a scrupulous attention to distinguishing marks and implements of trade, such as the Yeoman's "sheef of pecock arwes, bright and kene" with no feathers dropping, or the Pardonner's wallet which "lay biforn hym in his lappe / Bretful of pardoun, comen from Rome al hoot." In addition, he provides us with telling details of characteristic behaviour which may not be immediately visible to the eye but would certainly be deducible by a sharp observer during the period of the pilgrimage. The narrator would not have needed to visit the Parson's home village to learn that "devoutly would he teche" his parishioners and be understanding in remitting tithes for the needy, nor to be witness to the Monk's celebration of feasts to know that he loves a fat swan best of any roost when his figure "ful fat and in good poynt" and the self-indulgence of the fur at his wrists provide sufficient indication of his lack of abstemiousness.

In achieving such convincing realism, however, it was essential for Chaucer to create the illusion that he was himself present as a participant in the pilgrimage, an impression reinforced throughout the work by devices to bolster the firm sense of spatial and temporal actuality. The speaker warns that he can only function within the limitations of first-hand observation, describing events only "as it seemed me," and he repeatedly interjects a phrase to counter any expectation from him of omniscient narration. The Squire's age is offered cautiously— "Of twenty year of age he was, I gesse," and he has been unable to discover the Merchant's name—"but sooth to seyne, I noot how men hym calle." These are the minor strategies which cumulatively create the brilliant sense of immediacy

in his work.[29] Similarly an awareness of the exigencies and pressures of time pervades the *Tales* in place of the more leisurely modes of earlier literature, and the traditional *occupatio* of the narrator takes on a new sense of urgency. Chaucer himself sets the tone at the opening by determining to introduce the characters "whil I have tyme and space," and the desire to offer a full and detailed description of events is, among his fellow pilgrims too, repeatedly cut short by the limitations of time and the length of the journey. The Knight apologizes:

> And certes, if it nere to long to heere,
> I wolde have toold yow fully the manere.
> ...
> But al that thing I moot as now forbere.
> I have, God woot, a large feeld to ere,
> And wayke been the oxen in my plough.
> The remenant of the tale is long ynough.
> I wol nat letten eek noon of this route;
> Lat every felawe telle his tale about.
> (lines 875-90)

The Clerk, for the same reasons, reluctantly foregoes his introduction as being too long, and the Merchant, as so often in the work, curtails his account of January's wedding on the grounds that it would take too long to tell "every scrit and bond / By which that she was feffed in his lond."

Both aspects of this tension, the desire, if only he were given sufficient time, to relate the story in the fullest form possible as part of an absorbing interest in human affairs in all their attractive detail and, on the other hand, the need to be brief because time and space constrict, are symptomatic of the changed perspective in this period, the movement imaginatively into a finite world in which the eternal truths have their place but must share it with the temporal interests. The typological or allegorical reading of life had not been swept away, and it is quite true that the description of the Wife of Bath, for all its vividness of personification, contains many echoes of the traditional shrew from the medieval sermon, attempting to invert the biblically enjoined dominance of the male. However, to "read" her in exclusively medieval terms as if no alterations in sensibility had oc-

curred since the tenth century, or to regard the realism in her depiction as merely a useful anchoring in the contemporary world in order, by that realism, to convey the didactic message more forcefully is to underestimate the extent and quality of the new eagerness to be up and about, visiting the varied places of the earth and enjoying diverting social intercourse with fellow men and women.[30] She was not alone in her desire, within an ostensibly religious framework perhaps intended to quiet residual moral scruples

> for to see, and eek for to seye
> Of lusty folk—what wiste I wher my grace
> Was shapen for to be, or in what place?
> Therfore I made my visitaciouns
> To vigilies, and to processiouns,
> To prechyng eek, and to thise pilgrimages,
> To playes of myracles and to mariages.[31]

If she is intended to be condemned by the reader for her lively curiosity, then the entire *Canterbury Tales*, employing like the Magi paintings of its time the pretext of a religious journey for pleasurable observance of human activity, would have to be equally condemned—and condemned, indeed, for the very quality which makes it so compelling a work. Chaucer's delight in the details both of the physical world of nature in which man is placed and the social degrees, fashions, and appurtenances of man himself suggest that the *Tales* are offering something much more than a medieval sermon, that the *curiositas* so long discountenanced by Christianity, was asserting itself in a manner which the Church would find hard to resist.

Inevitably, such interest in temporal existence was liable to provoke crises of conscience in the fourteenth-century Christian caught between his abiding faith in the eternity of ultimate truth, compared to which this earth was but an anteroom, and his awakened fascination with the immediate realities of his surroundings in all their freshness and vivacity. Chaucer's own duality of response reflects that inner conflict, both in the warm sympathy he arouses for the Wife of Bath at the very moment when she is arguing for the flesh in invalid theological terms, and also in the retraction which Chaucer eventually penned, asking

divine forgiveness for the "worldly vanitees" he had written. Amongst those vanities he included "the tales of Caunterbury, thilke that sownen into synne." Were that body of tales in its entirety the work of orthodox medieval teaching it is claimed to be, it would scarcely require divine forgiveness for its worldliness or for the concern with vanities it contains; and perhaps, as the retraction indicates, no one was more conscious of that worldliness than Chaucer himself.

2

HIERARCHY IN THE
MYSTERY PLAYS

TO RECONSTRUCT WITH ANY DEGREE OF AUTHENTICITY THE ME-
dieval performance of a mystery play, whether in imagination or in practice, can
be a frustrating experience, despite the excellent work that has been invested by
F. M. Salter, Richard Southern, Glynne Wickham, and others in revealing the
physical format of the "stations," of the moving pageant-waggons, and of the
fixed stages being developed at the time.[1] In drama, among the most evanescent
of the arts, the bare text of such a play may lie open before us, but the style of
acting, the method of presentation, the degree of interaction with the audience
and, above all, the overall tone of the production have disappeared, leaving only
brief rubrics and sparse contemporary accounts to guide us in the reconstruc-
tion. The investigations by W. D. Hildburgh and Miss M. D. Anderson of ala-
baster carvings, stained-glass windows, roof-bosses, and misericords in search
of scenes in contemporary art which might have been based on stage presenta-
tions from these great mystery cycles has proved valuable in suggesting with a
great deal of probability certain details of such performances. From a church
window in Norwich depicting *The Massacre of the Innocents* we may gain some
sense of the horrific impact a stage performance would have had, as the babes in
that scene are waved aloft nauseatingly impaled upon the soldiers' swords, while
the bereaved mothers grapple helplessly with the murderers.[2] Yet, helpful
though such knowledge may be in revealing specific items of stage presentation,
the assistance it offers in understanding the subtleties or nuances of such dra-
matic productions is limited, especially with regard to the gradual stylistic

changes in treatment of the themes during this period, when these plays served first as the exclusive and later as the primary form of dramatic fare.

One scholarly controversy engaging historians and critics during this century has centred upon the place occupied by scenes of comedy and realism within these cycles. The view prevailing earlier in the century had tended, not always explicitly, to regard such scenes as the main justification for encouraging a study of the plays. Within the stiff, awkward drama of the medieval Church, it was implied, could be seen gradually emerging the first signs of a lively naturalism, which was to reach its climax in the full-blooded Renaissance stage.[3] Literary criticism, not yet freed from the idea of the "dark ages" of medievalism, was still concerned with establishing historical patterns of progression, assuming a development in theatre from dramatic infancy to maturity, rather than the recognition that each era creates the art forms intrinsic to its own needs and conceptions.

This evolutionary reading of theatrical history arose, as O. B. Hardison has interestingly demonstrated, from an unwarranted application to medieval drama of principles imbibed by nineteenth-century scholars from current Darwinian theory. In such monumental works as E. K. Chambers' *Mediaeval Stage*, the re-genesis of European drama was conceived as a progression from simple playlets to the more complex organisms developing within the cathedrals; and then, like those early creatures venturing from water to dry land, emerging from the confines of the church into the open-air guild productions where the mystery cycles could grow uninhibited. In fact, as more precise dating of the surviving texts has shown, drama was not subject to the principle of biological development from unicellular forms to more complex structures, since the more elaborately structured plays often preceded the simpler versions. Hardison concludes that a variety of theatrical innovations may be seen to have occurred simultaneously within the relatively brief period when the Christian drama prevailed on the stage.[4]

If chronological progression in structural development had been questioned, there was at least accord on one aspect—the increasing realism entering these plays, both in the comic scenes of slapstick and fisticuffs which had attracted so much attention among early critics and in the elements of naturalistic contem-

poraneity which began to infiltrate these plays. The rowdy wrestling of the shepherds as they fight over their wages in the *Prima Pastorum*, the marital dispute of Noah and his recalcitrant wife (presented visually in a stained-glass window at Malvern Priory, where she raises her hand against him—a scene popular in all the cycles), the mischievousness of Cain's irrepressible servant Garcio, all entered the drama after its transference to the supervision of the tradesmen's guilds. The traditional admiration of such scenes among modern readers, encouraged to regard them as embryonic instances of stage naturalism, received a jolt when the respected historian A. P. Rossiter, in his *Early English Drama* published in 1950, castigated such scenes as dramatically deplorable symptoms of the strange Gothic tendency to parody and mock its most sacred themes—as in the celebration of the Feast of Fools, the travesty of Christian hymns in dog-Latin rhyme by such wandering scholars as the Goliard poet of the *Carmina Burana* or the tradition of the Boy Bishop making burlesque of the church service. The degree to which such burlesque penetrated the cathedral itself is indicated by the Feast of the Ass held at Beauvais on January 14, which culminated in an extraordinary mass. According to the rubric, the priest, instead of concluding with the normal *Ite missa est*, was instructed to utter three times the Latin equivalent of "hee-haw," (*ter hinhannabit*), the congregation braying three times in response. Within drama, the result of such willingness to caricature the holy is, in Rossiter's view, to be found in the comic scenes, where we are left

> to wrestle with the uncombinable antinomies of the medieval mind; for these immiscible juxtapositions constantly imply two contradictory schemes of values, two diverse spirits; one standing for reverence, nobility, pathos, sympathy; the other for mockery, blasphemy, baseness, meanness or spite.[5]

Eleanor Prosser, no less disturbed by what she saw as the incongruity of mingling dramatic solemnity with comic realism, attributed the hybrid quality not to a Gothic ambivalence but to the intrusion of a coarse contemporary secularism into semi-liturgical performances once these plays had been removed from the auspices of the Church to the control of the trade guilds. Responding to the grave effect which they must have produced on a medieval audience,

viewing them less as theatre than as dramatic evocations or reenactments of the central miracles of Christian history redolent with awesome associations, she condemns the humorous scenes as damaging the carefully wrought atmosphere of reverential sanctity, a sanctity augmented by their performance on such holy days as Corpus Christi. In a revealing metaphor, she describes the growth and development of such scenes as constituting "an overgrown gargoyle who almost totally obscures the cathedral, the religious purpose" of the plays as a whole.[6]

V. A. Kolve's sensitive discussion of the formal play-game element in the medieval term *ludus* has done much to restore the integrative approach. He has pointed out in reply to Rossiter's charge that laughter and ridicule on the stage need not be shared by the audience, which at such moments as the taunting of Jesus or the amused scoffing at his bodily humiliation, would be sympathizing with the object of those taunts and, as the meditative exercises had taught them, identifying with the agony of the martyr in accordance with the Christian principle of *imitatio Dei*. The banns for the Chester cycle instructed those responsible for preparing the performance to be sure that the gravity of such scenes be duly preserved:

> See solemnly ye make of Christ's doleful death,
> His scourging, his whipping, his bloodshed and passion,
> And all the pains he suffered till the last of his breath.[7]

Yet even that explanation leaves one aspect untouched. In these contrasting readings of the cycles, the Crucifixion play has proved to be a natural testing-ground. For Rossiter, it marks the climax of the ritual defamation of sanctity, as, at the most sacred moment of the cycle, the soldiers, having drilled the auger-holes on the Cross too far apart, instead of correcting them, jokingly stretch Jesus' limbs to reach the prepared marks, and appear to hammer the nails into his hands and feet with a gruesome professionalism—a realism which is confirmed both by the surviving texts of the various plays and by a contemporary depiction in the Holkham Bible Picture Book (*fig. 19*). On raising the Cross, they complain that it does not fit into the mortise as it should, reproach each other, as workers will, for too much talking and too little action, then drop it heavily into place in order deliberately to jar the victim's body, remembering to insert

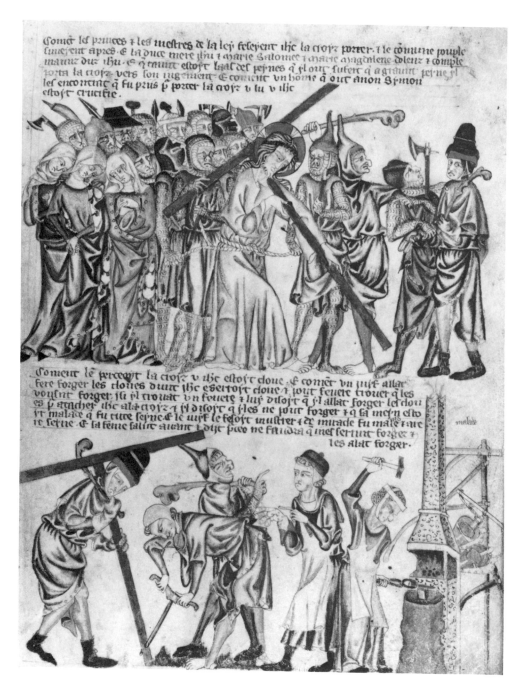

19. *Crucifixion Scenes*, Holkham Bible Picture Book

wedges to ensure that it will stand firm enough to bear the full weight. Many of these apparently casual details which Rossiter sees as distracting from the gravity of the scene in fact had their origin, as F. P. Pickering has pointed out, in Christological interpretations of passages from the Old Testament ("They have pierced my hands and feet: I have numbered all my bones," Psalm 22:17).[8] Nevertheless, an incongruity remains, for at the climactic moment when the physical agony of Jesus should be represented at its most acute (particularly in its aim of encouraging the audience's sympathy and identification with that suffering), his speech from the Cross in the most vividly actualized of all the versions, the York Crucifixion, is strangely stiff and didactic, a formally phrased message singularly inappropriate to a speaker racked by the bodily torment which the preceding dialogue and actions have conveyed so dramatically and so brutally:

> All men that walk by way or street,
> Take care lest you neglect this grief.
> Behold my head, my hands, my feet,
> And fully feel, now while there's time,
> If any mourning may be meet
> Or mischief measured into mine.[9]

The contrast is too marked to be fortuitous, and is indeed borne out elsewhere in these cycles. Rosemary Woolf has noted in her detailed examination of these plays how in the Trial, Buffeting, and Scourging scenes (in all the cycles) with their similar torrent of insults realistically hurled at the accused, Jesus himself remains almost silent. The sole exception is the *Ludus Coventriae* which, allowing for no elaboration, restricts his words to those attributed to him in the Gospels. In the Towneley Buffeting play, for example, he speaks only once, his silence underscored by Caiaphas' taunt:

> Though thy lips be stuck, yet might thou say mum,
> Great words didst thou speak, then when thou wert not dumb.[10]

Such discrepancy in stylistic treatment, the confrontation in some scenes of naturalism with artificiality, in others of boisterous humour with solemnity,

would seem, by its presence in all the cycles, to be characteristic of these mystery plays, whether or not such combinations are to be interpreted as dramatically deplorable.

I should like to suggest that behind such apparently haphazard juxtaposition there may be discerned a governing principle producing a more carefully integrated harmony than has generally been assumed, a unifying of medieval realism and "expressionism" in which each style is accorded its allotted place in the overall Christian vision; and that so far from undercutting each other, they serve by their subtle interaction to reinforce the effectiveness of the ultimate religious message which the mystery cycles were intended to convey. It is a theory reinforced by the existence of a parallel phenomenon in the religious art of the time, where these same scenes central to Christian belief were being painted on altarpieces to serve, like their dramatic counterparts, both as components of the liturgical celebration of feast and holyday and also as a means of disseminating the teachings of the church among a predominantly illiterate laiety.

It may be valuable to begin with an aspect of such painting which at first sight may appear scarcely relevant to our theme—the place of the donor's portrait in religious art. Its inclusion in an altarpiece was both votive in purpose and whimsically hopeful. After deliverance from personal danger in plague or war, a donor, particularly during the rise of secular patronage in the arts, might commission in thanksgiving a painting or altarpiece with himself and sometimes members of his family in adoration before a scene of martyrdom. Alternatively, such offerings might be related to no specific deliverance, but prompted by a more general desire to be eternalized after death in humble reverence before a holy Christian scene, forever worshipping in proximity to the divine.

In early versions, the donors are generally small figures, dwarfed by the major characters in a proportion dictated not by natural perspective but by sanctity, as if they realized their presumption in daring to be associated with such hallowed events; and they frequently appear not in the main scene of the altarpiece itself, but slightly below. In the Glatz *Madonna* of about 1350, a tiny figure representing the Archbishop of Prague, who commissioned this altarpiece, can be discerned in the bottom left-hand corner, kneeling at the foot of a stairway leading up to the large and dominant group of the Virgin and Child. By the late

fourteenth century, such donors have grown both in stature and in positioning. The Wilton diptych of 1377 has Richard II and his patron saints occupying the left-hand panel, where he is now both level with the holy figures and equal in size. In the exquisite Mérode altarpiece of 1425-28 (*fig. 20*) attributed to Robert Campin the Master of Flémalle, the middle-class man and wife who ordered the painting have become more intimately connected with the sacred moment. Although they are still located away from it in a separately framed panel of the triptych, the artist has depicted them as kneeling within a courtyard, as it were, outside the very room in which the Annunciation is taking place, with an open wooden door before them through which they appear to gaze as witnesses of the miraculous event, the door visually linking the two panels.

The next stage in development was, as might be expected, the inclusion of the donor in the main scene as if he were an actual participant in the event; and it is at this moment of his incorporation within the depiction of the biblical event that an element enters which may prove helpful for our understanding of the contemporary mystery plays, whose flowering has been placed between 1400 and 1450. In Jan Van Eyck's *Virgin with Canon van der Paele* of 1436 (*fig. 21*) we find what is to hold true for so many paintings in this category, namely the application of two different stylistic techniques within one unified painting; a subtle bifurcation in artistic presentation, dictated not by chance but by the nature of the characters themselves. While the Virgin and Child are here depicted as conventional figures of holy art, the Canon, as a human participant, is portrayed with such tender realism that art historians have long singled him out as illustrating the new interest in verisimilitude and individualism which begins to appear at this time. Particularly germane to our purpose, however, is less the realism as such than the distinction within one frame between the treatment of sacred and human figures. While the Virgin, clothed in the majestic folds of her purple cloak and enthroned beneath a rich canopy, remains remote and stylized, the balding canon in his simple white surplice (*fig. 22*) endearingly holds his spectacles awkwardly between his fingers as he attempts to turn the pages of his book, his deeply lined face and double chin indicating his years as he gazes thoughtfully before him. And as though to emphasize this duality of viewpoint, there is within this painting a rare double perspective.[11] While the orthogonals

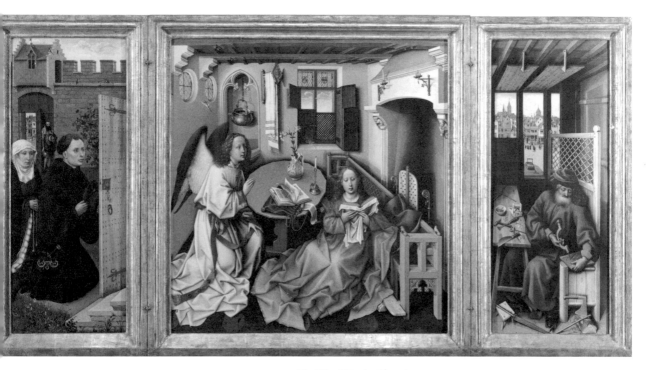

20. ROBERT CAMPIN(?), *The Mérode Altarpiece*

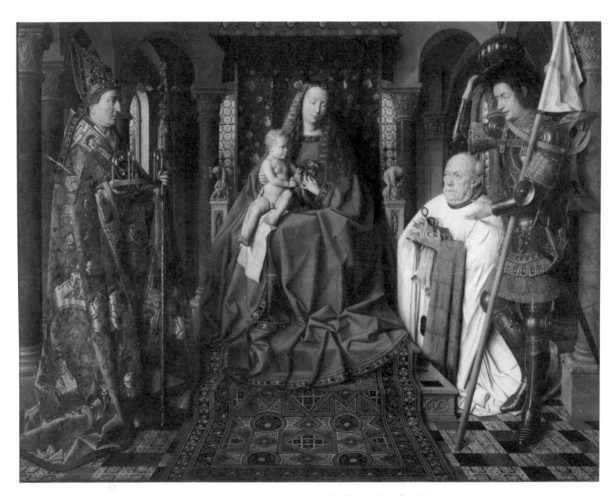

21. JAN VAN EYCK, *Virgin with Canon Van der Paele*

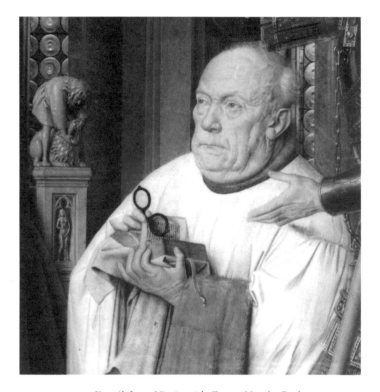

22. Detail from *Virgin with Canon Van der Paele*

of the floor-tiles and carpet lead, as would be expected, towards a vanishing-point located within the central group of the Virgin and Child, the base of the right-hand column is in contrast aligned away from them towards the Canon's head, drawing our attention to him as the secondary object of interest. St. George's hand seems to gesture towards the Canon, inviting us to direct our gaze to him, once we have responded initially to the central Madonna group.

The visual syntax of the painting suggests that the artist, with his growing interest in the actual and the human, had discovered a means of introducing a realistic depiction into the most sacred of scenes without in any way detracting from the aura of holiness. Indeed, the inclusion of the donor deepens the sense of reverence the painting arouses by the contrast it affords between the latter's passing years, the wrinkles and spectacles that age brings, and the everlasting,

73

unchanging scene before which he kneels as witness. Van Eyck's *Madonna with Chancellor Rolin* from approximately the same period (*fig. 23*), although it contains no double perspective, offers a similarly vivid contrast between the lifelike actuality of the chancellor, who seems almost capable of emerging from the painting in his rich brocaded gown, and the more aloof Virgin over whom a crown is symbolically held by a hovering angel as the Child lifts his hand in a formal, adult gesture of benediction.

With that duality of presentation in mind, we may pass from the donor theme to its more general application in religious painting of this period, where the ambivalence within a unified scene takes on greater subtlety. Dirk Bouts' *The Martyrdom of St. Erasmus* from about 1450 (*fig. 24*) depicts with chilling naturalness the saint's last moments on earth. To the left of the painting a muscular, bald-headed man energetically turns the handle of the windlass whereby the spit slowly extracts the saint's entrails from his abdomen, while a co-worker opposite bites his lower lip at the physical effort involved. Behind them, those who have ordered this particularly gruesome form of torture either watch disdainfully or turn away, the detailed landscape behind providing a realistic spatial perspective. Had the saint himself been presented with anything approaching that same degree of realism, he would be writhing in agony. Instead, he lies there gazing with untroubled countenance at his own disembowelment. There is here a fusion within the scene of two fundamentally different responses marking a merger of late medieval and early Renaissance techniques—a stylized superimposing of the spiritual content upon a realistic depiction of the physical. Ignoring the limits of chronology, the artist permits us in the portrayal of the saint an advanced glimpse of the martyr's eternal calm soon to be achieved in heaven, the bliss to be granted beyond the grave. This juxtaposition of cruel bodily suffering and a spiritual transcendence of the flesh was intended to reflect the central Christian message that this world was only the testing ground for the world-to-come, and that the greater the physical suffering, here represented in all its sadistic intent, the greater would be the rewards beyond. The realism in the portrayal of the human figures and the "expressionism" of the martyr function, therefore, not as discordant elements but as reinforcements from opposite directions of the unified message presented.

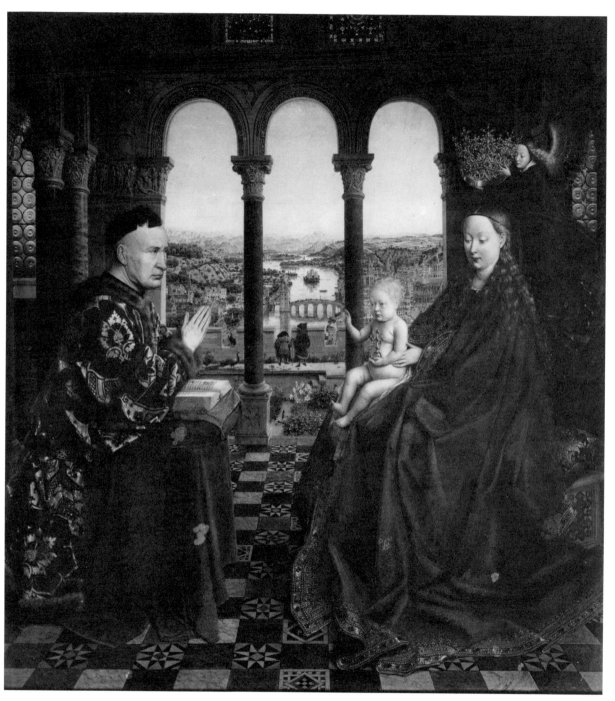

23. JAN VAN EYCK, *Madonna with Chancellor Rolin*

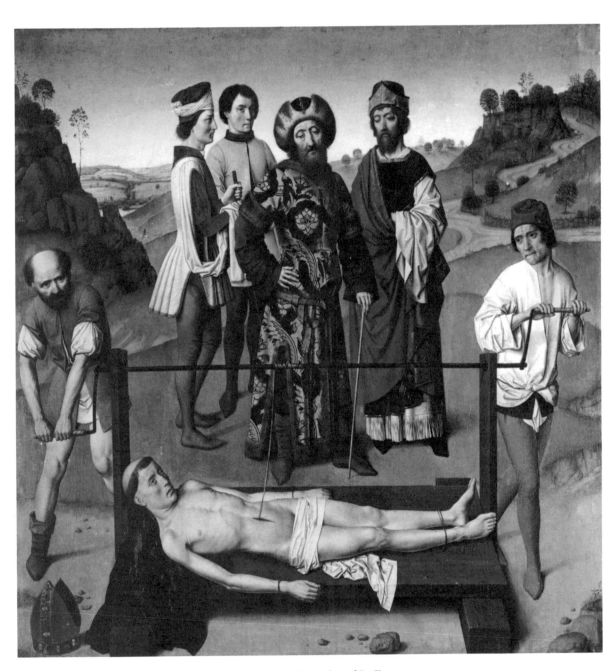

24. DIRK BOUTS, *Martyrdom of St. Erasmus*

What emerges from this examination of the painting is the possibility that we may find in the religious drama too, not a haphazard mingling of naturalism and stylization, as recent critical scholarship has suggested, but rather a distinction between sacred and human figures, a carefully graduated hierarchy in which the style is dictated by the place of the character upon its rungs. The saint at the upper level is, in his spiritual superiority to the bodily demands of this world, beyond any need for accuracy of depiction or naturalism, while the torturers in the York Passion play, like their counterparts in the painting of the time whose sole purpose for being included is to convey the physical horror of the pain they are inflicting, can be humanized, depicted with graphic naturalism in the workman-like performance of their task. The Master of Avignon, now identified as Enguerrand Quarton, has in his *Pietà* of about 1455 (*fig. 25*) provided a consummate example of this graduated hierarchy of portraiture translated into practice within one frame. As we move down the ladder of sanctity, so the expressionist treatment is relaxed, to be replaced by a more natural depiction. Christ himself, the holiest of the figures included, is highly stylized in presentation, his face Byzantine, with artificial rays emanating from it to form emblematically the combined image of sun and cross. Next in rank, the Virgin Mother, although less rigorously artificialized, remains icon-like both in face and posture, with the large decorative halo heightening the impression of elevated sanctity. At either side, Mary Magdalene and John the Baptist, although still formally haloed, are more naturally portrayed, their features softened, their bodies more flexibly bestowed; while the kneeling donor to the left, the only non-sacred human in the scene, is, with his high cheekbones, distinctively square jaw, slightly reddish nose, and realistically draped surplice, so vividly depicted that the spectator can immediately identify with him as a human like himself.

Such duality in stylistic treatment had occurred, so far, as an organic development within the major design, with the contrasting naturalness of the donor or torturer heightening the dignified solemnity of the martyrdom as an integral part of the scene. In the fifteenth century, however, there may be perceived a tendency on the part of the artist to exploit the presence of the less sacred characters as an opportunity for artistic experimentation, an occasion for exploring the possibilities of accurate physical representation for its own sake. But even in

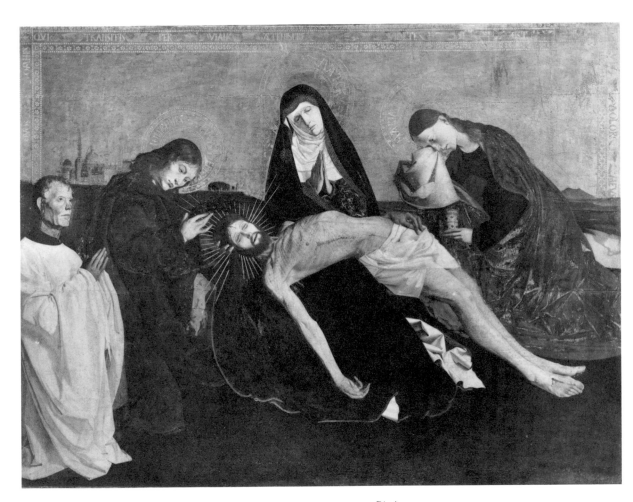

25. MASTER OF AVIGNON, *Pietà*

that context, the overall holiness of the scene is carefully preserved and the integrity of the work ensured. Antonio Pollaiuolo's *The Martyrdom of St. Sebastian* from 1475 (*fig. 26*), possibly painted in collaboration with his brother Piero, is an impressive example of that process at work. As in the York Passion play with its contrasting treatment of elevated martyr and earthy, realistic torturers, so here a pyramidal design places at its apex the idealized saint bound to the tree stump, his body shot through with arrows, while his gaze, signifying his spiritual surmounting of fleshly pain, is raised heavenward in calm anticipation of his celestial reward. Surrounding him below, six archers are busy with the practical and mundane task of despatching him from this world in a manner echoing the workmanlike hammering of nails and raising of the Cross on the contemporary stage. There is, however, a significant difference; for where the torturers in previous scenes, whether pictorial or dramatic, were there solely to convey to the spectator the physical suffering of the martyr, the six archers are here fulfilling an additional role—offering the artist by their careful positioning a superb opportunity for an exercise in anatomical perspective. The four standing figures are clearly drawn from the same male model, his muscles taut as he draws back the bowstring, but viewed in each instance from a different angle, left and right, facing and turning away, while the two figures in the foreground present him from both front and rear as he bends to prime the bow.[12] The Christian message is once again not weakened but intensified by the practical concern with the instruments of torture. However, the design of the picture has been adjusted by the artist to allow at the same time a full indulgence of his interest in the human form.

This was a period, we should recall, before secular patronage had raised the status of the artist. The increased demand for works of art was soon in the High Renaissance to provide the successful painter and sculptor with the wherewithal to pursue his craft and also to offer him greater freedom in choice of subject. In this earlier period, however, the materials for painting and sculpture were at a premium, too expensive for experimental use, and the artist was obliged to use every commission he received (still predominantly for ecclesiastical purposes) to explore new techniques. A sculptor could not waste valuable stone nor a wood-

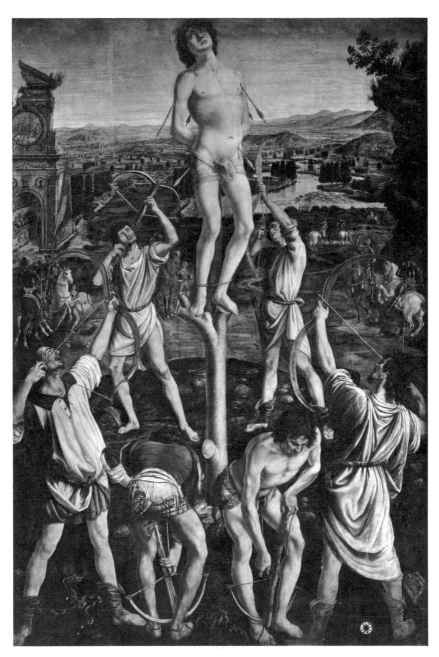

26. ANTONIO (AND PIERO?) POLLAIUOLO, *The Martyrdom of St. Sebastian*

carver a piece of good oak wood merely to indulge his whims, such as a propensity to depict natural or comic scenes, unless he could work those scenes into a commissioned piece where they would cause no offence. In contrast to the theme examined in the previous chapter where *The Canterbury Tales*, although describing a pilgrimage, made no pretence of being itself a holy work, here in the paintings to be placed upon the altar or in the ornamentation of a cathedral, the overall sanctity of the setting was paramount, the artistic works never to be authorized if any offence to Christian sensibility were felt. The places where they would cause no offence were restricted. Hence the proliferation of lively misericords and roof-bosses within the cathedrals and churches of the day. Such mundane or comic scenes could not be located on the high altar; but when elderly monks complained of being unable to stand for long periods during the church services and, out of compassion for them, the misericords were introduced—small ledges on the underside of hinged seats on which they could lean their weary bodies—the unused space beneath that ledge (one of the least sacred places in the cathedral, particularly as it was normally concealed from view) offered a wonderful opportunity for the imaginative carver, as did the roof-bosses above the cloisters, the ambulatory, or other less central locations in the solemn edifice. Hence the droll representation in stone at Wells Cathedral of a man suffering from toothache,[13] or the frequent puzzle-sculptures of wrestlers on roof-bosses with their limbs so cunningly intertwined that they can be viewed equally effectively from various angles. This was the period of the Perpendicular Gothic in architecture, when the splendid fan-vaulting spanning the nave and choir of English cathedrals, the high-pointed arched windows no longer blocked by the triforium of earlier years, and, from outside, the attentuated pinnacles and spires all drew the worshipper's eye upward from this world to the eternal, in much the same way as the central figure of the martyr on altarpieces gazes heavenward in renunciation of earthly life. Yet in such cathedrals, as in these paintings, the scenes depicting human, everyday activity had their place too, in those less sacred areas of the building where the artist could exercise his interest in the natural and quotidian without disturbing the larger, more solemn interest of the whole.

The relevance of all this to the mystery plays is no doubt by now evident.

Although the cycles had moved out of the cathedral into the charge of the trade guilds with, as Grace Frank has shown,[14] the blessing of the Church, they still depended for their existence upon the approval of the clergy. Under ecclesiastical rule, those vigorous scenes of ranting, wrestling, and comedy would never have been tolerated if they were felt to undercut the solemnity of the overall cycle or the gravity of the play's message. Inevitably, therefore, their beginnings are to be found infiltrating from the lower end of the sacred hierarchy, where no objection could be raised on the grounds of blasphemy. The characters most eligible for realistic elaboration, and indeed the first to be so elaborated, were clearly the villains of scriptural narrative, since the ridiculing of Christ's enemies was not only harmless but laudable. Through them, therefore, a more boisterous note first enters the play, with Herod soon becoming proverbial for his bombastic, tyrannical ranting, and introducing into the play, as in the Coventry version, a dramatic vitality beloved by the audience:

> HEROD: I stamp! I stare! I look all about!
> If I catch them I shall burn them alive!
> I rant! I rave! and now I run mad.
> (*here Herod rages on the pageant-car and also in the street*)[15]

The liveliness was captured on a roof-boss in the transept of Norwich cathedral, where Herod writhes in fury, held back with difficulty by two servants, and a fifteenth-century engraving presents him even more realistically chortling with glee over the slaughtered innocents.[16] The above stage direction, moreover, underscores the distinction between the characters examined here, for we know that often, before a performance began, Herod and Pilate (the latter no less notorious for his raucous voice)[17] would often, accompanied by minor devils, run among the spectators in the street, striking them over the head with harmless inflated bladders amidst general hilarity until the crowd quietened down and was ready for the play to begin. As non-sacred figures, they were free to mingle with the crowd, while the holy characters preserved, of necessity, a dignified distance.

Even less sacrosanct, and hence more readily available for dramatic elaboration, were the supernumeraries who, like the donors in the altarpieces, were not

included among the scriptural figures at all, or at the very least, were never specified there by name. Of Cain's servant Garcio there is no trace in the Bible, and the dramatist accordingly felt free to develop his cheekiness, particularly as the often obscene invective was directed at his master, one of the villains or "goats" of the biblical story. Similarly, Noah's wife, not acknowledged as an individual person in the original story, provided a scene popular in all the cycles as she refused, in defiance of her husband's authority, to enter the Ark, preferring to continue gossiping with her female friends, and eventually engaging in some marital fisticuffs. She was, as has been shown, an importation into the Noah play of the Shrew from the medieval sermon, whose function there was to teach all women, on analogy with the dire consequences of Eve's disobedience, the need for subservience to her appointed master.[18] Significantly, however, that realistic scene of marital brawling was never to appear in its more appropriate setting, the play of Adam and Eve; for Eve, unlike Noah's wife, was a central scriptural figure and the Fall too momentous in Christian history for humorous or even realistic elaboration. Only the periphery of biblical narrative could, like the margin of a Psalter, be so exploited.

As more naturalistic depiction rises up the rungs of the hierarchy, the next in rank of sanctity to be so treated after the villains and supernumeraries are the Old Testament characters who preceded the Christian era. However, as might be expected, that change only occurs as the Christological reading becomes weakened and the narrative there is seen on its own terms as a story of real human beings existing prior to Christ's coming. *The Sacrifice of Isaac*, accordingly, is in the earlier versions presented with uncompromisingly adumbrative connotations as a Crucifixion play, with Isaac described as "xylophorus," the bearer of the wood for the sacrifice upon his back to signify Jesus carrying the Cross to Calvary. In the Ludus Coventriae, therefore, Isaac is, like Jesus, a mature man and, like the Christian martyr on an altarpiece, welcomes the opportunity to die, thanking his father "full heartily" for fulfilling God's will by sacrificing him. But when the Christological reading is less dominant, as in the Chester and Brome plays, Isaac is portrayed in more human terms, as a child begging his father to cancel the harsh decree of death and simply to spank him if he has been naughty:

If I have transgressed in any degree
With a stick you may beat me.
But put up your sword, if you will,
For I am but a child.[19]

Similarly, the charming depiction in the Bedford Hours from 1423 (*fig. 27*) of Noah in more immediately contemporaneous terms as a mastercraftsman of the carpenter's guild, directing the apprentices working under his orders, reveals a sense of kinship far removed from the holier, more symbolic treatment of him in medieval commentary. In such earlier versions he was presented as a type of the Christian redeemer delivering mankind from destruction—as on the Doge's Palace in Venice where he leans against a vine to parallel the scene of Jesus on the Cross portrayed opposite. In this instance, in contrast, he is the Old Testament creature of flesh and blood, stripped of his typological connotations and at home in the world of reality, the world of the fifteenth-century artisan. He is placed in a setting displaying in detail the accomplishments of the joiner's trade—the smoothing of the planks with the heavy plane generally employed at that time, the use of contemporary drill, saw, hammer, and axe faithfully represented, the affixing of the roof slats to the wooden frame with long iron nails, all under the watchful eye of the richly robed guildsman Noah.

In the drama no less, the receding of the symbolic reading allows for him to emerge as an independent figure, and the proportional lowering in his sanctity produces a marked increase in the sense of contemporaneity. When the Ship-builders Guild undertook the preparation of the York play, the opportunity was not missed of representing Noah as a member of their own trade association, skilfully constructing a seaworthy boat, its joints firmly sealed to withstand the elements. In that representation, the order of the guild is intriguingly extended heavenward, so that God himself now becomes, as it were, the mastercraftsman whose instructions Noah, his accomplished apprentice, will meticulously implement:

To hew this board I will begin,
But first I will stretch out my line.
Now make it uniformly thin,
Lest flaws should spoil the smooth design.

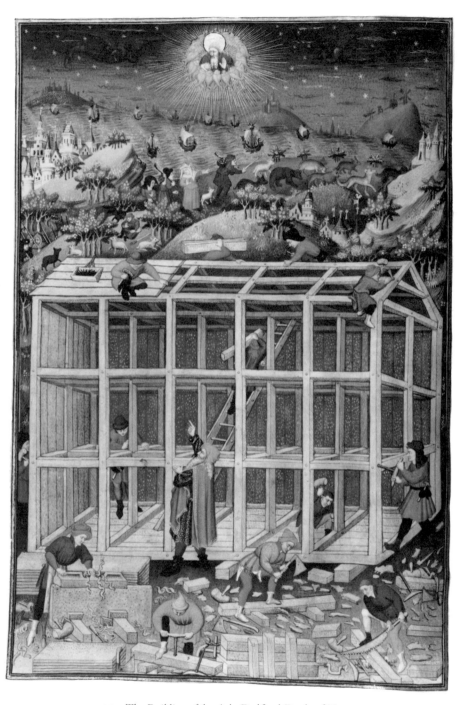

27. *The Building of the Ark*, Bedford Book of Hours

Then shall I join it sure and true,
Cementing with the finest glue.
Thus shall my work with skill be wrought
Just as my mastercraftsman taught.[20]

The process of more natural depiction began gradually to invade the New Testament scenes too, but once again first through the less sacred characters. The donor panel of the Mérode altarpiece discussed above (*fig. 20*, p. 71) forms part of a larger design reflecting this controlling pattern of humanization. Its central panel, *The Annunciation*, although becoming more realistic with, for example, the Virgin's halo omitted here, remains heavy with symbolism. We have learnt from one leading scholar how almost every item in this scene was, for the fifteenth-century viewer, fraught with allegorical meaning. The laver and basin serve as indoor versions of the garden fountain traditionally symbolizing virginal purity, the lions on the bench armrests refer to Solomon's throne in I Kings 10:18 ("On either side of the seat were armrests, and two lions standing beside the armrests"), and the still-smoking candle alludes to the Incarnation ("the smoking flax he shall not quench" Isaiah 62:3). If in the course of time some of the more obscure significations have been lost to us, it is obvious that the fireplace and screen, the two wall-brackets—one empty, one bearing a candle—conveyed further meanings for the generation of its creator, the Master of Flémalle.[21] In contrast, however, the right wing of the triptych is strikingly naturalistic. It is devoted to Joseph, a figure less integral to the Annunciation scene as one who had been the Virgin's husband only in name. Although it places him within the household into which the donors respectfully gaze, it significantly sets him in a room isolated from the sacred visitation—a workshop lacking any visible connecting door and in which he can work undisturbed at his carpenter's trade. There the scene is lovingly itemized not only in the variegated tools left untidily about in the midst of his work, but even in such details as the wooden pegs on the ceiling, securing the hinged window-shutters aloft to reveal a street scene in no way evocative of the exotic Holy Land, but such as would have greeted the artist himself on gazing out to the public thoroughfare of fifteenth-century Tournai.

Another scene close to the sacred episodes of the New Testament narrative which was nevertheless available by its nature for dramatic elaboration was the Shepherd Play, eventually to serve in these cycles as the setting for what is acknowledged as the liveliest and most amusing of such playlets; and the reason for its elaboration may be seen as closely connected with the theory suggested here. Even in its original form, the *Prima Pastorum* already suggests how deeply embedded in the aesthetic and religious consciousness of the time was this conception of two worlds, the mundane world of reality and the stylized world of sainthood. For although functioning as part of the Nativity scene and eventually merging into it, the preceding Shepherd Play was intended from the first to convey, by contrast with the Nativity, the grossness, materialism and discord of the common people, who walked in darkness before they saw the great light. The very clumsiness, greed, and brutishness of the shepherds in the humorous opening scene deepens the effect of their later conversion—their gentle faith and solicitude as they witness the birth and their earnest determination to follow a new way of life. To regard the cheating, horseplay, and jocularity in the brief *Prima Pastorum* as a secular invasion of the liturgical cycle is to misunderstand its purpose there, conveying as it does the universality of homage at the Nativity, embracing all strata of society from the royal Magi to the lowest levels of peasant stock. In the Chester version, the shepherds argue with each other, and dispute their rival claims for professional superiority, until the angel's *Gloria in excelsis*, comically misheard and only half understood by them, leads them to the solemn vision at the manger. There, reformed, they swear henceforth to leave their worldly tasks and, by disseminating among mankind their new-found faith, undertake to become shepherds only of the Lamb of God:

> Over the seas with God's grace,
> I shall wend my way now,
> To preach this in every place,
> And sheep will I keep none now.

To underscore this point, the banns for that cycle instruct the producers of the play to connect the mirth of the performance with the low status of the simple shepherds:

The appearing Angel and star upon Christ's birth
To shepherds poor, of base and low degree,
You painters and glaziers, deck out with all mirth.[22]

The method whereby the grossly human was here regarded as an integral part of the sacred whole can best be seen in the work of the painter Hugo Van der Goes, whose religious purpose in including both aspects cannot be impugned. An artist highly successful in his day, the dean of the painters' guild in Ghent for many years, he experienced in the latter period of his life a deepening of religious faith which led him to turn his back on the world and enter a monastery, where in 1476 he painted an altarpiece commissioned by the Portinari family, of which the central panel depicted *The Adoration of the Shepherds (fig. 28)*. It is a profoundly devotional work, as the circumstances of its painting would lead us to expect. There is reverential stylization in the portrayal of the Virgin, Child, and angels, a scene rich in religious symbols such as David's harp over the church door and the sheaf of wheat in the foreground signifying Bethlehem ("the House of Bread") to increase the remote sanctity of the scene. Yet in the upper right section of the panel the three shepherds, in contrast to the formalized posture of the angels, kneel in an utterly natural and plebeian way, their rough garments and coarse features emphasizing the power of the Nativity to affect even the most boorish of men. They remain, therefore, even after their conversion, representatives of mankind, human witnesses, like the donors, of the holy event, elevated by their presence at the scene and yet still rooted in the natural world of flesh and blood and subject to the exigencies of mortality.

Such, common to the various cycles, was the early shepherd play inherited by the Wakefield Master; and the process of its transformation into the more famous version marks a change in technique whose nature we know not only by observing parallel developments in the plastic arts but also from some evidence which has come to light comparatively recently. Pollaiuolo's exercise in anatomical drawing within the scene of a martyrdom, the woodcarvers' droll vignettes beneath the ledge of the misericords, and the sketches from daily life in the margin of the Psalter had indeed arisen from the artist's need to find some outlet for his growing interest in human activity by using the limited opportu-

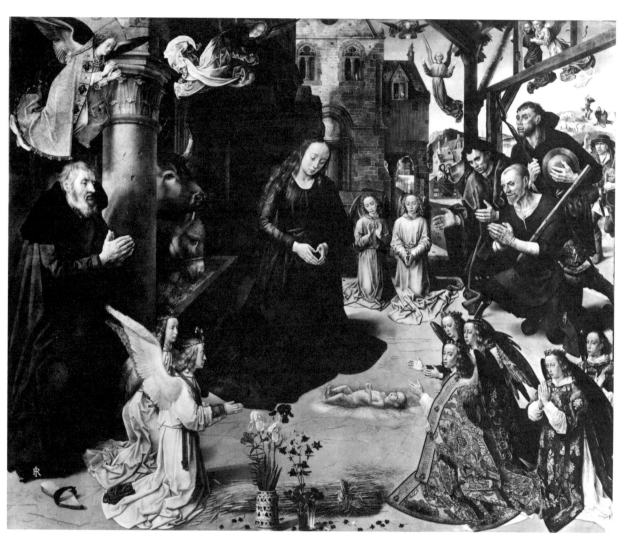

28. VAN DER GOES, *Adoration of the Shepherds*

nities available within the religious art of the period. But, as I have suggested, throughout this era the intrusion was neither brash nor haphazard. A natural reverence for the sacred carefully directed the artist to those areas in which his concern with the physical or human should in no way detract from the solemnity of the whole and, indeed, as in the more realistic depiction of the torturers, might even enhance the overall sanctity. For many years it was assumed that the Second Shepherd Play with its boisterous and yet subtly structured comedy was a natural outgrowth of the earlier versions, even though the leap from the primitive humour of the *Prima Pastorum* scarcely suggests organic development. It now appears, as a result of some interesting research, that it arose in fact as an engrafting of an already existent secular piece on to the older play, an engrafting skilfully effected by the Wakefield Master but an importation nonetheless.

The existence of an old ballad *Archie Armstrong's Oath* with a story similar to the Mak episode had long been known, but there was no evidence which of the two had come first. In an illuminating article published some half-century after its discovery, T. M. Parrott pointed out, by a study of the two endings, that the ballad must have been earlier.[23] In both versions a shepherd steals a sheep, disguises it as a baby in a cradle, and when charged with the crime amusingly swears that, if he is telling a lie, he will eat the occupant of the cradle. In the ballad, once the investigators have left, he accordingly salves his conscience by fulfilling his promise, and the entertaining rascal, by enjoying the succulent lamb he has stolen, thereby triumphs over society. The fulfilment of the oath is thus, as the title underscores, the climactic moment of the tale. In the Wakefield play, the pronouncement of the oath is also prominent, but once it has been proclaimed and the humour of his duplicity enjoyed by the audience, it is quietly shunted aside and forgotten. Mak's ruse is discovered towards the end of the play, as punishment he is tossed in a blanket, and the sheep is then returned to its rightful owner and placed in the fold, instead of being eaten.

It seems clear, therefore, that the more complete form of the story with the climactic fulfilment of the oath as in the ballad, was the original version; and the process of change can be reconstructed. The Wakefield Master, with his flair for comic dramatization, would have seen in that ballad perfect material for some lively drama but, like the contemporary sculptor lacking an appropriate piece of

wood or stone, he had no stage on which to present it other than that of the mystery cycle. The theme of the shepherds would have led him naturally to think of the shepherd play which, to his good fortune, occupied, by its pre-Nativity setting of unscrupulous worldliness, a low rung on the hierarchical ladder and was therefore ideally suited to his purpose. But a problem remained—that even the mild immorality of its comic ending, allowing the rascal to enjoy the proceeds of his crime and to pay no penalty, was inappropriate to the ethically didactic setting of the cycle in which it was to be placed. Accordingly, lest it harm that overall purpose, he felt compelled to change the ending even at the expense of losing a comic highlight of the play. Mak is made to return the sheep, pay a modest penalty, and to be reconciled ... with the demands of comedy, and be reconciled with his friends. But on the arrival of the angel and their proceeding to the solemn ... position of the two scenes—the Lamb within the ... the Lamb of God within the crib in the following ... parody, as some have assumed,24 serves rather ... red contrast between the pre-Nativity world of ... ed, duplicity, and rough humour, and the ele- ... scene itself, where the holy Lamb in the crib ... cept its message, an end to all such discord. In ... cordance with the current practice discernible in ... whereby the Wakefield Master carefully edged ... emn liturgical cycle in a manner not only avoid- ... ra of holiness but deepening it by the contrast it ... world of mortality and the celestial quality of Christian revelation.

Such gradual humanization of the characters at the lower level was bound eventually to affect in some way those on the higher range too, and the results in drama soon became apparent. As long as the entire play in which divine figures appeared remained remote from reality, *Deus* himself could appear in drama as an aloof and stern figure, omnipotent in his eternal grandeur. On a twelfth-century book cover (*fig. 29*), Christ in Majesty, representing the Kingship of God as pantocrator, is portrayed, as he is over the doorways of cathedrals, in austere benediction, with the Alpha and Omega marking his all-em-

29. Enamelled book cover, Limoges

bracing divinity, and surrounded heraldically by the four beasts symbolizing both Ezekiel's vision of the heavenly chariot and, by later application, the Four Gospels. In such awesome omnipotence he appears too in the early Chester cycle:

> DEUS: I am Alpha and Omega,
> Foremost and last,
> Being my will it should be so.
> It is, it was, it shall be thus.
> I am great and gracious God that never had beginning;
> The whole substance of begetting lies in my essence.
> I am the root of the Trinity that shall not split,
> Peerless patron imperial and Father of Wisdom.[25]

What I have termed the "expressionistic" or stylized depiction of saints and martyrs could in later years preserve that remoteness from the human world and isolate them for a considerable time from the encroaching naturalism. However, by the sixteenth century, when drama was no longer an exclusively liturgical entity and the stage was being made available to secular themes, God the Father had ceased to appear in drama, presumably because his presence was felt to be inappropriate as the stage became more humanized. The question began to be asked whether there was not some degree of blasphemy even in the idea of a man playing the role of Jesus. In 1530 Luther forbade dramatic representation of the life of Christ on the public stage and, although he relented in 1543, his vacillation was itself indicative of his concern.[26] What is clear from the records of the drama is that from then onwards the sacred figures began to be omitted from the cast in descending order of sanctity. The post-Reformation banns for the Chester cycle, for example, include the significant announcement that no actor will perform the role of God since such would be inappropriate. Instead only a voice will be heard intoning his lines.[27] As performances of the mystery plays became less frequent, not only God and Jesus, but the entire New Testament ceased to be available to dramatists as a theme for new plays and by the end of the sixteenth century all biblical drama, including that based on the Old Testament, disappeared completely from the English stage for some three hundred years, not

through an imposed censorship but, as I have argued elsewhere, through a growing recognition on the part of the playwright that the more naturalistic stage was no longer an appropriate setting for scriptural themes.[28]

Interestingly, in this respect drama and painting parted company; for in the visual arts no such gradual elimination of sacred characters occurred. There the saints and martyrs continued to occupy a position of centrality in religious art, even though the characters about them (and often they themselves) became increasingly humanized. Hieronymus Bosch's *Christ Mocked*, from about 1510 (*fig. 30*), could scarcely be more convincingly human in its presentation of Jesus as sweetly sad, resigned, and forgiving, while yet fully aware of the sadism of those around him as they pretend to lay gentle, comforting hands upon him, while one with a mailed fist viciously places the crown of thorns upon his head and the Judas-like figure to the left can with difficulty control his mirth.[29]

The different directions taken by the two media in this regard can be attributed, it would seem, to a basic distinction between painting and drama. For a painting, once completed by the artist, remains eternally unchanged, while drama passes from the hand of the dramatist to the actors, producers, and audiences over whom in subsequent years he can exert no control. The mockery in Bosch's painting can never slip out of hand and thereby damage the aura of sanctity surrounding Jesus. As we know from contemporary accounts, the same did not hold true for the performances of religious plays, however reverent the playwright may have been in constructing the text. In 1603, Henry Crosse complained bitterly of the scriptural plays still being performed in England: "Must the holy prophets and patriarchs be set upon a stage to be derided, hissed, and laughed at?" and Juan Luis Vives, the Spanish humanist who lectured in Oxford, in his commentary on *The City of God* described more specifically and with deep concern the catcalls and ribald laughter which he had witnessed at the performance of a Passion play in the Low Countries:

> And by and by, this great fighter comes and for feare of a girle, denies his Master, all the people laughing at her question, and hissing at his deniall; and in all these revells and ridiculous stirres Christ onely is serious and sever; to the great guilt, shame and sinne both of the priestes that present this, and the people that behold it.[30]

30. HIERONYMUS BOSCH, *Christ Mocked*

By that time, when the religious drama had become merely a dwindling part of a more lusty secular stage, and audiences had learned new and more vociferous forms of behaviour at performances, even the most solemn scenes were becoming subject to catcalls and laughter. In regard to the earlier period, however, when the presentation of a mystery cycle on the holy Corpus Christi day had been a deeply moving liturgical experience, it is apparent from the other art forms of the era that within the religious sphere the sanctity of the work had remained dominant in the minds of painters, sculptors, and dramatists, directing them to include their more naturalistic scenes only in those areas appropriate for preserving the overall solemnity of the cathedral or altarpiece. To return to Miss Prosser's metaphor, we must recall that the gargoyle in the late Gothic cathedral could not and never did appear on the high altar; nor was it ever permitted to overgrow or obscure the structure. Its assigned place was outside on the guttering, where in so innocuous a location it could contribute without offence to the awesomeness of the building as a whole.

Nor is this comparison of the gargoyle to the realistic scenes of drama mere metaphor. For in addition to the misericords and roof-bosses in out-of-the-way places, one of the most vivid instances of lifelike human carving derived from daily life in this period is to be found at the Cathedral of St. John in 's-Hertogenbosch of the Netherlands, rebuilt during the early fifteenth century after a disastrous fire. Those quotidian figures are, however, not in the cathedral at all. They appear together with the gargoyles, high on the flying buttresses outside, a host of ordinary townspeople—merchants, carpenters, and musicians—straddling the stonework as they strive to move heavenward, pursued by an occasional devil who has not yet despaired of catching a straggler or two (*fig. 31*). Far from detracting from the sacredness of the building, they represent in their very realism, like the homely shepherds of the Wakefield play or the middle-class donors on a painted altarpiece, the human role in divine worship, achieving spiritual elevation through their homage before the holiness of the scenes; but, as part of that homage, preserving a humble awareness of their own due place in the hierarchical order of sanctity.

31. Buttresses, 's-Hertogenbosch Cathedral

HIGH RENAISSANCE

3

THE IDEAL
AND THE REAL

THE PROCESS OF ACTION AND REACTION IN CRITICAL HISTORY, the tendency of each generation to question established opinions (sometimes more vigorously than is warranted in order to resist the authority which they have attained) has held conspicuously true for interpretations of the Renaissance. Jacob Burckhardt's admiring view of it as an essentially new age of self-reliant individualism, which he saw as nurtured by the rise of the Italian city-states, appeared at an auspicious time. It encouraged John Addington Symonds and other late nineteenth-century writers to regard that earlier period as an exemplary time of artistic vigour and personal creativity, a model to be contrasted with the debilitating and levelling effects of contemporary industrialism. That more positive response to the period has, of course, been contested no less trenchantly in our own century, with some opponents denying the very existence of any culturally cohesive pattern deserving separate identification under that term. The strange quality distinguishing this specific instance of critical oscillation is that, throughout the controversy, the excellence of the artistic and literary works produced in that period has never come into question. The validation or negation of the Renaissance as such has focussed rather upon the degree of originality it displayed. For Burckhardt the period constituted a genuine rebirth of the human spirit after the restrictive authoritarianism of ecclesiastical domination, while for later historians such a view was seen as seriously underplaying the medieval sources of that surge of intellectual creativity and enquiry, sources which, it was argued, could be effectively traced back beyond the thirteenth century. Herschel

Baker insisted that even as early as the ninth century there could be discerned in the writings of John Scotus Erigena the seeds of what was later to be called realism; and he concludes by rejecting the Burckhardtian reading of that period on the grounds that, so far from marking a revolution in man's conception of himself, "in its basic view of man the Renaissance preserved the continuity of medieval and pagan thought."[1]

This tracing back of Renaissance traits to their fainter foreshadowings in earlier periods has indeed proved eminently valuable to the historian, deepening our understanding of the complex interplay of ideas between generations. It has, however, produced a regrettable side-effect, the impression that such proof of intellectual ancestry automatically strips the Renaissance of its claim to originality or to uniqueness. A melon is no less a summer fruit because its seed was sown in the spring, nor conversely could that seed have germinated if planted in the summer. Each phase belongs to its own season. It is the process of metamorphosis that should be of prime interest to the historian, the gradual modification of the idea as its specific colouring, texture, or shape responds to changing climatic conditions, so that it becomes ultimately a product of its own time, at each stage integral to its own season.

Since the appearance of Panofsky's sophisticated defence of the concept of a Renaissance in Western art, with his subtle discrimination of the various "renascences" occurring within the main period, his acknowledgment of the medieval roots of much that was to be included and of the caution to be employed in any discussion of so complex a period, the term has come to be accepted with less discomfort by art historians.[2] In the realm of literary history, however, its reinstatement has been slower, and one of the most forthright attacks upon the concept of the Renaissance as a cultural entity continues, after nurturing over a generation of students, to head the list of recommended reading in the leading literary anthologies as the most reliable introduction to that period.[3] E. M. W. Tillyard's *Elizabethan World Picture*, examining the ideas of the cosmos at that time, of man's place within it, and of the ethical and philosophical implications of such an outlook for Elizabethan politics, morals, and social behaviour, devotes its opening pages to the view of the medievalists, attempting to prove that the "humanistic" views so often attributed to Shakespeare and his fellow writers

were merely commonplaces inherited from the philosophy and theory of the Middle Ages. Hamlet's speech extolling man's nature—"What a piece of work is man"—so often cited as a Renaissance assertion of human dignity against the humiliations of medieval misanthropy, is, he maintains, "in the purest medieval tradition . . . what the theologians had been saying for centuries"; and as evidence he quotes for comparison from a work by the fourth-century Syrian bishop, Nemesius, a passage which he sees as conveying the same philosophy of man's place in the universe:

> No eloquence may worthily publish forth the manifold pre-eminences and advantages which are bestowed on this creature. He passeth over the vast seas; he rangeth about the wide heavens by his contemplation and conceives the motions and magnitudes of the stars. . . . He is learned in every science and skilful in artificial workings. . . . He talketh with angels, yea with God himself. He hath all creatures within his dominion.

Certainly there is the seed of that later view here; but Tillyard does a grave disservice in blurring the distinction between the medieval conception of man and the Elizabethan. What Nemesius had not claimed for him was that very quality which lends such splendour to Hamlet's description and to the view of the Renaissance at large—the belief that man was not merely capable of navigating the seas and contemplating the heavens within the limits dictated to him by the Bible but that he was in his own nature boundless in potential. Abraham's plea for Sodom had long affirmed man's ability to converse with God and his angels, but the Renaissance saw him with new excitement as *infinite* in faculties, in form and moving express and admirable, in action like an angel, and in apprehension himself like a god.

This is no medieval view. Whatever continuation of earlier traditions may be discernible in Renaissance thought, nothing can negate the profound change which had occurred in man's conception of himself and his relationship to the divine. Echoing behind Nemesius's claim for man's preeminence over the creatures of this earth can be heard the verse on which it is based, the biblical assurance at the moment of man's creation that he should have dominion over the fish of the sea, the fowl of the air, the creature of the field, and every crawling thing.

If, then, we take that moment of Adam's creation and its representation in art as our touchstone, a comparison of any medieval depiction of the scene with a Renaissance version will reveal how fundamental was the reassessment. An early twelfth-century panel by Guglielmo carved on the facade of Modena cathedral (*fig. 32*) may be taken as fully representative of the medieval response to that scene. In the right-hand section it portrays Adam in accordance with the tradition then prevailing as an utterly weak and helpless creature, his knees literally giving way under him as he awaits the animating breath on which he is wholly dependent for life. Such portrayal is indeed faithful to the biblical account, where Adam, moulded from the lowly dust of the earth, is a lifeless lump of clay into whose nostrils God then graciously breathes the vitalizing spirit. So humiliating a depiction of man's creation did not suit Michelangelo's needs as he projected artistically through that scene (*fig. 33*) the new Renaissance sense of man's infinite potential and calm self-reliance. In this fresco, the details of the scriptural account are therefore quietly bypassed in favour of a more dignifying presentation of man's origin. The divine breath activating an inert mass of clay is replaced here by the scene of God's hand touching in consummating communion a creature already animate and handsomely formed. Adam, a muscular figure vibrant with potential vigour even before the life-giving moment, imperturbably extends one hand in a movement suggestive almost of condescension, to receive the final invigorating contact with the divine. By an ingenious structuring of the fresco, Adam appears reclining on a bank which slopes steeply upwards. The artist thereby reduces even further the humiliation implicit in the biblical account; for man here is presented not peering upwards but almost level with his Creator, equal to Him in bodily size as well as in beauty of form, and gazing fearlessly into His eyes with the intelligence of one in apprehension indeed like a god.[4]

For Hamlet (as for Michelangelo in subsequent scenes on the ceiling of the chapel) that is by no means the whole story, and his speech on the magnificence of man significantly concludes with the melancholy thought that this glorious creature is, after all, no more than a quintessence of dust. But if we shall return in a moment to that more sober assessment as constituting a vital part of the composite Renaissance image, for the present it may be sufficient to recall that

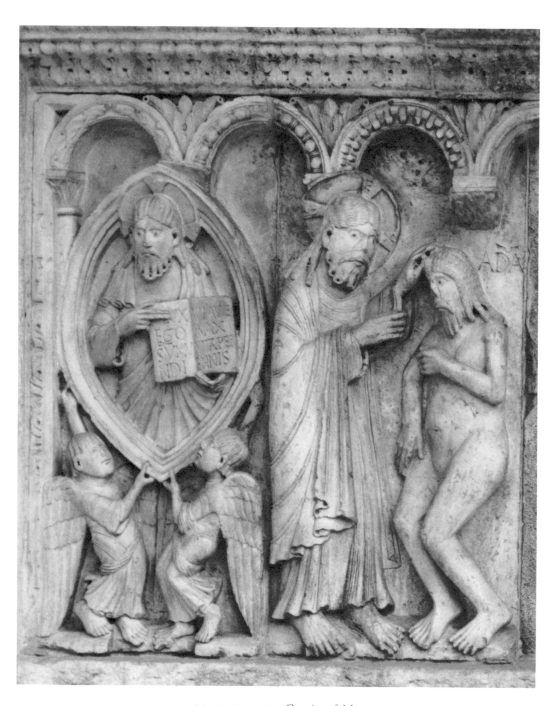

32. GUGLIELMO, *Creation of Adam*

the positive elements in the Renaissance concept of man, despite the assertions of Tillyard and others, did mark a dramatic movement away from the medieval emphasis upon his limited and modest position in the cosmic hierarchy. The greater potential accorded to him in the revived forms of Neoplatonism in this era cannot be ignored. Plato may not have been forgotten during the Middle Ages but, as Paul Kristeller reminds us, his influence had been severely restricted. Until the twelfth century, the sole Platonic dialogue available to a scholar in Latin translation was the *Timaeus*, with the remaining dialogues remaining for the most part inaccessible until the revival of Greek studies in the fifteenth century.[5] At the Platonic academy founded by Marsilio Ficino under the patronage of the Medicis there was not only the ambience of a newly founded cult but the liturgical trappings too, the veneration of a long-neglected master before whose bust a flame was to be kept constantly burning and whose birthday was celebrated by his votaries with the reverential singing of hymns composed in his honour. From Ficino's writings there emerges an enlarged sense of man's latent capabilities, the possibility of his ascent through love, as in Diotima's description in the *Symposium*, towards the celestial *calocagathia*. There, spiritual contact with the divine force of creativity would allow him to return to earth, no longer the unpretentious craftsman of medieval times but the divine artist, empowered to preserve for eternity in his works the otherwise fleeting and temporal; and thereby to achieve both for himself and for his patrons a fame which should last for perpetuity. Its impact had implications beyond that of the artist. As Ficino wrote to the young Lorenzo de Pierfrancesco in urging him to cultivate the new *Humanitas*:

> My immense love for you, excellent Lorenzo, has long prompted me to make you an immense present. For anyone who contemplates the heavens, nothing he sets eyes upon seems immense but the heavens themselves. If, therefore, I make you a present of the heavens themselves, what would be its price? . . . my gifted Lorenzo, go forward to the task with good cheer, for he who made you is greater than the heavens, and you too will be greater than the heavens as soon as you resolve to face them. We must not look for these matters outside ourselves, for all the heavens are within us, and the fiery vigour in us testifies to our heavenly origin.[6]

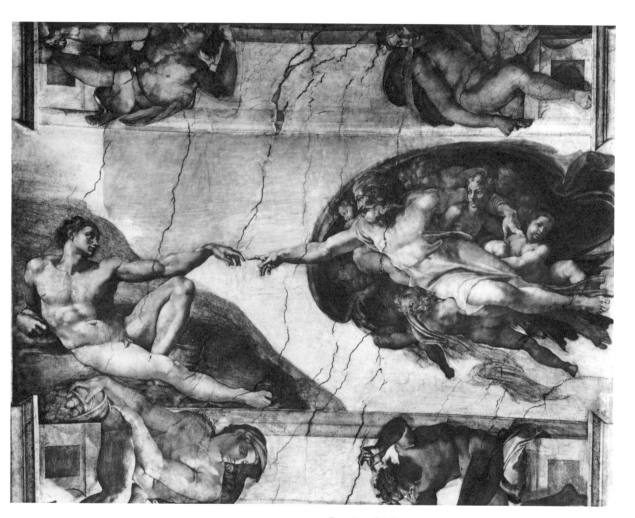

33. MICHELANGELO, *Creation of Adam*

On the other hand, such a view of humanism, attractive as it may be, is in its own turn inadequate as a comprehensive image of the age. That more optimistic assessment not only underplays the theme of the quintessence of dust but, as Hiram Haydn argued some years ago in a stimulating study, it ignores certain figures of the sixteenth century who can by no means be made to conform to the dominant Neoplatonic concept and who are at the same time too central to the intellectual history of the period to be conveniently relegated to the status of minor aberrants. In such leading thinkers and writers as Machiavelli, Luther, Copernicus, Montaigne, and Rabelais, he discerned a naturalistic or pragmatic reaction to the idealistic mode, and accordingly posited the existence in that period of what he termed a "Counter-Renaissance" whose adherents rejected or at the very least questioned the assumption of cosmic harmony and order in favour of a concern with provable facts. In line with the nominalism of William of Ockham and the fledgling empiricism of Roger Bacon, its proponents are seen within his book as perceiving in man's wretched state in this world, in the ruthlessness of power politics, or in the inconsistencies of astronomical calculations reason to challenge the Neoplatonic faith in universal hierarchy and to search more objectively for new, if often less comforting, explanations of man's place on earth.

In Machiavelli's *The Prince* Haydn sees a conscious repudiation of the traditional hierarchies, of the moral chain of being unifying the cosmos, and a conviction that morality is no more than mere "imagination." The conventional assumption that earthly rulers are governed by ethical imperatives and that as divinely appointed trustees of justice and order they are to be rewarded or punished by heaven in accordance with the degree whereby they fulfil their sacred tasks is for him not only foreign to reality, but perilously misleading, as is any ideal or "imagined" republic conceived on the Platonic model. Since his purpose in composing the treatise is declared to be utility, the proven achievement of Cesar Borgia's ruthless but remarkably successful rise to power will therefore serve him more effectively as a model of political expediency:

> But since I intend to write something useful to an understanding reader,
> it seemed better to go after the real truth of the matter than to repeat what
> people have imagined. A great many men have imagined states and

princedoms such as nobody ever saw or knew in the real world, for there is such a difference between the way we really live and the way we ought to live that the man who neglects the real to study the ideal will learn how to accomplish his ruin, not his salvation.[7]

The way one ought to live, the moral or ethical, is not wholly denied here, but it is reduced to irrelevance in the daily struggle for political survival. Copernicus, despite the anthropocentric universe assumed in biblical narrative (with a sun and moon created solely to serve man's purpose in distinguishing day from night and season from season), by suggesting on the basis of his own experimental calculations a heliocentric system, posited a cosmos in which man could no longer be conceived as the measure of all things but rather as a tiny creature on one of many thousands of similar stars orbiting in a vast heaven. The intellectual relativism implicit in this pragmatic movement led, Haydn suggests, to the scepticism, the discontent, and the spiritual disorientation of the Jacobean age, mourned so eloquently by John Donne in his *First Anniversary*, wherein "the frailty and the decay of the whole world" was represented as resulting directly from the New Philosophy.[8]

Haydn's insights have been valuable indeed in creating a deepened awareness of the empirical strain in Renaissance thought; but by assuming the existence of a dichotomy between the idealists and the empiricists in that age and by classifying "naturalism" as a countermovement resisting the dominant humanistic mode, he misses what should, I believe, be regarded as one of the most distinctive qualities of the Renaissance itself—its responsiveness to the essential duality of human experience and of the human condition. At times, it is true, that complex conception was expressed in polarized form, with Machiavelli marking the pragmatic extreme and Pico della Mirandola, at the other end of the Renaissance spectrum, urging an exclusive devotion to the ideal or celestial: "Let us spurn earthly things, let us struggle towards the heavenly. Let us put in last place whatever is of the world; and let us fly beyond the chambers of the world to the chambers nearest the most lofty divine."[9] But in both the art and literature of the period, the greatest achievements, it may be argued, are to be found when neither extreme was espoused, when these two essentially innovative philosophies (innovative at least in the form they took at this time) were enrichingly integrated

to create that rare combination of an infinite cosmic range coupled with an acute perception of terrestrial reality. Such Renaissance vision saw man as reaching in spirit to the stars, yet still standing firmly within the tactile setting of this earth, the latter no longer to be despised in medieval terms as a mere anteroom to eternity but to be respected, enjoyed, and appreciated in its own right. It produced, in addition to heroes rivalling the gods in love and war, Shakespeare's practical interest in the handling of a ship's tackle, in the bobbing of a flag upon a stream, in the technical details of falconry, or in the country names that shepherds give to the flowers of the field, all of which by the sharpness of image not only linked man's wide-ranging spirit to his earthly habitation but also lent to the account of such celestial strivings a dramatic credibility unrivalled in other areas.

There does exist at times, as Theodore Spencer perceived many years ago, a Renaissance conflict between the optimism implicit in Neoplatonic thought and the pessimism arising from a realistic examination of man's earthly condition.[10] By the force of his inner spirit, Lear majestically commands the storm in his wrath, yet learns the grim lesson that unaccommodated man is on this earth but a poor, forked animal, vulnerable to rain, cruelty, and cold. Yet that contrast which sees the celestial elements as good and the earthly as depressing is itself an oversimplification; for it must be seen to function at other times—even, indeed, within this very play—with reverse effect, as our sympathies are engaged by the realist at the expense of the dreamer. The blunt, honest Kent insists on acknowledging the facts as they actually are, urging Lear to let him be the true blank of the King's eye so that his master may at least see how the world goes. In comedy, Viola, by her attractive common-sense awareness of the ways of this world, her unhesitating recognition of her own disguise while those about her are unaware of theirs, amusingly exposes the romantic excesses and self-flattering delusions of Illyria. This Renaissance sensitivity to both aspects of human existence, the celestial aspiration and the objectively true, as well as its perception of both the recompenses and the dangers inherent in each, contributed in no small degree to creating that more complex and rounded view of man which emerges from the best literature of the time.

The theory that the splendour of the Renaissance derives in large part from the integration of these two modes of viewing the world finds significant con-

firmation in the aesthetic and literary theory of the time. In an earlier chapter, attention was drawn to the dangers implicit in the approach to historical processes in terms of "maturation"—the assumption, for example, that the growing interest in accurate spatial depiction constituted a linear progression from an initially experimental ineptness to the eventual technical control and skill achieved at the time of the High Renaissance. That process should be seen rather, I have argued, as a series of separate, successive stages each of which answered to the aesthetic needs of its period, the direction of development being determined less by accumulated momentum than by the shifting cultural requirements of succeeding decades. In this instance, the earlier period, as we have seen, restricted its pursuit of verisimilitude to surface details as part of its abiding belief in the ultimate transience of this world concealing the eternal verities beyond. Depth-perspective at that stage would have been not merely irrelevant but philosophically inconsistent or unjustified, a confusing of the merely terrestrial and the divine. Hence the fidelity to visual truth was initially deflected to the depiction of donors or marginal scenes, subordinate to the eternal sanctity of its more central message. By the latter part of the fifteenth century, however, there is a recognisable and, indeed, conscious change in the method of representing its scenes. The interest in spatial perspective has moved out of its subsidiary category and become endowed with a new status as an element now intrinsic both aesthetically and philosophically to the primary purpose of the work.

The care over accurate line-convergence and overall proportion in the drawing attributed to Luciano Laurana from 1462 (*fig. 34*) formed an indispensable part of his search for harmony in planning *An Ideal City*. In accordance with the new faith in all-embracing truths which lent validity to the phenomenal world by their relationship to the divine, such experimentation could now be aimed at clothing the practicalities of daily urban existence with a perfection borrowed from celestial forms. The medieval penchant for divorcing the soul from earthly contact in a desire for its spiritual purity is replaced by a new conviction that man's spiritual well-being is intimately related to his physical surroundings and to the harmony or lack of it implicit in that environment. Earlier Roger Bacon, even while praising the faculty of sight for the sweetness, beauty, and utility which it afforded, had nevertheless concluded the lengthy discussion of optics

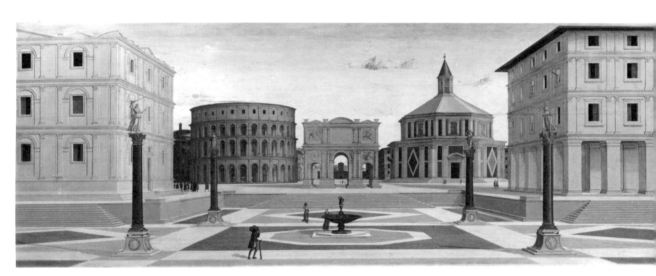

34. LUCIANO LAURANA(?), *Ideal City*

in his *Opus Maius* with the solemn reminder that man's physical eye perceives on earth only a weak and untrustworthy reflection of truth—seeing, as St. Paul had warned, only "as in a glass darkly." For Leonardo, however, all medieval warnings against the deceptiveness of sight fall away. The eye, no longer the se-ducer of the Christian spirit, has become in his luminous phrase the "window of the soul," establishing a healthy communion between the inner self and the outer surroundings of its habitation. So vital is that organ to the soul's existence, he points out, that when danger threatens, its immediate impulse is to protect the eye before any other part of the body. The soul, he argues, "is always in fear of being deprived of the eye, to such an extent that when anything moves in front of it which causes a man sudden fear, it prompts him to use his hands not to pro-tect his heart (which supplies life to the head where dwells the lord of the senses) nor to protect his hearing, sense of smell or taste; but the affrighted sense im-mediately, not contented with shutting the eyes and pressing their lids together with the utmost force, causes him to turn suddenly in the opposite direction; and not as yet feeling secure, he covers them with the one hand and stretches out the other to form a screen against the object of his fear."[11] In the drawing attributed to Laurana, as in the general tendency of art at this time, the accurate depiction of the tactile world was therefore not a counter-movement to Neoplatonism but a means whereby celestial forms could be incorporated into daily life, and the terrestrial thereby raised to some greater degree of participation in the divine.

The modern dichotomy between the liberal arts and the exact sciences (which even T. S. Eliot's protest against the dissociation of sensibility from in-tellect has failed to bridge) was, we should recall, not only foreign to Greek thought from which Neoplatonism derived its ideas, but would have violated the principles on which it was based. Those rules of universal harmony which Pythagoras believed to be operative throughout the cosmos had served to unify all aspects of the natural and spiritual worlds in a manner which appeared em-pirically provable. Numbers, while regarded as existing independently in the conceptual world untouched by the temporal, when they did pass into the ma-terial universe were seen as positive, creative forces. Two separate dots produced by their relationship a line, and hence dimension; three enlarged the figure to a plane; while the addition of a fourth (as in a triangle-based pyramid) predicated

the existence of volume. Thus from One, the conceptual monad equated in medieval Christianity with God the beginning of all things, there developed by extension all lines, planes, and solids of the tactile world, which, after its creation, continued to function in accordance with the mathematical dictates of harmonious and inharmonious relationships. From such ideogrammic patterns Boethius was able to bequeath to the Middle Ages the *quadrivium* or fourfold path to knowledge, consisting of arithmetic, geometry, music, and astronomy as embracing all forms of truth.[12]

Such close integration of the corporal and incorporal was particularly welcome to the Renaissance humanist who revived and extended the implications of this system. Nicholas of Cusa, whose influence on contemporary artists and thinkers, while it may have been exaggerated by Ernst Cassirer, was nevertheless extensive, lent added force to the Pythagorean system in the fifteenth century. He argued as part of the theological speculation in his *Idiota* and elsewhere that, although an infinite God is beyond human knowledge, the logical and mathematical processes which man in his mortal form is able to grasp, can at least aid him in moving towards such a comprehension. With a significant twist to the Platonic or Orphic conception, he offered as an example that God, being perfect, should be conceived geometrically as a sphere whose centre and circumference are identical. Such a figure cannot be apprehended by the human mind, but the knowledge gained from geometry can assist it in its attempt to achieve some intellectual awareness of God's transcendent being. In a metaphor which marked his desertion of medieval thought, he compared the human mind to a divine seed planted in the soil of this sensible world to enable it to blossom and bear fruit. For him, therefore, the phenomenal world was no longer the vale of mortality and corruption, but more positively a source of intellectual and spiritual nourishment for the soul seeking after the divine.[13]

What held true for the philosophy of the era became absorbed into the artistic precepts of the day. Verisimilitude, both in the accurate depiction of objects and in the concern with an organized spatial perspective, was no longer a distraction from the heavenly theme of a painting, nor a potential intrusion into the sacrosanct by the despised world of merely transitory existence but an authentic means of apprehending truth. The ultimate aim henceforth of painter, architect, and sculptor was to present in his work the attainment of a harmonious ideal by

means of fidelity to the actual, and thereby conversely to endow the terrestrial with divine proportion. To take as examples two of the best-known works of the period, in Leonardo da Vinci's *Madonna of the Rocks*, the holy figures are sensitively placed both in their own poses and in their relationship to each other so that together they convey a sense of infinitely restful harmony of form, a glimpse of celestial perfection idealized beyond reality; yet they are set within a scrupulously precise rendering of nature itself, with real geological formations behind resulting from the artist's careful researches, and with flowers and shrubs drawn lovingly leaf by leaf to frame that rarefied sanctity within the phenomenal world. Even the sacred figures themselves, however remote they may seem from the mundane, draw much of their impressiveness from those very anatomical studies in which the artist had engaged. The infants of earlier paintings had really been adults reduced in size. Leonardo was not only, as we all know, the first to dissect an embryo within the womb in order to establish its positioning and shape but also the first to perceive that the proportions of a child, as well as the formation of its head and facial features, are unique to that early period of growth. As he records in his *Notebooks*, small children, in contrast to adults, "have all the joints slender while the intervening parts are thick . . . and a flabby layer of flesh is found between one joint and the next."[14] It is that factual perception which produces with such charm the chubby innocence of the children within this holy painting. Moreover, the drape of the Virgin's voluminous cloak and the ringlets of hair falling gracefully to the shoulder are so visually persuasive that the dream world of the picture comes into close conjunction with the natural world as we know it. In the same way, in Michelangelo's sculptural group *Pietà* of about 1499, the idealization of the Madonna, whereby she appears there as a young girl no older than the dead son lying before her, allows the sculptor, at the expense of historical truth, to attain to a heightened sense of celestial grace. Yet the beauty achieved both for mother and son—for the latter even in death—remains an utterly human beauty, the comeliness of astonishingly real flesh, with veins branching along the dead Christ's arm, a fold of cloth caught between two fingers at the moment of death, and the shape of the Madonna's rounded breasts visible through the loose and magnificently draped garment she wears.

There is here no drifting away from the world into some impossible heavenly

perfection, but rather an apprehension of heavenly beauty through the reali-
ties of human existence, in a manner unique to this age. It was not unique in its
yearning for the ideal and sublime. In later years, romanticism was, with differ-
ent emphases and in a different context, also to respond to the concept of moral
impulses from nature inspiring man to harmony of spirit and noble thoughts;
but a poet such as Wordsworth excluded from his poetic world, as if it had no
place there, the actualities of natural existence, the vicious tearing of prey by bird
and beast, the rapacious satisfying of appetite which occupies so central a place
in the imagery and themes of Renaissance literature. Our own twentieth cen-
tury, on the other hand, has, under the tutelage of Darwin and Freud, become
only too aware of man's participation in the harsh battle for survival and of the
sadistic impulses within him, only thinly veiled by the veneer of civilization; but
it has surrendered its faith in the sanctity of the human spirit and in the potential
of man to attain to the divine. Only the Renaissance blended those two aspects
of ideal and real as intrinsically unified elements of its philosophy, incorporating
that duality into its art and literature to create its remarkable breadth and range
of vision.

This duality is not merely discernible retrospectively through a close study
of Renaissance productions, a quality to be uncovered by the patient historian or
critic, but should be recognized as intrinsic to the artistic principles promulgated
by the leading aesthetic theoretician of the time. The importance of Leon Bat-
tista Alberti in the development of fifteenth-century visual perspective was fully
acknowledged by his contemporaries, even though some elements of fixed-view
perspective had already been the subject of experiment before he wrote.[15] In the
dedicatory epistle to his *De pictura* (1435), he generously praised Brunelleschi for
the contributions the latter had made in that area, and we know that Masaccio's
Holy Trinity, with its striking effect of receding space achieved on a flat surface,
had been completed shortly before the publication of Alberti's treatise. Yet,
quite apart from the publicity he gave to the new principles of *costruzione legit-
tima*, he succeeded brilliantly both as practitioner and theoretician in formulat-
ing the new aesthetic for his age. His claim in this work seems, incidentally,
never to have been challenged, that he himself invented the widely adopted
velum or perpendicular grid through which the artist could, from some prede-

termined point, view the scene and thereby establish by means of the numbered square on that grid the corresponding place on his canvas on which each detail should appear. On the geometrical principle derived from Euclid, that the plane of the artist's canvas marked the intersection of a horizontal pyramid, with the painter's eye regarded as the apex of the pyramid and the scene to be painted as its base, he employed mathematical calculation relying on a monocular theory of optics to facilitate the translation of a three-dimensional scene on to a two-dimensional canvas, and to produce thereby an effect "as if the surface which they colour were so transparent and glass-like that the visual pyramid passed right through it."[16]

Here was an unequivocal statement of intent, the desire to record the natural scene with such fidelity that the canvas should function as a window through which the spectator gazes at reality. It was until this time a tendency more clearly marked in the Northern countries, notably in the paintings of the Master of Flé-malle and Jan Van Eyck; but that concern with naturalism had now become in-corporated as a conscious aim of Italian artists, with geometry and other math-ematical calculations henceforth employed to the full in the search for visual accuracy. Yet more relevant to our present study is the fact that the very same Alberti who marked a turning-point for fifteenth-century art theory in his de-mand for the accurate mirroring of nature was also the most forceful advocate of that second aspect of Italian Renaissance aesthetic, the principle that such work was to aspire to an idealized harmony and proportion. The painter, he ar-gued, must aim not at likeness but at beauty itself, like the ancient Zeuxis who, in order to create the perfection he sought, is said to have combined the best fea-tures of the five most beautiful maidens in his city. Alberti's *De re aedificatoria*, composed about 1452, urged architects to preserve with care those harmonious ratios discovered by the Greeks and adopted into later Roman buildings; and Ru-dolf Wittkower has shown how Alberti's followers scrupulously observed those ratios in their Renaissance buildings, not only in the relative height and width of each window, niche, or door within the carefully proportioned walls, but even in the placing of those elements within the walls and their distancing from each other.[17]

In this, he provided his own example for others to follow. The facade of

Santa Maria Novella, which he began redesigning in 1456 (*fig. 35*), may not at first sight appear unconventional if compared, for example, with that of the Romanesque San Miniato located not far away, but it marked a profound innovation in design, producing by means not immediately perceived by the viewer a more deeply satisfying sense of integrity and proportion. The height from the ground to the top of the pediment is exactly equal to the width of the facade, thereby creating a perfect square as the invisible frame of the structure. That geometrical form is echoed in the upper section which, if the scrolls are excluded, itself forms a perfect square precisely one quarter the size of the whole; and these harmonious relationships are extended throughout the rest of the facade, as in the two squares between columns on either side of the main door. The result illustrates his contention that in the same way "as in music when the base answers the treble and the tenor agrees with both, there arises from that variety of sounds an harmonious and wonderful union of proportions which delight and enchant the sense," so architecture must delight the eye by its conformity to the rules prevailing throughout nature. His theory was to culminate in a passage recognized in its day as the classic formulation of the new sensibility, that henceforth every work of art must aim at being a unified whole, so perfectly designed that any change, however slight, would prove detrimental:

> I shall define beauty to be a harmony of all the parts, in whatsoever subject it appears, fitted together with such proportion and connexion that nothing could be added, diminished, or altered but for the worse.[18]

Such a demand marked a major departure from medieval practice, typified by the Gothic cathedral both in its earlier and later phases. Not only were such cathedrals built over a long period with each succeeding master-builder adding to or changing the original plan (Gloucester cathedral begins its lower courses with heavy Norman columns, shifting to light Gothic tracery above) but, as Panofsky has shown more fundamentally, they reflected the schoolmen's desire for logical subdivision, an articulation of argument into schematic *membra* as in the *Summa Theologica*.[19] From the nave the openings to the transept are visible, but nothing beyond; and having reached them, the worshipper can see the transepts and choir, but the ambulatory and side aisles remain concealed. Each sec-

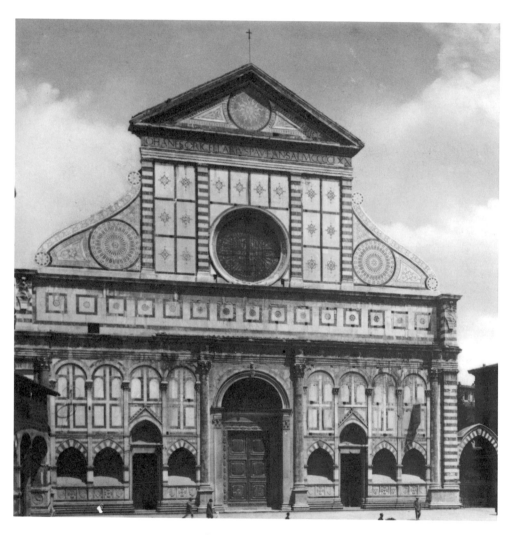

35. S. Maria Novella, Florence

tion through which he passes is to be responded to as part of an organized whole, but from no single point can that whole be perceived, as it was soon to be, largely under the influence of Brunelleschi and Alberti, in the centrally designed and henceforth often circular churches of the Renaissance.

This twofold validity accorded to ideal and real in Renaissance art, exemplified in the aesthetic theory of Alberti but extending throughout the creative thought of the time, is perhaps most strikingly illustrated in Raphael's so-called *School of Athens* painted 1510-11 (*fig. 36*). Its title, assigned to it in a later era, is misleading, as it presents not a Greek but a universalized view of philosophical speculation from classical to contemporary times. At the centre the two most prominent figures between the isolating arch are Plato pointing upwards to the heavenly source of ideal harmony and Aristotle pointing downwards to the earth to symbolize his empirical concerns. Not only is there no suggestion of conflict between them, but by their joint dominance of the scene they represent the amalgamation of these two apparently diverse views, the combined goal of the new age in its philosophical and artistic endeavours, drawing its inspiration from the past but adapting and remoulding it to suit its more immediate needs. The structuring of the fresco provides a translation into practice of that theoretical unity. On the one hand, the Aristotelian interest in actuality finds its expression in the spatial rationalization of the architectural setting, so accurately rendered with its broad stairway, decorative pilasters, and noble arches that it is believed by historians to represent the interior of St. Peter's as Bramante was actually planning it at the time. On the other hand, the harmonious depiction of that setting satisfies to the full the requirements of the Neoplatonic ideal. The consummately proportioned scene, with the lines of floor and cornice symbolically converging at a point between the two philosophers and the series of variegated arches culminating in the huge span in the foreground which frames and unifies the whole, lends a sense of calm and stability; while the figures, seemingly dispersed haphazardly about the hall in accordance with personal whim or mood, are in fact carefully grouped to create a subtle balance which the displacement or removal of even one would disturb. Significantly, Raphael places the portrait of himself on the right, within the group of geometricians gathered about Euclid, as if to affirm symbolically the union of art with the empirical and mathematical sciences.

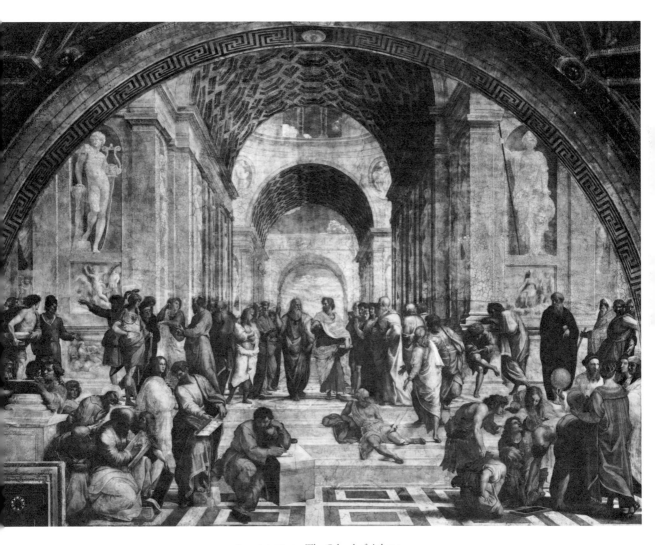

36. RAPHAEL, *The School of Athens*

In literary history, this Renaissance integration of ideal and real has been blurred by a number of factors. For many years, the philosophical implications of Neoplatonism for the era, profound as they were, have been emphasized at the expense of the naturalistic. When the cause of the latter was taken up more vigorously, as outlined above, Hiram Haydn's separation of these aspects into two opposed movements, Renaissance and Counter-Renaissance, left the former still principally identified with the ordered cosmos, even though the union of the two approaches may offer the most valuable key to interpretation. In addition, an ambiguity implicit in the use of the term *nature* in this period has served to conceal the distinctive elements which combine to form the complex scene, since the word could be used freely at that time to refer either to the tangible world of created matter or to the ideal world from which it drew its models. We owe to John Danby the recognition that in *King Lear* "nature" is employed to denominate on the one hand the factual world of lusty cohabitation and with it the accumulation of wealth and property which the pragmatic "natural" son Edmund wrily claims as his "goddess," and on the other hand the celestial sanction for moral order and benevolence to which Lear prays for the restoration of "natural" filial piety and love.[20] Through the gentle ministrations of Edgar, Kent, and to a lesser extent the Fool, the king must learn gradually to acknowledge the claims of both worlds, of the poor and naked wretches whose lack of financial means exposes their bodies to the cold and storms of the natural world and also the ideal love between father and child derived from heavenly sources which Cordelia comes to symbolize for him in contrast to the "unnatural" hags who have so pitilessly caused his suffering.

Formal treatises in this period continued often to preserve the traditional subordination of Art to Nature, in accordance with Plato's regretful derogation of the imitative arts as being a mere counterfeit of reality's shadows. Robert Fludd in 1617 graphically illustrated this inferiority, as he conceived it, in the diagram of the universe which he included in his history of the macrocosm. Nature in the form of a woman stands half within the celestial spheres and half within the material with one hand linked by chain to the divine above, while with the other she herself controls, as God's representative, the created world below. On the earth beneath her, Art, represented as an ape, tries simply to

mimic her and the objects within her realm, and its inferiority in the hierarchical scale is thus seen as axiomatic.[21] Similarly, Erasmus in his *Praise of Folly* declared, "Much better in every respect are the works of Nature than the adulteries of Art," and Calvin, seeing man as nature corrupted through the Fall, regarded art or the products of the human imagination with the gravest distrust.[22] But as the Renaissance respect for art as a universalizing and perfecting of nature's specific forms infiltrated England from the continent, a more positive view of it began to prevail, with George Puttenham now describing it as superior to nature and "in some sort a surmounter of her skill."[23] When Shakespeare defines through Hamlet's lips the function of drama—in the very image that Leonardo da Vinci used for painting[24]—as the holding of a mirror up to nature, his comment might mistakenly be construed (particularly in the context of a warning to the players not to overact) as being restricted to mirroring the truths of the actual world; but the continuation of that definition reminds us that its function is at the same time more universal, "to show Virtue her own feature and Scorn her own image," thereby evoking its larger purpose, its examination of truths valid for all generations. In exposition of that duality, Hamlet himself becomes at one and the same time so vividly human and real that a personal sense of loss is experienced at his death; and yet in a more universal sense he constitutes too an abstract or epitome of man's eternal perturbation over the significance of human life, a combination that earlier drama had never achieved.

The most influential statement of the new view appeared, of course, in Sidney's *Defence of Poesy* where, prompted partly by the Puritan need to justify literature against the charge that fiction was moral falsehood and partly by a desire to counter Plato's exclusion of it from the ideal commonwealth, he laid the main emphasis upon poetry's ability to teach verities beyond the palpable world. There is, he affirms (with literature included) "no art delivered to mankind that hath not the works of nature for its principal object." The geometrician and physician are restricted to the empirically observable, but the writer "disdaining to be tied to any such subjection, lifted up with the vigour of his own invention, doth grow in effect into another nature, in making things either better than nature bringeth forth, or quite anew, forms such as never were in nature." Poetry, therefore, is both *mimesis* in the sense of imitating actuality, and at the same time

a surpassing of nature, the depiction of those elements which man's Fall prevents him from attaining but which his "erected wit" may know in their perfected forms. Furthermore, in accordance with Alberti's formula for art as a planned and proportioned integration of all parts, so poetry uses words, Sidney argues, not "as they chanceably fall from the mouth" but through the selection of "each syllable of each word by just proportion according to the dignity of the subject."[25]

Some of the broader implications of this art theory for Elizabethan literature will be discussed in subsequent chapters, but Sidney's interest in the choice of words or the diction of poetry may lead us to examine at this point a problem particularly relevant to the present volume, the reason why England developed its own High Renaissance in literature so late in the final decades of the sixteenth century, some eighty years after Italy, despite its awareness of the changes occurring on the continent and its eagerness in many ways to follow its course. At the very height of the artistic flowering in Florence, Henry VIII provided evidence of that interest by inviting Pietro Torrigiano from there to design the magnificent Renaissance tomb for the chapel he was erecting within Westminster Abbey in his father's memory. In the rich Italianate style of its day, it occupies there a position of centrality in marked contrast to the Late Perpendicular Gothic of the chapel in which it stands. Torrigiano executed a number of works for the court, among them the sensitively worked effigy of Margaret Beaufort in Westminster Abbey as well as terracotta busts of Henry VII and his son.[26] On his departure for Spain in 1519, he left a group of Italian craftsmen to complete various commissions. Cardinal Wolsey, too, imported Italian artists and sculptors to contribute their skills at Hampton Court while it was in his possession; and Hans Holbein the Younger, although himself of German origin, as a profound admirer and imitator of the Italian manner, from 1532 furthered its acceptance on the English scene under the active patronage of Sir Thomas More.

There were no doubt economic and social factors involved in the slowness of England's own response to the continental modes, even though the old theory attributing the dazzling period of literary creativity at the end of the century to the country's burgeoning sea-power, its replacement of Antwerp as the financial centre of Europe, and the comparative security of the throne can no longer be

taken very seriously. The very connexion between national self-confidence and literary success should itself be regarded as suspect, since surges of creativity seem to occur at least as often during times of national disillusionment, stress, and doubt. The works of Tolstoy, Dostoevsky, and Chekov were nurtured in the soil of a corrupt and obviously decaying Czarist regime; and if national self-confidence, military prowess, and expanding territorial conquest are the criteria for literary success, we should need to inquire why Nazi Germany which so abhorrently possessed all these qualities produced no literature of lasting merit. Moreover, what are by general agreement the most impressive of Shakespeare's plays were written not during the securer reign of Gloriana but in gloomier days under James I. Doubt has also been cast on the long-established belief that the arts are generally encouraged by the presence of a generous and powerful patron, since instances widely quoted as authority for such a belief have been shown only too frequently to have been fictions carefully cultivated by the supposed patrons for political ends. We have learnt from E. H. Gombrich how tenuous was Lorenzo di Medici's claim to being the Maecenas of the Golden Age of Florence. Although in his day he demanded and received lavish acknowledgment for his patronage and loved to pose as a benefactor, in fact he commissioned and paid for remarkably few works.[27] We may recall how true the same principle holds for Queen Elizabeth, herself extolled in her age by splendid tributes to her generosity and patronage, yet extraordinarily niggardly in making good the promises she so freely dispersed. With her fingers firmly on the strings of her purse, she would hint diplomatically at possible offices awaiting the aspiring writer; but the melancholy refrain, subdued but audible beneath the louder praise of her reign, is exemplified by Lyly's final outburst of bitter complaint addressed in desperation directly to her: "Thirteen years Your Highness's servant, but yet nothing . . . a thousand hopes, but all nothing; a hundred promises, and yet nothing."[28] It would appear, therefore, unlikely that the late flowering of the English Renaissance is to be attributed either to the country's delayed economic and military expansion or to the need for a suitable benefactor.

There is, however, one factor closely related to the artistic elements examined above which, although it may not have been the sole reason for the long delay in the English literary Renaissance, must, from the frequency with which

it was discussed, attacked, and defended in that era, have proved a major obstacle to its development—the state of the English language. Style at its best is, of course, not the mere clothing of thought but an organic outgrowth of the thought itself, reflecting in its own forms the content it conveys. In order to serve effectively as the vehicle for the new Renaissance modes, the English language needed to possess a twofold potential, a simplicity of diction to serve the accurate depiction of reality and, with it, a more sophisticated range of vocabulary and more complex syntactical forms from which could be forged the rolling rhetorical periods and wide-ranging philosophical speculation related to the more universal elements of humanist thought. French, as the language of diplomatic communication between the French and English courts since the time of the Norman invasion, had long possessed these resources,[29] as had Italian which marked the culmination of an uninterrupted tradition leading back to classical times; but English was as yet in many ways undeveloped, lacking one major facet of the qualities required. Its more limited vocabulary had been perfectly suited to the descriptive narrative, the humorous irony, and the pretended naiveté of Chaucer's verse. Even as late as 1470, Malory's *Morte Darthur* had achieved its most moving effects, its sense of an unmediated simplicity, by the same predominantly monosyllabic diction and uncomplex sentence structure which recreated in literary form a world of uncompromising clarity in morals, affections, and allegiances, as in the touching scene beside Queen Guinevere's grave:

> And when she was put in the earth Sir Launcelot swooned, and lay long still, while the hermit came and awaked him, and said: Ye be to blame, for ye displease God with such manner of sorrow making. Truly, said Sir Launcelot, I trust I do not displease God, for he knoweth mine intent. For my sorrow was not, nor is not, for any rejoicing of sin, but my sorrow may never have end.[30]

Here is the elemental directness of depiction, the opening of a window upon reality apparent in the verisimilitude of a Rogier Van der Weyden painting and which in a more sophisticated form Alberti demanded as one aspect of Renaissance art; but it was not a language capable of dealing with abstractions, the

evoking of those celestial ideals and harmonic proportions which formed the second aspect; and the lack was sorely felt. Hence the ferment of activity in the following decades as writers, translators, and educators sought to supply that urgent need by importing, adapting, or inventing new words, succeeding in expanding the vocabulary, as one researcher has discovered, by almost forty percent by the end of the sixteenth century.[31] For reasons of national pride, protests were heard from time to time, including Thomas Wilson's complaint against the use of "inkhorn" terms as a seeking "so far for outlandish English that they forget altogether their mother tongue," or Sir John Cheke's plea in a letter to Hoby that the language should not be completely bankrupted by foreign loan words. But the work proceeded nonetheless in providing what Thomas Elyot termed "the necessary augmentation of our language"—his justification for advocating *maturity* as a more appropriate word to describe human development, the old English *ripe* to be restricted thenceforth to fruit and vegetables.[32]

It is in that context that even those most bitterly opposed to the new-fangled words admitted, however reluctantly, the legitimacy of the charge that English was bare and rude as a language—"Shall we then think the Scottish or English tongue is not fit to write any art into? No, indeed. But peradventure thou wilt say that there is not Scottish words for to declare and express all things contained into liberal arts; truth it is."[33] For purposes of "art," in its expanded Renaissance sense, the language was inadequate. Accordingly, in turning to the classical rhetoricians as models for their pupils, sixteenth-century educators were hoping not only to improve their Latin but, perhaps even more, to improve their English. In introducing into the school curriculum an intensive campaign of translation back and forth in Latin and English, they selected Cicero's *De oratore* and the works of Quintilian for their primary sources because these were believed to contain stylistically those very elements felt to be lacking in English for the fulfilment of the new tasks, namely a "high" eloquence and what Richard Sherry called "an ample majesty, very garnished words . . . and grave sentences."[34] Towards the end of the century, just as the literature of England did begin its great blossoming, writers could at last pride themselves that the need had been filled, claiming with George Pettie in 1581 (in language which itself testified to the enriched vocabulary) that he now dares to write in English "as copiously for vari-

ety, as compendiously for brevity, as choicely for words, as pithily for sentences, as pleasantly for figures, and every way as eloquently" as any writer should do in any other language whatever.[35]

Within the prose of this era, that mingling of heightened grandeur and vivid verisimilitude of detail creates, as in Renaissance art, an embedding of the harmoniously abstract or rarefied in the specific and localized. Giovanni Bellini's *Doge Leonardo Loredano*, painted in 1501, by the quiet dignity of pose, the gaunt thoughtfulness of expression, and the perfect placing within the canvas, elevates the sitter into a universalized symbol of grave, responsible leadership valid for all generations while at the same time the stiff, ornamental brocade of his gown, conveyed with such scrupulous fidelity to texture and colour, places him as an individual in the clothes of contemporary fashion. So English prose of the sixteenth century, as part of the conscious desire of English writers to achieve a more sophisticated and artistic level of discourse, frequently draws upon the new "augmented" diction to soar into the universalities of philosophical thought, until a concrete visual simile usually worded in simpler Anglo-Saxon forms, brings such speculation to earth and into conjunction with man's daily affairs. With such stylistic technique, Thomas Elyot defends the hierarchical structuring of society, concluding with a sharply actualized illustration:

> Augmentation of honour and substance . . . not only impresseth a reverence, whereof proceedeth due obedience among subjects, but also inflameth men naturally inclined to idleness or sensual appetite to covet like fortune and for that cause to dispose them to study or occupation. Now to conclude my first assertion or argument, where all thing is commune, there lacketh order; and where order lacketh, there all thing is odious and uncomely. And that have we in daily experience; for the pans and pots garnisheth well the kitchen, and yet should they be to the chamber none ornament. Also the beds, testers, and pillows beseemeth not the hall, no more than the carpets and cushions becometh the stable.[36]

In Elizabethan fiction, that stylistic tendency to indulge in florid rhetoric is particularly marked, as the author, in accordance with current fashion, seeks to impress the reader with a grandiloquent display of verbal fecundity to lend a

learned and philosophical tone to his writing; but as it becomes necessary to move the plot forward and return to the actual events of the story, he slips into the simpler, livelier forms, thereby accommodating the twin aspects of his style. In his prose romance *Rosalind*, Thomas Lodge concludes an elaborate and verbally dignified passage with a sudden change to concrete and vivid narration, relating how Rosader

> did not this upon any malicious intent or niggardize, but being brought up in the country he absented himself as not finding his nature fit for such youthful company. Thus he sought to shadow abuses proffer'd him by his brother, but in vain, for he could by no means be suffered to enter; whereupon he ran his foot against the door and brake it open, drawing his sword and entering boldly into the hall.[37]

Even outside dramatic narrative, as in Sidney's *Arcadia* (which was narrative in only the loosest sense as providing a vehicle for the sonnets, eclogues, and lengthy speeches), that combination of disparate forms is again present. The sweet-flowing, delicately modulated prose rhythm creates an elevated effect, but part of the sophisticated charm which won for that work its reputation as the first English romance to rival the continental models was the wit whereby Sidney ironically contrasts the idyllic world of pastoral with the realities of daily life, often by the insertion of a homely detail or parenthesis which, like a sharp pull on the string of a kite, keeps the imaginative flights in check. As the princess is about to bathe, unknowingly watched by her hidden lover, nature itself is cleansed and ennobled to participate in the mythological ambience of the amorous scene.

> [The river] ran upon so fine and delicate a ground, as one could not easily judge whether the river did more wash the gravel or the gravel did purify the river; the river not running forthright but almost continually winding, as if the lower streams would return to their springs or that the river had a delight to play with itself. The banks of either side seeming arms of the loving earth that fain would embrace it, and the river a wanton nymph which still would slip from it.

Into this dream-like fantasy the writer introduces a creature from the phenomenal world, described with all the joy of artistically detailed observation as well as the humour of a worldly-wise courtier. The princess and her companions, preparing to bathe,

> though it was so privileged a place upon pain of death as nobody durst to come thither, yet for the more surety, they looked round about, and could see nothing but a water-spaniel, who came down the river, showing that he hunted for a duck, and with snuffling grace, disdaining that his smelling force could not as well prevail through the water as through the air, and therefore waiting with his eye to see whether he could espy the ducks getting up again; but then a little below them, failing of his purpose, he got out of the river, and shaking off the water (as great men do their friends, now he had no further cause to use it) inweeded himself so, as the ladies lost the further marking his sportfulness.[38]

The water-spaniel, one notes, is a means of amusingly introducing, through a parenthetical image, the shaking off of friends in this world by self-interested politicians—a moment of harsh cynicism contrasting with the undisturbed perfection and remoteness existing within the pastoral scene. Such use of that domestic animal, the dog, to inject a note of realism into a mythological or sacred scene would seem to have been more integral to the Renaissance mode than might at first appear. It had, we may recall, been one of the techniques for adding everyday interest to the sacred Magi pictures in the early Renaissance in the colourful processions winding through the countryside or even, with a touch of mild humour, in the foreground of Gentile di Fabriano's version (*fig. 13*, p. 35). That the choice was not fortuitous is suggested by a sixteenth-century *cause célèbre* concerning the academic freedom of the painter which had centred upon his introduction of that creature into a holy canvas. It indicated a conflict between the older establishment view, represented by the Catholic Inquisition, that sacred painting be stylized and remote from reality and the Renaissance painter's insistence on embedding such scenes in the real world—in effect on his right to determine what constituted art, sacred or otherwise. In a version of the Last Supper completed in 1573, originally entitled *The Feast in the House of Simon*

(*fig. 59*, p. 219), Paolo Veronese had designed a magnificent canvas (to be examined in more detail later) presenting the scene in heroic dimensions, yet anchoring it in the everyday world by the presence of elements familiar from contemporary banquets, such as entertainers and, not least, a large dog seated before the disciples' table. On its completion, he was summoned before the Inquisition on a charge of profanity, a sin compounded by his refusal to replace the dog by a figure of Mary Magdalene, as had been requested by the Prior responsible for the refectory in which the painting was to hang. His spirited reply at the trial was regarded in its time as a classic defence of the painter's right to determine the content of his canvas as he saw fit, using, as he claimed by a significant comparison with literature, "the same licence" that poets take. Ordered by the judges at the conclusion of his trial to institute the appropriate changes at his own expense and within a maximum of three months, he demonstrated his contempt for the ruling by the method whereby he complied. He changed only the name of the painting, altering it to *The Feast in the House of Levi*, and thereby removing its association with the Last Supper. As a result he was able to leave the canvas as it was, preserving that mingling of mythological grandeur and fidelity to the human setting which had originally motivated him in designing it.[39]

To return to the interwoven duality of prose style at this time, we may note how profoundly it contributed to the impressiveness of Francis Bacon's essays, which so often open with an arresting sentence phrased with utter simplicity, such as "Houses are built to live in and not to look on"—monosyllabic, factual, and unelaborated—and proceed from there into the stately reverberance of Latinate rhetoric as he propounds the broader philosophical implications of his theme. With that contrast between the specific and the universal he opens one of his most famous essays:

> Men fear death, as children fear to go in the dark; and as that natural fear in children is increased with tales, so is the other. Certainly, the contemplation of death, as the wages of sin, and passage to another world, is holy and religious, but the fear of it, as a tribute due unto nature, is weak. Yet in religious meditations, there is sometimes mixture of vanity and of superstition.[40]

Whatever affinities may be perceived in the contemporary modes of art and literature, the differences between the plastic and verbal media remain. A painter cannot within a static, unified canvas easily shift from high seriousness to humour, as the writer can from paragraph to paragraph or even from phrase to phrase. Accordingly, Veronese's dog does not itself possess any comic quality. Yet if we allow for the inherent restrictions of each medium, the dominant tendencies, if not always their specific application, have much in common, deriving as they do from the same aesthetic principles. Raphael's *The Betrothal of the Virgin* from 1504 (*fig. 37*) marks the epitome of the ennobling presentation of a holy scene in accordance with the new rules of order and proportion. The circular temple is placed with perfect centrality within the upper arch of the panel, the tessellated paving leads the eye from below towards the symbolically open doorway of that temple, and the wedding-ring, which forms the thematic focus of the work, is located at the visual pivot of the canvas between the two groups of participants, male and female, as well as directly in line with the doorway above. All this with a slight variety in the stance of the figures (such as the officiant leaning to one side) to relieve monotony while yet preserving the overall integrity of mood. Yet within this noble depiction of the sacred event, remote in its harmonious perfection of form, Raphael has included a livelier touch, drawn perhaps from the contemporary literature of romance, as in the right foreground a suitor, disappointed in his hopes for the Virgin's hand, vents his frustration by testily snapping across his knee the rod which had refused to flower.

The English, as Pevsner has argued,[41] had in any case a more distinctive penchant for mingling comic realism with the seriousness of art, as in the babooneries (whose origin can be traced to England) as well as in the copious instances of humour and liveliness on the bosses of English cathedrals. That same tendency may be seen at work in the English versions of the Italian sonnet too, although here such modification of convention may have had a deeper purpose, facilitating the transplanting of that literary form into English soil by modifying the more passionate devotion of the continental sonneteering tradition to suit the cooler temperament of England. The Petrarchan fashion which swept across England in this period produced a plethora of solemn and often uninspired im-

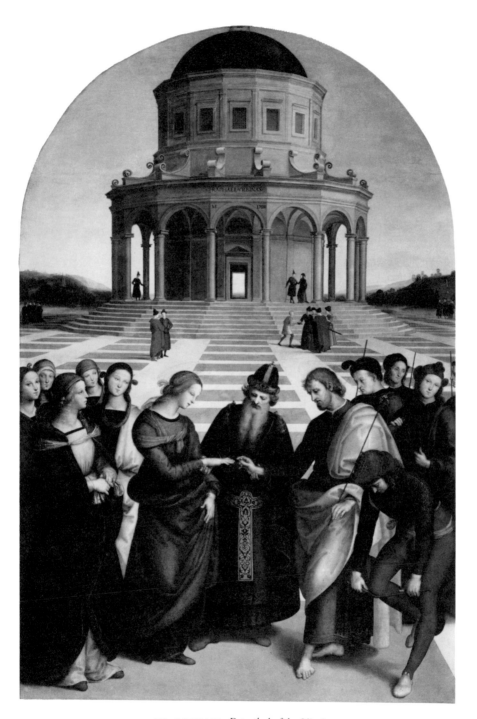

37. RAPHAEL, *Betrothal of the Virgin*

itations of the continental version; but Yvor Winters may be right in suggesting that the best English poems written in that tradition, and often those most English in their tone, are the sonnets in which the speaker, while accepting the basic premises of the genre, the all-consuming power of idealized love and the anguish of its frustration, at the same time gently mocks at the absurdity of his own amorous condition, as he sees with momentarily unjaundiced eye the ridiculous extravagance of his own emotions.[42] Wyatt was long criticized for failing to achieve the same intensity and seriousness in his poetry as had Petrarch, as if imitation had been his sole aim; but he was writing in a different age and for a different audience, and it may well be argued that his refusal to surrender completely to the expected servitude to a mistress lends his verse its refreshing attractiveness and made the continental genre more palatable to English *sang-froid*. For Petrarch, love and beauty were indeed etherial and transcendent, Laura becoming not only the object of his love but, as an elevated symbol of love itself, desirable in her very unattainability. For an earthly lover she is the unrealizable ideal for which the sonneteer hopelessly yearns, and her connexion with this world was tenuous. The death of the real Laura from plague in 1348 had little effect upon the fervour of the speaker. She was merely raised in his poetry one degree further towards heaven.

Wyatt, however, in an age now more positive in its response to physical actuality, although deeply impressed by his contact with that revered poetic tradition during his diplomatic missions to the continent and eager to introduce into his country its mellifluous tones and the self-pitying dejection of its mournful lovers, in his most original poems, refuses to relinquish completely his pragmatic response, creating in true Renaissance fashion an artistic merger of the two. He sees, side by side with the nobility of his suffering, the sheer unmanliness of his subjection to a cold, unfeeling mistress, and perceives, through her ennobling Petrarchan garb, the fickleness which makes her ultimately unworthy of his adoration. A sonnet beginning with a solemn lament for the "painful woe" experienced by other lovers and seeming about to declare the speaker's own even greater pains suddenly shifts direction in the sestet:

But as for me, though that by chance indeed
 Change hath outworn the favour that I had,

I will not wail, lament, nor yet be sad;
Nor call her false, that falsely did me feed;
But let it pass and think it is of kind,
That often change doth please a woman's mind.[43]

The English admiration for the Italian sonnet form and for its thematic conventions was genuine, as Sidney's influential *Astrophil and Stella* and the sonnets by Shakespeare confirm; but the English variety in many respects transformed the genre not only to suit its own temperament but perhaps even more to suit the changing tastes of the time, since they only entered England when that country was responding to High Renaissance rather than Early Renaissance norms. In Sidney's series, the innovative linking of the sonnets into a narrative sequence added a significant dimension of actuality to the Petrarchan tradition. Each sonnet, although still an independent poem exploring the lover's moods, by being placed in chronological order of the situations prompting the speaker's responses, allows the reader to perceive through the variegated passions the pattern of events to which he is reacting—his first view of Stella, the despair of ever winning her love, the exhilarating triumph of a first kiss, and the subsequent reconciliation to their parting. The introspective recounting of the emotional experience is thereby provided with an outer temporal and spatial framework, much as the etheriality of the holy scene in Raphael's *Betrothal of the Virgin* is placed within the firmly delineated architectural perspective to supply an actualized setting. Since there is always a danger that an extended concentration upon a single art-period may dull one's awareness of its uniqueness, it may be helpful to contrast that painting for a moment with Matthias Grünewald's powerfully disturbing Isenheim altarpiece *The Crucifixion* (*fig. 38*) which stands outside the High Renaissance mode in its conscious rejection of Italian classicism. There a harshly expressionistic depiction of the agony and grief of the mourners and of the twisted, decaying body of the dead Christ is in no way tempered by harmony or beauty of form, and the scene itself is abstractly set in some unidentifiable wasteland darkened by the cosmic enormity of the event.

Within Shakespeare's sonnet collection, the situational sequence, while still discernible, is more faintly perceived than in Sidney's. The speaker's relationship to "W.H.," to the dark lady, and to the unknown rival must be constructed

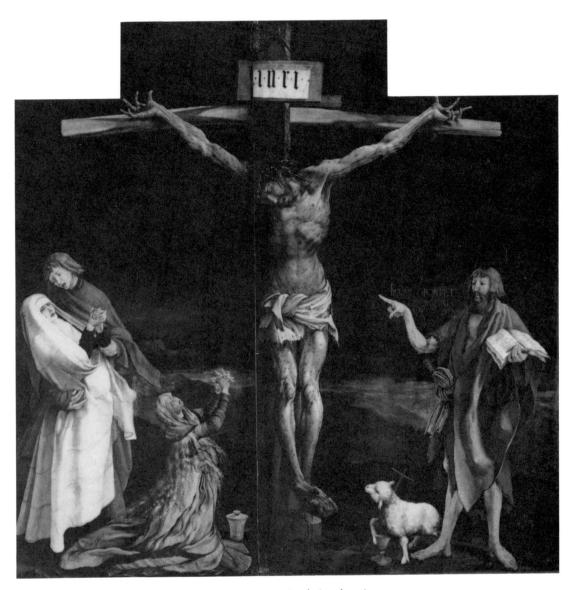

38. GRÜNEWALD, Isenheim altarpiece

conjecturally from passing allusions in the poems in contrast to the explicitness of Sidney's plot setting, where no guesswork is required to identify the intoxicating moment of the lover's triumph:

> Then since (dear life) you fain would have me peace,
> And I, mad with delight, want wit to cease,
> Stop you my mouth with still, still kissing me.[44]

The factual tethering in Shakespeare's sonnets is perhaps to be found less in the plot line or dramatic setting than in the richly particularized imagery, no longer restricted to the conventions of the genre but drawn instead from the poet's keen observation of the natural scene, as well as the diversified activities of human society in the courtroom, the artist's studio, or the religious pilgrimage. The contemplative moods of the lover, with their shifting emotional patterns, are sharply visualized in terms of the bailiff's arrest of a defaulting debtor, the durability of brass and stone, the perspective employed in the painter's art, the vaulted choir of a deserted abbey, a summons to the lawcourt, the overacting of an inexperienced player on the stage, or the shaking by rough winds of the buds of May. The close interweaving of such variegated imagery into the warp of the lover's sensitive spirituality, his hurt pride, gratitude, or dissatisfied longing, suggests that no withdrawal from the daily responsibilities of commerce or professional duty is possible, however he might wish to nurse in solitude the pain of his grief. By means of such tactile imagery, the active world of travel follows him even into the silence and privacy of his bed:

> Weary with toil I haste me to my bed,
> The dear repose for limbs with travel tired;
> But then begins a journey in my head,
> To work my mind, when body's work's expired;
> For then my thoughts, from far where I abide,
> Intend a zealous pilgrimage to thee.[45]

The more vividly conceived imagery was only one component of the change effected in the sonnet at this time, the structural form responding even more markedly to those forces already at work in Renaissance painting and architecture. The demand for a more integrated unity in the finished artistic work, the

interest in a carefully designed proportion aimed at evoking a sense of ordered perfection which even the slightest alteration would spoil, was operative in the literary genre too, as the looser structure of the earlier versions began to be replaced, particularly in England, by a tighter, more cohesive pattern of thought. Both Dante and Petrarch had preferred a less restricted format, the octet often flowing into the sestet in both meaning and rhythmic pulse, while the sestet itself had no fixed pattern, varying in rhyme scheme from twin tercets such as *cdc, dee* to threefold couplets *cd, cd, cd*. With those poets, the opening line usually struck the high note of the sonnet, to which, after an intervening meditation, the conclusion cyclically returned. Thus Petrarch's exquisite sonnet 61, *Benedetto sia 'l giorno* . . . , blessing the day on which he was first made prisoner by two fine eyes, ends (in Joseph Auslander's translation):

> Blest be the words and voices which filled grove
> And glen with echoes of my lady's name;
> The sighs, the tears, the fierce despair of love;
>
> And blest the sonnet-sources of my fame;
> And blest that thought of thoughts which is her own,
> Of her, her only, of herself alone!

The effect is thus of a sustained mood rather than a progression of thought.

The structure of the sonnet form which Surrey introduced and to which Shakespeare gave his name needs no illustration here, with its declaration of theme in the opening quatrain, the enlargement or modification of that theme in the second, a light break in thought or direction at the movement into the sestet, and a concluding couplet which by a witty turn of phrase or shift in angle of approach consummates the argument and draws the entire poem together, the complex movement being reflected in the carefully patterned rhyme scheme of the poem. Logic, the rational faculty of the human mind, had entered to impose artistic order upon the scene, like the mathematically calculated lines initially sketched onto a canvas or onto the preliminary design of a building to ensure by their underlying presence the harmony and due proportions of the finished work.

Yet for all his serious regard for the tradition, Shakespeare, like his fellow

sonneteers in England, remained aware of the comedy inherent in its situations and literary conventions. *Love's Labour's Lost* makes joyous parody of it, with Berowne scorning his friends, as they surreptitiously pin their sonnets on the barks of trees, for indulging in an idolatry which "makes flesh a deity / A green goose a goddess," while he himself prays desperately that no one will discover his own sonneteering extravagance dedicated to a similar "goddess." Even Sidney, as Astrophil bemoans in all seriousness the grievousness of his pains and woes, will insert a mischievous protest, again with the humble canine as the engaging contrast to the elevated lover:

> Dear, why make you more of a dog than me?
> If he do love, I burn, I burn in love;
> ..
> Bidden, perhaps, he fetcheth thee a glove,
> But I unbid, fetch even my soul to thee.[46]

From within this English setting with its ambivalent response, its mingling of genuine admiration for the elevated Petrarchan tradition and a realistic awareness of its exaggerations and absurdities, emerges Nicholas Hilliard's *Portrait of a Young Englishman (fig. 39)*, which catches that mood to perfection. The unrequited lover in this marvellous miniature leans sadly against a tree beneath a motto mournfully proclaiming his woes, *Dat poenas laudata fides*, with thorns entwined about him to signify the suffering which his fidelity to a cruel mistress has brought upon him. But there is at the same time a sly ridiculing of the young man, supposedly distraught and inconsolable, yet so impeccably dressed in the very latest fashion, with elegant white stockings showing off his shapely legs to best advantage and a richly embroidered doublet, meticulously reproduced here, to convey the care he has taken over his apparel before venturing forth into the public eye to enjoy, like his dramatic counterpart Orsino, the "grief" of his self-assigned Petrarchan role.

Within the Renaissance view, therefore, a complex change had occurred both in the conception of the celestial and in its relationship to the earthly. The developing interest during the later Middle Ages in everyday human activity, such as the carpenter's trade or the rough humour of shepherds, had been only

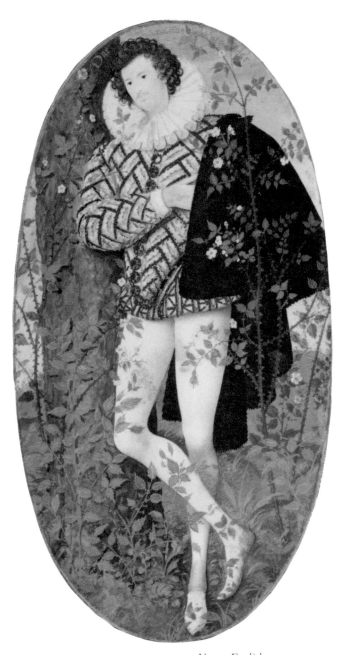

39. NICHOLAS HILLIARD, *Young Englishman*

hesitantly introduced into art and drama as being acknowledgedly inferior to the eternal and sacred. But in the revised apprehension of the cosmos in Ficino's terms, the earthly was no longer an illusory setting for the carnal temptations to be resisted by the true Christian but an integral and respected part of an interrelated harmony, which attained its universal and heavenly form only as the summation of the authentic particular. These philosophical assumptions found their expression in art by combining accuracy of spatial perspective with the attainment of an overall proportion and harmony of design. In literature they produced in their finest form an impressive tethering of the sublime in the actual and the human, whether at the stylistic level with its merging in prose of the rhetorically lofty with the monosyllabic and particularized or in its broader choice of dramatic themes—whereby a romantic Othello dreaming of his love in terms of a world of purest chrysolite is pitted against a pragmatic Iago cynically putting money in his purse. It is a merger unknown on the Attic stage with its stylized *stichomythia*, its masks and buskins to elevate the scenes above the natural, and its tradition that all human action must be performed offstage. For the Elizabethan, however, in ways to be explored in the following chapters, that conjoining of the sublime and the mundane, the anchoring of the airy imagination in the localized setting, was the essence of its art, with the poet's eye glancing

> from heaven to earth, from earth to heaven;
> And as imagination bodies forth
> The form of things unknown, the poet's pen
> Turns them to shapes, and gives an airy nothing
> A local habitation and a name.[47]

4

SPENSER AND THE
PAGAN GODS

THE INDEBTEDNESS OF RENAISSANCE WRITERS AND ARTISTS TO
the models of ancient Greece and Rome has never required scholarly confirma-
tion. It was acknowleged on every side by the humanists themselves. Petrarch,
moved "beyond words" by his visit to the ruins of Rome, boldly reversed the
traditional conception of Christianity as the enlightener of the world and, de-
spite his continued faith as a Christian, in his poem *Africa* began the movement
to regard the medieval period, however unjustly, as the "Dark Ages" before
which the classical era had shone as a glorious radiance. In the words of his dis-
ciple Boccaccio, he inspired in his own and subsequent generations so ardent an
admiration of the classical heritage as "reinstated Apollo in his ancient sanctu-
ary."[1]

On the other hand, the eagerness with which Greco-Roman literature,
sculpture, mythology, and philosophical modes of thought were adopted as the
patterns on which the new age was to be designed has perhaps obscured the de-
gree of eclecticism in that imitative process. On the Renaissance stage, despite
the lip-service paid to Aristotelian theory, the major influence was exerted not
by the leading dramatists of Greece such as Aeschylus, Euripides, Sophocles, or
Aristophanes writing at the time of the stage's greatest artistic splendour, but
rather by the lesser Seneca, with Menander, Plautus, and Terence. In the same
way, the more eminent historians Thucydides, Livy, and Tacitus, were almost
ignored in favour of the immensely popular Plutarch; and while Ovid's *Meta-
morphoses* permeated all aspects of Renaissance art and poetry, both Horace and

Juvenal, although admired, were destined to wait until the eighteenth century before receiving similar adulation. Rather than a submissive self-modelling on the entire cultural range offered by the ancient classics, humanism should be seen as being primarily a selective search within classical art and literature for only those elements which would suit its own most urgent contemporary needs.

On the English scene, it required the unconventionality of the late C. S. Lewis to perceive, through all the assertions of sixteenth-century writers and the assumptions of later historians, how little the finest of English Renaissance literature is actually modelled on classical sources. It is true, he admits, "that many movements of thought which affected our literature would have been impossible without the recovery of the Greek language. But if there is any closer connexion than that between the *renascentia* and the late sixteenth century efflorescence of English literature, I must confess that it has escaped me."[2] To extend his observation, we may note that the entire sonneteering tradition so characteristic of the Elizabethan period had no prototype in classical sources on which to model itself, that *The Fairie Queene* could certainly not be described as classical in poetic form, in content, or in timbre, and that the same holds true in large part for the stage. Elizabethan tragedy, for all its indebtedness to Senecan models in its earlier phase, produced its finest achievements only as it deserted the gruesome scenes of amputated limbs and rhetorical messenger-speeches inherited from those ancient revenge plays and moved away to independence, developing instead an interest in the subtle human motivation behind the bloodshed. It may be wiser, therefore, to reverse the critical process. Instead of examining, as has become customary among historians, the extent or profundity of the classical influence upon the Renaissance, we should rather attempt to identify within the latter period the nature of the selectivity, the deeper needs which prompted the humanist to prefer one model or theme over another and to choose from the wide-ranging and variegated classical tradition only those artistic concepts and forms which could be of assistance to him, as, under the aegis of that respected cultural heritage, he sought august protection and support in his withdrawal from the still-powerful jurisdiction of the medieval Church.

One aspect of that process was, of course, the resuscitation of the pagan gods and their incorporation into the predominantly Christian world of the fifteenth

and sixteenth centuries. That this revival of the ancient deities helped to secular-
ize the Renaissance and justified an un-Christian eroticism in both the art and
literature of the period has long been recognized; but the evidence available sug-
gests that, although such was the later effect produced, it was by no means, even
subconsciously, the original intention behind their revalidation. In the initial
phase, the metamorphosis which the gods underwent as they emerged from
their more limited medieval roles was in the direction neither of prurience nor
particularly of paganism. It was calculated rather to qualify them for the new
function they were required to perform in the changing world of Renaissance
thought.

As Jean Seznec has demonstrated, the gods of classical Greece and Rome
had, in fact, survived throughout the Middle Ages in various restricted forms.
Arabian scholars, at a time when they led the world in mathematical and astro-
nomical studies, had imported them as convenient symbols into their celestial
systems to represent the various planets and constellations, often weirdly orien-
talizing them in the process of that integration. Hercules appears there in unfa-
miliar guise, turbanned and wielding a scimitar; and when the gods were even-
tually reabsorbed into the western world together with the astronomical
treatises, certain of those oriental characteristics incongruously lingered for a
time.[3] Within the medieval Church, the gods had often been introduced for di-
dactic purposes, usually as warnings of pagan sins to be avoided, and were fre-
quently even presented as personifications of those sins. On stained-glass win-
dows and in manuscript illustrations Luxury might, in contrast to her nobler
sister Charity, appear in the form of Venus, ungracefully sprawling either upon
the ground or upon the waves in dishevelled and unattractive nakedness and gaz-
ing into a mirror at her supposed, but deliberately undepicted, charms (*fig. 40*).

The new role they were assigned in the Renaissance would seem initially to
have been connected with a significant development in the concept of allegory.
The tradition of personifying man's temptations and aspirations, which per-
vaded medieval iconography (originating within Christianity in Prudentius'
fifth-century *Psychomachia*) had emblematically represented the Virtues and
Vices as perpetually warring with each other to gain the ascendancy within man.
In that context a thirteenth-century series of sculptures on the west portal of

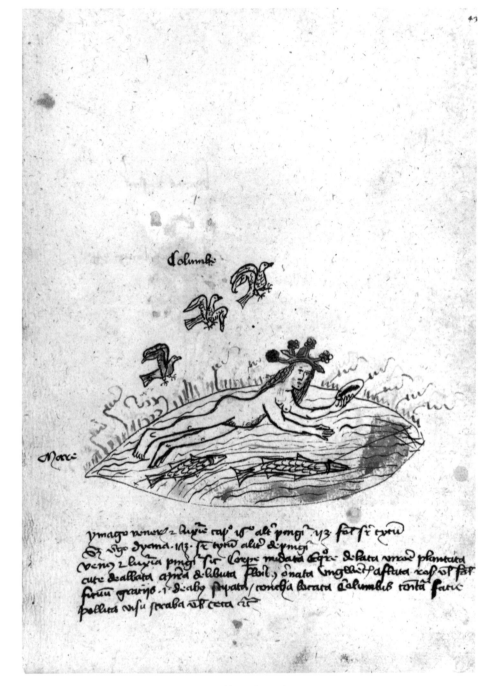

Columba

Mare

ymago veneris z luxurie cap⁹ ie° alt⁹ pingi. ijz fat ſe tyru
ſt virgo dyona. iiiz. ſe tyru aliud dimgi
vene z luxuria pingi ſit corpe mudata exgta de patta vre ad plantata
cute deallata aurea delibuta flebil, ōnata ingellacī aſtuta ras vt fat
ſtuu graviis . i. diaby pupata / roneǁa lacrata columbis rcta ſaue
pollutā vſu ſcaba vt cera cẽ

40. *Venus-Luxuria*

Amiens Cathedral devoted to that theme depicted Fortitude (*fig. 41*) as a robed figure, helmeted, and bearing symbolically a sword and a shield. On the one hand, it represented literally the contemporary code of chivalry, the warrior knight dedicated to the service of the Church, while on the other hand it echoed metaphorically the command of Paul to take "the shield of faith wherewith ye shall be able to quench all the fiery darts of the wicked: and take the helmet of salvation and the sword of the spirit which is the word of God" (Ephes. 6:16-17). Particularly noticeable in the light of the changes that were to follow is the fact that, in keeping with the more modest estimation of mankind prevalent at the time (not least the Church's insistence upon the need for Christian humility), the figure representing the human quality of fortitude in no way excels mortal form. The very fact that it can be read either as an emblematic representation of an abstract virtue or as the figure of a contemporary knight reveals how close the allegorical personification of spiritual qualities was to human and earthly di-

41. *Fortitudo*, Amiens Cathedral

147

mensions. That same restriction to human stature holds true for the morality plays on the late medieval stage, where the behaviour of Beauty or Strength conforms to distinctly quotidian ways, as they exemplify in their speech and actions the social norms of the time. Fellowship in *Everyman* is himself a hail-fellow-well-met, whom one can visualize cheerily slapping his friend on the back as he assures him of his readiness to while away the time in good sport:

> FELLOWSHIP: If thou wilt eat and drink and make good cheer,
> Or haunt to women the lusty company,
> I would not forsake you while the day is clear,
> Trust me verily!
>
> (272-75)

He is, admittedly, if not a vice at least a very suspect virtue; but even Good Deeds and Knowledge, symbolizing virtues fully advocated by the Church, are depicted as no more than "good friends," reliable companions prepared to accompany Everyman on his journey:

> GOOD DEEDS: Nay, Everyman, I will bide with thee.
> I will not forsake thee indeed;
> Thou shalt find me a good friend at need.
>
> (852-54)

Within the medieval tradition of allegory, then, there is no enlargement of the human spirit implied, no elevation above the mundane such as the humanist yearned for in his dissatisfaction with the Church's reiterated insistence on the debasing mortality and limitations of the flesh. Man's growing sense of his own potential competence in this world, both physical and spiritual, demanded an expansion of the framework and, proportionally, of the allegorical system whereby the new concepts were to be metaphorically projected. It is within that context that the importation of the classical gods should be seen. In philosophy that amplification was supplied by Neoplatonic thought, particularly the version fostered in the Florentine Academy which was, not surprisingly, specifically adapted to suit those contemporary needs—the belief that man, even during his terrestrial existence, was capable of rising, through the cultivation of reason or

his "higher soul," towards communion with the divine and participation thereby in the forces of universal harmony. It was through that augmented conception of human aspiration and as yet untried human achievement that the Renaissance was prompted to turn for its more elevated system of allegory to the world of classical mythology, seeing within its ancient stories, at least in this earlier phase, less the sportings of pagan deities upon Olympus than an opportunity to provide, with the authorization of classical precedent, godlike embodiments of man's inner qualities projected in magnified form into a celestial setting.

In Mantegna's painting *The Triumph of Wisdom over the Vices* (*fig. 42*), human wisdom is no longer, as in orthodox Christian doctrine, a limited, often misleading faculty in which man is warned never to place his trust: "Let no man deceive himself. If any man among you seemeth to be wise in this world, let him become a fool, that he may be wise. For the wisdom of this world is foolishness with God" (I Corinth. 3:18-19). Here in Mantegna's painting it is represented instead in more exalted form, as the goddess Minerva garbed in the full paraphernalia of war. With divine ease she routs the centaur-like Vices frolicking within a stagnant pool near their patroness Venus, as the sister Virtues gaze approvingly at the victory from a heavenly cloud above. This process of endowing human affairs with a celestial ambience was to culminate in such paintings as Veronese's *The Apotheosis of Venice* (*fig. 43*) completed in 1586 for the Doge's Palace, in which, on the analogy of the classical deification of such mortals as the Roman emperors, the man-made city-state of Venice is allegorically awarded her heavenly crown in a scene of awesome magnificence previously reserved only for the most sacred scenes of Christian faith. And in Rubens' *Apotheosis of James I* on the ceiling of the Banqueting Hall in Whitehall, a mortal king was to be similarly exalted, if only allegorically, to the status of god.

Within English literature, that enlargement of human virtues and potentialities has a close counterpart. Spenser, despite his acknowledged allegiance to a Puritan tradition suspicious of pagan importations and although conveying in his work an overtly Christian message which might appear to resist such deification of man's qualities, nevertheless adopts the new Renaissance aesthetic by presenting Una, as he does the female personifications of man's virtues in the later books, as a godlike figure of coruscating splendour. While she represents

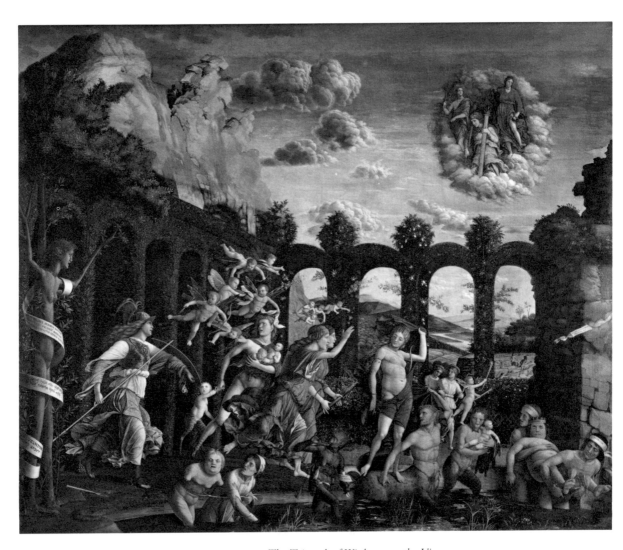

42. MANTEGNA, *The Triumph of Wisdom over the Vices*

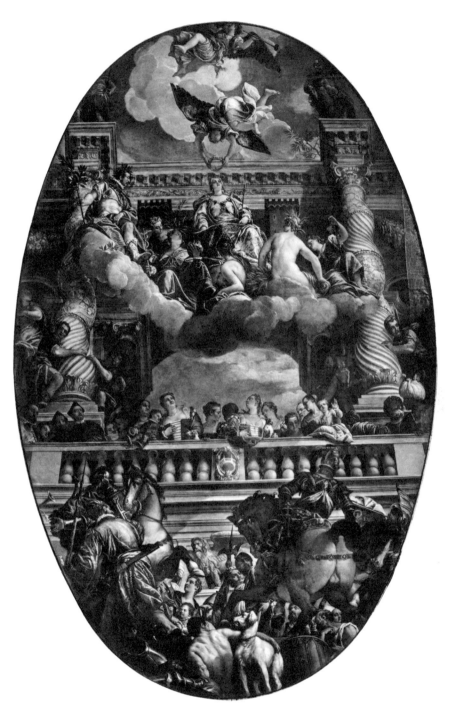

43. VERONESE, *Apotheosis of Venice*

primarily the human impulse for Truth warring within man against his own less noble inclinations, she is depicted at the same time in terms of a celestial ideal in which human virtue is now seen to participate, a vision so dazzling as to outstrip all possibility of poetic praise:

> The blazing brightnesse of her beauties beame,
> And glorious light of her sunshyny face,
> To tell, were as to striue against the streame.
> My ragged rimes are all to rude and bace
> Her heauenly lineaments for to enchace.[4]

The validation of physical female beauty in this description, offered as a means of enriching the moral attractiveness of the symbol, highlights a further and no less fundamental shift in sensibility. In the Mantegna painting, we may note, Venus had continued to represent, as in the Middle Ages, the dangerous allurements of the flesh, and was thereby grouped together with the Vices over whom she rules. Now, with the acknowledgment that at the very apex of the Neoplatonic hierarchy in the ideal world stood a combination of the Beautiful-and-the-Good, a union at times equated in Christian Neoplatonism with God himself, beauty of form, no longer the despised vanity of the scriptures, becomes itself a divine quality, while love, even in its physical form, is to be recognized in accordance with Diotima's advice as a means of ascending to the divine experience. In that regard, both primary attributes of the goddess Venus had become newly validated. If she was still to be associated with Eros in her voluptuous attractiveness and grace, she was also to be seen in terms of Christian Agape as an embodiment of ideal and divine love. Accordingly, her incorporation into the select club of the Virtues became henceforth an axiom of humanist thought, even in its most Christian forms.

The transition in her status, particularly in its earlier period, was fraught with potential danger, not only from the direction of a traditionalist Church but also from within the conscience of the humanist himself, still for the most part genuinely committed to the basic tenets of his Church. An aesthetic sensibility did not dwell easily with a Christian *contemptus mundi* nor even with a *contemptus*

pagani, and Lorenzo Ghiberti provides in the autobiographical section of his *Commentarii* a telling instance of the way such conflicts affected men at that time. Some ancient classical sculpture, he relates, had been unearthed by chance at Siena during the fourteenth century. The townspeople, delighted at the find, proudly exhibited the statuary in the marketplace for all to admire, until before long their fears and scruples as Christians overcame their artistic pleasure. Disturbed lest they be regarded in their admiration of such pagan works as idolators and thereby incur divine wrath, on second thoughts they hastily destroyed the sculpture and reburied it where it could do no harm, Ghiberti being compelled to rely for his knowledge of it on hearsay.[5]

The humanists, too, for all their desire to welcome classical models, were for the most part anxious that their more liberal views remain reconcilable with the Christian beliefs to which they still adhered. Ficino, we recall, at the comparatively advanced age of forty when he had long been established as a leading humanist, took holy orders, was appointed canon, and is reputed to have performed the duties of his religious office with great devotion. Even Pico della Mirandola, although earlier charged with unorthodoxy in his writings, was not only eventually vindicated but in the last years of his brief life began writing a major work intended to defend the teachings of the Church, and was himself planning to enter the monastery of San Marco. Accordingly, the cleansing of Venus from her medieval association with lasciviousness in order to prepare her for her new role as Love in its purest form was a task which needed to be performed with caution. Even though access to the Platonic dialogues had been limited in the Middle Ages, the concept of the combined *calocagathia* had been known. It had, however, not been permitted any effective influence. Thomas Aquinas, amply aware of the threat such a conjunction of physical beauty with divine love might pose to a system demanding disdain for the flesh, had carefully distinguished between the two components of the Platonic ideal. In the *Summa Theologica*, he declared that beauty, since it appealed only to the cognitive faculty, was intrinsically the inferior of the two; and he therefore directed the Christian to concentrate on the main element enthroned on Plato's hierarchical summit, namely Love as Agape. Such a dichotomy did not suit the Renaissance

mood and, as might be expected, in the fifteenth-century Florentine Academy the close interrelationship of those two divine elements was fully restored, with Beauty now forming an integral part of the Good.[6]

The absorbing of the classical deities into the Renaissance Christian world is a process fascinating to trace, particularly as it arose less from conscious design than from an instinctive need for the broader allegorical framework it offered. By an ironic quirk of history, the pagan gods became in large part legitimized by the very process of multilevelled exegesis which, after having been applied for so long to the Bible, was now being weakened in that scriptural application as the early Reformers placed increasing emphasis upon the literal meaning of the text. The typological reading which had seen beneath the surface narrative of the Old Testament a foreshadowing of Christian events could now, as an exegetical tool hallowed by medieval usage, be made to serve the turn of the humanists. As the medieval *Processus Prophetarum* and the tradition of the Nine Worthies both confirm, there had been an admission long before the Renaissance that certain secular figures of history deserved respect even if, through no fault of their own, they stood outside the pale of the Christian community. The Christian testimonies offered in the *Processus* by Vergil and by the Erythraean Sybil, which were believed to refer to the coming of Jesus, and the inclusion of Alexander the Great among the Worthies suggested that the restriction of salvation to the believing and baptized Christian was not quite as rigid as might appear.[7] On the other hand, if there was a certain softening towards the pagan heroes, the medieval attitude to the pagan gods remained for the most part hostile, even contemptuous, supporting as it did the view of the third-century Greek mythographer Euhemerus that such figures were in origin mere mortals retrospectively deified by the foolishly exaggerated veneration of the people.[8]

The early Renaissance adopted probably the only method which could in a Christian society restore some degree of divinity to those pagan figures, when after a heavenly vision confirming his suspicions, Nicholas of Cusa in his *De pace fidei* argued for a universality of divine inspiration. Even though the ultimately true inspiration was that accorded to the Judeo-Christian, all peoples of the world in all ages had, he maintained, been allowed to glimpse at times a semblance of that truth, if not always in a fully valid form then at least in some of its

essentials.[9] With the assistance of his disciple Pico, through whose advocacy the
system was to achieve wide currency, typological reading was reemployed to
domesticate Greek and Roman mythology into the Christian dispensation, the
pagan gods now being conceived either as early adumbrations of leading figures
from Christian history or, in more general terms, as representing aspects of the
Christian soul. Apollo, the god both of male love and of the sun, by being as-
sociated with Christ gave a more universal dimension to central religious scenes,
particularly when the English language allowed for wordplay on Sun and Son.
A vision of the Crucifixion takes on a more cosmic quality as it incorporates the
classical concepts into the Christian:

> There I should see a Sunne, by rising set,
> And by that setting endless day beget.[10]

This more liberal attitude helped corroborate the growing influence of the
fourteenth-century *Ovide Moralisé* which, together with Boccaccio's *Genealogy
of the Pagan Gods*, had already begun to arouse new interest in classical myths.
The Duke of Mantua's Palazzo del Té could now be decorated by Giulio Ro-
mano and his assistants with scenes from the pagan story of Psyche and Cupid
on the assumption that they conveyed symbolically the search of the Christian
Soul (Psyche) for union with divine Love (Cupid) to produce eventually their
offspring (Pleasure). Similarly, David and his musicians could gradually be re-
placed by Apollo and the Muses, not as a substitution of the biblical by the pagan
but with the reassuring thought on the part of the humanist that he was offering
the same biblical scene of divine and harmonious accord in its parallel classical
version.[11] Such Christianization of classical myth found expression even in mi-
nor elements, often with broad implications. One may note the growing use in
this period of the secondary name "Jove" in preference to "Jupiter," presumably
because this eponym, by its rough approximation in sound to *Jehovah*, sug-
gested some degree of identity between the two Fathers of Heaven. An appeal
for Jove's aid or an oath sworn in his name sounded by that device markedly less
blasphemous in a Christian setting, and the merger in nomenclature encouraged
a sense that the classical world, by its echoing of Christian truths, was ultimately
not inimical to them. Ficino, searching for common ground between the two

systems, went so far as to speculate that God may have originally chosen the seventh day, Saturday, as the original day of rest because of its connexion with Saturn, the god of contemplation;[12] and a network of interrelationships began to be established, bestowing an aura of sanctity on the supposedly pagan deities of Greece and Rome.

To reinforce the moral reading of the classics, there lay ready to hand not only the system of prefigurative typology but also the other constituents of the fourfold method of scriptural exegesis. The laminated structure which it had assumed for the text allowed for a literal reading often blatantly contradicted by the allegorical, yet existing compatibly beside it on the assumption that each was simultaneously valid in its own right.[13] On the other hand there is clear evidence to corroborate the view argued here that the quattrocento application of the system to the classics was highly selective, being employed only when the resultant reading happened to suit the needs of the humanist. In a rare moment of candour, Ficino admitted that the fourfold principle of exegesis was applied by himself and his colleagues quite inconsistently, in accordance with the specific presupposition that the interpreter wished to prove:

> Just as the Christian theologians find four senses in the sacred word, the literal, the moral, the allegorical and anagogical, and follow up the one in one passage and the other mainly in another, so have the Platonists four modes of multiplying the gods and spirits, and apply a different mode of multiplication in different places, as is fitting. I too am used in my commentaries to interpret and distinguish the deities differently as the context requires.[14]

Perhaps the most profound of the mergers of Christian and classical archetypes, with manifold ramifications for the era, was the gradual recognition of Venus, despite all obvious counter-indications, as the classical figure corresponding to the Virgin Mary. Among the Goliardic poets such parallels had, it is true, been made earlier, with the name of Venus substituted for the Virgin in well-known parodies, or slily introduced into poems with a fervour normally reserved for the hymnal:

> quicquid Venus imperat, labor est suavis,
> quae nunquam in cordibus habitat ignavis.[15]

But such replacement had for the Wandering Scholars a primarily ribald intent, a conscious desertion of the cult of the Virgin in moods of springtime amorousness in favour of the goddess of flirtation and dalliance. Now the humorous substitution began to be replaced by the reverend acknowledgment of a genuine identity, the amalgamation being facilitated by an earlier recognition, based on Pythagorean belief, that Venus was a twofold deity, residing in both celestial and infernal regions. Bernard Silvestris, for example, had in his commentary on Vergil's *Aeneid* asserted that there existed a heavenly Venus inspiring concord and love in man and a shameful Venus, the goddess of lechery and concupiscence.[16] In developing the identity with the Virgin Mary, therefore, the less palatable version could be quietly discarded in favour of the nobler conception. Even the ostentatious absence of virginity in the classical goddess became less troublesome in the light of the *Symposium*'s validation of physical love as a stepping-stone to the divine, a belief now revived as part of the new philosophy. In Titian's painting of *Sacred and Profane Love* (*fig. 44*), the representatives of those two forms of love are depicted not as rivals but as affectionate sisters, as the kindly gaze of the right-hand figure bearing the lamp of eternity confirms. Between them, Cupid busily stirs the water in a circular motion to symbolize that the ideal is to be achieved by moving smoothly and harmoniously from earthly love to the divine, and then back again.[17]

If to the uninitiated, the naked female in this painting may appear most naturally to represent fleshly or profane love, the contemporary readers of allegory of course knew better (although the potential confusion was certainly not without its advantages to the artist). With the body regarded in Platonic thought as the "rags" in which the soul is clad for its earthly stay, the purest elements of the soul could legitimately be pictured as naked, in an allegory offering at the same time a splendid opportunity for cultivating the new aesthetic interest in the beauty of the human body. Botticelli's *The Birth of Venus* from 1482 (*fig. 45*) in addition to depicting an incident from classical myth, was intended to represent symbolically the arrival of untainted etherial Love at the shores of the earth where a handmaid is about to clothe her in the robe of the flesh. The wonderfully airy quality of the Venus figure, a quality achieved partly by the delicately attenuated neck, partly by the placing of her body's centre of gravity well ahead of the shell so that she seems to be floating weightlessly above the waves, conveys

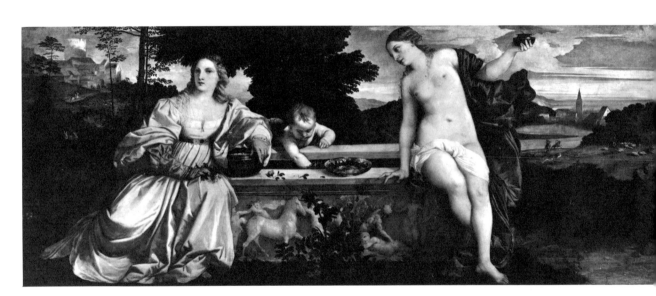

44. TITIAN, *Sacred and Profane Love*

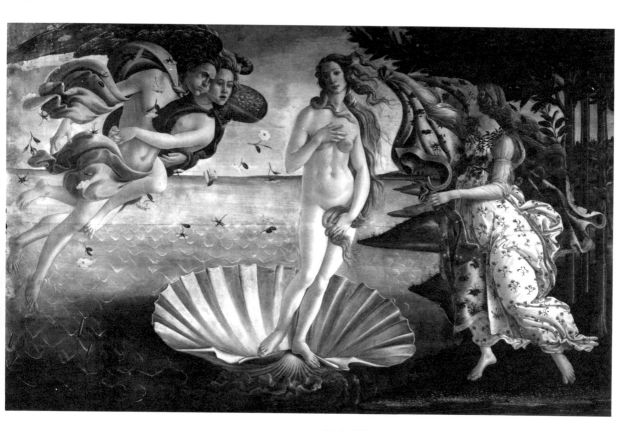

45. BOTTICELLI, *Birth of Venus*

visually the insubstantiality and etheriality of the celestial aspect of Love before its contact with the earth. If, despite its symbolic theme of Love coming to dwell upon earth, the painting seems remote from any connexion with the Virgin Mary, we may suspect that here too contemporary viewers would have been more responsive to the filaments uniting the two figures, if we recall an event which would have been prominent in their minds when the painting was executed. Only six years before, in 1476, Pope Sixtus IV had, with wide publicity, given formal approval to the doctrine of the Immaculate Conception, the belief that the Virgin had been born into this world free from original sin. With that recent ratification still fresh in the public consciousness, this painting, emphasizing in both title and theme the birth of Venus not as a result of sexual union but from the divinely impregnated foam or *aphros* of the sea (Aphrodite) would have suggested mythic associations of immaculate birth connecting these two symbols of celestial love. The contemporary merger of the two figures is to be seen (interestingly, in reverse form) in the same artist's *Primavera (fig. 46)* completed ten years earlier, this time with Venus appearing in the guise of the Madonna. With Cupid hovering above her, she presides over the pagan rites of spring not in nakedness but decorously clothed. In appearance she is, in fact, the Virgin Mary just as she would be seen in some stained-glass window or in a painting of the Annunciation, her hand held aloft in a gesture familiar from her greeting of the angel Gabriel in such scenes.

The strongest bond between the two, however, was in their motherhood of a male child representing Love, and the mutual transformations necessary to validate their coalescence confirm the impression that there was not simply a one-directional absorption of the classical deities into Christianity, but a shift in emphasis within Christianity too, which their importation facilitated and in a sense also confirmed. In medieval art, the Madonna of the icons had been depicted predominantly in sadness, as a mother haunted by her tragic premonition of her son's Crucifixion. In the thirteenth-century painting by Cimabue (*fig. 47*), she gravely holds upon her lap a man-child already fulfilling the duties of a saviour as he lifts his hand in blessing; and her expression there is one of deep melancholy. The cult of the Virgin Mary burgeoning in the early Renaissance deserted that tradition to portray instead the affection between mother and child, a turn-

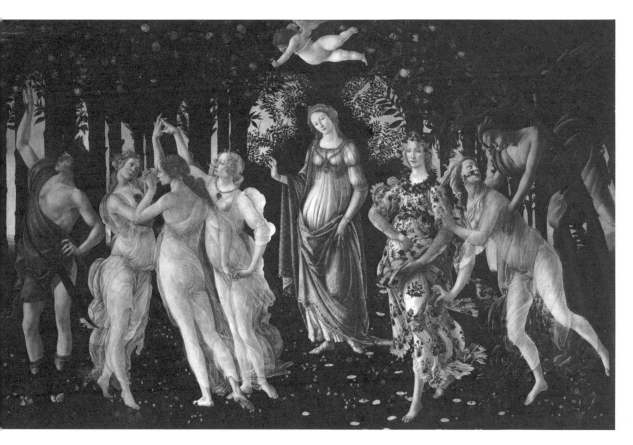

46. BOTTICELLI, *Primavera*

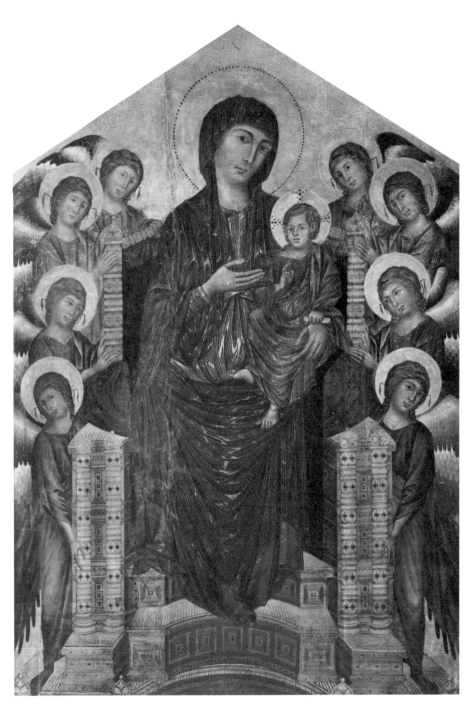

47. CIMABUE, *Madonna, Child, and Angels*

ing-point in the history of sculpture being the silver-gilt statuette donated in 1339 by Jeanne d'Evreux to the Abbey of St. Denis in Paris. She gave in her commission specific instructions that the artist should emphasize in that statuary group the maternal aspect of their relationship. Accordingly, the babe there is portrayed as stretching out his hand lovingly to touch his mother's cheek in a gesture which was to be imitated repeatedly in subsequent sculptural and painted versions of the scene. The culmination of that tendency was to be expressed by Perugino and, through him, in the paintings of his pupil Raphael. In place of suffering, the theme has here become maternal benevolence, harmony, and peace, the fulfilment of a mother as she fondly watches her child at play (*fig. 48*). The underlying geometric form now adopted for such paintings to reverse the suffering implicit in the earlier icons was the isosceles triangle, the perfect symbol of undisturbed stability and rest. Often, as in the painting illustrated here, there is a superimposition of three or more such triangles to create by a process of echo or complementation an even deeper sense of serenity through all parts of the painting. An outer triangle, with the Madonna's head as apex and embracing the entire group, encloses an inner triangle formed by the two children, now with the Madonna's shoulder as apex; and a third uses the leaning cross to counterbalance the figure of the child Jesus. The presence of a cross duly reminds us of the religious theme of the canvas, but it is treated here as a plaything, allowing the mellow golden colouring, the tranquillity of the scene, and its structural stability to create the predominant sense of gentle love.

The use of the triangle may have deeper implications, particularly if one notes in such Renaissance paintings the innovative introduction of the infant John the Baptist in order artificially to add a third to the group. In more general terms (not in connexion with the paintings discussed here), Leslie Fiedler has argued that the cult of the Virgin Mary emerging in this period indicates that there occurred in the public imagination a gradual substitution of the traditional patriarchal Trinity by a matriarchal one.[18] Exaggerated as this may sound at first encounter, if we bear in mind that the summit of Neoplatonic hierarchy was now a combination of beauty, love, and goodness, for which the traditional head of the Christian Trinity, God the Father as the symbol of wrath and vengeance, seemed singularly unsuited, the suggested substitution, a new Trinity of which

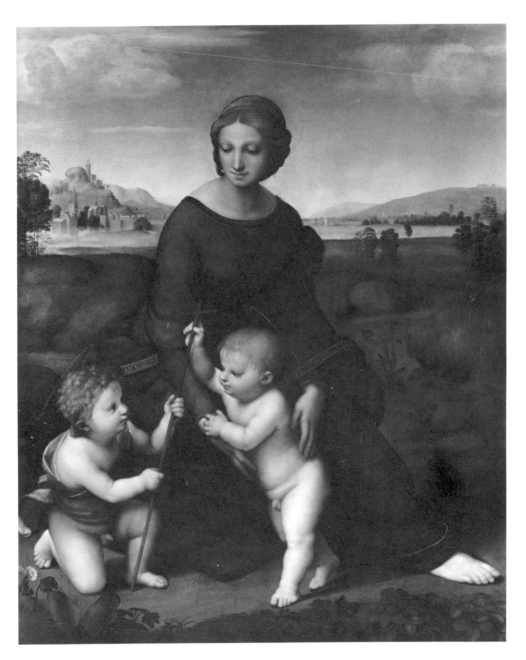

48. RAPHAEL, *Madonna of the Meadow*

maternal Love and Harmony was the apex, becomes more feasible—not, of course, as a theological dogma, which Christianity could never have tolerated, but rather as an unofficial, contemporary way of responding to the changed sense of the divine.

Accordingly, the young Jesus becomes in Raphael's Madonna paintings (as in Da Vinci's *Madonna of the Rocks* which influenced them) no longer a man-child but a figure more closely approximating to the infant love-god Cupid, while in a reverse process the winged Cupid becomes absorbed into art as a Christian "cherub." The *putti* of Renaissance art, flitting impishly about the holy figures, have become so familiar an iconographic device as to seem to belong naturally within such scriptural scenes; but their introduction into art at this time involved, we should recall, a radical departure from biblical sources. A cherub in the scriptures was, of course, not an infant but a full-grown warrior angel, such as was commanded in Genesis to stand on guard with flaming sword at the entrance to the destroyed Eden in order to prevent mankind from reentering it. The absurdity of visualizing an infant cherub from Renaissance art in that military capacity signifies the gulf which needed to be bridged in order to accommodate the pagan *amoretti* to the Christian setting. Milton, knowing his biblical sources so well, returns to that original meaning, ignoring the intervening changes effected by Renaissance art, when he describes his own powerful Satan as a "Fallen Cherub," or records

> that proud honor claim'd
> Azazel as his right, a Cherub tall:
> Who forthwith from the glittering Staff unfurl'd
> Th' Imperial Ensign.[19]

Yet a passing reference by biblical commentators that these adult cherubim possessed the faces of innocent children[20] was regarded by Milton's Renaissance predecessors as sufficient to justify the far-reaching metamorphosis; and in religious paintings from this time onward, the presentation of naked "cherubic" *putti* clustered adoringly about the feet of a Christian saint at the moment of heavenly ascent, or encircling a holy figure from above in benediction, served as the seal to this Renaissance merger of the pagan and Christian child-gods of Love.[21]

Such blending of the secular and religious concepts of Love can be seen as a cornerstone of Spenser's writing. On publishing his *Four Hymnes* he was careful to explain in a dedicatory preface to the Countesses of Cumberland and Warwick, that the first two poems in honour of earthly love and earthly beauty had been written "in the greener times of my youth" and needed to be retracted or reformed. Yet, one notes, he neither retracted nor reformed them, preferring to publish them rounded out by the addition of two further hymns devoted to their heavenly complements, thereby acknowledging his acceptance of Love's two-fold quality. Even in those hymns supposedly eulogizing "profane" love, the echoes of biblical phraseology (such as the plea for the "god-head" to overspread the speaker with "the shadow of thy gentle wing" and the evident evocation of a religious Renaissance Madonna painting in the scene of Cupid in the maternal lap) reveal how intimately the classical child-god is associated with his Christian counterpart, the infant Jesus:

> words should faile me, to relate
> The wondrous triumphs of thy great godhed:
> But if thou wouldst vouchsafe to ouerspred
> Me with the shadow of thy gentle wing,
> I should enabled be thy actes to sing.
> Come, then, O come, thou mightie God of loue!
> Out of thy siluer bowres and secret blisse,
> Where thou doest sit in Venus lap aboue,
> Bathing thy wings in her ambrosiall kisse,
> That sweeter farre then any Nectar is.
> *(An Hymne in Honour of Love*, 17-26)

This equation of the Greco-Roman child-god with the infant Jesus was more than a literary device for expanding the range of poetic imagery or even for endowing with classical status the emerging poetry of Elizabethan England. As Spenser's apology would seem to indicate (offered, we may note, only outside the poem and not within), it marked an attempt, by means of that identification, to bestow a new Renaissance dignity on human love, so scorned by the celibate traditions of the medieval Church. Although of particular interest to a Protestant poet resisting the conventual and monastic pressures of Catholicism, it was,

as can be seen from Italian painting, discernible also in the Catholic manifestations of the Renaissance, as part of the humanist desire to enlarge man's earthly experiences by giving them a status approaching the divine. In the religious sphere, the demand for Christian humility still acted as a restraint on such emboldened self-aggrandizement as the deifying of human love. But the line of demarcation between an amused adoption of pagan myth and the more genuine devotional response becomes, perhaps deliberately, blurred and indefinite, allowing the pagan treatment to lead imperceptibly into a more overtly Christian fervour. Cupid, Spenser informs us in the continuation of that poem, raises his votaries to celestial joys; but the terminology employed is that of the Church rather than of Olympus:

> So thou thy folke, through paines of Purgatorie,
> Dost beare vnto thy blisse, and heauen's glorie.
>
> *(Ibid.,* 278-80)

The conclusion to this poem, with the suppliant praying for release from the pains of unrequited love and for the achievement of its full satisfaction, emerges as a prayer not only undistinguishable from a passionate Christian thanksgiving addressed to God himself but by now patently inapplicable to the child Cupid, even if he remains the ostensible addressee:

> Then would I sing of thine immortall praise
> An heauenly Hymne, such as the Angels sing,
> And thy triumphant name then would I raise
> Boue all the gods, thee onely honoring,
> My guide, my God, my victor, and my king.
>
> *(Ibid.,* 301-5)

The reverse process, the clothing of Jesus in the garb of Cupid, generally had less profound implications; but the coalescence was available for subsequent poets wishing to employ it. George Herbert, in principle opposed to the use of pagan sources, could in a devoutly religious poem which was certainly in no need of classical authentication, nevertheless rely upon that established merger to create the picture of Christ as an archer shooting forth the arrows of divine

love in order happily to strike from afar even those of his devotees still woefully distant from the proximity to God which they craved:

> Then let wrath remove,
> Love will do the deed:
> For with love
> Stony hearts will bleed.
>
> Love is swift of foot;
> Love's a man of war,
> And can shoot,
> And can hit from far.
>
> Who can scape his bow?
> That which wrought on thee,
> Brought thee low,
> Needs must work on me.
> ("Discipline," 17-28)

The introduction of classical deities into the art of the Renaissance was, of course, by no means exclusively religious in purpose, and if this present chapter focusses more upon the underlying seriousness of such classical importation, it is in order to counterbalance the prevalent association of such scenes with a thinly veiled attempt (often literally so) to introduce into art a secular delight in the flesh. Certainly, mythological scenes of gods and goddesses which began now to adorn in stucco, oils, or tapestry the long galleries and staterooms of Elizabethan mansions such as Hardwick Hall (a practice originating, as usual, on the continent but now increasingly adopted by English artists and craftsmen)[22] had a marked vein of erotic interest, with scenes of voyeurism prominent among them. In the comic induction to Shakespeare's *Taming of the Shrew*, Christopher Sly is offered a selection of pictures obviously titillating in their subject-matter and, from the reference to their realism, presumably in their depiction too, yet morally sanctioned by classical precedent:

> SECOND SERVANT: Dost thou love pictures? we will fetch thee straight
> Adonis painted by a running brook,

And Cytherea all in sedges hid,
 Which seem to move and wanton with her breath,
 Even as the waving sedges play with wind.
LORD: We'll show thee Io as she was a maid,
 And how she was beguil'd and surpris'd,
 As lively painted as the deed was done.
 (2: 51-58)

In *Cymbeline* too, Iachimo, in a sensuous account of his visit to Imogen's bedchamber—where he claims he slept not, but "had that was well worth the watching"—describes as evidence of his visit the carved chimney-piece portraying chaste Diana bathing, so vividly executed that she lacked only motion and breath to come alive. And, on the continent at least, the practice was occasionally extended from picture to flesh. Charles the Bold, we are told, was in 1468 confronted in real life by three quite naked females posing in a *tableau vivant* of *The Judgement of Paris*.[23]

On the other hand, whatever eroticism this validation of pagan gods introduced during the later period into both art and literature, the religious sincerity at least of many of its initial proponents must be acknowledged. The tradition of the *Ovide Moralisé*, with its legitimizing of the most lascivious tales on the grounds of their supposedly symbolic meaning, has, particularly for the modern reader, an air of hypocritical convenience about it.[24] It is perhaps difficult for us to take seriously Arthur Golding's declaration, in the preface to his 1565 translation from Ovid's *Metamorphoses*, that his purpose there was solely to convey the moral teachings hidden within the stories:

As for example in the tale of Daphne turned to Bay,
A mirror of virginity appear unto us may.

Yet he wrote from within a world in which the biblical Song of Songs, no less prurient in its surface meaning, with its frank delight in the maiden's breasts or the smoothness of the lover's thighs, had long been read allegorically as the expression of Christ's love for his Church. Arthur Golding was no Hugh Hefner of the Renaissance, nor even like Thomas Nashe who admitted a readiness to "prostitute" his pen when his purse ran dry in order to exploit popular taste for

commercial purposes.[25] Golding was a Puritan in the fullest sense of the term, recognized in his day for the strictness of his personal behaviour, a devout translator of Calvin's works, and, by his own declaration, bitterly opposed to "taverning, tippling, gaming, playing, and beholding of bearbaiting and stage plays to the utter dishonour of God."[26] He seems, therefore, genuinely to have believed that he was, as a translator of Ovid, unravelling moral lessons hidden allegorically within that work.

The multitude of rape scenes in Renaissance art offers substantiation for Golding's view, for there can be no doubt, strange as it may seem to the modern viewer, that the original sanction for such paintings was religious in nature. Artists ransacked classical mythology at this time for opportunities to represent an Io, Europa, or Danaë at the moment of being ravished by a god who has descended to earth for that purpose in the guise of a cloud, a bull, or a shower of gold; yet even in such apparently secular versions as Titian's *Danaë*, with the maiden languishing in full-length nakedness on a couch, there was present in the mind of the sixteenth-century spectator an awareness that the scene represented allegorically the ravishing of the Christian soul by the divine spirit and, by extended allusion, even symbolized the mystic impregnation of the Virgin.[27] It is an awareness once again more easily understood in the light of the contemporary depiction of the soul as a naked female stripped of the clothing of mortal flesh. Veronese's *Rape of Europa* (*fig. 49*), painted in 1576, is redolent with Christian meaning, as, so far from a rape scene in any secular sense of the term, the heroine's companions lovingly assist her to take her place on the back of a bull too docile to be violating her, while angelic *putti* circle above in fond approval of the act. Similarly, the expression on Europa's face in the version by Guido Reni (*fig. 50*) is clearly that assigned by convention to a saint in religious ecstasy.

This tradition has a direct bearing upon our reading of Spenser, and of the apparently erotic passages in his poetry. In the context of such contemporary scenes, there can be nothing unconscious or unintentional in the imagery of sexual surrender which enters his description of religious union with the divine, as it was not only intrinsic to Renaissance conception but even encouraged by leaders of the Church. Both in the Catholic and Protestant versions of the revived meditative tradition, preachers were urging the believer to exploit every aspect

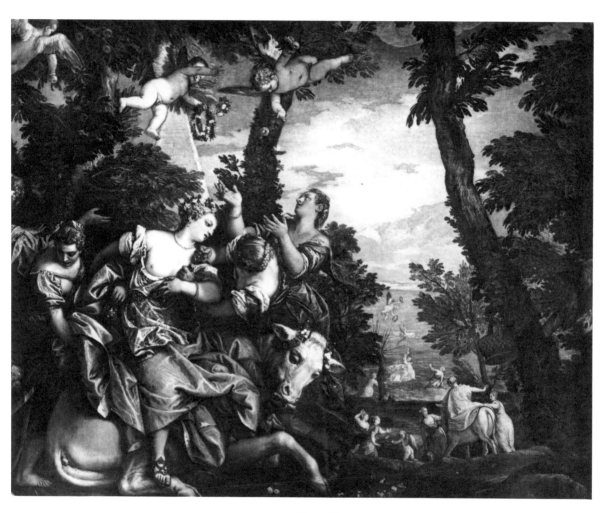

49. VERONESE, *Rape of Europa*

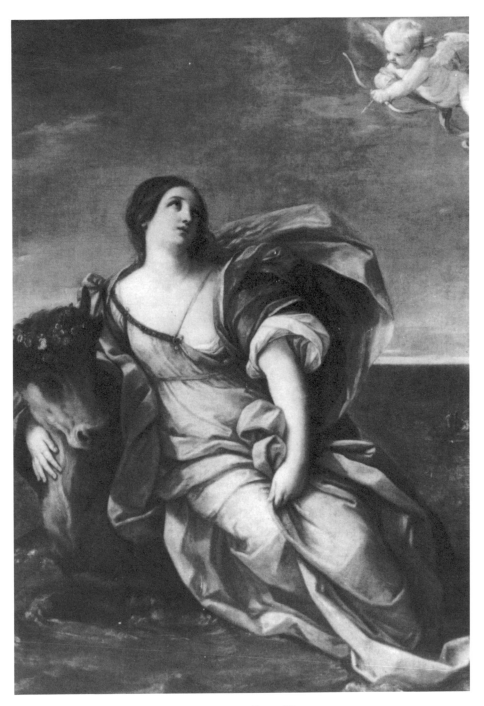

50. GUIDO RENI, *Rape of Europa*

of human experience, including that of earthly love, in an attempt to conceive the essence of spiritual love, perceiving a fundamental connexion between the two. Thus François de Sales, like the English Richard Baxter after him, exhorted the Christian to take the romantic tradition of love as a springboard for his cultivation of its divine form:

> As they that be enamoured with human and natural love have almost always their thoughts fixed upon the person beloved, their hearts full of affection toward her, their mouths flowing with her praises; when their beloved is absent, they lose no occasion to testify their passions by kind letters, and not a tree do they meet withal but in the bark of it they engrave the name of their darling; even so such as love God fervently can never cease thinking upon him, they draw their breath only for him, they sigh and sorrow for their absence from him.[28]

In that religious setting, Spenser's use of the human orgasm and indeed of rape itself to depict the soul's ecstatic union with the celestial would have come as no surprise to a contemporary reader, the ravishment inflaming the entire body with burning passion:

> Then shalt thou feele thy spirit so possest,
> And rauisht with deuouring great desire
> Of his deare self, that shall thy feeble brest
> Inflame with loue, and set thee all on fire
> With burning zeale, through euery part entire,
> That in no earthly thing thou shalt delight,
> But in his sweet and amiable sight.
> (*A Hymne of Heavenly Love*, 267-73)

The markedly sensual element in religious painting of this time, particularly in the art of the Venetian Renaissance, is relevant too to the description of the Bower of Bliss in *The Fairie Queene*, which has so often been seen (by Yeats among others) as militating against the moral didacticism of the poem as a whole. If, even in a Catholic setting with its continued advocacy of celibacy as an ideal, erotic images drawn from human love were, as we have seen, endorsed by the Church as legitimate means for mirroring forth the most devout religious

experiences and for encouraging the worshipper to attain to spiritual ecstasy, they may be seen as doubly legitimate in a Protestant context, where sexual fulfilment within the framework of marriage was not only authorized but advocated. Wantonness such as that described in the Bower of Bliss was to be morally condemned; but a positive response to the attractiveness of naked or lightly garbed female beauty in that description was an element which would itself be valid were it only diverted from "licentious toyes" to the purity of the marriage bed. Those feasting upon such sights in the Bower are indeed described there as frail or lustful, for their Christian principles have failed to direct or restrict their desires to the approved spheres; but in contrast to the medieval presentation of Venus (*fig. 40*, p. 146) as ugly and dishevelled, here the very real attractiveness of the near-naked Acrasis is acknowledged:

> Vpon a bed of Roses she was layd,
>> As faint through heat, or dight to pleasant sin,
>> And was arayd, or rather disarayd,
>> All in a vele of silke and siluer thin,
>> That hid no whit her alabaster skin,
>> But rather shewd more white, if more might bee.
>>> (*FQ* 2.12.77)

The permissible delight in such attractiveness is both authenticated and approvingly recounted within the same poem, in terms echoing those employed to describe religious ecstasy, when at the marriage of Scudamore and Amoret we are told how, at its consummation, they "in pleasure melt / And in sweet ravishement" within each other's arms (3.12.45).[29]

On the other hand, even the Catholic church did, of course grant its blessing, however reluctantly, to marriage, and some of the subdued eroticism in such Botticelli paintings as his *Mars and Venus* becomes more understandable in a painter as deeply religious as we know him to have been, in the light of the view, now shared by most art historians, that they were commissioned as gifts to decorate a wedding chamber, perhaps even to serve as headboards for the marriage bed itself, where once again the setting legitimizes the sensuality.[30]

This more positive response to female charm embellished too the allegorical

presentation of the Virtues, who in this period appear not simply heraldically, like the otherwise unimpressive figure of Fortitude endowed with symbolic sword and helmet, but in the warm, physical attractiveness of feminine beauty. The three Graces adopted from classical mythology to represent the ideals of Christian Platonism are, as in Botticelli's *Primavera* (*fig. 46*, p. 161), no less alluring in their transparently clothed nakedness than was Acrasia, even though one of those Graces is intended to represent Chastity itself. Here too, the divinely beautiful has become part of the divinely good, with female loveliness in its human form now serving as a foretaste of the heavenly perfection beyond. This Renaissance conception led to some incongruous results, perhaps best typified by Giulio Romano's Vatican portrait of Pope Leo X, representative by his office of the ascetic and celibate life, surrounded by a number of scarcely clad voluptuous females intended to symbolize such attributes as Moderation (*fig. 51*).

The enticing comeliness of the Virtues produces, it is interesting to note, a powerful contrastive effect in Spenser's poem; for their opposites, the Vices, now become loathsome in a manner beyond anything to be found in the earlier morality genre. Duessa, once stripped of her camouflaging outer robes, is revealed in a nakedness so physically repulsive to the sight as to make even a reading of her description a nauseating experience:

> Her craftie head was altogether bald,
>> And as in hate of honorable eld,
>> Was ouergrowne with scurfe and filthy scald;
>> Her teeth out of her rotten gummes were feld,
>> And her sowre breath abhominably smeld;
>> Her dried dugs, like bladders lacking wind,
>> Hong downe, and filthy matter from then weld;
>> Her wrizled skin, as rough as maple rind,
> So scabby was, that would haue loathd all womankind.
>
> <div align="center">(FQ 1.8.47)</div>

The heightened response within all the arts to the pulchritude of the human form, both male and female, as partaking of a celestial quality has, then, its converse in a more horrific depiction of human ugliness. Such polarization was a

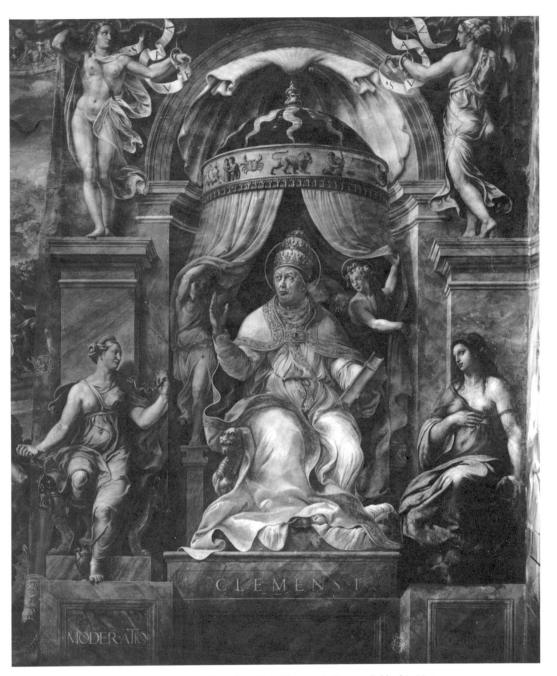

51. GIULIO ROMANO, *Pope Leo X as Clement I, Surrounded by his Virtues*

natural concomitant to the expansion of aesthetic sensibility in that era, to the enlarged range of artistic appreciation which the absorption of the pagan gods into a more universalized philosophical framework had both authorized and facilitated.

This polarization created problems for the Renaissance allegorist, and Spenser at times falls into a trap of his own making. Within the framework of his firm moral didacticism, his repeated direction of reader response towards the good and away from evil, the Virtues and Vices are to be even more unequivocally praised or condemned than in the earlier tradition. Where Fellowship, even though failing Everyman at the moment of testing, had nevertheless been convivial, amusing, and pleasant in himself, in *The Fairie Queene*, Malbecco, the personification of marital Jealousy and therefore to be wholeheartedly condemned in Spenser's poem as a Vice, cannot be permitted to win our pity however pathetic his situation may become. The result is a moral *impassse* for the reader. Having learnt his lesson, Malbecco begs his wayward wife to return home:

> where all should be renewd
> With perfect peace and bandes of fresh accord,
> And she receiu'd againe to bed and bord,
> As if no trespasse euer had bene donne.
> 			(*FQ* 3.10.51)

At the human level, the reader's compassion is aroused for Malbecco, the latter's gentle plea for forgiveness creating the natural hope that after his severe punishment and subsequent reformation he will be granted a new start to his marriage. Yet within the framework of a moral allegory in which Malbecco, as the personification of a Vice, can never change his character, Jealousy must not be condoned. Dutifully, therefore, Spenser casts him into the cave of eternal anguish. The frustration of the reader's sympathy with Malbecco at that point in the story is more than a minor literary blemish; for in a sense it contradicts the main religious thrust of the poem in its advocacy of the Christian life. To condemn not the sinner but the sin is a cardinal Christian principle and to welcome the penitent, if not always with a fatted calf then at least with understanding, forms the

corollary. When, however, as in such allegory, the sinner is identical with the sin itself and the expanded Renaissance conception of man's potential for good and ill has distanced virtue from vice even further, the impossibility of allowing for such forgiveness at times undercuts the moral effectiveness of the religious message and of the fictional narrative itself.

Despite the tactile quality of the description of Duessa quoted above, in broader terms Spenser's poem may appear to contradict that underlying twofold quality in Renaissance art and literature suggested in an earlier chapter, the close integration of the ideal and the real. Spenser has, after all, selected as the setting for his poem the dream world of fable, a series of imaginary landscapes peopled by magicians, impossibly noble heroines, and dedicated knights in armour, all apparently far removed from the everyday world. He seems, indeed, to be striving to create an entity beyond the confines of human experience, repeatedly stressing that the beauty and splendour of his heroines far excels anything known to man. The elevation of human virtues to the level of the divine may seem to divorce his work from this world. Britomart is revealed to Artegall as "so divine a beauties excellence" that, gazing long upon her, he at last

> fell humbly downe vpon his knee,
> And of his wonder made religion,
> Weening some heauenly goddesse he did see.
> *(FQ 4.6.22)*

And lest we should imagine that such description is merely the conventional imagery of the epic tradition, echoing perhaps the first meeting of Odysseus smitten with the godlike beauty of Nausicaa, the divinity of Britomart's appearance is at once corroborated by a second viewer Scudamour who, awakening at that moment, is amazed at the wondrous sight:

> And drawing nigh, when as he plaine descride
> The peerelesse paterne of Dame natures pride
> And heauenly image of perfection,
> He blest himselfe as one sore terrifide;
> And turning his feare to faint deuotion,
> Did worship her as some celestiall vision.

There is, it is true, some sharp detailing of portraiture here—her fair hair is like a golden border framed in a goldsmith's forge with cunning hand; but, the poet assures us, she is beyond the beauty of this world, and the finest artistry known to man can only give a faint impression of her far greater glory:

> Yet goldsmithes cunning could not vnderstand
> To frame such subtile wire, so shinie clear.
>
> (*FQ* 4.6.20)

The imagination is thus spurred to soar beyond the actuality of this world to visualize heavenly scenes far excelling those known to man.[31] Indeed, throughout the poem, everything scintillates with brilliant embellishment or, at the opposite extreme, appalls with explicitly repellent horrors to convey respectively the zenith and nadir of man's spiritual experience metaphorically projected into the fantastic world of the poet's creation. The problem is complicated by an even further distancing from reality, on which his connexion with Renaissance painting may shed some light.

There have been many painters with whose work Spenser's has been compared, among then Giorgione, Titian and Bronzino;[32] but the most instructive parallel remains, I believe, Sandro Botticelli, although perhaps for reasons other than those generally acknowledged. While much admired in his own day and also since the revival of his reputation during the Pre-Raphaelite era, Botticelli has been widely regarded as a painter left a little behind by the quattrocento surge of interest in deepened perspective, in richer and more mellow tones, and in heightened naturalism—somewhat like Dürer who, as a member of a Northern Renaissance reaching its apogee much later than the Italian, came into contact with the new styles when comparatively advanced in his career and, for all his eagerness to absorb its techniques, never shook off completely the Gothic quality in so much of his work. A similar Gothic quality persists in Botticelli's work. However, Botticelli was, we should remember, not geographically isolated from the artistic ferment in Florence, but at its very centre, receiving training from a master who was closely involved in the contemporary transformations of art and a leading exponent of them. Fra Filippo Lippi had inherited from his own teacher Masaccio a flair for the dramatic rendering of movement as well

as a concern with visual fidelity in perspective. He had introduced an experiment in foreshortening into a tondo of the Magi in 1445, and in general, cherished the depiction of his saints and bystanders as individualized and realistic portraits of his own personal acquaintances. The contrastingly austere, idealized canvases of Botticelli, with their shallow perspective, surface embellishment, and stylized techniques suggest, in a painter reared within this ambience of artistic exploration and change, not a falling behind but rather a conscious turning away from its innovations, a deliberate cultivation of the older medieval heritage which he regretfully saw as passing away.

Indeed, Leonardo, who in 1483 was painting with meticulous accuracy the geological formations in the background to his *Madonna of the Rocks*, scorned Botticelli for not depicting his landscapes naturalistically (as if that had been the latter's purpose). How far Leonardo was from the truth is evidenced by a close examination of *The Birth of Venus* (probably executed at the very time when Leonardo was working on those geological formations). There, Botticelli, in defiance of such tendencies toward realism, executes his "shading" of the trees in gold paint, in return to the stylized forms of the International Gothic; and this at a time when naturalistic shading had become so central a concern of painters as a means of lending an apparent solidity and depth to two-dimensional depictions. The waves in that painting are similarly no more than tokens—chevrons merely hinting at the idea of waves at a time when Leonardo's meticulous studies of eddying streams and wave-formations were being eagerly discussed in artistic circles.[33] Yet for all Botticelli's harking back to outmoded forms, his centrality to Renaissance art remains unquestionable, not least in his Neoplatonic beliefs and his being among the very first to introduce classical mythology into Renaissance painting as a major theme.

That Janus-like quality in Botticelli, looking both forward and backward simultaneously, and implying a desire to move into the new age coupled with a reluctance imposed by a nostalgic admiration for the past, is significantly close to the predicament expressed in the overall artistry of Spenser. He too was unquestionably a Renaissance figure, his verse marking a turning-point on the English scene, introducing to poetry a melodiousness and harmony of stanzaic form as well as an exalted imaginative setting which was to become a model for

subsequent generations of writers.[34] Yet at the very threshold of the era which he was to help inaugurate, he too experienced an unwillingness to desert the past, a longing to restore some of the glories of the age which was ending. At a time when a predominant element in all forms of English literature then being produced was the enormously expanded vocabulary of the language, its augumentation both from classical and foreign sources to accommodate the more sophisticated eloquence and philosophical speculation of the time, his own regard for the earlier English traditions led him to reject such innovations in favour of the archaic and, in his view, more reverend tradition from the Chaucerian world. Whether "E.K." was, as some believe, a pseudonym for Spenser himself, or the initials of a friend close to the poet's own tastes and inclinations, there can be no doubt that the *Epistle to Gabriel Harvey* prefixed to *The Shepheardes Calender* expressed what were essentially Spenser's own views. There, after protesting at the importation of new words which had made "our English tongue a gallimaufray or hodgepodge of all other speeches," the writer singles out for particular commendation Spenser's conscious rejection of such innovations in favour of an outmoded but nobler diction from a past age:

> For in my opinion it is one special praise of many which are due to this poet that he hath laboured to restore as to their rightful heritage such good and natural English words as have been long time out of use and almost clean disinherited.[35]

The antiquated spelling upon which the poet insists together with the obsolete idiom is, like the shading of trees in gold, a public declaration of the artist's identification with a style sorrowfully recognized as superseded, a token gesture of respect which, although he knows it will not stem the tide of change, may restore dignity to it and perhaps even arouse renewed deference on the part of his contemporaries. As "E.K." recalled, "oftimes an auncient worde maketh the style seeme graue and, as it were, reuerend." In the same way, Botticelli in his *Mystic Nativity* of 1500, which was painted at the flowering of the High Renaissance, reverts to obsolete medieval perspective dictated by order of sanctity rather than optical realism, with a Virgin disproportionally larger than the Magi and shepherds around her, and with tiny grotesque devils, such as had long dis-

appeared from High Renaissance art, skipping playfully about in the foreground of the canvas.

Yet the pastiche becomes for each not an empty gesture of nostalgia but a positive constituent of their work, helping to create that very artificiality which separates it from the burgeoning naturalism within contemporary art and lends it a distinctive quality. Certainly in *The Fairie Queene*, if not in *The Shepheardes Calender*, the stylized distancing from actuality contributes profoundly to creating the ethereality of his scenes, the element of imagined myth, as it had to Botticelli's *Birth of Venus*, removing the stories from the corporeality of the material world into the realm of fantasy. Furthermore, the deliberately shallow perspective of Spenser's allegory, describing surface texture and visual appearance rather than creating the illusion of depth and solidity sought by others of his time, serves to intensify the conscious effect of its being an artefact. Like the contemporary tapestries hanging fashionably in Tudor halls, his scenes are to be admired more for their artistry and mythological allusion than for such verisimilitude as was then being achieved in oil-painting and fresco. In his description of the bride Medua, there is a tinsel effect, a glittering, spangled, metallic loveliness which lifts her out of reality and into a dream-world of unearthly beauty:

> Then came the Bride, the louely *Medua* came,
> Clad in a vesture of vnknowen geare,
> And vncouth fashion, yet her well became;
> That seem'd like siluer, sprinckled here and theare,
> With glittering spangs, that did like starres appeare,
> And wau'd vpon, like water Chamelot,
> To hide the metall, which yet euery where
> Bewrayd it selfe, to let men plainely wot,
> It was no mortall worke, that seem'd and yet was not.
> (*FQ* 4.11.45)

Despite his return to certain of Chaucer's techniques, Spenser has moved away from him, and there is a profound change to be remarked in his method of observation—one of those shifts in perspective which mark a new way of looking upon the world. Chaucer's artistic eye had been focussed upon the external

details of dress, gesture, or speech on the assumption that such outward indications supplied all that was needed to comprehend the individual, to determine his social class, his profession, and his intellectual standing, as well as to reveal the degree of sincerity with which he practised his calling. In Spenser's poetry, the new dimension now entering such observation is his recognition of the deceptiveness of the visible, the urgent need for man, in a more sophisticated and complex society, to distinguish between appearance and reality. In the brief passage quoted above, even though the figure represented is virtuous, the reader is reminded three times that her garb *seem'd* like silver, did *appeare* like stars, and that the metal "*seem'd* and yet was not." Man, it is suggested, must be for ever on his guard against dissimulation; and a theme reiterated throughout the epic poem is the need for discrimination in a world riddled with speciousness and plausibility. The Church itself was not only no longer one, but had split even further into numerous sects and factions each claiming exclusive rights to the Christian hope of salvation; and the scarlet Whore of Babylon, Spenser warns us, could, like Duessa, appear at times as comely and gentle as Una herself. For the Red Cross Knight, as for the Renaissance Christian at large, any momentary error in the bewildering pageant of life, any failure to penetrate the disguises about him and to perceive the truth within, could be fatal to his eternal hopes. And the new view extended well beyond the religious sphere, with political order, love, and even justice seen to be more complex and elusive than had previously been thought.

Within painting that same concern is apparent. In allegorical terms, Botticelli's *The Calumny of Apelles* painted in 1495 (*fig. 52*) takes as its overt theme the speciousness prevailing in this world. Based in subject matter upon Lucian and following a specific recommendation in Alberti's *De pittura*, it portrays the false charge of treason levelled against Apelles by a jealous rival—the victim being dragged before an ass-eared judge by Calumny, accompanied by her friends Envy, Treachery, and Deceit, while Ignorance and Suspicion whisper falsehoods into the judge's ears. In marked contrast, however, to the medieval tradition representing vice as ugly, each of those evil personifications is depicted as an outwardly beautiful woman; and their faces are as lovely as that of the naked virtue Truth on the left. Only Remorse is depicted in ugliness, and her function

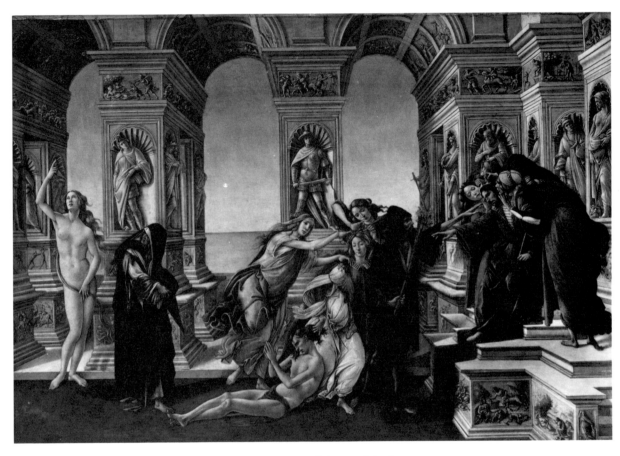

52. BOTTICELLI, *Calumny of Apelles*

here is not to deceive. No less indicative of the need for man to be educated to-wards a distrust of sensory experience is Bronzino's *Venus, Cupid, Folly, and Time* from 1540 (*fig. 53*), comparable to Botticelli's painting in theme, if not artistic technique. Deceit there presents a puzzle which the viewer himself must learn to solve by the same kind of close scrutiny and cautious research in this allegorical form as must be applied by him in real life. Beside Venus, a pretty, innocent-looking girl leans forward proffering a gift of honey in her right hand. Only the wary would perceive something disturbing about that hand—that al-though it seems to emerge from her right side as she crouches half-concealed behind the figure of Jest, its fingers fail to conform; for it is in fact her left or "sinister" hand inverted, and the gift she really intends to bestow, a poisonous insect, is clasped behind her in her right hand. Only after such perception would the spectator know that he must search further, to discover in the shadowy back-ground her hidden snake-like body with the griffon's claws. So is the Red Cross Knight deceived by the surface beauty of the apparition made outwardly to re-semble his own lovely Una by the magician Archimago:

> Who all this while with charmes and hidden artes,
> Had made a Lady of that other Spright,
> And fram'd of liquid ayre her tender partes
> So liuely, and so like in all mens sight,
> That weaker sence it could haue rauisht quight:
> The maker selfe for all his wondrous witt,
> Was nigh beguiled with so goodly sight.
> (*FQ* 1.1.45)

The apparent remoteness of this poem from the sixteenth-century world in its dream-like setting of noble knights battling impossibly evil monsters is thus countered by a message of immediate relevance to the Renaissance reader. The call for distrust of external appearances in this world implied the need for a sus-picious scrutiny of reality before finally distinguishing the good from the bad. Whether that solemn advice referred to the practices and doctrines of the various rival churches or to broader secular matters, it both reflected and itself encour-aged the sharpened visual perception characteristic of the Renaissance. If that

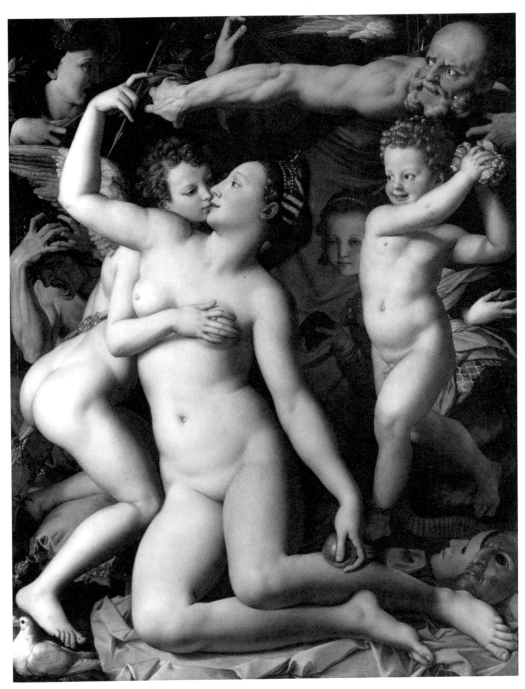

53. BRONZINO, *Venus, Cupid, Folly and Time*

message was presented here in an idealized and distantly allegorical form, in that respect it remained intimately related to the more practical concerns of its day.

There are, moreover, two further ways in which the poetic experience offered by *The Fairie Queene* was, despite its antiquated and often abstract form, embedded in reality. The first and more obvious is that the poem was not merely an allegory in general terms about man's moral obligations and commitments, but was intended *ab initio* (as Spenser specifically informs us) to be applied to the age in which he lived, and more precisely to the court of Elizabeth. For his readers, there was throughout *The Fairie Queene*, in addition to its broader concern with mankind, a crisp topicality which rooted the fantasy in the familiar world of courtly life. The famed description of Errour disgorging its unsavoury vomit of loathsome books and pamphlets may be a striking image for false doctrine as a whole; but for the Elizabethan it conjured up a more immediate reference to the scurrilous pamphlets recently aimed against the Queen by the Catholics.[36] In that context, there was a sense of personal urgency and contemporary relevance in the knight's combat with the source of that danger, which both threatened the safety of the English throne and had indeed defiled the place in which they dwelt. The unexpected present tense of the final word in the stanza underscores the topicality:

> Therewith she spewd out of her filthie maw
> A floud of poyson horrible and blacke,
> Full of great lumpes of flesh and gobbets raw,
> Which stunck so vildly, that it forst him slacke
> His grasping hold, and from her turne him backe:
> Her vomit full of bookes and papers was,
> With loathly frog and toades, which eyes did lacke,
> And creeping sought way in the weedy gras:
> Her filthie parbreake all the place defiled has.
> (*FQ* I.I.20)

The invocation to the Muse which introduces the first book confirms Spenser's intention defined in his letter to Sir Walter Ralegh, that by the Fairie Queene he means in part "the most excellent person of our soveraine the Queene, and her kingdom in Faery Land." Yet it also reflects in its own presen-

tation that merger of classical and religious, the unembarrassed drawing together of pagan and Christian deities which characterizes the Renaissance. In turning to the sacred muse for inspiration ("Help, then, O holy virgin!"), Spenser has carefully phrased his petition to produce resonant connotations both of the holy Virgin Mary, to whom a Christian would turn most naturally in prayer, and of the Virgin Queen to whom he will soon turn in praise. Next, the glorious love of Truth which is to impel the Red Cross Knight of Holiness in his Christian quest is seen as implanted in his breast by Cupid, the representative both of highest Jove (again with allusions to the biblical Father of Heaven) and of Venus, the mother of Love:

> And thou, most dreaded impe of highest *Ioue*,
> Faire *Venus* sonne, that with thy cruell dart
> At that good knight so cunningly didst roue,
> That glorious fire it kindled in his hart.

In the stanza of that proem, the allusions are crystallized in an invocation to Queen Elizabeth herself, addressed in terms which in medieval times would have constituted blasphemy; for although mortal, she is seen here without qualification as a divinity, a shining celestial figure representative of the newly expanded image of human attainment even in this world:

> Goddesse heauenly bright,
> Mirrour of grace and Maiestie diuine,
> Great Lady of the greatest Isle, whose light
> Like Phoebus lampe throughout the world doth shine.[37]

Once again, in the proem to the following book, Spenser protests that any response to his epic as merely "a painted forgery" betrays a failure in the reader's imagination. In an age when countries and regions previously unthought-of were being discovered through hardy enterprise, the line between fiction and reality could, he suggests, no longer be clearly drawn; and he concludes with the repeated assurance to his Queen that the supposedly fabled world of his poem is ultimately but a mirror of "thine owne realmes"—an assurance confirmed by the appearance at various moments throughout the poem of such familiar figures as

Burghley, Leicester, and Sidney in easily penetrable guise.[38] By his own statement, therefore, the artefact of his stylized world remained nonetheless rooted in the reality of Elizabethan England and the court-life upon which it centred. If it added by the mythological projection of contemporary moral aspirations a certain archetypal authenticity to the age's love of pageantry and masque, that too formed part of the enriching interchange between the two worlds of ideal and real, of the celestial and the mundane.

The second element in his poetry which militates against any excessive abstraction lies in the nature of his allegorical figures. In the morality plays, as we had cause to note in a different context, the personified human traits such as Sloth, Envy, or Ambition behaved, as might be expected, entirely in accordance with the Virtue or Vice they were intended to portray. Sloth is never brimful of energy and Envy never affable or generous towards others, but both function exclusively within the limits of their defined personalities. That quality holds true for Spenser's peripheral figures, those which appear briefly to symbolize passing moods or emotions in the journey taken by the central characters:

> After them went Displeasure and Pleasaunce,
>> He looking lompish and full sullein sad,
>> And hanging downe his heavy countenance;
>> She chearefull, fresh, and full of ioyance glad,
>> As if no sorrow she ne felt ne drad;
>> That euill matched paire they seemd to bee:
>> An angry Waspe th' one in a viall had,
>> Th' other in hers an hony lady-Bee.
>> *(FQ* 3.12.18)

In his main figures, however, Spenser introduced a significant change. The surprise offered at the very opening of *The Fairie Queene* is that the Red Cross Knight, who might be expected, as the symbol of Christian Holiness, to be the tried and valiant champion of the tale, is, we are told, as yet unproven in battle. The mighty suit of armour he wears is indeed indented with the scars of previous warfare, but the man within is untested—"Yet armes till that time did he never wield." His battles still lie before him, battles which he will not always win

without the aid of others. Like his peers in the later books, the knight is human in his weaknesses and fears, faltering at moments of severe trial, easily deceived by false dreams, and at times deserving the contemptuous rebuke of his Lady: "Fie, fie, faint-hearted knight . . . fraile, feeble, fleshly wight!" (1.9.52–53).[39]

Such stern reproof might, in any other tale of adventure, have lowered the hero in our estimation, providing a humiliating rebuke of his cowardice and weakness; but within an allegory depicting beneath the surface narrative the inner conflicts of man's spiritual life, the voice castigating his backsliding represents the voice of his own conscience rather than that of an outsider, and its success in rousing the knight to renewed and successful combat marks his own praiseworthy victory over a temporary failure of nerve. More importantly in this context, such moments of hesitation and despair in Spenser's heroes confirm that the tales no longer employ as their central figures pure embodiments of abstract Virtues and Vices but have become more intimately concerned with the human personality. Holiness, as represented by the Red Cross Knight, is not an ideal quality with which he has been endowed from the outset but a virtue towards which he must strive as a fallible mortal, battling with counter-forces from both within and without, until he has matured into the role he has been assigned. Only then will he be worthy to be wedded to Truth and symbolically sprinkled with holy water at the matrimonial ceremony to mark the achievement. In that respect, Spenser revitalized the cruder morality tradition with its simpler choices between good and evil, transforming it into a more sophisticated and flexible instrument with which to investigate the human struggle for self-mastery—or to use the term coined by a recent critic, the process of "self-fashioning" which forms so central an element in the Renaissance mode.[40] Augustine, haunted by the enormity of man's original sin and the need for total abasement before God, had warned the Christian against attempts at self-advancement: "Keep your hands off yourself! Try to build yourself up and you build a ruin"; but for Spenser the purpose of his poem as he defined it was the very contrary of Augustine's advice, the aim being "to fashion a gentleman or noble person in vertuous and gentle discipline." It was that fashioning, the educating of man within this material world towards celestial ideals conceived in terms of godlike splendour, yet now believed attainable by man, which, to-

gether with the melodious harmonies of his verse, constituted Spenser's primary achievements as a Renaissance poet. He may be seen, indeed, as the English exemplar of those emergent aesthetic propensities which had, upon the continent, determined the forms of High Renaissance painting. It is an affinity revealed in his elevated conception of man's spiritual potential, his belief in the universality of myth endowing the pagan gods with the attributes of Christian theology, his distrust of illusory surface appearance, and even his nostalgic cultivation of antique modes while he was yet inaugurating an essentially new poetic style.

5

A KINGDOM FOR

A STAGE

THE INVENTION OF PRINTING, IT HAS BEEN ARGUED, DID MORE than accelerate the dissemination of ideas in the Renaissance. If we are to accept Marshall McLuhan's provocative thesis, the communications media have served in all eras not only as vehicles of expression but as moulders and re-creators of the messages they transmit.[1] The introduction of letter-type, together with the increase in literacy in the fifteenth century, had inculcated the new habit of reading a book consecutively through from beginning to end and thereby generated, he suggests, linear modes of thought. One result was to encourage among writers the development of sequentially integrated prose narratives, more responsive to the fixed orders of chronological and spatial organization than had been familiar from medieval usage. In that earlier period, it is true, even the educated layman with a knowledge of Latin could gain little sense of a cohesive, developing narrative from the recital of biblical passages in church, excerpted to suit the cycle of the liturgical calendar rather than as sustained history; while the less-educated layman had relied for his knowledge of the Bible mainly on hearsay, from allusions to scriptural incidents in the vernacular sermons of the preachers.[2]

Yet even a reading of the biblical text itself would have offered only a limited sense of realistic storytelling; for, as Erich Auerbach wisely perceived, biblical narrative was little concerned with the fixed coordinates of time and place. Abraham, we may be told, "rose early and went unto" the place commanded by God; but "early" here implies moral readiness rather than the morning hours,

and his journey is presented as if it took place in a vacuum, with no glance either to right or left during the long days of travel.[3] The silent and the unspecified create the mystery of the scene, a sense of transcendent moral truths in which the dictates of ordered narrative are deemphasized. The tales move back and forth not only in time but even in their assumptions. The announcement in the second chapter of Genesis that in the Garden of Eden "there was no man to till the ground" is offered as if we had not already been informed in the previous chapter of the momentous creation of mankind, both male and female, on the sixth day. Unconcernedly, the narrative doubles back to recount the event once again, this time in richer detail and from a man-centred viewpoint rather than from within the broad cosmic setting of the Creation.

To the nineteenth-century Wellhausen school, such doubling back seemed by its repetitive form to provide evidence of multiple authorship for the Pentateuch;[4] but if such theory made the ancient texts fit more neatly into narrative patterns familiar to the nineteenth-century scholar, the very fact that most ancient forms of literature shared this more relaxed mode of narration, savouring the manifold aspects of its stories and preferring the anecdotal to the more rigidly progressive, suggests that it was a style of writing peculiarly suited to the thought-processes and philosophical outlook of those times. The Homeric epic (also ascribed by the nineteenth-century scholar to variegated authorship) displayed a similar latitude in structure, beginning traditionally *in medias res*, with the earlier adventures of the hero to be recounted much later to some rapt admirer within the tale. And in the leisurely pace prevailing then, the epic narrator, even at moments of high tension—as the hero raises his shield to deflect the swiftly descending sword of his adversary—would pause to describe in unhurried detail the nature of that shield in terms of its history, ornamentation, or divine properties, before resuming the interrupted account. In the Middle Ages, no less, the merging of scriptural stories in accordance with the precepts of patristic typology had furthered this loosening of chronological division, with Abraham in the Brome *Sacrifice of Isaac* invoking the Holy Trinity in a manner anachronistic to modern ears.[5]

Yet to assume that linear sequence did not function as an acknowledged structural element in such earlier writing is to focus only upon the progressional

discrepancies. In the presentation of the mystery cycles, for example, it could indeed be argued that during the time of the *stationes*, when they were performed simultaneously at fixed points within the cathedral, spectators could theoretically attend them in any order; but their emergence into the streets upon pageant-waggons circling through the town in strict chronological sequence, testifies to the intention of the Church and the guilds that they should be seen in accordance with the overarching pattern of Christian history, stretching from Creation to the Harrowing of Hell. Such sequence was reflected too in the many cycles of scriptural scenes executed in sculpture, oil, or fresco. The series on the rear panels of Duccio's *Maestà*, or by Giotto on the walls of the Scrovegni Chapel in Padua, both follow the natural or linear order of the events even though they were painted long before the technological revolution instituted by Johann Gutenberg to which such diachronic sensibility has been attributed.

The far-reaching development, however, which does make itself felt at this time and which, reinforced as it may have been by the new reading habits, had certainly shown signs of emergence before then, was a sharpened interest in narrative movement—an interest which was profoundly to affect the forms of literature in this period, transforming them from the anecdotal or episodic into unified works relying upon a substructure of interlocking themes and schematically designed plots. That this tendency predated the technological revolution is clear from the changes in that direction discernible in all the arts in the early fifteenth century. In painting, for example, there can be perceived an attempt to break through the isolating frames of contiguous scenes in order to create a thematic sense of forward movement. The individual incidents within a story begin to be conceived differently, less to be cherished for themselves as sacred scenes worthy, like ancient icons, to serve in isolation as objects of reverence and meditation; they were now seen rather as passing moments in a developing saga. Parallel to the new three-dimensional sensitivity to space as a volumetric entity consisting of identifiable points in fixed mutual relation, time too is now conceived as an unchangingly-paced forward progression and therefore as divisible historically into its ordered and consecutive parts. The typological view weakens, to be replaced by the acceptance of time as a fourth dimension, subject to the same objective criteria of fixed measurement as the newly conceived optical perspec-

tive prevailing in painting; and the close connexion between their developments in this era testifies to their interrelationship.

On the panels which Ghiberti designed for the Florentine Baptistery, for example, whose influence upon subsequent art cannot be questioned, a process of change is to be discerned in the artist's developing awareness of these spatial and temporal factors as he works upon the panels, an incipient consciousness of the imperatives of all four dimensions gradually imposing itself during the course of the work. The scenes on the first two pairs of doors had, in the main, followed the Gothic tradition, not least in the unlocalized vagueness of the setting. The neutral, undefined background of its panels is evocative both of the flat gold-leaf so characteristic of medieval painting and at the same time of the unmodulated blue of the mosaics from Ravenna such as Giotto had adopted for some of his own frescoes. Both techniques had been intended by their unvaried, unspecified quality to convey the ethereality of the holy scenes, removed in time and space from the earthly. The third pair of doors, however, the so-called *Porta del Paradiso* facing the Cathedral, upon which Ghiberti worked from 1425, introduced a recognizably more palpable setting for each panel, a tree-studded landscape, a distant walled-city, or an architectural complex against which the biblical figures were individually proportioned to create, within the narrow dimension of each frame and the low relief available to the artist, an effect of receding depth and optical rationality. The figures are, as Ghiberti himself proudly declared, so disposed on the planes that "those which are near appear large, those in the distance small, as they do in reality."[6] Where in the Giotto series each scene had been a moment frozen in time—*The Sacrifice of Joachim* or *The Meeting at the Golden Gate*—here each panel relates a multiform story complete in itself. *The Creation of Adam* contains, against a more natural but still indistinct background, three successive events within one frame. Adam to the left is raised from the dust; in the centre of the panel Eve emerges from his rib; and to the right we are presented with the expulsion from Eden. Although comparatively rare, there were precedents in art for the inclusion of such multiple scenes within one picture setting,[7] and the originality here should be perceived rather in the artist's attempt to achieve a new flexibility of narration. The events not only merge into each other without break or division, but discourage by their form of presenta-

tion any tendency to view them as separate units. The angels watching over the formation of Adam encroach upon the adjacent scene, thereby blurring any imagined line of demarcation. As yet, however, there is little apart from this slight encroachment to join the scenes or to suggest unified narration.

The innovative technique entering art at this time is the placing of such multiple scenes against a single unifying background to lend them architectonic coherence. In a penetrating study of the origins of the Renaissance stage, written at a time when few such interdisciplinary studies had appeared, George R. Kernodle argued for the close relationship between the various forms of stage developing in the sixteenth century and the conventions of late medieval painting or *tableaux vivants* which were familiar to audiences and upon which the dramatist could rely for emblematic and symbolic associations. As part of that interconnexion, he noted how such painting, probably in unbroken tradition from the classical era, had adopted the convention that both artist and subject are in the open air. In Greek drama, both audience and actors were in an uncovered amphitheatre where all dramatic action took place in front of a *scaena*, that is before the outside wall of a building, while any interior scenes such as the murder of Agamemnon would be rolled out on an *eccyclema* or wheeled platform in posed and motionless form. So painting of the later Middle Ages, he argues, presents its Annunciation and Nativity scenes out-of-doors, or at most in an airy pavilion open to the spectator's view. In the mystery plays, the same device was employed; and in the Elizabethan playhouse with its projecting, covered stage a convention was adopted whereby even a scene supposedly within a throneroom would be unconcernedly acted out in front of the street scene or house fronts which formed the unchangeable background for the stage. The Italian proscenium arch Kernodle sees as evolving directly from the baldacchino which in medieval painting so often framed the central religious scene and was now introduced to the stage in order to lend unity to the variegated actions occurring within it.[8]

All that is true, but even more characteristic of the Renaissance stage, it may be argued, was the unity imposed not by the proscenium arch framing the forestage but by the new background architectural setting so carefully introduced by such stage-designers as Serlio to create a realistic coherence to the action, and

probably deriving from a parallel usage in art. Ghiberti, for example, as he reached the *Jacob and Esau* panel, clearly felt the need to impose a more comprehensive visual coherence upon the sequential scenes which in both painting and the mystery plays had, until then, been offered in processional form, as separate incidents each portrayed in isolation. In his version (*fig. 54*), the various scenes of the selling of the birthright, Isaac's command to bring venison, his mistaken blessing of Jacob, and the latter's flight from home at his mother's bidding together with the appearance of an angel to approve her actions (all events more naturally to be depicted inside the home) are here presented before a monumental structure whose arches by spanning the sequence of events seem thereby to unify them symbolically as occurring within the context of a family home and as components of an integrated narrative. The lines of the paved floor confirm this effect by drawing the spectator's gaze from along the entire width of the foreground, and directing it through the various scenes portrayed towards a single centralizing vanishing-point placed at the rear centre of the panel, carrying us, as it were, into the interior of the home even though the events are disposed outside.

Such unifying narrative technique began to be extended by others even to those Christological readings of the Old Testament which had symbolically connected events occurring at moments far distant in time. The intimately causal relationship which Christianity had established between the Fall of Man and the coming of the Redeemer had made juxtapositions of those two scenes in medieval paintings or on the sculpted portals of Gothic cathedrals typologically self-explanatory.[9] The change which now becomes discernible in that presentation is exemplified in Giovanni di Paolo's *Annunciation* of 1450 (*fig. 55*), where the two remote events, instead of being merely adjacent to suggest a theological relationship, are here anecdotally integrated as if occurring sequentially and in the same locality. The interest in the narrative sequence thus obliterates the intervening centuries. Eden has charmingly become a private garden adjoining the Virgin's home. From it the fallen parents of mankind are being expelled for their sin at the same moment as Gabriel enters from that garden into the porch to bring to the Virgin the tidings that she will conceive the Redeemer of the Fall. The airiness of the open porch, with its slim, widely spaced columns allowing

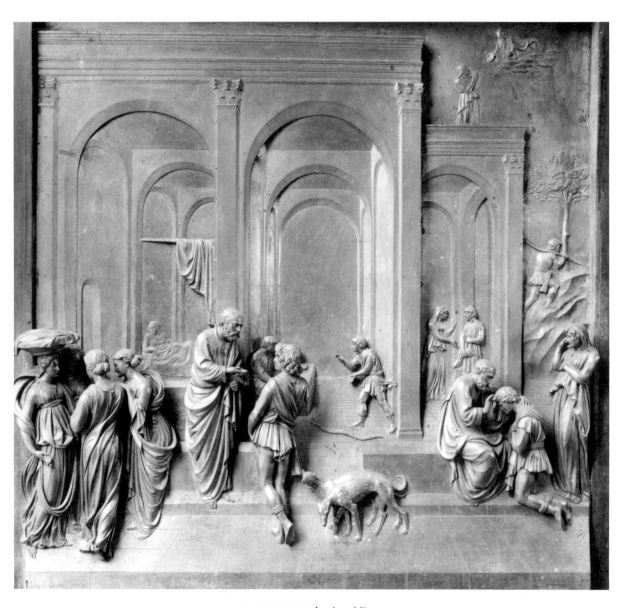

54. GHIBERTI, *Jacob and Esau*

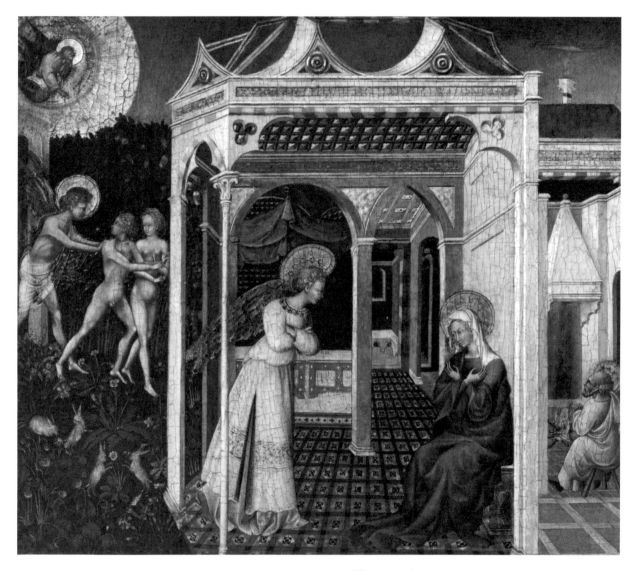

55. GIOVANNI DI PAOLO, *The Annunciation*

free access to and from the garden, increases the sense of fluidity, as does the depiction of Gabriel in motion, still in the process of entering, with his left foot not yet reaching the ground and his body leaning forward. Iconologically joining the two events are the rabbits playing in the foreground of the garden. As the traditional symbols of sexual procreation and lust, they here represent on the one hand the carnality of the fallen pair on whose side they appear, and on the other, by contrast, the triumph over such carnality in the Virgin Birth which the angel has come to announce.

This departure from the traditional sequence of statically juxtaposed holy scenes in favour of integrated narration led Hans Memlinc soon to adopt a somewhat different technique, yet aimed at producing a similar unifying effect. In *The Seven Joys of Mary (fig. 56)* from 1478, as in the paintings he devoted to other New Testament figures, he sets the various events in Mary's life within a broad natural landscape, an overview of a small town nestling among the hills. The incidents are still, as in the mystery cycles, presented in isolation, the Murder of the Innocents being located in a courtyard forming, as it were, an independent staging area; but the narrow lanes winding their way from one site to another encourage the spectator to let his gaze wander from the house of the Annunciation to the stable of the Nativity, from the burial ground with its sepulchre to the garden where Christ appears before the Magdalene. Viewed in its entirety, the painting, by its simultaneous presentation of events separate in time, still remains close to the medieval telescoping of chronological perspective in disregard of historical accuracy. Yet the viewer is invited, by this placing within a natural rural panorama, to focus upon the different scenes in sequence, moving uninterruptedly from one event to the next within a pleasant, realistically depicted environment.

The new interest in narrative progression is, once again, not identical in its pictorial and literary manifestations. Painting is by nature more static in form, normally recording a single moment in time. The greater flexibility offered by this sequential device of smoothly connected scenes cannot therefore on canvas achieve the momentum of the character development available for verbal narrative. On the other hand, the emergence of these techniques in painting does suggest a contemporary desire among artists for a more freely flowing move-

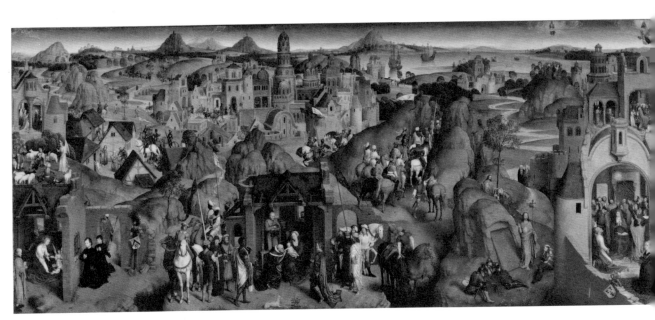

56. MEMLINC, *The Seven Joys of Mary*

ment in storytelling, a structural mobility for which medieval artists had shown little concern either within drama or painting. Scriptural subjects, it is true, had offered some sense of narrative movement by association. The dramatist and artist of the Middle Ages were able to assume on the part of audience or spectator a knowledge of the context of the work even when a scene was presented in isolation, so that a Madonna and Child presupposes, with or without the presence of iconological symbols, both the Virgin Nativity preceding it and the Crucifixion which is eventually to follow. But for non-scriptural themes in that period, whether religious or secular, where such inbuilt linear progression was lacking, medieval artists had evinced little interest in supplying it. In history, the insistence upon accuracy so evident in classical writers such as Thucydides or Livy, the careful placing of events in their due order and the search for cause and effect in their succession, had been supplanted by an interest in the universal moral lessons to be deduced from *exempla* selected from the past, irrespective of their historical placing. Collections of saints' stories and their martyrdoms, such as the widely read *Legenda Aurea* by Jacobus de Voragine composed about 1297, lack any coordinating thread or rational order other than their shared didactic purpose—a lack which was no doubt responsible for the work's sharp drop in popularity during the Renaissance, when historical perspective and artistic unity had come to be valued and to be expected by readers.

It is evident that, during the next fifty years, the introduction within literature of a framing device, not unlike that employed by Ghiberti or Memlinc, to impose some degree of outer structural unity on a work did not arise fortuitously but, by its gradually improving implementation, was supplying a newly felt need. Boccaccio repeatedly experimented with such framing designs in a series of different works, continually refining the tactic to suit his purpose. In his *Filocolo*, of about 1336, he first introduced the technique of an enveloping setting for anecdotal narration as Fiametta, elected by a company of friends to preside over their entertainment, proposes a general discussion of love's problems, the specific theme to be suggested by each of the participants in turn. A little later, in his pastoral romance *Ameto* of 1341, the device became more integrative with the adoption of a more specific and hence a more effectively unifying theme. Now seven nymphs, with a shepherd acting as their moderator, celebrate a fes-

tival devoted to Venus by appropriately recounting their own unhappy experiences of marriage and the satisfying compensation they found in extramarital love. The *Decameron* in its turn marked a twofold advance in the application of this device. In the more vivid description of the setting to the stories, with its grim account of the horrors of the plague from which the group of narrators has fled to the safety of a country home, it introduced a sharper realism to the situational framework; and by the need to while away the time till the plague should subside, it greatly broadened the range and number of the stories, with ten tales related daily over a period of ten days, all but the first being accorded its specific topic.

Yet for all its innovative tightening of narrative structure, the framing device is as yet limited here in its effectiveness. The plague setting has no relevance to the content of the tales, offering only an excuse for leisurely self-entertainment; the topics chosen to coordinate each day's anecdotes, such as "stories providing a happy conclusion to a series of misfortunes," are sufficiently vague to constitute only the loosest of coordinators; and the transitional passages between the tales, which might have pictured the varied reactions of the participants and thereby enlivened our interest in them both as people and as narrators, are generally restricted to such disappointingly bare connectives as: "With Neifile's story over and generally acclaimed, the queen indicated it was her pleasure to hear Filomena, who spoke as follows."[10] Nevertheless, the contribution that device added to the work is out of all proportion to the small space it occupies, not only creating a convivial setting to the *Decameron* at large but providing some degree of forward movement from story to story, however disconnected they may really be.

Chaucer's selection of a pilgrimage as the organizing framework for his enveloping narrative, to provide his collection of tales with a flexible, realistic setting in time and space, quite apart from the more attractive bustle of activity it offered in the lively preparations at the Tabard Inn and the subsequent movement though an English landscape, employed the technique more creatively, a technique he may have learned from Boccaccio, although there is no firm evidence that he had read the *Decameron* itself.[11] No longer a mere receptacle into which the stories could be conveniently deposited with little attention to their

order or content, here the framing element determines to some extent both the subject-matter of the tales and their sequence. The individualized portraits of the variegated travellers—the account of their profession, class, and personal idio-syncrasies—evoke from the reader an amused interest in the appropriateness or, occasionally, the inappropriateness of the traveller's choice of theme, the match-ing of pilgrim and tale affecting also the style of its narration in accordance with the educational background and social standing of the narrator. The story of Pa-lamon and Arcite, set in an ancient Athens remote from fourteenth-century England, takes on an added appositeness and grace when related by a Knight freshly returned from the Crusades, himself a worthy representative of the con-temporary version of the same chivalric code. At times, the setting of the tales is used to determine even the order of narration as the Reeve's anger at the Miller's slighting of his trade leads him to insist on immediately rebutting it with a story of his own; and it has, of course, been argued that the grouping of the tales around the theme of marriage marks a sequence of attempts by the various pil-grims to correct the impression created by the previous narrator.[12] Here, the anecdotes remain essentially independent entities, and in that respect the struc-tural integration is as yet embryonic; but as in the Memlinc painting the overall setting, the realistic depiction by the painter of the contemporary country-town-ship in which the holy scenes are placed or the localized description provided by the poet of the setting-out from Southwark, lend an immediacy to the narration of distant events, as well as a sense of aesthetic unity to the otherwise disparate tales.

In drama, too, the transition from the medieval presentation of events *in vacuo*, suspended as it were in some sacred eternity, to their embedding within a palpable reality, often employed at this time a similar framing device, in order to locate the historically remote scene within a more familiar and contemporary environment. The earlier morality play, however lively its scenes of carousal be-fore the reckoning must be paid by Mankind or Everyman, had remained di-vorced from the phenomenal world of its audience. The spiritual lessons it im-parted might be highly relevant to the individual watching the play, but the allegorical personification of abstract ideas employed as the vehicle for convey-ing those lessons removed the scenes to the sphere of fantasy. Its successor, the

dramatic interlude, arising within the halls of noble houses as an entertainment between courses at a banquet, might have been expected, both by its secular nature and by its freedom from direct ecclesiastical control, to have given readier expression to the everyday world of its writers, actors, and audiences. Yet in one major respect, it remained firmly linked to that concern with abstract notions and universally conceived truths; for it originated, its themes suggest, as a dramatization of the debates commonly held at the high table. Castiglione had recorded for Urbino the practice of discussing at that cultivated court such lofty themes as the nature of beauty or love, or the advantages of one art medium over another, and through Sir Thomas More we know of a similar humanist custom in the distinguished English home of John Morton, later Archbishop of Canterbury and Lord Chancellor, where More served as a page. Accordingly, the earliest English interludes, appearing mainly from within the Morton household and circle, took as their topics such moral debates, with, for example, Henry Medwall's *Fulgens and Lucrece*, first performed in 1497, arguing the merits of Inherited Wealth versus Studious Poverty. While the theme was here innovatively transferred from allegorical form to a social setting, and the two diverse concepts were respectively embodied in the patrician Publius Cornelius and the plebeian Gaius Glaminius as two young suitors between whom a noble Roman lady Lucrece must choose, the placing of that choice in ancient Rome to preserve the elevated associations of humanist debate effectively removed it from the day-to-day world of the audience. Yet with that comic realism which made England in some respects closer to the Northern than the Italian Renaissance, the noble universality of the central theme is placed within a realistic outer framework which, like the settings of Chaucer and Memlinc, localizes the ancient or legendary tales in the present. Here that anchoring is perhaps more obtrusive, for it seems deliberately to flout the rules of dramatic illusion by repeatedly interrupting the Roman tale in order to remind the audience of the local setting for the performance and the immediate festive occasion for which it has been commissioned. The two anonymous servants, designated only as A and B, who amusingly break through the dividing-line between audience and stage, at one moment incongruously ask a spectator to open a hall door for an actor's entry, at another,

request the audience's assistance in finding a missing letter essential to the plot, and then halt the dramatic action to assure the hungry-looking diners that there will soon be an interval for them to be served the next course.

The introduction of this stage device into any single play might have been no more than the humorous invention of an individual author. But its appearance as a staple ingredient of these interludes suggests that it was fulfilling some requirement more germane to the period. In *Hickscorner, The Nature of the Four Elements*, and *The Interlude of Youth* among others, the actors repeatedly disrupt dramatic illusion, turning to the audience to comment amusingly or in pretended need of advice—"How say you, lords, shall I smite?"[13] This shared technique betrays a certain discomfort with the principle of fiction as such, at a period when verisimilitude in art, the pressure to achieve optical accuracy and perspective, was changing the format of drama too. Such comedy as A and B supply in their purposeful disruption of dramatic illusion may be seen as a device for overcoming the reservations of a new generation more responsive to the authenticity of the temporal and no longer content with the Middle Ages' exclusive validation of the afterlife. In both the mystery and morality plays, before such sensitivity arose, the audience had been in a very real sense participants in the eternal drama being enacted before them, a drama which they were living out in their daily lives as Christians called upon to choose by their faith and deeds between eternal salvation and damnation. Bethlehem and Calvary were to be ever-present even outside the confines of the stage, and in the Towneley *Resurrection*, as in so many other plays in this genre, Christ's solemn speech to those about him upon the stage supposedly witnessing the original Resurrection is addressed no less to the audience beyond, calling across the centuries to those witnessing the reenactment in play form:

JESUS: Earthly man, that I have wrought,
 Lightly awake and sleep thou nought!
 With bitter bale I have thee bought
 To make thee free;
 Into this dungeon deep I sought
 And all for love of thee.[14]

207

Everyman and Mankind, too, had been more than abstract ideas translated into human form. Despite their remoteness from reality, at a moral level they had served as projections of each member of the audience into the allegorical setting of the psychomachia, and were therefore intimately related to his or her immediate fears, hopes, and faith. In contrast, the new *mise en scène* for drama—the forum of ancient Rome, the forest of Athens on midsummer night, or the battlefields of early English history conjured up for the spectator by the Tudor playwright—depicted imaginary regions; and whatever they might offer applicable to his own life, such non-Christian scenes were for the spectator acknowledged illusions.[15] The deepened concern in this period over Plato's repudiation of fiction as being a mere reflection of a shadow reveals how troublesome to the thinking of reader and audience the element of falsehood in literature and drama had suddenly become. It was not by chance that the Puritans in their frequent attacks upon the stage at this time emphasized the deception implicit in acting, often pointing triumphantly for corroboration to the Greek term *hypocrites* for an actor, knowing that thereby they touched upon a sensitive nerve in the Elizabethan conscience:

> a just man cannot endure hypocrisy; but all the acts of Players is dissimulation, and the proper name of Player . . . is *hypocrite*: a true dealing man cannot endure deceit, but Players get their living by craft and cozenage.[16]

This sensitivity to the falsehood implicit in acting marks, perhaps, a more fundamental reversal of outlook than we have generally acknowledged, a readjustment of both visual and intellectual perceptions. The medieval actor had, we know, experienced doubts over the possible impropriety of daring to play the role of God or of other sacred figures upon the stage. He saw himself as a transient mortal who might thereby defile by his fleshly ephemerality the divine truth of the scene he presented. In the eleventh-century Shepherd Play from Rouen, for example, while all minor roles were played by men and boys, the Virgin Mary was represented by a constructed image; and Gerhoh of Reichersberg, displaying a similar fear of sacrilege in the following century, solemnly warned any monk who played the part of Herod or Antichrist in the mystery plays that, in taunting or scorning Jesus, he himself became guilty at that mo-

ment of the very evils he was portraying.[17] The dramatic action, therefore, was seen in that earlier period as the eternal truth, the authentic reality beside which the player and audience were evanescent. Now in the Tudor era, the opposite view has come to prevail—the staged action has become the entertaining vanity or illusion, and the haptic world of the actor and audience the true referent by which the drama must be either justified or condemned. Sir Philip Sidney, in attempting as an enlightened Puritan to answer the more general Puritan charge, is unable to deny that poetry, with drama included, does create "another nature" not conformable to reality. To defend such fantasy he must fall back for justification on the moral purpose of the dramatist and poet, the virtue which the illusion is intended to teach.[18]

Such reservations on the part of this more empirically oriented audience concerning the "vanity" of drama, whether consciously acknowledged or not, needed to be allayed, and it would seem that in this play, as in so many others from this time such as *Hickscorner* and *The Interlude of Youth*, the frank reminders in the midst of the action that their spectators were really seated not in a Roman villa but in a Tudor banqueting hall was intended to be disarming in effect, releasing during the moment of laughter their subdued hesitations at entering the world of fiction, and thereby freeing them for a more ready surrender to the illusion of the noble scene within. The choric servants A and B, commenting upon the action of the play, since they were themselves fictional creations, might on logical grounds be thought ineligible for the task; but by coming from the more realistic outer framing, they function like Chaucer's pilgrim narrator as intermediaries between the concrete world of palpable truth and the more remote fictional world of the inner tale, thereby lending credibility to the narrative within, as well as providing a needed interrelationship and momentum to the individual scenes.

The Renaissance need to reinforce the spectator's sense of security in the tactile world before imaginatively seducing him into the realm of illusion may be seen exemplified with extraordinary aptness in the Stanza di Elidoro in the Vatican, where Raphael worked from 1511 to 1514. He introduced there a fresco, *The Deliverance of St. Peter (fig. 57)*, depicting the incident when the saint dreams of an angel descending in dazzling splendour to release him from his im-

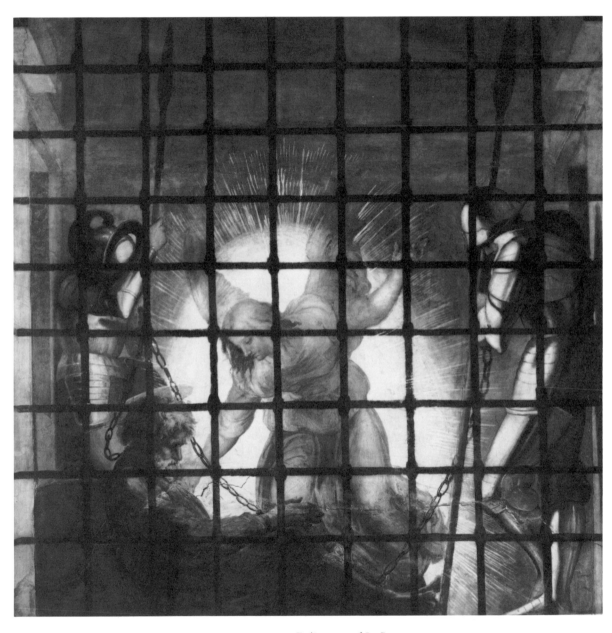

57. RAPHAEL, *Deliverance of St. Peter*

prisonment and then wakens to find that the dream has come true. The innovation of the painting, and clearly a primary reason for its powerful impact, lies in the heavy, black grille interposed between the viewer and the transcendental vision, the iron bars confirming by their solid impregnability the palpable world of the spectator and of the earthly prison in which the saint sleeps. Only after that confirmation of the physical setting are we permitted as it were, to gaze through the bars into the contrasting brilliance of the miraculous scene beyond. One has only to imagine that fresco with the grille removed to perceive the resultant weakening of its effect. Like the soldiers in the opening scene of *Hamlet*, prosaically stamping their feet in the bitter cold as they await the relief of their watch, the grille provides the reassuring solidity of the everyday and the familiar as a stepping-stone for a meeting with the more remotely fictional or supernatural.

However, in the same way as Raphael's masterly control of that technique could not have been achieved without those gradual transitional changes in perspective discernible in the panels of Ghiberti and the canvases of Memlinc, so in the drama and, indeed, in Shakespeare's own development as a dramatist, the easy control of imaginative stage techniques exemplified in the maturer plays was not reached without earlier doubts, experimentation, and even, at times artistic exasperation. The opening chorus of *Henry V*, the apology for the poverty of the Elizabethan stage, has long been seen as a classic formulation of the constrictions inherent in the dramatist's craft, constrictions less operative in other media, as the prologue acknowledges the sheer impossibility of presenting credibly within the physical confines of a narrow stage the spaciousness and multiformity of the fields of Agincourt and the historic battle fought upon them:

> But pardon, gentles all,
> The flat unraised spirit that hath dar'd
> On this unworthy scaffold to bring forth
> So great an object: can this cockpit hold
> The vasty fields of France? or may we cram
> Within this wooden O the very casques
> That did affright the air at Agincourt?

With regard to visual perspective, the medium of painting would indeed seem to possess a major advantage, because of the ability of the human eye to adjust to diminished proportions and to compensate optically for the most drastic reductions in size. The artist is thus at liberty to depict convincingly upon his canvas a broad landscape stretching to the distant horizon (the "vasty fields of France"), a massed cavalry charge with all the turmoil of its innumerable participants or, indeed, such a scene of naval might as the Chorus of *Henry V* must soon, through the inadequacies of his own dramatic calling, beg the audience before Act 3 to conjure up in its mind's eye, urging it to play with its fancies and thereby to behold

> the threaden sails
> Borne with the invisible and creeping wind
> Draw the huge bottoms through the furrow'd seas
> Breasting the lofty surge. O, do but think
> You stand upon the rivage and behold
> A city on the inconstant billows dancing;
> For so appears this fleet majestical.

Even beyond such verisimilitude, the painter may, like Hieronymus Bosch or Salvador Dali, portray the fantastic chimeras of his imagination unfettered by considerations of gravity and space, while the dramatist is constrained not only by the physical dimensions of his stage but even by the anatomical proportions of his actors, who, even if they represent spirits and fairies, must still retain their human size and move corporeally across the defined actuality of a rigid platform stage.

Yet the history of the theatre should remind us how unfounded such an assumption really is; that the Chorus's plea for audience cooperation, so far from being a universally valid animadversion on the restraints operating in all stage presentations, catches rather the dramatist's mood of inhibition at a specific and unusual moment in theatrical history. On the Attic stage, such frustration on the part of the dramatist would have seemed totally irrelevant. The raised buskins worn by the tragic actors to elevate them above mortal height, the megaphones concealed within their masks to add an inhuman, booming resonance to the

voice, the fixed expressions borne by the masks themselves, and the artificial *stichomythia* adopted for the dialogue provide ample evidence that naturalism formed little part of the tragedian's purpose in designing such ritualized performances. All art aims at creatively overcoming the limitations of its medium to produce its illusory effects, even though the spectator remains aware at one level of consciousness that he is witnessing art and not reality. The most startlingly realistic painting, as we are called upon to recognize while gazing on it, is still ultimately a framed, two-dimensional canvas masquerading as a window; a "breathing" statue makes no attempt to conceal the texture of its cold marble; and in the theatre such long-established conventions as the "aside," audible to the audience yet supposedly unheard by an actor two feet away, have in many periods proved invaluable for satiric or comic effect.

The Chorus's attempt, therefore, to propitiate the audience, to beg its indulgence for the inability of the play to match the battlefields in size or the serried hosts in number is less significant for its universal application to drama (where no apology is required) than as marking a turning-point in Shakespeare's own art. It catches him at that transient moment in his career when the pressures for visual authenticity upon the stage, for a naturalist perspective relying upon chronological and spatial rationality have, as in contemporary painting, reached their sharpest intensity. Only shortly before, in Bottom's fellow characters Moonshine and Wall, the latter solemnly holding out his fingers to provide the chink through which the lovers speak, Shakespeare had himself ridiculed the inapplicability of antiquated symbolism to the new stage. The iconography of medieval art and drama had been needed as a means of concretizing and hence of apprehending the abstract verities of the spiritual life. A lily in an Annunciation painting conveys in visible form the chastity of the Virgin, a personification of Envy on the stage depicts that insubstantial emotion in human shape. But as, in Shakespeare's age, the validity of truth was passing from the eternal to the temporal and tangible sphere, the principles of symbolic representation became superfluous and outmoded, and any insistence upon their continuation absurd. The physical wall separating the lovers requires no allegorical characters to "signify" it, nor is there need, as Quince more aptly puts it with echoes of medieval *figura*, for them "to disfigure or to present the person of Moonshine."

As so often in comedy, beneath the hilarity and burlesque can be perceived a more serious concern, a vexatious problem besetting the dramatist in this transitional period. The simple artisans led by Quince, blandly unaware of contemporary changes in theatrical sensibility, assume that the authenticity of the medieval stage has been passed on to their drama too, that their lion will terrify the ladies as the sombre devils of the mystery plays had genuinely terrified a medieval audience, that the death of Pyramus will horrify as had the solemn reenactment of the Crucifixion. They have failed to recognize that the sense of awe which a medieval audience brought to the mystery play as a representation of solemn historical truth no longer applied, and that an Elizabethan audience would need to be actively seduced by the dramatist's art into the acceptance of an illusion. Hence the comic absurdity of Bottom's solution—that they compose a prologue assuring the audience that all is mere pretence and thereby destroying all hope of dramatic illusion:

> BOTTOM: I have a device to make all well. Write me a prologue, and let the prologue seem to say we will do no harm with our swords, and that Pyramus is not killed indeed; and for the more better assurance, tell them that I, Pyramus, am not Pyramus, but Bottom the weaver.
>
> (*MND* 3.1.15-21)

The plea at the opening of *Henry V* should be seen, therefore, as being the serious complement to Bottom's comic prologue, the recognition of that urgent need dramatically to persuade. Validity here is accorded unquestionably to the historical event which took place at Agincourt nearly two hundred years before. The staged version is an acknowledged fiction; and the audience is therefore urged to make the imaginative effort of accepting the fiction despite the visible contradictions. As in the earlier interludes (although now more earnestly), the spectator's attention is directed to the drab physical environment in which scenes of great moment must somehow be persuasively recaptured. On the one hand, Shakespeare is no doubt expressing here, in an age more rooted in the palpable actualities of earthly existence, a genuine sense of frustration at the enormity of the gap to be bridged between the imaginary and the real. Yet on the other hand, the plea to the members of the audience for their assistance in piec-

ing out the play's imperfections with their thoughts, in *supposing* when they see one soldier that they see a thousand, is at the same time a vindication of the imaginative process itself and, even more, of the enchanting power of poetry. The apology is ultimately no more than an artistic ploy—a sop, if you will, to the Cerberus of the rational mind guarding the intellect against deception. Such a plea foreshadows Coleridge's assertion, intended to allay the rational resistance of a later generation, that poetry demands the willing suspension of disbelief. There too it was a ploy, for it is never the reader who consciously suspends his disbelief, but the poet who must actively seduce him from it.[19] The only effective means at the poet's command, as illustrated in this very speech of Shakespeare's, is, after lulling the audience's latent suspicions of fiction, to excite its imagination by the force of figurative language and the vividness of the vision he conjures up, and thus to validate that fiction as ultimately truer than prosaic reality. Hence, after wearily acknowledging the mundane setting, the Chorus (drawing his evidence from that very world of empirical factuality which he must resist—the mathematical symbol which can in "little place" attest a million) allows his speech to rise imperceptibly from flat, pedestrian tones to a stirring eloquence, firing the imagination with the verbal splendour of "two mighty monarchies," exhilarating the mind and reducing to irrelevance the visual poverty of the wooden stage. The narrow girdle of the playhouse walls becomes imaginatively expanded, able to contain, after all, those kingdoms and princes which only a few moments before he had despaired of introducing:

> O pardon! since a crooked figure may
> Attest in little place a million;
> And let us, ciphers to this great acompt,
> On your imaginary forces work.
> Suppose within the girdle of these walls
> Are now confin'd two mighty monarchies,
> Whose high upreared and abutting fronts
> The perilous narrow ocean parts asunder.

In this dual perspective, such emphasis upon the drab foreground of the scene in which the audience is settled is calculated to make the imaginary background

setting open up into an expansive vista, stretching far beyond its actual dimen-
sions in both space and time.[20]

How close in practice the theatre of this time was to the metaphor I have just
used is indicated not so much in the Elizabethan playhouse, which remained
conservative in its setting until it needed to compete with court masques, but
rather on the Italian stage. The discovery in 1486 of Vitruvius's architectural
treatise, of which Book X dealt with the theatre, had revealed the forgotten fact
that the ancient Greek stage had used backdrops or flat scenery. Initially the ef-
fect of that discovery was to encourage on the Renaissance stage a similar use of
fixed scenes representing housefronts or street scenes, against which plays could
be performed—a tradition later incorporated into the Elizabethan playhouse.
Before long, however, as Baldassare Peruzzi, Raffael San Gallo, and eventually
Sebastiano Serlio took the hint much further, the newly developed techniques of
illusionist perspective created beyond the solidity of the foreground and within
the narrow space available behind the platform stage, the impression of sweep-
ing vistas culminating in some remote prospect, and carrying the eye away from
that foreground into the far distance.[21]

The most impressive instance, fortunately still preserved for us to see, was
in the Teatro Olimpico in Vicenza. There, behind each of the three openings left
in the solid stone setting erected by Palladio, but with particular effectiveness in
the central arched opening, Scammozzi introduced in 1585 a sharply raked floor,
rising so steeply as to make it difficult for any but an experienced actor to walk
upon. On either side of that slope (*fig. 58*), the *trompe l'oeil* of slanting orthog-
onals makes the tall buildings of the street appear to recede not only into the dis-
tance but as far as the horizon; and the contrast between the heavy monumen-
tality of the marble *frons scaenae* and the vision of unlimited space beyond, of
which the openings offer a glimpse, increases the effect of grandeur and ampli-
tude.

There can be no doubt, after the detailed research of Stephen Orgel, Roy
Strong, and others, that the major impact of this illusionist perspective upon the
English stage was felt in the royal masques when, under James I, the court the-
atre became a generously subsidized tool for monarchal adulation.[22] The pur-
pose was there magnificent spectacle, a ravishing of the senses, a gasp of wonder

at the gorgeous visual effects produced by the complex machinery offstage. A copy of Serlio's *The First Booke of Architecture*, translated by Robert Peake in 1611, was one of the most heavily annotated books in Inigo Jones's collection, attesting to his indebtedness. On the other hand, our knowledge of that later impact should not, by hindsight, be allowed to distort our understanding of the earlier intervening phase, the period between the rediscovery of Vitruvius and the masques themselves; and the caution applies to Italy no less than England. The dazzling spectacles for which Italy became famous were not contemporary with Serlio's work of 1545 but many decades subsequent to its appearance. The fashion of elaborate *intermezzi* in fact eventually made obsolete the fixed stage setting which he had advocated. The optical feast provided for Girolamo Bargagli's play *La Pellegrina*, which has been described as one of the great landmarks in theatrical history,[23] took place at the Uffizi Palace later in the century in 1589, and it served as the model for the equally famous masque festivities celebrating the marriage of Cosimo de Medici to the Archduchess of Austria at Florence in 1608, when Inigo Jones and Ben Jonson were already well advanced in their careers as designers of masques, their first collaboration having been on *The Masque of Blackness* in 1605.

I have stressed the dates here in order to focus upon that important but often neglected period between the appearance of Serlio's work and the full flowering of the masques, a period in which the more sober ideas of both Vitruvius and Serlio helped encourage a visual enlargement and enhancement of the stage as a background setting for traditional plays, rather than the relegation of drama to being an appendage for musical and visual extravaganzas. Serlio, it is true, does mention "wonderful" devices such as a rising moon and a sixteenth-century version of the *deus ex machina*, but his main concern is for an architectural perspective which "gives us in a little space a view of superb palaces, vast temples, and houses of all kinds, and, both near and far, spacious squares surrounded by various ornate buildings." His detailed suggestions for a fixed setting to be used for tragedies places its main emphasis on the need for representations of stately homes, since the violent deaths of heroes normally occur within the palaces of lords, dukes, or kings. That this more limited purpose held true for England too at this time is suggested by John Dee's comment in 1570, in advocating the new

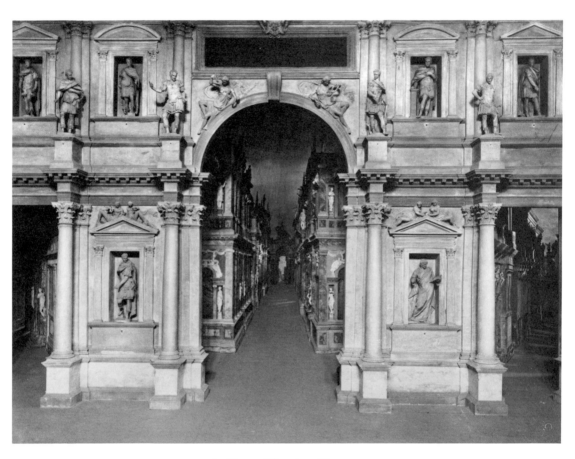

58. Teatro Olimpico, Vicenza

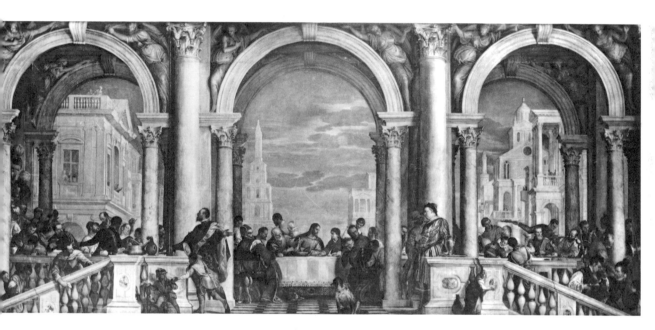

59. VERONESE, *The Feast in the House of Levi*

illusionism, that by means of such perspective "we may use our eyes, and the light, with greater pleasure, and perfecter judgement."[24]

An idea of the effect achieved upon the stage in the period prior to the masques is perhaps best provided by that most theatrical of contemporary painters, Paolo Veronese, who in 1573 employed a setting remarkably similar to that of the Teatro Olimpico, even though the latter had not yet been erected. It may represent some theatrical setting which the artist had seen earlier elsewhere or may simply represent his parallel response to the heroic dimensions now required for human activity and to which Serlio was giving expression in the theatre. His canvas *The Feast in the House of Levi* (*fig. 59*), on which he had taken his stand against religious censorship, depicts three scenic openings behind a wide but relatively shallow stage. The impressive banquet scene, filled with numerous figures in movement, often caught in dramatic poses, occupies the entire foreground of this broad eighteen-foot-wide canvas. The feast itself possesses a theatrical rather than a religious character (as the Inquisition obviously sensed), not least because the banquet is skilfully placed above eye-level, as though upon a raised stage, the effect of elevation being reinforced by the two balustraded stairways on either side. The human participants, in contrast to earlier traditions in painting, here occupy less than one third of the canvas's height, the three massive arches and columns towering over the scene, with each arch, such as Scamozzi was to introduce to the Teatro Olimpico, offering a view beyond into spacious streets, nobly proportioned structures, and open skies. Significantly, there is no impression that the banqueters are dwarfed by such monumentality. On the contrary, the architectural splendours are of recognizably human design and execution, constituting extensions of human activity and thereby intended to serve the needs of such splendid feasts; and the convergence of the floor-lines on the central group of diners leaves no doubt of the focus towards which the viewer's attention is directed.[25] The overall effect is thus a sense of man's expanded power, the magnificence, wealth, and splendour which now lie within his control, and the broad areas of the world beyond, into which such control can be further extended.

The revolution which Marlowe effected in the English playhouse of this time partakes, it would seem, of the same imaginative extrapolation of perspective

beyond the physical confines of the stage. In 1587, with all the brash confidence of a young graduate fresh from the university, he scorned in his first dramatic prologue the "jigging veins" of previous English plays, promising to present instead a Scythian Tamburlaine "Threatening the world with high astounding terms, / And scourging kingdoms with his conquering sword." The "mighty line" for which he soon became famed, already reverberating within this prologue, was the poetic vehicle he needed to forge in order to enlarge his dramatic themes beyond the civilized debates of the interludes and their generally pusillanimous dramatic progeny. One need only place beside *Tamburlaine the Great* a play such as *Gorboduc: or Ferrex and Porrex*, selected by Sidney only shortly before the former's appearance as the most distinguished of English plays to date, in order to perceive the nature of the change, and the new amplitude of vision which had entered the arts. *Gorboduc,* in relatively prosaic terms, discusses the moral question of a king's division of his realm between two sons, translating that discussion into practice by demonstrating the ensuing disturbance as military skirmishes take place between the neighbouring rivals. Both the language and the scenes evoked are rational, restrained, and modestly proportioned:

> PORREX: Shall I give leisure by my fond delays
> To Ferrex to oppress me all unware?
> I will not, but I will invade his realm
> And seek the traitor prince within his court.
> Mischief for mischief is a due reward.[26]

In contrast, the range of Marlowe's heroic drama continually suggests that there exists beyond the scene visible upon the stage a further world of opulence, of unimaginable variety, and of inconceivable scope which, for all its magnitude, seems yet too restricted for the insatiable ambition and energy of the protagonist. The tempting offer Tamburlaine makes to win over an enemy general to his side titillates the minds of the audience too with its vision of glorious and infinite conquests yet to come:

> TAMBURLAINE: Besides thy share of this Egyptian prize,
> Those thousand horse shall sweat with martial spoil
> Of conquered kingdoms and of cities sacked;

Both we will walk upon the lofty cliffs,
And Christian merchants that with Russian stems
Plough up huge furrows in the Caspian sea,
Shall vail to us, as lords of all the lake.
Both we will reign as consuls of the earth,
And mighty kings shall be our senators.
Jove sometimes masked in a shepherd's weed,
And by those steps that he hath scaled the Heavens
May we become immortal like the gods.[27]

The diction of the play has become dynamic with, as Harry Levin has pointed out, a frequent use in the play of energizing participles in place of static epithets—"mounting" substituted for "high," and "fainting" for "low."[28] That stylistic form adds force to the play's own thrust against the spatial limitations both of the stage and, by extension, of this world, forcing its way through to the enlarged cosmos which man now seems to enter as an active and determining participant. For an Elizabethan audience, educated to a belief in the divine hierarchy as a settled institution and trained from Seneca's works in the dangers of human *hybris*, such vaunting confidence and daring challenges to the gods as Tamburlaine utters at the end of the above quotation must have sent shivers of premonition down their spines in expectation of his dread fall; yet in this play (written originally as an independent drama to which the sequel was only added later in order to capitalize on its success) there is no hint of retribution, divine or otherwise. Tamburlaine in all his rising splendour achieves his supreme love and his far-reaching empire impervious to the ominous threats of his enemies. If in such later plays as *Dr Faustus* and *The Jew of Malta* Marlowe appears more hesitant, tempering the fascination which power and wealth exert by acknowledging the price which must eventually be paid in an ordered universe, here in his first drama his authentication of the widened sphere of human activity, of the attractive vistas reaching far beyond the foreground of the stage, is exuberant and uninhibited.[29]

The placing of the figures on Veronese's large canvas has further implications for innovations on the contemporary English stage. Some years ago, Madeleine Doran's *Endeavors of Art* examined in detail the development of Elizabethan dra-

matic structure in the light of Heinrich Wölfflin's artistic theory of "style," the belief that Renaissance art, as opposed to the baroque mode of Rubens and Rembrandt, had aimed at a "multiple unity."[30] Where in later decades baroque art, he argued, generally subordinated all parts of the canvas to its major figures to leave no doubt of the focus of attention, on a Renaissance canvas the separate elements or figures are accorded comparative equality in material value, being treated as independent units or free members. Their coordination into an articulated whole was achieved by a carefully organized recessional perspective which, despite the material equality of its various parts, ultimately gave prominence to the most significant or crucial element of the event depicted. Such artists as Leonardo, Raphael, and Holbein had seen objects, he suggested, in a linear or tactile way, employing clarity of outline, while the baroque school he described as "painterly," using colour and light to emphasize certain parts of the canvas at the expense of others.

Wölfflin's distinctions, stimulating as they were at the time of their publication, have since been challenged as less efficacious than they had initially appeared. It is, for example, difficult to see how the terms "linear" or "clarity of outline" can be justifiably applied to the deliberately misty effect of Leonardo's most famous paintings. On the other hand, there was an undoubted truth in Wölfflin's recognition of the unified diversity in Renaissance art, its ability to draw the independent elements of a scene into an organized pattern instead of, as in later painting, subjecting everything in the scene to some dominant swirling movement or chiaroscuro contrast between light and shade. Strangely, however, Miss Doran in her otherwise illuminating application of this theory to the Renaissance English stage, restricts the insights it offers. She applies the theory only to the main plots of Elizabethan drama, examining the structural order of their development, the sense of propriety they convey, the mirroring of nature, and the indebtedness of all these varied elements to classical and Renaissance dramatic theory. What she leaves aside is, I believe, one of the most interesting aspects of such "multiple unity," the developing orchestration of main plot and subplot during the sixteenth century, which would seem to be of primary relevance to this patterning of main and subordinate elements in Renaissance painting.

Throughout English drama of the sixteenth century the tendency to mingle serious scenes with comic, had for the most part followed the tradition of the mystery and morality plays, particularly in their later phase. There the minor devils or Vices had provided scenes of knockabout farce, either to intensify by contrast the solemnity of the main message or as a simple catering to the tastes of a popular audience, whose shorter attention span needed at times to be re-stimulated. In subsequent secular drama, such comic scenes often had little connexion with the main plot. As David Bevington has demonstrated, they seem frequently to have been devised less for their content or their relationship to the subject-matter of the larger play than with an eye to the requirements of a cast limited in number which needed to double up parts and hence to make swift costume changes between scenes.[31] Since each actor would no doubt be soon recognized by the audience in his alternate role, such doubling would at the very least have suggested some equations or contrasts between main plot and subplot roles, and the result can be seen in a biblical interlude such as the anonymous *King Darius* (ca. 1565) which, as the casting instructions inform us, "six persons may easily play." The allegorical figures in the intermediate scenes—including Charity, Importunity and Constancy—roughly correspond in the virtue or villainy they personify to the leading traits of the characters in the main play, as the epilogue confirms retrospectively:

> Zerubabel by name,
> Did remain in Constancy, and keep the same.

However, that articulated unity of parts which Wölfflin identified as a Renaissance quality has by no means been achieved in this play, where the contact between main plot and subplot is merely tangential. One rare and early instance pointing towards the more accomplished dramatic integration of later years is again to be found in that remarkably innovative interlude *Fulgens and Lucrece*, perhaps because it arose not as popular drama but from within the more sophisticated circle of Morton and More, sensitive to the new winds blowing across from the continent. In that playlet, A and B, initially, as we have seen, standing outside the main interlude as "choric" spectators commenting upon it, not only step at times across the dividing-line separating actor from audience but also

cross the invisible boundary on the opposite side, separating them as contemporary characters from the inner play set in ancient Rome. B's insistence that he wishes to participate in the Roman plot leads them to join Cornelius and Gaius as their servants and, once within, they inaugurate a humorous subplot for that internal play which could have constituted an interlude in its own right—their rivalry for the hand of Lucrece's maidservant. Commanded by that pert wench to undergo a series of comic trials in singing, wrestling, and jousting in order to determine which of the two should prove worthy of her choice, they are each laughingly rewarded by her at last with a clout on the head as she informs them that she has long been promised to another. In accordance with Renaissance tradition, no overt connexion is made, but the echoing of the main plot—Lucrece's need to choose between her suitors on the basis of their moral qualities—in the low-life slapstick in the kitchen suggests the kind of dramatic correlation or multiple unity which in more sophisticated form was to distinguish English drama in its High Renaissance phase.

The combination of an aristocratic main plot with a low-life comic subplot was long to be retained on the English stage, arising at this time no doubt as a reflection of widening social distinctions not yet apparent in Chaucer's day. It has been remarked by historians how little difference there had been in the late medieval period between the furnishing in a nobleman's home and that in a poorer homestead, both offering only the barest provision, with a simple wooden table and stools generally sufficing for both households.[32] The expansion of trade in sixteenth-century Europe and the swift advance in the wealth of the upper classes, by encouraging the cultivation of more polished manners and more elaborate settings for such activity had, by widening the social gap, made the clumsy peasant now seem to belong to another world, an object of amusement. It has, for example, been a cause for some surprise to scholars that the lively comedy *Gammer Gurton's Needle*, which captures with such realistic humour the thick rural dialect of the peasants, the pride of the mud-covered labourer Hodge that the village milkmaid smiled upon him last Sunday after church, and the villagers' search for a lost needle to repair his torn breeches in time for his next Sunday meeting, was composed by a Master of Arts at Cambridge.[33] Yet the same holds true, we should recall, for the no less vivid paint-

ings from precisely the same time by Pieter Brueghel the Elder, known as "the peasant Brueghel" for his creation of such lively canvases as *A Village Wedding* (1565) or *A Peasant Dance* (1566) conveying the uncouth but harmless antics of the lower class at work and at play. His nickname, indeed, is a misnomer derived from his paintings. Like the author of *Gammer Gurton's Needle*, he was a person of education and culture, who numbered leading humanists among his friends. For him the boorish peasants were to be viewed with the sympathy one extends to children, and the depictions of Hodge's pride on the stage finds its counter-part within his paintings in the satisfied smirk on the face of the village bride, seated for the first and no doubt the last time in her life at the centre of public attention. It is essentially the same mood of humorous condescension as later contrasts the clownish love-making of Touchstone and Audrey with the deli-cacy and wit of the courtly lovers in that play.

Perhaps the first fully developed exemplar of such structural integration in England was Thomas Lodge's prose romance *Rosalind* of 1590, containing a complex plot so perfectly designed in its dramatic development as to be adopted almost unchanged for Shakespeare's stage version *As You Like It*. The variegated strands, apparently diverse, are interwoven to form a rich, closely knit tapestry. There is the expulsion of the rightful duke by a usurper, a humble shepherd's devotion to the scornful shepherdess Phoebe, two brothers in rivalry for an in-heritance, the delightful "wooing" of the disguised Rosalind by her unsuspect-ing lover, and the reformed brother's ardour for her "low-born" friend. Yet de-spite their diversity, so intricately are they connected that at one stroke—the dénouement when Rosalind finally doffs her male disguise—all difficulties are immediately resolved; and on the restoration of the duke to his previous emi-nence, the three marriages can be celebrated at court without further delay. Quite apart from the artistic unity these multiple plots achieved, the alternation of themes implicit in such interweaving offered, in addition to the broadened range, new opportunities for creating dramatic suspense. One theme could now be interrupted at a climactic moment, and the audience's tension increased as it must wait for the duration of a further scene or two before the topic is taken up again.

This interest in multiform plot-lines was, as might be expected, reflected in

contemporary dramatic theory; but the existence of such changes in all the arts of the time casts, perhaps, a fresh light on the nature of the discussion. It suggests that the ferment of activity among theorists during the late sixteenth century, mainly in Italy but soon in England too, over Aristotle's requirement of unity of action in a play is once again more interesting for what Renaissance critics were trying to read *into* classical authority than for any supposed influence upon them. Aristotle's comment, by no means central to his thesis, that drama should consist of "one action and that a whole" became the new focus of interest, being interpreted by some in more general terms as a call for a multiplicity of dramatic action which yet retains an underlying cohesiveness and by others, notably Scaliger and Castelvetro, as part of a more rigid formula, restricting by implication the locale and the time span of the play as well. Minturno and Guarini belonging to the first group perceived that classical comedy, notably the plays of Terence, had employed double plots so skilfully intertwined that they in no sense violated the demand for unity, while even Castelvetro, who is usually associated with the stricter rules soon to be adopted by the French theatre, in fact came down strongly in favour of double plots, on the grounds that the best plays in the history of drama had generally adopted them.[34]

Whatever the specific conclusions of each theorist, what does emerge at this time is the shared conviction that a dramatic work must achieve artistic integrity, the same principle, indeed, as Alberti had formulated for painting and architecture and which had been taken up with such readiness by the subsequent generations of artists and builders until it became an unquestioned axiom of Renaissance art.[35] Shortly before Castelvetro's treatise *La Poetica di Aristotele vulgarizzata* was published in 1570, these principles laid down for architecture had reached their fulfilment in a building which was to become a model for all Europe. Palladio's Villa Capra, more popularly known as the Villa Rotonda, a country house completed just outside Vicenza in 1554, had merged perfectly two contrasting geometrical forms, the circle and the square, creating the stately symmetry of four classical porticoes projecting from the sides of a square building in which a round reception room is crowned by a circular dome. A graceful belvedere intended for entertaining guests rather than for use as a permanent home, it was, in addition to the originality of its own design, the first known

instance in western architecture of the blending of a building into the surrounding landscape, with the axes of the house continued into the spacious grounds to ensure from within enchanting vistas in all four directions. Its effect, above all, was of architectonic harmony, a proportioned integration of diverse parts which allowed each majestic portico a validity in its own right, while echoing and complementing its fellow members.

The adoption of Alberti's principles was in one respect less complicated for architecture than for the sister arts of painting and drama. For in both latter media, the attempt to attain an idealized harmony was hampered by a contrary desire, no less an accepted aesthetic principle of the age, to achieve a faithful mirroring of nature. The importance of the sphere in Neoplatonic thought as the only geometrical form which remains unchanged from whatever angle it is viewed reflected the search for an idealized perfection, and perfection is by definition the absence of any disturbing element. Such was the distinction of the Villa Rotonda; but painting could scarcely restrict itself to tranquil scenes of benevolent Madonnas when so much else beckoned the artist. The solution for scenes less serene in theme was to assign those contrary principles of harmony and verisimilitude to different aspects of the canvas. The individual figures could be faithfully depicted in their discordant moods or actions, often represented in fury or violence as isolated entities, on condition that the overall design, by an intricate system of counterpointing, achieved the calmness and harmony to which Renaissance art aspired. The system involved not only a subtle balancing of the figures, of their placing upon the canvas, of their bodily movements and even of their gestures—a balance so subtle that the spectator would not be conscious that art had been employed—but also a tonal discrimination, since lighter patches of colour were by then perceived to carry greater optical "weight" than more subdued hues.

Da Vinci's *Last Supper* (*fig. 60*), despite its poor state of preservation—the doorway cut into it in later years, and the fading of its colour—remains a consummate example of such sensitivity in design. In contrast to most earlier versions,[36] it depicts not the supper as such, the meeting of the disciples with Jesus to receive the sacramental bread and wine, but the dramatic moment at that supper when Jesus has just declared to the consternation of his disciples that one of

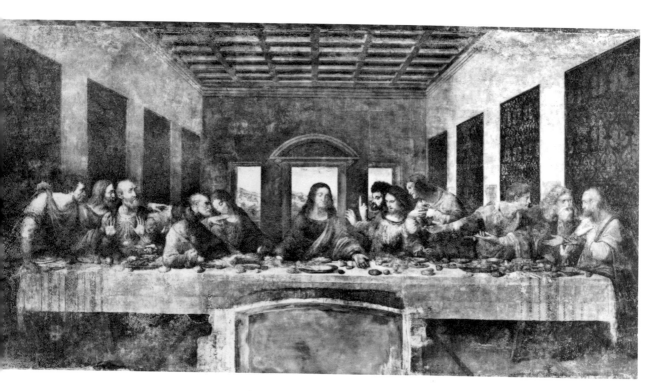

60. DA VINCI, *Last Supper*

them will betray him. In agitated movement, they have broken up into groups expressing shocked incomprehension, protestations of innocence, or urgent consultation, with only one shadowy figure, that of Judas himself, clutching his money bag in momentary isolation. The painting is charged with the emotional turbulence created by the unexpected pronouncement; and yet the final effect of the scene is to convey a profound sense of ordered serenity and spiritual reassurance. The calm dignity of Jesus centrally placed beneath an arch which acts as a symbolic halo does much to produce that emotional response, as does the deeply recessed perspective of the room. For the effect of that perspective is not simply to lend volumetric verisimilitude. The purpose of most such frescoes of the Last Supper commissioned for the refectories of monasteries was indeed to remind the monks during their meal of a sacred supper being, as it were, reenacted in an extension of their own hall and hence made as spatially realistic as possible. Here, however, the sharply angled perspective creates an impressive reverse movement, not of recession but rather of the radiating outward of a universal message of love from the central figure to mankind at large. Nevertheless, neither the centrality of Jesus nor the radiating perspective could have achieved its harmonious effect were it contradicted by the agitated motions of the disciples. Instead, their spiritual discomposure is here conveyed with a complex contrapuntal effect to create an overall balance of design while preserving the shocked response of each individual figure. The initial surprise at the announcement splits them, standing or sitting, into four equal groups of three, which are yet sufficiently varied in composition to preserve the impression of involuntary movement, the two outer clusters forming visual counterweights at either end to ensure a comprehensive stability. Similarly, within the right-hand group, the disciple's outstretched hands gesturing back towards Jesus compensate for the distracting direction of his gaze, while nearby, another figure recoiling in astonishment resists the potential imbalance of his two companions leaning forward. In both instances, as elsewhere in the fresco, such movement and countermovement produce a rhythmic harmony which, without reducing the impression of dramatic spontaneity among the participants, contributes to the predominant tranquillity, the sense of completeness achieved by the scene as a whole.

If the intricate design underlying Shakespeare's plays, a design which be-

comes increasingly subtle in its interlocking forms as he matures towards his major phase, has long been recognized, it has been seen rather as exemplifying Shakespeare's peculiar genius than as his masterly application to the Elizabethan stage of the new aesthetic principles motivating Renaissance art at large. The contrasts (obvious enough to the literary analyst but so smoothly integrated into the developing plot-line as often to elude conscious identification by the audience) between Hamlet's procrastination in avenging his murdered father and Laertes' unbridled impetuosity in a parallel role, or between Hamlet's assumed madness and Ophelia's only too genuine insanity, not only had no precedent on the English stage in their meticulously patterned structure but constituted an essentially new conception of theatre as an intricately worked art-form. The progression of *Tamburlaine* with all its variety and range is, in contrast, basically episodic, lacking the tight cohesiveness of such interrelated plotting; and *Dr. Faustus*, splendid as it is in its stirring speeches, is so poorly structured in its intervening section as to have suggested to most critics that certain of its scenes were the work of an uninspired collaborator. The central figure there fascinates us as embodying the spiritual conflict between medieval faith and the power which the knowledge within man's grasp was now offering; but an element sadly missing from that play is the presence of other *dramatis personae* whose contrasting traits could act as foils to the central character's strengths and weaknesses and thereby provide a depth of characterization to support and intensify the inner struggle, effectively articulated only in his opening and closing speeches. That highlighting by contrast is a quality which contributes incalculably to the plays of Marlowe's greater contemporary—the dour, pragmatic Bolingbroke pitted against a poetic and overly sensitive Richard, a fiery Hotspur compared to the truant Hal, a suspicious Cassius set beside the nobly credulous Brutus, where the contrasts are sufficiently delicate to convey in each figure a mingling of admirable and reprehensible traits which make them so intensely human in their appeal. The technique produces, moreover, a rhythmic counterpointing of figures, revealing a patterned substructure not unlike those geometrical designs which the Renaissance artist sketched out on his canvas to ensure the harmonious proportions of the finished work. There is also some evidence to suggest that in producing the plays for an Elizabethan audience, the

Lord Chamberlain's Men displayed a sensitivity to the visual effects of the dramatic groupings too. An illustration of a scene from *Titus Andronicus*, dating from 1595 and attributed to Henry Peacham, does show the figures carefully posed to create a complex balance evocative of the counterpointing aimed at by painters of the time. Titus' staff, held perpendicularly, acts there as an optical pivot for the standing and kneeling persons on either side. Although the placing of the figures here may be the work of the artist rather than the stage producer, it was in all likelihood based on the scene as he had witnessed it, and would therefore suggest some fruitful interplay between the media.[37]

Thematic interaction occurs, of course, not only within the main plot but often through the blending of two or more different stories in order to effect a universalising reinforcement of the main theme. The casket scenes from the *Gesta Romanorum* inserted into the tale from *Il Pecorone* provide obliquely, in their warning not to judge by externals, a symbolic enactment of the principal message of *The Merchant of Venice*, the contrast between the harsh outer letter of biblical text or contract and the merciful inner spirit.[38] So cunningly are the two merged that only the patient scholar, like the art-restorer with his X-ray equipment, can reveal the joins. Even more significant was the engrafting of the Gloster theme from Spenser's *Arcadia* on to the ancient tale of *King Leir* where, far beyond a shared theme of misused parental authority, their proximity and interconnexion within the play offer the opportunity for mutual enrichment, to create thereby a more profound exploration of the journey from spiritual blindness to moral perceptiveness.

The Renaissance demand for artistic cohesiveness is apparent no less in the functioning of the comic scenes within the tragedies, where the looser usage of earlier drama no longer suited the new sensibility. Thomas Preston's play of 1569, *A Lamentable Tragedy Mixed Full of Pleasant Mirth, Containing the Life of Cambises King of Persia*, is best remembered today for the ridicule directed at it by Shakespeare when the humble artisans offer for the refined tastes of Theseus and his court their own interlude incongruously entitled *The Most Lamentable Comedy and Most Cruel Death of Pyramus and Thisbe*.[39] Yet we should recall that Preston's play, a clumsy attempt to satisfy all tastes by combining history, tragedy, and morality with interspersed scenes of farce, seems to have succeeded in

its aim. The barbed allusion to it in 1596 would not have been caught by the audience were it not still being performed over twenty-five years after its initial presentation. As the ridicule suggests, however, the time for more tightly structured drama had arrived, and Shakespeare, in one of his rare comments on the nature of drama and its performance, leaves us in no doubt of his consciousness that a change needed to be implemented. Even without such later critical insights as De Quincey's, who perceived in the scene of the drunken Porter a brilliantly planned dramatic *volte-face*, a redirection of the audience's moral response from sympathy with Macbeth to sudden identification with the forces of order knocking for admittance at the now recognized gates of Hell, we would have known in any case from Hamlet's instructions to the players of the new centrality of the comic scenes as contributions to the advancement of the main plot. Shortly after the dismissal of William Kempe from the company of the Lord Chamberlain's Men (no doubt for the very offence of which Hamlet speaks) and his replacement by the more sensitive Robert Armin, Shakespeare has his prince solemnly warn the actors to let their clowns speak no more than is set down for them lest they set on some quantity of barren spectators to laugh, "though in the meantime some necessary question of the play be then to be considered."[40] The comic scenes, no longer mere entertainment or slapstick, have thus become organic to the play, often concealing within them some element necessary for its understanding or furtherance. It was a principle amply exemplified a little later in the same play as the gravedigger jests within Ophelia's grave of the time it takes for a body to decompose in the earth. Even the songs, as Shakespeare criticism has long been aware, belong intrinsically to each specific play, fortifying or sensitizing the theme however casual their insertion may appear; hinting to an Olivia in excessive mourning for a lost brother that youth's a stuff will not endure, or providing Lear's Fool with snatches from popular ballads which are fraught with meaning for the troubled king.

Indeed, the Elizabethan song itself, part of that musical outburst whereby, as one contemporary put it, "manual labourers and mechanic artificers of all sorts keep up a chanting and singing in their shops, the tailor at his bulk, the shoemaker at his last, the mason at his wall,"[41] was itself in some degree a side-product of this demand for artistic integrity and cohesiveness. Within the polyphonic

systems of liturgical music developed by the Franco-Flemish school and reaching their culmination in the work of the fifteenth-century English composers Leonel Power and John Dunstable, the various voices had been intertwined in euphonic counterpoint; but in the process the liturgical text had been obscured. As each section of the choir began its singing of the verse at a different point, the words in unison became indistinguishable to the listener. Significantly, it was in Italy at the beginning of the sixteenth century, where the requirement of artistic integrity in all aspects of a work was becoming dominant, that a desire began to assert itself to restore the validity of the text as an intrinsic element of the choral performance. The rise of the madrigal reflected that desire for integrating the musical and verbal elements, first in its replacement of Latin by the vernacular to make the latter comprehensible, and secondly by the musical expressionism it introduced. Such words as *smile* or *joy* began to be lightly trilled, *grief* and *despair* intoned more solemnly to create an essentially new musical vocabulary conveying the varied modulations of human emotion. The flood of songs sweeping across sixteenth-century Europe, including the courts of Henry VIII and of his daughter Elizabeth, produced accordingly a demand for music amenable to poetic text and, conversely, for poetry which could be easily set to music. The popular English miscellany *The Paradise of Dainty Devices*, published in 1576, assured its readers that the poems it contained were all "aptly made to be set to any song in five parts, or sung to an instrument." Thomas Morley stressed the need for composers to vary their music in accordance with the changing mood: "you must in your music be wavering like the wind, sometimes wanton, sometimes grave";[42] and even the division of the sonnet in this period into octet and sestet, frequently with a break in tone at the division, may have reflected the contemporary desire for contrasting moods in both poetry and song. It is as part of this integrative process in music that the songs of Shakespeare's plays should be seen, their musical setting intended, like the appropriateness of the words, to complement or moderate the prevailing mood of the specific scene.

The stately mansions now being erected in England by the landed aristocracy display a similar movement away from the haphazard accretiveness prevailing in medieval domestic architecture in favour of more disciplined and coordinated designs. Earlier English manor houses, although already becoming emancipated

from the need to act as fortifications, had still preserved something of a defensive mentality in their construction, with the sites often chosen for inaccessibility and with the exteriors, if not always forbidding, at least not aspiring to aesthetic appeal or impressiveness.[43] Stokesay Castle, for example, incorporates into its late thirteenth-century building (*fig. 61*) a Tudor extension, without the slightest consideration for visual congruity, the second-storey addition jutting out as an

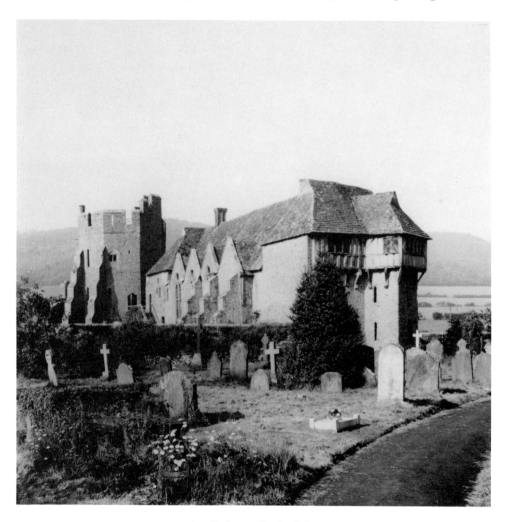

61. Stokesay Castle, Salop

235

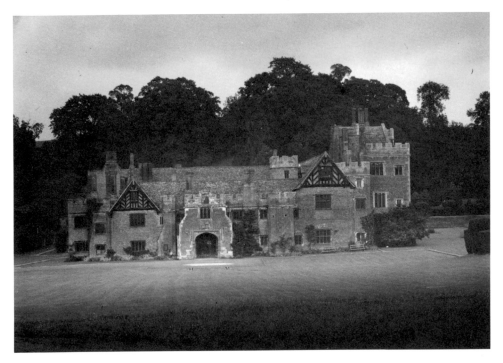

62. Compton Wynyates, Warwickshire

obvious architectural afterthought. Compton Wynyates, begun in 1480 (*fig. 62*), with its strange mixture of medieval battlements and Tudor gables (the latter even inserted at varied heights) and the massive doorway thrust disproportionately to one side, preserved the same tradition of architectural conglomeration. In contrast, the new mansions rising at the time of Shakespeare's play attest to a degree of artistic sophistication such as England had not yet attained in its painting. Intended to rival such elegant French chateaux as Blois and Chambord, they demonstrate the discrimination and responsible planning of their designers. Such houses as Robert Smythson's Wollaton Hall of 1580-85 and Hardwick Hall (*fig. 63*) probably built by the same architect for the Countess of Shrewsbury in 1590-97, were organized on firm, well-proportioned lines with clear axials, and with spacious windows planned for their effectiveness both within and without. They were designed to offer effective lighting for the halls

236

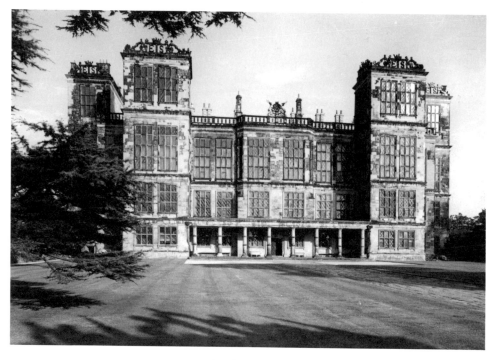

63. Hardwick Hall, Derbyshire

and chambers inside and at the same time to present an imposing frontage, lend-
ing symmetry and grandeur to the entrance façade, as well as to that on the gar-
den side. Without as yet adopting those stricter geometrical forms beloved by
Inigo Jones, the cubes and double-cubes of Wilton House and the Banqueting
Hall, these houses preserve, like Shakespeare's plays, a fluidity of composition
to provide for the wide variety of needs while ensuring the overall unity of the
work, often forming in their totality the shape of a letter *H* or *E* the latter per-
haps in delicate compliment to the Queen.[44] The innovative placing in Hardwick
Hall of the banqueting hall and long gallery above instead of below the servants'
quarters (the taller windows can be seen in the illustration) was intended to pro-
vide for the guests a more splendid view of the countryside, reflecting the
thoughtfulness that went into the planning.

The purposeful blending here of practicality with artistic form was, of

course, the Renaissance principle advocated by Francis Bacon in his essay *Of Building*. Requiring that utility should not be forgotten in the midst of the new emphasis on aesthetics, he suggests that for better efficiency the larger reception and dining rooms be located in one wing and the domestic apartments in the other, adding the important proviso that symmetry must be preserved in the façade: "I understand both these sides to be not only returns but parts of the front; and to be uniform without, though severally partitioned within; and to be on both sides of a great and stately tower in the midst of the front that as it were joineth them together on either hand."[45] This specific design for a central tower flanked by two wings was a personal preference (exemplified, incidentally, by Burghley House among others), but it voiced the contemporary desire in architecture for a balanced and carefully proportioned structure organizing its varied inner components into an aesthetically pleasing whole.

The complex yet integrated structure of Shakespeare's plays was thus not only a mark of the dramatist's personal talents, but part of a larger Renaissance sensibility. In the same way as in the paintings of Raphael, in the design of an Italian palace, or in the new stately homes of England, the coordinated uniformity of diverse parts had become a cherished aesthetic aim, so in Shakespeare's dramas in contrast to those preceding them, every scene, every speech, every song, and (as we learned only this century) even every image and image-cluster has its due place, creating through the purposeful juxtapositions, analogues, contrasts, and interactions with plot and subplot the "multiple unity" of the artistic work, from which, in the accepted formula of the age, nothing may be removed except to its detriment.[46]

6

SHAKESPEARE'S ARTISTIC
ALLEGIANCE

THAT SHAKESPEARE RESISTS NEAT CLASSIFICATION INTO ANY
single artistic mode should be no cause for surprise. His parody of the fixed
genre divisions ("tragical-comical-historical-pastoral") as solemnly recited by
Polonius, his own use of hybrid forms, as well as (to the despair of Ben Jonson)
his refusal to be bound by the unities attributed to classical precedent,[1] suggest
an independence of judgment in him which would seem to militate against any
attempt to place his work within the framework of a specific style. On the other
hand, his very rejection of classical rules itself marked a desire to create for the
stage a dramatic idiom more suited to its immediate needs and, as such, may be
seen to place him closer to the artistic movements germane to his own time than
were, for example, those of his fellow dramatists who preferred to imitate clas-
sical models. Moreover, there is a matter of principle involved here; for stylistic
classification, to be in any sense valid, must rely not on the imposition of fixed
patterns but on the flexibility of an inferential process. The nature of each artistic
style is to be determined, in other words, not by a Procrustean stretching or
cramping of writers to fit some preconceived notion. It must arise organically,
as a pattern emerging from the major works of the period, which themselves are
to determine its contours and delineations. Any definition of comedy, for ex-
ample, which results in the exclusion of Falstaff must *ipso facto* be invalid; it is
the definition and not Falstaff which will need to be disqualified. So here, any
conception we may have of the larger aesthetic configuration of the period
which fails to accommodate Shakespeare will itself need to be modified, revised,

if necessary fundamentally reconstructed, until his work rests within its parameters.

For this very reason, the contradictory attributions to which Shakespeare's work has been subjected in recent years by responsible historians of milieux must prove disturbing. He has been claimed with equal confidence as belonging intrinsically to three contrasting modes—to the High Renaissance, to mannerism, and to the baroque—and such discrepancy would appear to cast suspicion either upon the process of aesthetic periodization itself or, at the very least, upon the degree of critical precision in defining the stylistic movements of the time. Originally he was considered the dramatist *par excellence* of the High Renaissance. But from the time that the two other art terms began in later years slowly to percolate into literary criticism, first, as René Wellek has shown, on the German scene and only in more recent years in England,[2] Shakespeare has been firmly appropriated by advocates of the two other main movements of the period. There are those like Peter Skrine who place him centrally within the baroque mode for the "opulence" and "grandiloquence" of such plays as *Othello*, and others who focus rather on the shifting norms, the ambivalences and the tensions in his dramas to categorize him as basically manneristic in style.[3] Nor can this inconsistency be dismissed as a mere matter of affixing arbitrary labels. For the serious interdisciplinarian, the obtaining of any genuine insights into a work by placing it within its larger artistic setting must depend in the final analysis upon the appropriateness of that contextualization, upon the demonstrable affinities to the specific art movement. While variety of approach is in general the lifeblood of literary criticism with its continual need for reassessment and revaluation, in this instance the failure to achieve any consensus in artistic attribution is liable to weaken confidence in the efficacy of such investigation.

It may be argued, however, that the responsibility for critical discrepancy on this point lies not with the historians of milieux attempting to apply the lessons of art history to literature, but rather in the imprecise vocabulary of art history itself, from which the terminology has, of necessity, been borrowed. The monumental authority still accorded in that latter discipline to Heinrich Wölfflin's *Renaissance and Baroque* has perpetuated well into our own era an unfortunate blurring of definitions. His study was indeed impressive for the period in which

it was written, in the perceptive distinctions it made between the two major styles it defined, especially in relation to architecture. But it appeared long ago, in 1888, at a time when Vasari's early identification of mannerism as an authentic style, intervening between those two modes and overlapping with the latter chronologically, had disappeared from the consciousness of the historian. Accordingly, the formulations Wölfflin offered for baroque art were often misleading. By ignoring mannerism as a separate style, his study embraced two disparate, often contradictory forms within one definition, with, for example, the vestibule of the Laurentian Library in Florence, now recognized as mannerist, cited by him as evidence of the "accelerated linear movement" of the baroque. The result was a confusion of terminology which later attempts at correction did little to change.[4] The pioneering, often brilliant work of Werner Weisbach, Max Dvorak, and Walter Friedlaender in the early decades of this century temporarily resuscitated an awareness of the forgotten mannerist school, perceiving it afresh as an independent, consciously anti-classical movement reacting to Renaissance norms, although in a direction divergent from that of the baroque. Where the baroque was authoritative, rejoicing in the physical, in the dynamic, and in the monumental, mannerism was attenuated, anti-rational, and introspective. The latter was thus seen to be ineligible for grouping under either of Wölfflin's two headings, and deserving examination as a phenomenon in its own right.[5]

The revival of interest in mannerism during the early part of this century and the belated recognition that it had constituted not a debilitation of High Renaissance forms but a conscious reaction to them coincided on the European scene with a similar rejection of traditional values in painting and sculpture. In the area of literature too, the convoluted forms, the abrasive wit, the startling ambivalences of such mannerist poets as Donne and Marvell were stimulating renewed admiration, and metaphysical poetry had become the exciting model for poetic experimentation. Willam Empson's validation of ambiguity as a positive force in poetry led to the New Critical school's focus upon the complex web of connotation in verse, not least in Cleanth Brooks' celebrated essay on Donne's "Canonization" as exemplifying the creative use of "The Language of Paradox"—all of which were to make outdated and strangely irrelevant in literature the writings of such earlier critical giants as George Saintsbury and Sir Arthur

Quiller-Couch.[6] Yet while these fundamental changes were occurring in literary criticism, art history remained profoundly conservative, with Wölfflin's work retaining its position of authority. After that brief flirtation with mannerism, despite the latter's patent relevance to contemporary stylistic changes in both art and literature, the rediscovered movement failed to hold the interest of historians and writers subsequent to Friedlaender, and critics reverted to the pejorative use of the term, retained well into the 1960s, with mannerism designated as "a sort of neurosis" among ineffective artists unable to cope with the crisis of their era.[7] Only in the last few years, as the work of John Shearman, Linda Murray, and others have begun to make themselves felt, have art historians tended to shed those negative epithets and to regard the finest proponents of that style with the same respect as they accord to other artists.[8] It is perhaps understandable, therefore, why in 1955, before that recent reinstatement, Wylie Sypher should have used mannerism as a means for pointing only to the supposed weaknesses in Shakespeare's art—the salaciousness which he found in Hamlet's "unbridled pornographic mirth" or the "hysteria" of Isabella in *Measure for Measure*—and not as a means of assessing the more positive aspects of his art.[9]

Since the revalidation of mannerism as an art form, the brooding self-doubt of Shakespeare's tragic figures, the dissatisfaction with the human condition, and the troubled questioning of the harmonious world-order pervading his plays from *Richard II* onwards, spilling over from tragedy into the so-called "problem" comedies too, have in recent years led to the association of Shakespeare with the mannerist phase of European art. He is seen as part of the deliberate rejection of Renaissance norms which motivated writers and artists in the sixteenth and seventeenth centuries to desert the ideals of rational perspective and harmonic proportion and to express instead a disturbed reaching out beyond the phenomenal world to the realm of the spirit. In his wide-ranging study of mannerism, Arnold Hauser has, like others, argued cogently for that attribution, and there is indeed much to support the view.[10] Yet there are also strong counter-indications which should give us pause. The majestically integrated design of Shakespeare's plays, explored in the previous chapter, with the complementing of character and foil to create, despite the inner disturbance, an overall balanced and proportioned structure, the expanded but still securely terrestrial

settings to his plays, and the powerful attractions of worldly wealth and influence, are qualities characteristic of the High Renaissance in the fullest sense of that term, and remote from the mystically phosphorescent or elongated forms of a Tintoretto and El Greco in art, or the ingenious virtuosity of a Gongora and Marino in literature. Even in the most disruptive of his plays, when the hostile forces of self-interest have destroyed the social fabric, casting doubt on the possibility of its ever being satisfactorily restored, as many critics, notably Irving Ribner, have reminded us,[11] it is the traditionalists in these plays, Cordelia, Edgar, and Kent, Desdemona, and Macduff, dedicated to the moral principles of the old hierarchical system who win our respect and trust, not despairing of this world to turn their hopes exclusively to the life beyond, but determined to uphold here on earth the natural duties of filial piety, of a subject's loyalty to his monarch, or a wife's devotion to her husband as reaffirmations of man's participation in the cosmic design of nature. This is in no sense to ignore, or even to underplay, the harrowing recognition of evil in the major plays, the agonizing tensions and moral perplexities. They are central to the dramatic movement; but even those critics most sensitive to the dual modes of perception in Shakespearean drama, the commitment of his heroes to such seemingly irreconcilable principles as reason and passion, law and freedom, have for the most part acknowledged with Norman Rabkin that such contrary commitments ultimately "coexist in a single harmonious vision" to be worked for in this haptic world of temporal existence, and not, as in Donne's yearning for the ecstatic moment when body and soul separate, postponed to some apocalyptic time.[12] Such strong Renaissance affinities in Shakespeare would thus seem at the very least to cast doubt on the mannerist identification.

There is, moreover, a historical factor to be considered. The tardiness of the English Renaissance upon the European scene, some eighty years after the Italian, meant that the Englishman looking to the continent for his models found available for his use not only the products of classical humanism but also the later mannerist reactions to it in both art and literature.[13] He could, at least theoretically, have moved directly into the second phase, circumventing the first. What did in fact occur in England, the general preservation of the sequence, appears to confirm the view that each cultural entity must work its own way through

the processes of action and reaction in their due course without relying upon the experience of others. Nevertheless, the chronological discrepancy between England and the continent does leave open the possibility of less clearly defined boundaries between the two forms, a haziness of outline particularly during the intermediate, transitional phase.

To this transitional phase Shakespeare perhaps most appropriately belongs. Primarily Renaissance in his aesthetic and philosophical sensitivies, he displays in all but the latest of his plays a firm sense of the authenticity of this world. While always aware of the bourn from which no traveller returns, of the life-to-come which Macbeth, as he contemplates earthly ambition, would so care to "jump," Shakespeare nevertheless views that afterlife from within the secure setting of his Elizabethan or Jacobean world. He will part from a dying hero with the prayer that flights of angels sing him to his rest, but will not in his major phase follow him imaginatively beyond the confines of the terrestrial into the insubstantial realm of the heavenly and the disembodied which so dominated the sensibilities of the mannerist artist and writer. The anguish and questioning of order present embryonically in Shakespeare's earlier dramas and emerging with increasing intensity as his dramatic career advances, while they certainly reveal mannerist tendencies, do not as yet break through the barriers of Renaissance form, but rather press against their limits in their sensitivity to approaching changes which have not been fully accommodated in his own work.

There was a precedent for such artistic transitionalism on the Italian scene too. Michelangelo is justifiably recognized in his major period as marking the epitome of the High Renaissance. If such statuary as the earlier *Pietà* in St. Peter's, the sculpture of *David* in Florence, and the ceiling frescoes in the Sistine Chapel are not supremely characteristic of that style, then our definitions of it will need to be modified beyond recognition. Yet as art historians have noted, unlike his older contemporary Leonardo, he did not remain throughout his life fully within its traditions, displaying in his later period a restlessness and a tendency to disharmony of form which were to exert a powerful influence on subsequent artists. The Medici tombs, on which he worked from 1521 to 1534, are still presided over by idealized, heroic statues of the Medici brothers in Renais-

sance style, courageous, thoughtful, self-confident; but the ambiguous, androg-
ynous, allegorical figures below, seeming about to slip off their curved supports,
create a sense of puzzling instability, a questioning of this-worldly forms; and
the great altarpiece of the Sistine Chapel, originally commissioned as a Resur-
rection scene, became by the time of its execution some twenty-five years after
the completion of the ceiling, a forbidding *Dies Irae* with the figures of those
called for judgment floating in some vague vortex about the figure of Christ or
dragged down bloated by sin to the amorphous darkness below. While many
creative artists have indeed embodied in their work a single aesthetic code, con-
sciously undertaking the task of interpreting or representing it for their contem-
poraries (as Alexander Pope was to do for Augustanism or Caspar David Fried-
rich for the romantic mysteries of nature), others have spanned a wider range of
forms, undergoing a metamorphosis during their artistic careers, moving some-
what away from their original allegiances without entirely deserting them. Such
change, one may note, is not necessarily a process of artistic maturation and en-
richment—the final phases of both Michelangelo and Shakespeare are not gen-
erally seen as their most aesthetically satisfying. But the change occurs because
some alteration in the artist's sensibilities or in the period at large have made the
earlier forms no longer relevant. While we should, therefore, be conscious of the
major stylistic affinities of Shakespeare's development, any attempt to interpret
the corpus of his writings in accordance with a single artistic mode is liable to
prove abortive.[14]

In Shakespeare's earlier period, the High Renaissance quality is especially
marked. The sense of spaciousness which had entered painting with the broad
vistas of a Veronese canvas replacing those charmingly miniaturist street scenes
perceived through a narrow window or framed opening (as in the right-hand
panel of *fig. 20*, p. 71), presupposed a wider scope for human activity too, and
within the theatre an extended range of imagery and setting was required to ac-
commodate the augmented roles of the leading dramatic figures both in their
actions and their aspirations. Not long ago, such a statement asserting the en-
largement of the human image and of human enterprise at this time might have
appeared a truism; but the reactions to the Burckhardtian conception of the Ren-

aissance, briefly discussed in an earlier chapter, have led to a tendency still current among historians today to deny that view. In an influential study, it has been argued that quattrocento and cinquecento artists introduced no significant change in the conception of man himself, only in his contextualization. He did not, we are told, "discover man in the flesh or in his human condition—the medieval sculptor and poet had already done so; but he *situated* the image of man, confidently, within a new world-order, within a new coherent space and perspective."[15] It may well be claimed that even the situating of man in a new world-order would itself entail a fundamental reassessment of his human condition, a revaluation of his altered responsibilities and his potential within that changed environment, thereby making this distinction between artistic representations of the human image on the one hand and of the outer setting on the other of little practical relevance; but even divorced from this setting, the contrast between the medieval and the Renaissance portrayal of man is too marked to be ignored.

Sculpture, which by the nature of its medium presents man for the most part in isolation, with little or no background to influence the viewer's response, may offer the most cogent evidence of the transformation. The horseman from Bamberg Cathedral (*fig. 64*), representing in the late thirteenth century the medieval ideal of aristocratic knighthood, conveys above all the sensitivity and spiritual dedication implicit in its code. Withdrawn from the temporal world in meditation, the reins held loosely in his hand, he gazes thoughtfully into the distance, his head turned away from the direction the horse faces as if he has little interest in reaching any destination localized in this world. Neither rider nor horse poses any physical threat to a potential enemy, rather evoking the epithet "gentil" in both contemporary meanings of that term. Even in the later period of medieval chivalry, when valour and personal prowess had come to occupy a more prominent place in the system, the courage demanded for jousts and battles was sensitized by its subordination to a spiritual aim, a devotion both to God and to the ideal of courtly love. At times when love or warfare seemed more urgent, there still remained a predominant awareness that all earthly joys and victories were ultimately to be subordinated to the Christian responsibilities of a knight dedicated to a holy cause, and Malory's moving account of the penitence and shriving of Sir Launcelot testifies to this prevailing commitment:

246

Then Sir Launcelot wept with heavy cheer, and said, Now I know well ye say me sooth. Sir, said the good man, hide none old sin from me. Truly, said Sir Launcelot, that were me full loth to discover. For this fourteen years I never discovered one thing that I have used, and that may I now blame my shame and my misadventure. And then he told there that good man all his life, and how he had loved a queen unmeasurably, and out of measure long: —and all my great deeds of arms that I have done, I did the most part for the queen's sake, and for her sake would I do battle were it right or wrong, and never did I battle all only for God's sake, but for to win worship, and to cause me to be the better beloved, and little or nought I thanked God of it.[16]

Reflecting that phase, Donatello's statue of the warrior saint *St. George* from 1415-17 (*fig. 65*) is indeed more military in bearing than that of the Bamberg horseman. The legs are set apart in firmer stance than was customary in medieval art, the face turned more resolutely towards a possible adversary. Nevertheless, the impression it creates is still of contemplation rather than challenge, of pensive refinement as the shield is held lightly at rest before him, the body slim and youthful rather than stalwart or intimidating. Although within the next thirty years, Donatello moved further away from medieval forms, and his equestrian stature of Erasmo Da Narni (*Gattamelata*) captured something of the dignity of Roman imperial statuary, the change was limited. The ball on which the horse's front hoof rests, as well as the calm posture of the unhelmeted rider, suggest not a battle but a ceremonial occasion, a review of troops or a formal procession.

In contrast, Verrocchio's bronze statue of Bartolomeo Colleoni (*fig. 66*) completed (although not cast) by the time of the sculptor's death in 1488, gives consummate expression to the martial spirit of the Renaissance in its assertion of physical strength, individual self-reliance, and an unswerving determination to achieve personal victory. The *condottiere*, seated firmly in the saddle, his legs braced forcefully against the stirrups, is in total command. The aggressive forward thrust of elbow and shoulder, the intimidating gaze, the armour designed to resist the heaviest of blows, bode ill to any opponent. Such is the posture of warlike confidence which, with all the conflicting calls of honour and pleasure,

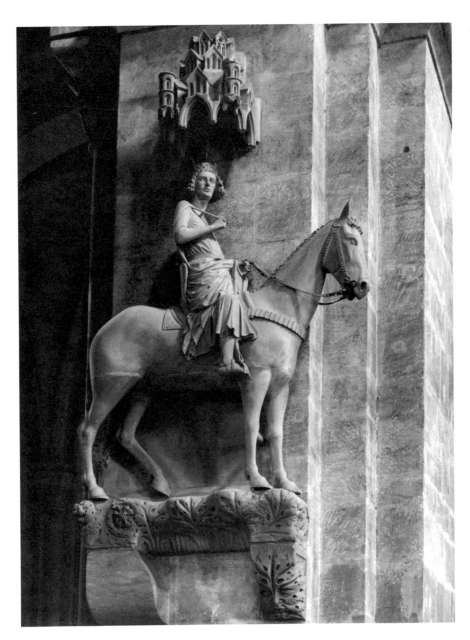

64. *Horseman*, Bamberg Cathedral

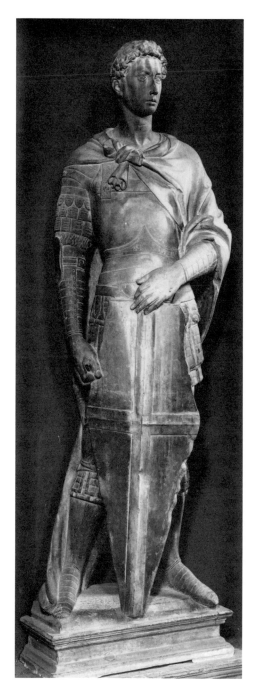

65. DONATELLO, *St. George*

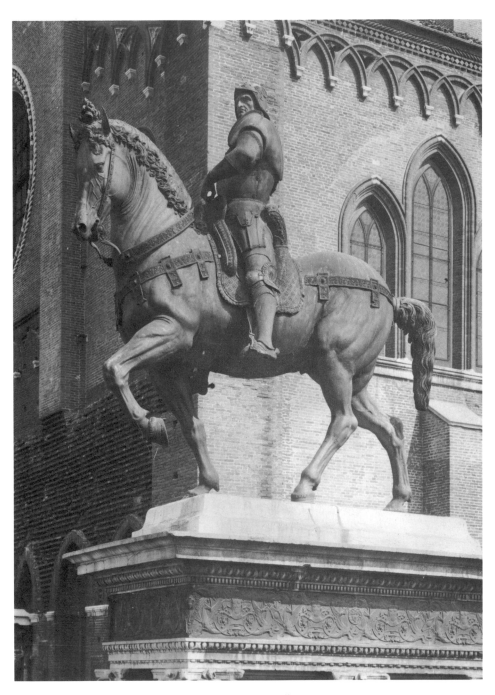

66. VERROCCHIO, *Colleoni*

of moral responsibility and personal ambition, emerges as the dominant military ideal in Shakespeare's history plays—the bold exhortation to battle and to victory:

> Stiffen the sinews, summon up the blood,
> Disguise fair nature with hard-favour'd rage;
> Then lend the eye a terrible aspect;
> Let it pry through the portage of the head
> Like the brass cannon.[17]

The stiffening of sinews which the King advocates here, like the forceful straining against the stirrups in the Colleoni statue, forms part of the new prominence accorded to thews and muscles in art, an interest extending beyond the contemporary advancements in anatomical knowledge, to function more potently as an iconographic symbol. The dissection of corpses for the artist's needs had been utilitarian in purpose, motivated by the desire for accuracy in depictions of the human body; but in the new semiotics of the era replacing the traditional allegories of Christian art, such portrayal of muscular strength exemplified the physical power which man now felt capable of exerting within the temporal world. The comparative frailty of both rider and horse in the earlier Bamberg composition, the sense elicited from the viewer that they could easily be toppled by a resolute adversary, has been superseded in the Verrocchio sculpture by the burly physique of both man and steed. The animal's broad chest and solid haunches, the thick tendons of its bent foreleg and its powerful forward movement under the firm guidance of the rider directly affect the image of man here, not merely as placed or "situated" within a corporeal setting but as controlling its forces with a purposefulness and courage absent from earlier representations. In this instance, the rider's body is obscured by his armour, but one has only to compare the naked figure of Adam in Van der Goes' *Garden of Eden* from 1460 (*fig. 67*), the thin, pale body devoid of strength with the robust, muscular figure in Michelangelo's *Creation of Adam* (*fig. 33*, p. 107), to perceive the metamorphosis that had been wrought in that image.

Within the history plays, Shakespeare's Renaissance affinities are evidenced not only by the exercise of man's physical resources in warfare but by that com-

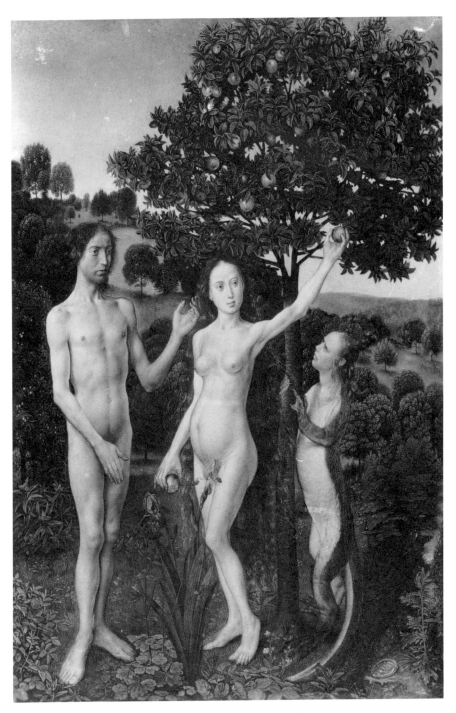

67. VAN DER GOES, *Garden of Eden*

bination of pragmatism and idealism indigenous to the Renaissance. And with the concept of monarchy as the central theme of these plays that duality is of particular significance. While the divine sanctity believed to hedge about a king, his heaven-derived protection, was, for understandable reasons, given major prominence in the sixteenth century as a discouragement to potential rebels, in fact, as both the monarch and the people well knew, the power of the throne rested upon a twofold principle. The more abstract idea of celestial right was required at all times to be buttressed by the necessary consent of the people—a consent expressed not by direct vote but through the leaders of the shires, the barons of the land. As Ernest Kantorowicz has shown, with that public consent withdrawn the throne for all its divine sanction would fall.[18] The delicate balance between the hierarchical ideal on the one hand and, on the other, the practical worthiness of the monarch in the day-to-day running of the state, in handling foreign affairs, in directing the economy, and in the control of the barons, which together would win him the confidence of the people, is the theme which fascinated Shakespeare at this time—in effect, the firm grasping of the reins of office represented symbolically in the Colleoni sculpture.

Shakespeare's most sensitive exploration of this theme, the deposition in his play *Richard II* of a king lacking such practical drive and martial energy, has become the focus of an illuminating study relating its dramatic form to one of the bye-ways of art history, but a bye-way which, like all forms of art, reflects contemporary modes of thought. The "anamorphic" paintings of the Renaissance, although never of major importance, formed a natural side-product of the flurry of experimentation with perspective in that era, experimentation typified by the extreme foreshortening of Mantegna's *The Dead Christ* startingly viewed from a point near the feet of the prostrate figure. The use of such foreshortening for more playful purposes probably began, once again, with the inventive Leonardo. According to his disciple Francesco Melzi, he depicted a dragon fighting with a lion which, when viewed frontally, was mere confusion, but when viewed through a peephole bored in the wooden frame at an angle almost parallel with the surface of the painting, was "a wonder to behold." It has not survived, but others have. Dürer's pupil Erhard Schön produced in the 1530s a number of woodcuts and engravings in that manner, some amusing in theme—

such as the engraving of an old man with a young wife, the accompanying an-amorphism when viewed correctly revealing her naked in the embrace of her young lover.[19] Although generally intended to entertain, the technique was occasionally incorporated into more serious works, and would have been familiar to Shakespeare from the derivative portrait of Edward VI by William Scrots, on display at Whitehall, and probably also from the more famous painting *The Ambassadors* by Holbein the Younger (*fig. 68*) which is believed also to have been hung there for a time during this period.

Ernest Gilman was not the first to recognize in Bushy's speech to the Queen within *Richard II* a reference to anamorphic painting; but he was the first to develop from Shakespeare's image a theory for understanding the play as a whole.[20] In the Holbein painting, for example, an impressive double portrait of Jean de Dinteville and Georges de Selve who were envoys at the court of Henry VIII, the achievements of the Renaissance in its practical aspects are magnificently expressed, not only in the dignity of the two representatives of the civil and religious offices of the French realm, but also in the collection of books and instruments arranged on the shelved cabinet between them. The presence there of lute, globe, astrolabe, and hymnal symbolize their mastery of the varied disciplines of music, geography, astronomy, and theology as forming accomplishments of the courtier. Yet weirdly slashing across the foot of the painting is an indecipherable blur, only to be "read" by being viewed from an angle almost level with the canvas and in line with its axis, when it is revealed to be a skull. Its insertion there, partly a pun on the artist's name, is believed also to be an ironic *memento mori*, counterpointing the splendour of the main scene with a reminder of the transience of human glory.

Within the play, Bushy introduces the image of such anamorphic painting (known popularly at that time simply as "perspectives") in order to assure the Queen that her vague premonition of grief on parting from her husband is unfounded:

BUSHY: Each substance of a grief hath twenty shadows,
 Which show like grief itself, but is not so;
 For sorrow's eye, glazed with blinding tears,
 Divides one thing entire to many objects,

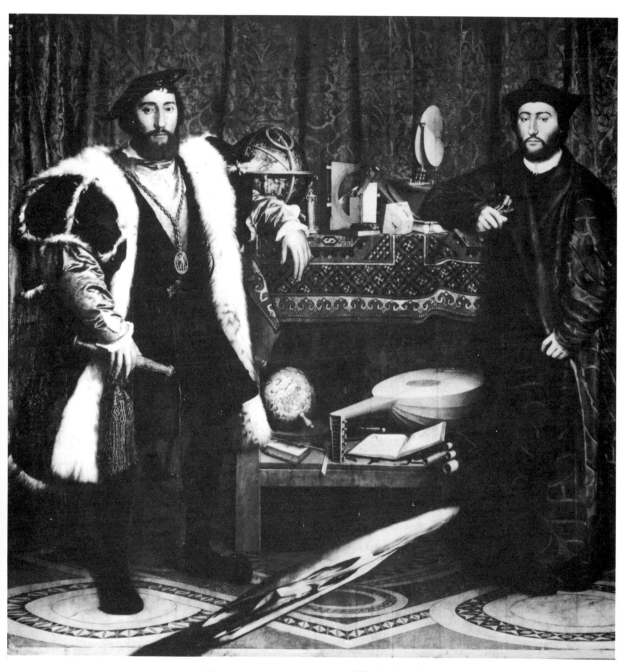

68. HOLBEIN THE YOUNGER, *The Ambassadors*

Like perspectives, which rightly gazed upon,
Show nothing but confusion—eyed awry,
Distinguish form. So your sweet majesty,
Looking awry upon your lord's departure,
Find shapes of grief more than himself to wail,
Which looked on as it is, is naught but shadows
Of what is not.

<div align="right">(2.2.14-24)</div>

For Bushy, then, truth lies only in the frontal view, in gazing "rightly" at a painting when the anamorphic section is naught but shadows, taking shape only if seen "awry."[21] However, the fact that Bushy is to some extent proved wrong by the retrospective confirmation of the Queen's premonition serves, Gilman argues, as a key to the play as a whole, revealing, as in *The Ambassadors*, a duality of viewpoint which allows the developing plot to be interpreted at any moment from two different and respectively valid angles. It can be seen, as in a frontal viewing of the Holbein painting, in terms of worldly Renaissance achievement, the splendour of the golden chain of office awarded for merit, the ermine robe and scientific instruments symbolizing the power to be attained by wealth and knowledge. According to such practical criteria of statehood, King Richard has proved woefully inadequate, deserving to be replaced by a better monarch. Alternatively, the play can be seen, like the skull, in terms of eternal values, a *memento* of the untouchability of divine kingship.

This valuable reading of *Richard II* in terms of contemporary anamorphic art offers us an opportunity for exploring further the artistic and philosophical implications for the period at large and the recognition that in the drama of this time both aspects lay their claims upon us. Such plays do not rely upon a mannerist dematerialization of this world, an assertion of the exclusive authenticity of the eternal or spiritual vision, but rather on an essentially High Renaissance conception of the mutual interdependence of the celestial and the mundane, and of the equilibrium which must be preserved between the two. In both anamorphic forms, in the Holbein painting which presents an alternation and in such pictures as the portrait of Edward VI which offers only confusion when viewed frontally, the dual outlook is implied. The spectator as he gazes through

the peephole provided in the frame or bends to see from an unfamiliar angle the blur which then takes on a recognizable shape, knows at that moment that he is only temporarily deserting the established norm of frontal vision representing the real world in which he lives, and that the validity of that norm has been neither cancelled nor even impugned. Within that more stable viewpoint of everyday frontal vision are to be found, as in the painting of the ambassadors, the legitimate claims of terrestrial existence, the call to exert human ability and will in order to attain its tangible rewards.

The resulting alternation of vantage-point, true for the Renaissance at large, can be illustrated in many parts of this play, not least in the climactic scene when in a fit of petulance Richard breaks the mirror, claiming with self-pitying extravagance, "How soon my sorrow hath destroy'd my face." Such poetic hyperbole is, as elsewhere, intended to mark a failure in the discrimination requisite for a king, his inability to distinguish between metaphor and fact, and the pragmatic Bolingbroke, echoing Bushy's earlier distinction, provides the necessary practical corrective, that it is only, in fact, the "shadow of your sorrow hath destroy'd / The shadow of your face" (4.1.292-93). Nevertheless, as soon as Bolingbroke, however indirectly, has laid hands on the King's sacred person, and thereby violated the celestial pole of Elizabethan monarchist belief—the divine sanction—the viewpoint shifts from the pragmatic to that of the eternal hierarchies as Bolingbroke is now condemned in his turn, penitently undertaking but never destined to fulfil, a pilgrimage to purge himself of that dreadful guilt. The validation thus oscillates between the two viewpoints, ultimately confirming both.

Such alternating authentication of pragmatic and ideal epitomized by the anamorphic analogy (an aspect of the duality examined in an earlier chapter) has its counterpart in comedy too, although it functions there on different principles. The distinction in the Teatro Olimpico between terrestrial affairs and the imagined world beyond, between the forestage on which the action takes place and the prospects leading to the distant horizon revealed only through the openings in the *frons scaenae*, did not, of course, apply to the more flexible stage of the Elizabethan playhouse. There, the romantic comedies moved easily back and forth between on the one hand the city with its fixed social norms, its legalism,

and its political struggles, and on the other, the attractive green or golden dream worlds furnished with elves and fairies, magic caskets, or idyllic settings. Since the seminal study by Northrop Frye on the genre traditions and C. L. Barber's application of similar archetypal principles to Shakespearean comedy, that movement back and forth from city to fantasy world has been seen afresh in terms of seasonal change, as a festive spring ritual, a symbolic release from the wintry oppressiveness of obstructive elders and urban authoritarianism into a liberating celebration of youth's own season, the only pretty ring time of love.[22] The process of that celebration has been rightly understood not as mere escapism but as an exploration, free from everyday pressures, of aspects of human behaviour which require clarification or readjustment. The fickleness in love which so exasperates Helena within the walls of Athens is not left behind as the youngsters flee. It is carried with them into the forest on midsummer eve where, in its fairy-tale setting, the magic juice of the herb "love-in-idleness" will, through Puck's mischievous ministrations, allow the lover to see, magnified as in some crystal ball, the absurdity of his own perverse infidelities in real life. Their return to the city bemused by vague memories of their night's dream brings with it, as Demetrius wonderingly admits, a new health in love to which he now swears evermore to be true.

This enlightening reading of the comedies has been presented and developed in recent years primarily in anthropological terms, as part of an archetypal impulse for seasonal renewal pertaining in all eras; but such a reading does little to explain the distinctive quality of the Shakespearean pattern of such renewal and its difference from such other festive comedies as those by Aristophanes, Menander, or Plautus, none of which includes a "green-world" of this type. In those earlier plays, a festive society may be created to replace the normal, when an *eiron* figure in the form of a resourceful slave takes over his master's house to run it as a brothel during the latter's absence; but that is far from the world of Arcadian idyll or dream fantasy operating in Shakespeare's romance period. While Frye acknowledges the difference, calling Shakespearean comedy the "fourth phase," he offers no explanation for the change. It may be argued that, while conforming in general outline to that mythic pattern of seasonal rites, the specific quality which Shakespeare gave to it made it intrinsic to the Renaissance

itself; for it adjusted the archetypal modes of comedy to that twofold perspective inaugurated, or at least first formulated, by Alberti, according validity both to this world and to the more harmonious setting of the imagined world beyond. In its more contemporary sixteenth-century form, Serlio's stage contrast between the level foreground (upon which the activity of human affairs was presented) and the illusionist raked background beyond is particularly relevant; for it confirmed physically the twofold perspective expressed only imaginatively on the Shakespearean stage. As Serlio informs us, it was on that more remote section of the stage that the scenes of wonder appeared. Here "the gods are made to descend from the skies and planets to pass through the air. Then there are presented diverse intermezzi, richly staged in which performers appear dressed in various sorts of strange costumes both to execute morris dances and play music. Sometimes one sees strange animal costumes worn by men and children who play, leap, and run, to the delighted wonder of the spectators. All these things are so satisfying to the eye and the spirit that nothing made by the art of man could seem more beautiful."[23]

This artistic context would seem, for example, to be of more immediate relevance to an understanding of *The Merchant of Venice* than the mythic theory of the green world to which it has been connected; for the magic terrain of Belmont distant from daily life is neither forest nor any other natural scene which could appropriately symbolize the annual cycle of blossom and decay or the triumph of spring over winter. Instead, it is a land of golden artifice far removed from seasonal change, a perennial world of financial abundance subject to no hibernal chills. In contrast to the harsh commercial reality of Venice with its burdensome debts, its extortionist money-lending, its worrisome investments in merchant ships, and its binding legal contracts, Belmont represents the dream-like exemplar of unlimited resources and boundless generosity. There Portia will unhesitatingly commit the husbandry and management of her richly appointed home to a Lorenzo whom she has barely met, yet with no thought of legal document or surety to confirm, limit, or guarantee her trust. Wealth, like love, flows there spontaneously and unconfined; and if at first the fantasy world is remote from the real, the two meet and blend before the close. Portia must journey from Belmont to Venice, from the ideal world to the mundane in order to

introduce into its grim lawcourt the gentler message of Christian mercy, the moral of selflessness and compassion which should temper the transactions of men even in the everyday realities of fiscal affairs. The letter of the law, the detailed actuality of this world, although it must be modified by the heavenly spirit, is not negated but recognized as a valid part of the duality, just as the Holbein painting affirms the twin viewpoints. Shylock's bond is never abrogated in the play. On the contrary, its claims are repeatedly endorsed by Portia, who warns that any flouting of its validity would endanger the very upholding of law and commerce in Venice. Bassanio's plea that the law just this once be "wrested" to suit the needs of mercy she rejects out of hand, confirming the practical needs of the city:

> PORTIA: It must not be, there is no power in Venice
> Can alter a decree established:
> 'Twill be recorded for a precedent,
> And many an error by the same example
> Will rush into the state, —it cannot be.
> (4.1.214-18)

Instead, preserving the rights of the law, she finds within the wording of the contract, within the necessary technicalities of day-to-day business dealings, the clause whose formulation allows for the inclusion and fulfilment of the missing moral concept, the mercy which droppeth as the gentle rain from heaven, blessing him that gives and him that takes, imposing harmony and proportion upon the realities of daily commerce.

An isolated painting obviously cannot present a developing plot of this kind, a dramatic progression which eventually provides as its climax the fruitful amalgamation of ideal and real; but *mutatis mutandis* the principle of an integrated duality of perspective may be seen to function in that medium with similar effectiveness, even when no anamorphism is employed. One of the most influential and admired canvases produced in this period, Giorgione's *Pastoral Symphony* (*fig. 69*) of about 1508, in which some believe his pupil Titian may have had a hand, appealed precisely because of the expression it gave to this merger. Two Renaissance gentlemen entirely of this world, elegantly dressed in the very

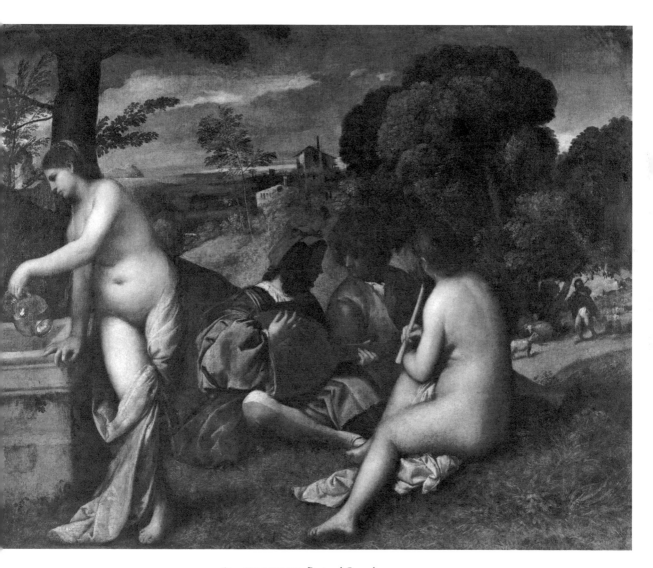

69. GIORGIONE, *Pastoral Symphony*

latest city fashion of the time as if they have just arrived from the nearby town whose outlying villas are visible on the hilltop behind them, are seated upon the grass in the heart of nature, while a shepherd and his flock shelter from the sun nearby. One of the men sings to the accompaniment of his lute while the second listens attentively. As if it were the most natural thing in the world, two naked females relax unembarrassedly beside them. For the sixteenth-century viewer the scene represented in its mingling of myth and actuality, its mellow tones, languid grace, and deeply satisfying composition, the heavenly harmonies achieved in the music and poetry of this world. In that setting, the females would have been recognizable to the alert viewer as the muses of those two arts who have descended from heaven to join their votaries. One holds a recorder in her hand, the other, in a pose evocative of Titian's personification of Sacred Love (*fig. 44*, p. 158), turns to draw water from the pure well of poetic inspiration. How specific this merger of celestial and terrestrial was to the Renaissance is evidenced by the markedly different response in another era. In 1863, a period no longer accepting the Neoplatonic integration of celestial and earthly, Edouard Manet, taking this canvas as his model,[24] painted his famed *Déjeuner sur l'Herbe*—again with two men fully dressed in the fashion of that day resting on the grass together with two females, one of whom is nude. The picture aroused a torrent of protest for its supposed indecency. The men here are, we may note, like their Renaissance counterparts, oblivious of their female companions as they engage in serious discussion, perhaps of art or philosophy, and again one of the females symbolically draws water from the nearby stream; but the merger was now unacceptable. Art of the Victorian era, both in England and across the Channel, could tolerate, even welcome, nude females as remote symbols of abstract ideals—of Beauty, Wisdom, or Knowledge—set, as it were, upon some pedestal distancing them from life; and as such they appeared frequently in painting and statuary. Yet it vigorously rejected any attempt to introduce them into a terrestrial setting, as Giorgione had done so naturally and so acceptably for his own generation in accordance with the integrative philosophy of his time.

It was Shakespeare's easy mingling of the two worlds, including his authen-

ticating of the terrestrial, which made the earlier plays so clearly part of the High Renaissance itself. But that more general integration was not to last, and the shift in sensibility which occurred in his art is particularly evidenced by a qualitative change in the leading characters of the plays he composed at this time. The shadow which falls across Shakespearean drama as he moves into his major phase—his deepening concern with the decay of this world, with the awesome vulnerability of man, and with the puzzling intricacy of the human character— was soon to make the determined Renaissance hero which Verrocchio's statue had symbolized no longer relevant. As Harley Granville-Barker wisely noted, in Shakespeare's middle period the resolute figure typified by Henry V, while it has not been totally disqualified, has been moved to the background "where his name is Fortinbras and he is often . . . cut out of the play altogether."[25] A firm response to the call of honour, as embodied in Fortinbras and Laertes, is now regarded by the dramatist as both simplistic and suspect. Occupying the centre stage is a figure who, for all his self-condemnation on the grounds of his own failure to act and his paralysis of will, becomes admirable to us for his recognition of the problematic condition of man, a condition of which Fortinbras seems utterly oblivious.

That profoundly introspective quality, the dramatist's change of focus from the outer to the inner man with its new insistence upon the complexity of the individual, has been seen as major evidence of mannerist "disturbance" and a distrust of external forms. Hamlet's protest that he knows not "seems," that he has "that within which passeth show" as well as his putting of an antic disposition on to conceal the interior truth of his being, suggest a shift in perspective, a negating of that Renaissance delight in optical fidelity to external appearance— the surface texture of rich embroidery, the dew-drop resting lightly upon a petal, the fold of a falling cloak as it is revealed to the eye. Instead his concern is with the hidden self and the protection of that self from prying eyes. As Guildenstern refuses the proffered recorder pleading his inability to elicit any harmonies from it, Hamlet's angry rejoinder reveals how deeply the prince cherishes the privacy of his inner being and how dearly he values the "mystery" of its ultimate incomprehensibility not only to others but even to himself:

HAMLET: Why, look you now, how unworthy a thing you make of me!
you would play upon me; you would seem to know my stops; you
would pluck out the heart of my mystery; you would sound me from
my lowest note to the top of my compass: and there is much music,
excellent voice, in this little organ; yet cannot you make it speak.
'Sblood, do you think I am easier to be played on than a pipe?

(3.2.379-87)

The torment and spiritual tension of the central figure here would indeed
seem to indicate a mannerist unrest, as has been argued. But there is again need
for caution and for considering once more the possibility that the play marks a
transitional phase. For this very fascination with the inner mystery of the human
personality, so far from constituting a reaction to High Renaissance modes, re-
flects one of the most significant achievements of its portraiture at the peak of its
maturity, as artists learned to convey the elusiveness in the character of a sitter,
hinting at an indistinct world within, whose very impenetrability endowed that
individual with dignity and interest. What might appear at first sight as a dis-
tancing from optical realism in order to attain to a more psychologically ori-
ented inner perception was interestingly a direct outcome of the search for visual
accuracy. Leonardo's meticulous study of light and shade had revealed to him
the surprising fact that the two interpenetrate and blend, so that shadows, al-
though sometimes sharply defined, are more often "like smoke, with bounda-
ries that cannot be perceived."[26] The result was his introduction into Renaissance
painting of the widely imitated technique of *sfumato*, the blurring of outlines to
create a softer, less artificial effect. Elsewhere, he had declared it to be the task
of the painter to portray not only an individual in the act of sitting or moving
but also the intention of his soul, the inner motivation behind the act. The com-
bining of these two purposes resulted within his own portraits in that delicate
shading at the corners of the eyes, nostrils, and mouth, which, for example,
contributes so much to the aura of mystery in his *Mona Lisa*. Facially not espe-
cially beautiful, even matronly in pose, La Gioconda has preserved her fascina-
tion for generations largely by her tantalizing expression, which puzzles us with
the enigma, the question forever beyond verification, whether she smiles in
amusement, in melancholy, in gentle mockery, or whether, indeed, the suspi-

cion of a smile is altogether of our own imagining. Such portraiture marked in no sense a denial or transcendence of the haptic world but a recognition of the complexity of the human character as it exists in reality, a broader and more comprehensive acknowledgment of the mystery implicit in its emotional and philosophical range.

To compare Ghirlandaio's portrait of a young lady (*fig. 70*), dating from before the *Mona Lisa*, with Titian's canvas of a young man dating from about 1540 when the effects of *sfumato* had been absorbed (*fig. 71*), is to discern the change that occurred between Shakespeare's two-dimensional presentation of King John during his earlier period and the compelling subtlety and depth of his Hamlet and of his subsequent Jacobean figures. In the Ghirlandaio portrait, the girl stands out sharply against a contrasting background, her features unequivocally delineated, as she looks directly ahead, conveying to the viewer the impression of a pleasant, well-mannered young lady of no particular profundity of character. In contrast, the young Duke of Norfolk on the Titian canvas, half-merging into the sombre background, evokes a sense of philosophical brooding as, in sensitive, absorbed contemplation, he gazes through and beyond us, pondering some unknown question, and by that very inscrutability becoming more convincing to us as a sensitive being, conscious of the insoluble problems attendant upon human life. Yet the young Englishman, as this figure is sometimes called, stands, despite his thoughtful, abstracted gaze, with the worldly self-confidence of the courtier, his gloves held ready for some formal engagement, the chain about his neck asserting the dignity of his social standing. Hamlet, too, however ill all may be about his heart, however meditatively withdrawn he may seem from the social activity about him, remains for all that the accomplished leader of fashion, his wit flashing out when he is among friends, his judgment perceiving with humour the excess of Osric's flourishes of phraseology or bonnet, and in his physical prowess still excelling even in this more philosophical phase as the most skilled swordsman in Denmark.

On the other hand, countering such High Renaissance qualities are the mannerist tendencies towards bafflement, paradox, and introspective self-probing represented, among other elements, in such linguistic forms as the *hendiadys* which George Wright has recently shown to be employed with far greater fre-

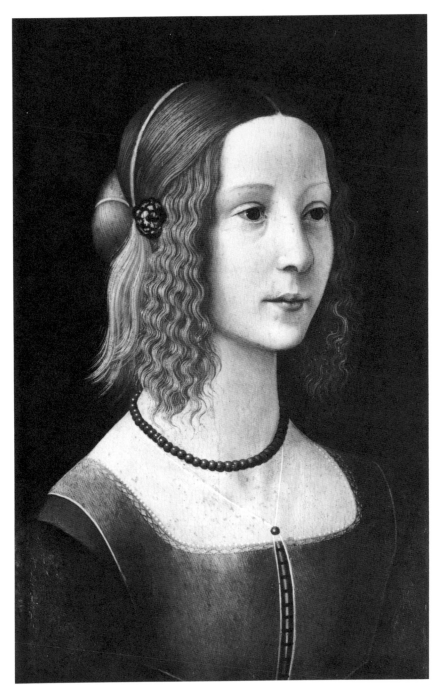

70. GHIRLANDAIO, *Portrait of a Young Lady*

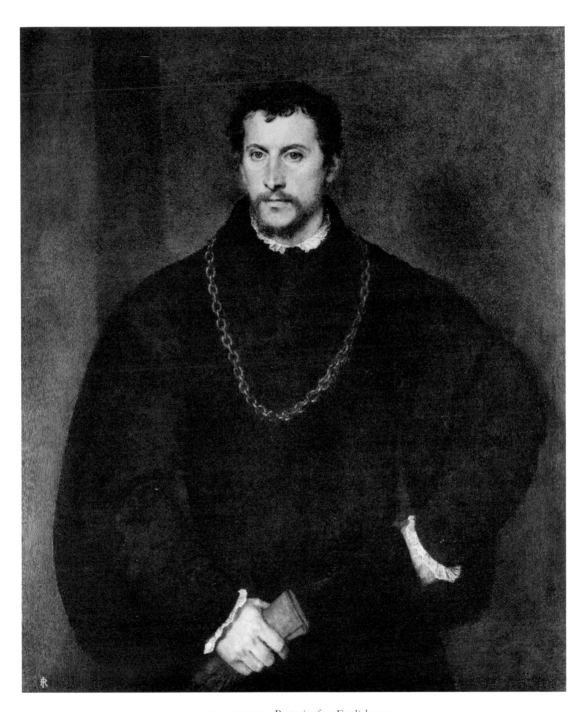

71. TITIAN, *Portrait of an Englishman*

quency in this and subsequent Shakespeare plays than in his earlier dramas.[27] The use of two nouns loosely joined instead of the more familiar noun and modifier ("with cups and gold" instead of "with golden cups") often puzzles here by the unexpected juxtaposition of the nouns, and by the disturbing logical elisions implicit in their conjunction; and it is a disturbance fundamental to the play. By the phrase "in despite of sense and secrecy" (3.4.192), Hamlet presumably means "despite good sense which calls for secrecy"; but with the connexion between the two nouns left unspecified, an uncertainty of direction is created, a sense of conditions problematic for determined action, and this syntactical figure functions throughout the play to reflect the hesitancy and perplexity of the central character. Such linguistic disturbance extends beyond Hamlet himself to the play at large. Laertes, in warning Ophelia that the prince is limited in the choice of a bride, uses language dubious in its referents:

> LAERTES: And therefore must his choice be circumscrib'd
> Unto the voice and yielding of that body
> Whereof he is the head.
> (1.3.22-24)

The ambiguity of image and linguistic form together produce a momentary disturbance in comprehension similar to the feeling of instability consciously evoked by mannerist architecture, when the steps of an altar seem to disintegrate as one approaches.[28] In this passage, one would expect the head to possess the voice, the body to provide the yielding; and the blurring of roles in the anatomical image, together with the deliberate looseness of the *hendiadys* vaguely combining "voice and yielding," evoke a questioning of those fixed relationships associated with hierarchical and social order which had dominated at least the earlier part of Elizabeth's reign.

The mannerist distrust of the senses may also appear to have some connexion with the recurrent theme of "sight and insight" in Shakespeare's plays, the recommendation to ignore externals and penetrate to inner truths, which, after its more simple presentation in such earlier scenes as Bassanio's choice of the leaden casket rather than the golden, received its far subtler and more sensitive treatment in *King Lear*. Central to mannerist thought was the conviction that man's

soul, yearning for eternal, heavenly truths, is obstructed by the grosser responses of the imprisoning body. El Greco is said (in accordance with Loyola's instructions in *The Spiritual Exercises*) to have closed the shutters on the bright views of Toledo at mid-day lest its scenes disturb the visions of his inner eye as he meditated in darkness. In English poetry, Marvell was to record a similar sentiment. In his "Dialogue Between the Body and the Soul," the soul bitterly complains that the corporal organ of sight blocks it from perceiving celestial scenes, that the physical organ of hearing drowns in worldly sounds the harmonies from above:

> O who shall, from this Dungeon raise
> A Soul inslav'd so many wayes?
> With Bolts of Bones, that fetter'd stands
> In Feet; and manacled in Hands.
> Here blinded with an Eye; and there
> Deaf with the drumming of an Ear.[29]

In *King Lear* too, the painful odyssey must teach him to distinguish between the external verbalizations of love audible to the human ear such as he demands from Cordelia and the inner love unheard, unseen, but intuitively sensed. The proliferation of eye imagery in the play, as Robert Heilman pointed out many years ago, implies that man must see beyond the facade of things to the verities concealed behind.[30] Kent's urging of the impetuous king in the opening scene: "See better, Lear; and let me still remain / The true blank of thine eye" (1.1.161-62) and Albany's doubtful comment, "How far your eyes may pierce, I cannot tell" (1.4.368) are hints of a deeper theme echoed and re-echoed throughout the developing drama that the King, like Gloucester, only attains to true sight when he learns at last to suspect outer appearances. It is a process we have been following from the early Renaissance, with Chaucer's delight and trust in the visible world of externals, in the details of dress and gesture seen as reliable keys to inner character, and later modified by Spenser's growing discernment of the deceit or disguise which may at times obscure the truth. That trend reaches its culmination here in an embittered distrust of all outward manifestations as not only misleading but for the most part deliberately fraudulent in intent.

Yet there does, once again, exist a profound distinction between this and the mannerist viewpoint, a distinction to be perceived in the nature of those truths to which Lear is directed by his friends and which he himself eventually accepts. For revealed to him at last are not celestial truths which the mortality of the flesh prevents him from seeing but rather the realities of mortal existence itself, here in our daily life, realities concealed by the knavery or cunning of unscrupulous men and women. Kent's offer to act as the true blank of Lear's eye is the offer not of a visionary but of a plain, blunt servant, disgusted by court intrigue, who would help his master see through the sycophancy about him to the honest facts; and the verity which Lear finally acknowledges is the existence of corruption and hypocrisy prevalent in human affairs here on earth, the simulars of virtue that are incestuous—in brief the way in which *this* world goes:

> LEAR: What, art mad? A man may see how this world goes with no eyes.
> Look with thine ears: see how yond justice rails upon yond simple
> thief. Hark, in thine ear: change places; and hand-dandy, which is the
> justice, which is the thief?
>
> (4.6.153-57)

Lear's response on making that discovery is not a mannerist withdrawal from life into some meditative or spiritual experience remote from daily vice but a physical act of identification with the suffering victims of his realm, the stripping away of his royal robes so that, exposing himself to the pain poor wretches feel, he may strengthen his resolve to correct the injustice, as far as lies within his reduced power, and shake the superflux of his kingdom's wealth to those in need.

Nevertheless, this sensitivity to man's frailty, although it remains framed within a social, familial, and political setting, does mark a shift away from the High Renaissance confidence in the tactile world and in the muscular potential of man for achievement within it. The disillusionment did not represent a return to the late-medieval view expressed in Van der Goes' painting of a frail Adam or in the play of *Everyman* reflecting man's weakness before temptation in the eyes of heaven but, in a strictly human setting, it perceived his defencelessness in the flesh before those humans about him who would exploit his pitiful vulnerability.

In painting, that desertion of the more optimistic Renaissance view is touchingly conveyed in Dürer's unflattering self-portrait where, deserting the classically proportioned idealizations of human form, he presents himself instead with uncompromising honesty in full frontal nudity. Ungainly in shape, leaning awkwardly and uncertainly to one side, his flesh creased in unattractive folds, his genitals exposed and unprotected, it is only the sensitivity of his face which redeems the figure from pathos. That sense of man's weakness marked a dissatisfaction with Renaissance aspirations, a dissatisfaction which was to lead to the eventual rejection of its norms. The earlier ennoblement of the human body, with voluptuous and naked goddesses representing celestial beauty, began to be replaced both in art and literature by a gloomier awareness of the tortures and ills to which the body was heir, with human nakedness now symbolizing not comeliness but suffering and exposure to peril. The anguished, twisted shapes of figures in physical or spiritual agony such as were to prevail in painting during succeeding years are reflected in such moving scenes upon the stage as Lear's recognition that Tom o'Bedlam, shivering miserably in the cold, is indeed the thing itself—that "unaccommodated man is no more but such a poor, bare, forked animal as thou art" (3.3.112-13).

Shakespeare's major tragedies, therefore, while they do betray a growing distrust of certain Renaissance assumptions are, by their concern with man's condition in this world rather than the next, still rooted in its traditions. *Antony and Cleopatra* alone reveals a commitment to mannerist perspective and sensibility, and even then only after some initial uncertainty, an uncertainty which, in a sense, forms the main theme of the play. Within the context of this present study, the play may indeed be seen as a paradigm of that process of artistic choice between the two modes which faced the writer in this transitional period, a projection into dramatic terms of the playwright's own dilemma, with Antony's conflict between the rival claims of Rome and Egypt representing a final moment of hesitation between the obsolescent Renaissance ideal and the new mannerist patterns. Rome presented here in its rational order, its pursuit of worldly honour, its firm hierarchical discipline, and its urge for territorial conquest symbolizes in some degree the older Renaissance confidence in earthly achievement, holding out to Antony the glory of being a triple pillar of the physical world,

and perhaps eventually its sole emperor—the dazzling prize which had animated Tamburlaine, Fortinbras, and other Renaissance seekers after monarchal or imperial power. In contrast, Egypt offers qualities very different in form, and closer to the mannerist dispensation. It is a kingdom defying limitations of time and space, transcending in spirit the measurable restrictions of temporal existence, with a queen whom age cannot wither nor custom stale, whose infinite variety and fascinating unpredictability elude any imposition of rule or order, and who, as in her opening scene, offers a love soaring beyond terrestrial bounds to require new heaven, new earth for its fulfilment. It offers a pliancy of vision outreaching the empirical, in which the world, in the rich imagery of this play, contracts at one moment into "this little O the earth" and at the next expands into an unprecedented cosmic vastness.

In order to convey the agony of Antony's choice during the earlier part of the play, these two contrasting philosophies of life are made interchangeably attractive and repellent, and the dramatic alternation of those qualities creates an often violent oscillation in audience response. Rome may symbolize the virtues of nobility, military prestige, and moral imperatives, but at other moments it represents the failings of sexual frigidity, barrenness, and political venality. Egypt may be wonderfully variegated, fertile, and colourfully exotic, but it is also reprehensibly sybaritic, licentious, and effete. For Egypt, however, these less attractive features gradually fall aside as, towards the end of the play, Cleopatra's triumph becomes a distinctly mannerist victory of spirit over matter. Caesar, the material victor, is left on this earth below to add one more petty kingdom to his measurable tracts of land—the High Renaissance conqueror now reduced to insignificance; while the souls of the two lovers, spurning "this vile world," have soared imaginatively beyond his reach to unite in the richer realms of Olympus where they will be forever the cynosure of the admiring celestial spirits. In a closing scene unprecedented in Elizabethan tragedy, death has become not a grievous ending to life but pleasurable and welcoming, a lover's pinch which hurts but is desired, a gateway to the queen's splendid reunion with the curled Antony awaiting her above. Her "immortal longings," as she adorns herself in full regalia of robe and crown to transcend her death, create a scene which, however distant in its ideological, even pagan orientation, is in its aes-

thetic and formal patterning a secular version of El Greco's brilliant canvas *The Burial of Count Orgaz* of 1586 (*fig. 72*). There the figures below, attending the ritual entombment of the Count's body, clad in its rich, elaborate armour, are only dimly aware of what the artist and viewer so clearly perceive—the shimmering scene of glorification above, where the spirit of the Count, risen heavenward, is about to enter into ethereal life.

In *Antony and Cleopatra*, death is no longer the ghoulish and macabre figure of the Early Renaissance, gleefully seizing upon its victims at the moment of their earthly glory, as in the woodcuts of Guyot Marchant and Holbein (*fig. 73*) or as so vividly described in Shakespeare's *Richard II*:

> for within the hollow crown
> That rounds the mortal temples of a king
> Keeps Death his court, and there the antic sits,
> Scoffing his state, and grinning at his pomp.[31]

Nor is death, as the High Renaissance had fondly hoped, to be overcome by lasting monuments of fame on earth. Pope Julius II, for example, planned for himself in 1505 a tomb so vast and grandiose that the old St. Peter's would have proved too small to contain it, a tomb which in the words of its sculptor was to have no equal on earth.[32] That faith of the tomb-builders in durable memorials to fame had been echoed, and indeed, challenged in that period by the poets, claiming the superiority of their own art as a posthumous preserver of man's achievements:

> Not marble, nor the gilded monuments
> Of princes, shall outlive this pow'rful rhyme;
> But you shall shine more bright in these contents
> Than unswept stone besmear'd with sluttish time.[33]

Now, however, all earthly glory even in its artistically preserved form is seen itself as ephemeral. The terrestrial begins to lose its solidity and permanence in both art and literature as thoughts turn away from it towards the afterlife, towards some existence, Christian or otherwise, beyond the grave, to which this mortal span of life is only a shadowy anteroom. Shakespeare never surrenders

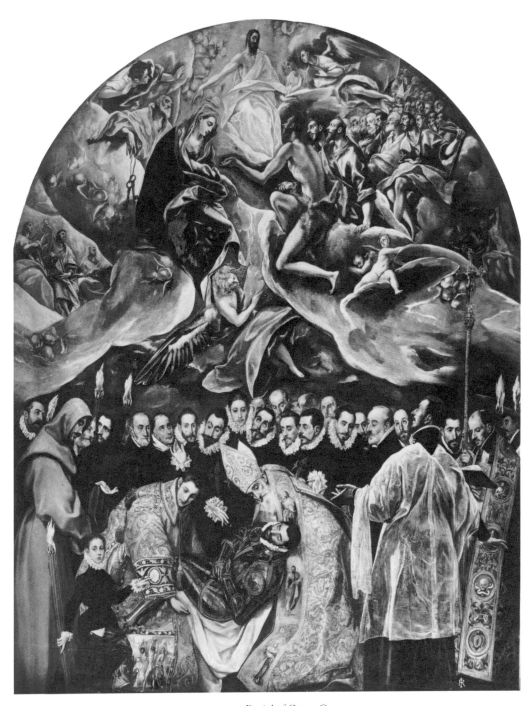

72. EL GRECO, *Burial of Count Orgaz*

73. HOLBEIN, *Dance of Death*

totally to this mannerist or metaphysical disposition, but in the final phase of his career an evanescent quality enters the scenes he presents. The ascetic elements in *Measure for Measure* had already introduced a hauntingly medieval ambience, with both the Duke and Isabella attracted to monastic or conventual withdrawal from daily affairs, inclined to renounce this world in favour of "the life re- mov'd." An ambiguity now prevails, as the previously clear line of demarcation between life and death becomes blurred. In *Pericles, Cymbeline, The Winter's Tale*, and *The Tempest*, the supposedly dead strangely reappear into life, as graves have "wak'd their sleepers, op'd, and let 'em forth."[34] The realm of dream or fantasy is no longer, as in *A Midsummer Night's Dream*, a green world offering opportunities for exploring the human condition before returning to the prac- ticalities of the city. In these later romance plays the dream world exists in its own right, an insubstantial pageant of magicians, monsters, and airy spirits, preferred by a dramatist apparently no longer at ease in the more vigorous High Renaissance environment of his earlier plays.

275

MANNERISM AND CLASSICISM

7

VARIETIES OF SEVENTEENTH-CENTURY PROSE

SINCE THE APPEARANCE OF MORRIS CROLL'S MAGISTERIAL ES-says in the 1920s, the distinction between the Ciceronian and what he termed the "Attic" prose stylists of the late sixteenth and early seventeenth centuries has become fully established. In Montaigne's complaint against the emphasis upon an ornate style in prose—"Fie upon the eloquence that makes us in love with itself and not with the content"[1]—he discerned a break-away from those classical authors so long advocated by the humanists as models for rhetoric and the advocacy of a more personal idiom for which Seneca and Tacitus could serve as more effective guides. Throughout Europe, not least in England, the rhythms of natural speech, the broken syntax, the abruptness, and the often unlinked juxtapositions of the "curt" style began to be preferred to the well-rounded sentence, the polished phrases, and the formal tripartite cadences cherished by Renaissance writers. Above all, Croll's essays drew attention to the new tendency of seventeenth-century writers to reflect in their prose the very process of thinking itself. Instead of being offered the formulated conclusions of philosophical or theological speculation, as in the writings of Richard Hooker, the reader is now made to feel that he is present at the very moment when ideas are being generated in the author's mind, witnessing a spontaneous flow of thought. The break was not, of course, complete. There was still room in the new prose for rhythmic patterning, for ornamentation, and for a certain formalism in diction; but the impression which results from that new style is of an author still engaged not only in the act of committing his ideas to writing but at an even earlier stage, as

279

he searches for the continuation of an idea still forming in his mind, or is swept along by the momentum of developing emotion towards a conclusion which had not been determined, or at least appears not to have been determined, when he began his opening paragraphs.[2]

Croll's essays were to prove seminal for subsequent scholarship. As an editor of collected modern critical essays in that field has remarked "in a very real way, Morris Croll is the only begetter of this anthology. . . . The techniques he employed may have been extended and refined, but they have never been superseded."[3] They were original in another regard too, constituting one of the earliest instances among English-speaking critics of an attempt to place such literary change within the broader European patterns discernible in the visual arts.[4] Developing a passing reference in the epilogue appended to the 1924 edition of Geoffrey Scott's *The Architecture of Humanism*,[5] he termed the prose of the anti-Ciceronian writers "the baroque style," using that as the title for his major essay published in 1929. In a period when the separation of the baroque movement into two phases as argued by Dvorak and Friedlaender had not yet made itself felt on the English scene, the reference was clearly to what would now be called the "mannerist" style, that is, the individualistic art form exemplified by El Greco, whose works Croll cites most frequently as the artistic exponent of the parallel mode.

The newly emerging prose style does indeed display the drama of a personal meditation in process, a probing enquiry into the isolated self. In place of the more authoritative Ciceronian phrases, there is in Donne's sermons, for example, an urgent, often labyrinthine movement towards some incandescent truth whose import is only fully grasped at the climactic moment of final perception. The religious message, universal though it may be, is presented from the viewpoint of the self, the lone meditator, visualizing with anguish the series of discoveries by which his spiritual journey proceeds, and we are permitted to witness that process of discovery in action:

> [W]hen I shall need peace, because there is none but thou, O Lord, that should stand for me, and then shall finde, that all the wounds that I have, come from thy hand, all the arrowes that stick in me, from thy quiver; when I shall see, that because I have given my selfe to my corrupt nature,

thou has changed thine; and because I am evill towards thee, therefore thou hast given over being good towards me; when it comes to this height, that the fever is not in the humors, but in the spirits, that mine enemy is not an imaginary enemy, fortune, nor a transitory enemy, malice in great persons, but a reall, and an irresistible, and an inexorable, and an everlasting enemy, the Lord of Hosts himselfe.[6]

The long sentence is, it is true, broken into rhythmic, echoing patterns— "when I shall need . . . when I shall see . . . when it comes to this height"—but they are not the golden triplets of Cicero savoured for their balance or to be admired for their rhetorical effect. They are the pulsations of a mind vividly evoking sequential scenes in the progress of the soul as it draws ever closer to the Judgment seat. In the powerful conclusion, the epithets applied to God are chosen not for their symmetry but as an incremental revelation of God conceived as an enemy of the sinner, not only real but irresistible, not only irresistible but inexorable, not only inexorable but eternal, with the dread recognition in that final epithet that the sinner's suffering in hell may be everlasting too. This is indeed a prose which catches in its rhythms the motions of a soul and not its state of rest—antinomian, like the paintings of the mannerists, in its concern not with proportions or aesthetic rules calculated to produce a pleasingly unified effect but with the emotional impact of the work as a projection into art of the tortured longings and fears of the artist's individual and inner experience.

The English writer whom Croll selects as the main representative of the new style is, however, not Donne but Sir Thomas Browne, in whose *Religio Medici* he sees the perfect instance of a preference for forms expressing "the energy and labor of minds seeking the truth, not without dust and heat" to those expressing a contented sense of the enjoyment and possession of it. That choice, since it has continued to hold its place in later criticism as exemplifying the so-called "baroque" style, deserves, I believe, closer examination.

The individuality of the *Religio Medici* is certainly one of its greatest charms. The warmth of personality—a quality which Joan Webber termed "the eloquent I"[7]—shines throughout. The man himself is there before us, admitting with an engaging candour to his own idiosyncrasies in a manner which evokes the reader's indulgence, thereby establishing rapport before the author embarks on his

more universal musings upon death or the cessation of oracles. "I love to lose my selfe in a mystery," (p. 69), he confides, and of his own religious doubts concedes, "More of these no man hath knowne than my selfe, which I confess I conquered, not in a martiall posture, but on my knees" (p. 85).[8] The work, as he informs us in the preface, was composed as "a private exercise directed to my selfe"; and although he remains conscious of his reader's presence as he writes, that self-contemplative mood is the starting-point for any wider circlings of thought and it is to that central self that the meditation will keep returning. A discourse on the decay of human flesh begins not, as one might expect from a physician, with an account of post-mortems performed nor with theological animadversions on mortality but with a confession, a personal disclosure of a trait rare in others; and if the "I" shifts soon to a more general "us," the note of intimacy has been struck and echoes on in the mind as he proceeds to the larger axioms:

> I have one part of modesty, which I have seldome discovered in another, that is (to speake truly) I am not so much afraid of death, as ashamed thereof; tis the very disgrace and ignominy of our natures, that in a moment can so disfigure us that our nearest friends, Wife, and Children stand afraid and start at us. (p. 111)

Sir Kenelm Digby, responding within a few days of its publication, could see no possible justification for such self-centredness. He was merely irritated by it: "What should I say of his making so particular a Narration of personal things, and private thoughts of his owne; the knowledge whereof can not much conduce to any man's betterment?"[9]

Modern criticism, however, has, as we have seen, tended in the opposite direction. That personal element in Browne's writings, the "self-exploring curiosity" of a mind pursuing the truth, actively engaged at the moment of setting pen to paper in an individual quest for verity, has come to be seen as one of his primary attractions, offering to the reader "not the result of a meditation, but an actual meditation in process." More specifically, there has been perceived in Browne's work a struggle between the outward Pyrrhonian *ataraxia* and an inner dissatisfaction, between the fixed pattern of the more measured prose

rhythms and an agitated forward movement so that there emerges an energetic effort at imaginative realization, creating as in an El Greco painting (to use Croll's comparison) tortuous lines that "leap upward beyond the limit of the canvas." The continuation of that reading is to be found in Austin Warren's similar contention that the *Religio Medici* expresses in prose form "the movement of ordering the mind in the process of thinking."[10] That dramatic movement D. C. Allen attributed to the spiritual distress inherited from a Jacobean era unable to accept the Renaissance certitudes and therefore no longer capable of introducing the calm authority of Ciceronian opulence into its prose.[11] Margaret Wiley in the same tradition has discerned behind Browne's protective quaintness and the cadences of his Latinity "an exciting search for truth" in a world torn by the conflicting claims of the new philosophy and the old faith.[12]

It is curious that such valuable insights into one of the emerging styles of the period should have been applied to a writer for whom they are so inappropriate; for it would seem from a close reading of the *Religio Medici* that it belongs to a very different stylistic mode. In Browne's work there are, it is true, certain affinities to the introspective meditation, such as his tendency to narrow down the focus from the universal to the sole, contemplative self. Providence, he argues at one point, is not an outside force exerted upon nature, but intrinsic to the life span of all creatures. That broader view is then made sharply, even painfully personal as he ponders momentarily the possibility of his own early death ("as me before forty"), before he gazes upwards once again towards the hand of God which determines all:

> Let them not therefore complaine of immaturitie that die about thirty, they fall but like the whole world, whose solid and well composed substance must not expect the duration and period of its constitution; when all things are compleated in it, its age is accomplished, and the last and generall fever may as naturally destroy it before six thousand, as me before forty; there is therefore some other hand that twines the thread of life than that of nature; wee are not onely ignorant in Antipathies and occult qualities, our ends are as obscure as our beginnings, the line of our dayes is drawne by night, and the various effects therein by a pencill that is invisible; wherein though we confesse our ignorance, I am sure we doe not erre, if wee say, it is the hand of God. (p. 114)

It is a remarkable passage, moving in its rhetorical force and, although Browne has been reproved for the poverty of his metaphors,[13] concluding with that haunting image of the invisible pencil; but there is no energetic forward movement of spontaneous thought here such as would distinguish a mind progressing "without meditation, stating its idea in the first form that occurs." Donne, we may assume, had also established his theological tenets before composing the sermon, yet in the tradition of the religious meditation intended to revitalize faith by stimulating the imagination to visualize scenes of martyrdom or bliss, the act of writing itself, as well as the oral delivery of the sermon, is aimed at conjuring up the immediacy of the visionary experience and of the deepening emotional response it evokes. The progression through the stages of discovery in the passage from a sermon quoted above creates the momentum which Croll so rightly discerned; but it is a momentum absent from Browne's treatise. His is an assertion of a belief already formed and personally confirmed. The "therefores" do not mark stages in a developing argument, but serve as buttresses to the main structure, strengthening a concept already propounded. With the broad tolerance which constitutes one of Browne's greatest charms, he presents his conclusion with a modicum of caution—"I am sure we doe not erre, if we say"—but he is in fact restating the view offered more confidently a few lines before the quoted passage, his conviction that God's wisdom both determines and accomplishes the "secret glome or bottome of our dayes."[14] This is not a difference merely of intensity but of the thought-patterns themselves. The Donne passage is dramatically alive, producing the effect of ideas conveyed instantaneously as they are struck out in the mind, while Browne's is a more formal discourse, presenting in reasoned periods the author's beliefs offered for the reader's interest and delectation.

The assumption that Browne's outward calm is offset by an agitated inner exploration finds little support even in those endearing admissions of personal idiosyncrasy with their aura of introspective discontent. Frequently couched in confessional terms, they arouse in the reader's mind, particularly within this context of a meditation on faith, associations with the dissatisifed self-searchings of the religious penitent. "I am, I confesse, naturally inclined to," "I could never hear the *Ave Marie* Bell without," "I confesse I have had an unhappy curiosity"—

such phrases recall the yearning for self-improvement which the spiritual meditation in both the Loyolan and Protestant versions sought to encourage, the reviewing of the worshipper's own sins before he posed to himself the urgent questions, "What have I done for Christ? What ought I do for Christ?"[15] There is, however, a strange consistency in Browne's confessions—that despite their penitential and self-critical phrasing, they lead to the eventual acknowledgment not of personal failings but of virtues, or, at the very least, of traits which ultimately redound to the confessor's credit. The first of the above quotations continues, "I am, I confess, naturally inclined to that, which misguided zeale termes superstition" (p. 63), subsequently justified as a civility which serves to increase his devotion. Although as a Protestant he admits he could never hear the *Ave Marie* bell without elevation, we are soon to learn that, while the Catholic worshippers "directed their devotions to her, I offered mine to God, and rectified the errours of their prayers by rightly ordering mine own"; and his "unhappy curiosity" which led him to question the veracity of the Scriptures, he laughed himself out of, he informs us, with a piece of Justine (p. 97). To deduce from such personal revelations that there exists below the surface a dissatisfied self-probing is to relate only to the opening phrases and to ignore their conclusions.

The list of such "confessions" is long. He admits to being uncontentious, immune to fears of death or hell, he could lose an arm without a tear, would never think of himself before God, country, or friends, gives charity only to fulfil the word of God, has escaped the vice of Pride (a comment which aroused the ire of his contemporary, Alexander Ross),[16] loves music because he himself is harmoniously composed, and, though he grants in the accepted language of devotional works that he is the heir to Adam's vices and acknowledges his own unworthiness compared to the true Elect, he seems serenely confident that, if he will not be in the first ranks of the saints, he will at least bring up the rear (p. 131). Significantly, when he does admit to a failing, it is always placed firmly in the past, as something manfully overcome and long settled. The manifold religious doubts he confessed to in the passage quoted above were, he concedes, conquered not in a martial posture but on his knees (itself a creditable admission); yet conquered they have been. Where the disturbed religious meditator

would despair of forgiveness for the enormity of his past sins, and often seemed to reach back to them as a means of intensifying his present anguish and his awareness of a final dependence on divine mercy, Browne regards his own with equanimity. His prose is free of the impassioned, broken rhythms of the true meditative tradition, the spiritual self-flagellation typified by Luis de la Puente's cry:

> O God of vengeance, how is it that thou hast not revenged thyself on a man so wicked as I? How hast thou suffered me so long a time? Who hath withheld the rigour of justice that it should not punish him, that hath deserved so terrible punishment?[17]

In contrast, Browne cheerfully dismisses his own past sins with an easy finality as having been fully expiated and therefore as worthy to be forgotten:

> For my originall sinne, I hold it to be washed away in my Baptisme; for my actuall transgressions, I compute and reckon with God but from my last repentance, Sacrament or generall absolution: And therefore am not terrified with the sinnes or madnesses of my youth. (p. 145)

Cumulatively, these personal passages create the picture of a man not perhaps complacent, for he knows well his ultimate need for grace, but certainly confident that he has won through to a sane outlook on life and a healthy balance between the realities of this world and the mysteries of the next. It is ironical, in fact, that the very writer selected to represent a rejection of any contented "enjoyment and possession" of truth should in fact have used those very words to defend the opposite view in his dislike of controversy: "A man may be in as just possession of Truth as of a City, and yet bee forced to surrender; tis therefore farre better to enjoy her with peace than to hazzard her on a battell" (p. 66). It would seem that, at the time of writing the *Religio Medici*, he felt himself to be already in possession of the truth or, at the very least, of those truths meaningful for him, and the long-established picture of Browne as what we might term a doubting Thomas, searching for as yet unattained truths in the process of composing the work, does not withstand a close reading of the text.

He contradicts himself, of course, as he shifts from mood to mood. He will

declare at one moment, with the pride of a patient displaying his wounds for all to see, that he is deeply melancholic, "the miserablest person extant" (p. 109), and at the next that he is of a happy disposition (p. 154). He reveals his unique traits and preferences and then insists blithely that he is free from idiosyncrasies (p. 133). He assures us that his many attainments, such as his knowledge of "no lesse then six languages," have left him free of any sense of superiority towards his fellow men, yet a few lines later allows us a truer insight into his real self, his resentment when those attainments are not respectfully acknowledged.

> I know the names, and somewhat more, of all the constellations in my Horizon, yet I have seene a prating Mariner that could onely name the poynters and the North Starre, out-talke mee, and conceit himselfe a whole Spheare above mee. (p. 147)

If such glimpses allow the reader to form a more rounded impression of his character, including his weaknesses as well as his strengths, the author remains genially impervious to such contradictions in himself. Paradoxes he certainly affirms with that love of mystery in which he delights, but they are not the riddling paradoxes of a character torn within itself, nor even the theological paradoxes which leave the believer in despair of ever finding his salvation. His are the *resolved* paradoxes, where the soul recognizes the limits of reason and bows respectfully to the religious truths that lie beyond—"and this I think is no vulgar part of faith to believe a thing not only above, but contrary to reason, and against the arguments of our proper senses" (p. 72).

And yet something is missing in the picture. Browne does not turn his back on the darker aspects of human life, nor ignore the problems and doubts that arise in the minds of men. We trust him because his range is so wide, his vision so inclusive. He is the physician who is familiar with our human ills, who acknowledges our suffering and, if he encourages us to bear the pain with fortitude, is sufficiently aware that the disease is fatal. It is, indeed, that calm self-assurance as he attends us, the sympathy of one who has himself experienced the grievous malady, which wins our confidence even as he presses upon the tenderest points of pain.

The *Religio Medici*, then, is not a tortuous search for certitude as we have been

led to believe, but rather the celebration of an achieved equilibrium of spirit. Its brilliance as a literary work and, indeed, its enduring attraction derive to no small extent from its ability to avoid any impression of complacency despite that self-confidence, and it does so by its careful introduction of the doubts and fears of mankind while yet avoiding any disturbance of the overall equilibrium. The effect is obtained partly, as we have seen, by subtly relegating such torments to the past as completed stages in his own movement towards maturity, and partly also by his technique of deceptive first-person "confessions" which ultimately lead towards affirmations of that calm of mind. So far from there being a visible struggle between inner agitation and outward calm, there is, I would suggest, only an *illusion* of personal disturbance to that overall serenity of spirit, its purpose being to acknowledge the existence of the darker shadows in the human condition and to strengthen our own confidence in the author's wider experience. To put it differently, Browne deliberately creates a momentary impression of emotional tribulation in order to heighten the subsequent triumph of the sane, reasoning self which has assigned in a divided world the paradoxes and mysteries to the realm of faith. Thereby it has fortified its own dominion elsewhere, creating a separation of kingship between Reason and Faith with each "exercising his Soveraignty and Prerogative in a due time and place, according to the restraint and limit of circumstance" (p. 85).

The following must surely rank among the most affecting passages in the work, seeming to reveal as we read it a profound spiritual ordeal; yet it is really *trompe l'oeil*:

> But it is the corruption that I feare within me, not the contagion of commerce without me. 'Tis that unruly regiment within me that will destroy me, 'tis I that doe infect my selfe, the man without a Navell yet lives in me; I feele that originall canker corrode and devoure me, and therefore *Defenda me Dios de me*, Lord deliver me from my self, is a part of my Letany, and the first voyce of my retired imaginations. There is no man alone, because every man is a *Microcosme*. (p. 152)

If one were to ask precisely what fear disturbs him, the answer would be hard to come by. The fear is diffused into generalized terms. The "unruly regiment

within" or "that originall canker" inherited from Adam are resorted to in place of specifics, and the purpose, it transpires, is really to lead up to "the Apophthegme of a wise man," the Ciceronian axiom that no man is less alone than when he is alone.

For some critics such last-minute withdrawal from a direct confrontation with his own doubts and fears has seemed to mark a failure in Browne's art. Stanley Fish particularly has faulted him within the context of the searching dialectical tradition of the seventeenth century for revealing a basic indifference to pain, for being more concerned with the making of a better artifact "than with the sounding of souls and the making of better persons."[18] But if Browne does not belong within that dialectical context at all, then the criteria themselves are inapplicable. It may be that his artistic purpose has been misunderstood, that he should be placed not within the category of meditative self-probing but elsewhere in the developing patterns of seventeenth-century thought.

Since the "baroque" identification of his prose began in the context of the visual arts, perhaps we should return there. Aesthetically, the *Religio Medici* has little affinity to the paintings of El Greco with which it has, on Croll's initiative, so long been compared. In those canvases, such as El Greco's *Resurrection* from about 1598 (*fig. 74*), anguished figures stretch upwards in religious ecstasy, striving away from actuality in their yearning for the eternal. Theirs is a faith snatched from despair, echoing the tormented cry of Fulke Greville at the wearisome condition of man, divided between reason and passion:

> Born under one law, to another bound,
> Vainly begot, and yet forbidden vanity,
> Created sick, commanded to be sound.[19]

Such religious mannerists as El Greco and Tintoretto escaped from the dictates of reason and the new empiricism by placing their hope in a transcendence of reality, a closing of the shutters on this world, whose forms eventually lose their accustomed shape or their final validity before the spiritual vision of a soul reaching beyond. Browne, with his sharp interest in natural phenomena, his careful tabulation "of places, beasts, fowles, & fishes," the depth of mines and the subsistence of cities, has no part in this rejection or even derogation of ac-

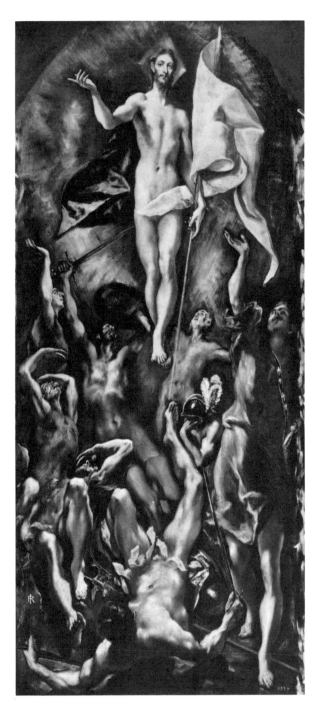

74. EL GRECO, *Resurrection*

tuality. Although he declares that he will not "so forget God as to adore the name of Nature" (p. 79), nevertheless, since he sees in it the wisdom of the divine plan, to study and engage in deliberate research into His creatures is "the debt of our reason wee owe unto God" (p. 75). While never underestimating the significance of eternal life, he can, by his firm awareness of the division of realms, indulge his empirical bent to the full. Hence the absence of any tension between his tasks as a physician and his religious beliefs as a Christian; and hence also his achievement of a resolution between the natural and the spiritual.

If we must beware of any easy classifications of the various aesthetic forms in which the conflict between reason and faith expressed itself in that era, at least the broader groupings are comparatively clear within the visual arts. Both mannerism and baroque rely on an emotional response to the physical world, one despising it as merely temporal, the other glorifying it as the work of God's hand. But there is a third style emerging in the early seventeenth century, exactly contemporaneous with Browne's treatise, which may be more relevant to his writings.

After a number of unsuccessful attempts in Rome to imitate the opulence of the Italian baroque artists, the style which Nicolas Poussin inaugurated on his return to France was the portrayal of apparently passionate scenes, over which the calm dictates of rational restraint are made to prevail. The technique he employed to achieve that effect is, I believe, instructive for an understanding of Browne. *The Worship of the Golden Calf (fig. 75)*, for example, which Poussin painted in 1636, depicts ostensibly the fervour of the religious celebrants as they dance in honour of their new god. In the tradition of Titian's scenes of bacchanalian orgy, the figures are presented at the moment of revelry; but where Titian swings the spectator into the sweeping movement of Bacchus' own leap from the chariot, Poussin remains aloof. He creates only an illusion of revelry rather than genuine abandonment. The key to that technique is revealed only on closer scrutiny; for each figure, seemingly whirling in a circle of dancers, is, in fact, carefully poised upon one leg in perfect equilibrium. Were the dancers to release hands, each would remain upright and stable.[20] As a result, we are led to imagine that we are witnessing a scene of human surrender to passion but, since the passion is posed, are artistically prevented from surrendering to it ourselves, and hence our confidence in rational control is strengthened.

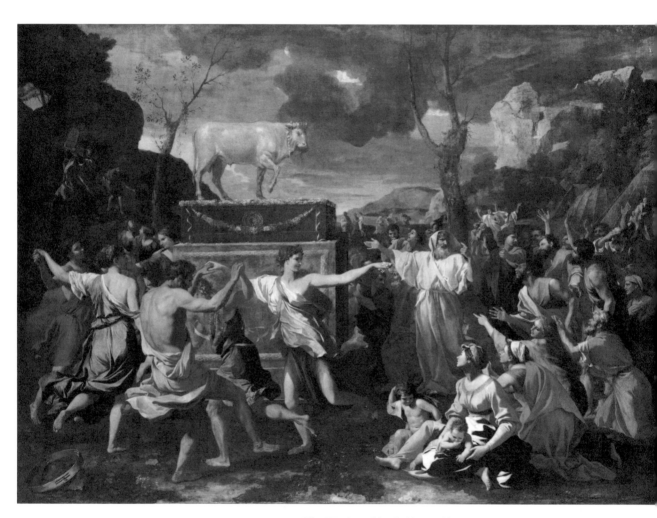

75. POUSSIN, *The Worship of the Golden Calf*

The "modes" or rules for painting which Poussin introduced into France and which, through his pupil Charles LeBrun, were to dominate the French Royal Academy throughout the reign of Louis XIV, established the so-called "classical" style with its respect for rationalism. "We must not judge by our senses alone," he declared, "but by reason"; and he demanded "a certain restraint and moderation" in the portraying of all scenes however violent or passionate they might be in theme.[21] To achieve such restraint a method he adopted in his own paintings was to avoid the depiction of spontaneous emotion by employing instead dramatic gestures which, like the device of the static posing of dancers, would serve to indicate passion without implying personal involvement. Where the figures in El Greco's *Resurrection* are caught at the very moment of revelation, writhing in torment or flung violently backwards by the immediate shock of the vision, the worshippers to the right of Poussin's painting are calm and motionless. Their inner feelings are not displayed but rather suggested by their stance—an outstretched hand, a turn of the head, a pointing finger. The only real passion seen in action, Moses' fury as he dashes the holy tablets to the ground, is significantly relegated to a dark patch in the background, where it could easily be missed were it nor for the heads of two revellers below, turned away from the celebration to gaze at the source of the disturbance. The religious fervour of Moses, therefore, although intrinsic to the biblical scene, is by that means separated from the main action, alluded to but not permitted to affect the dominant calm of the picture. In the same way, *The Rape of the Sabine Women (fig. 76)* which he completed in the following year, presents what should by its subject-matter be a scene of passion and turmoil. Such is, indeed, the initial impression, once again suggested by the gesturing women held aloft by their captors and by the group about the half-naked soldier in the foreground, evocative of the Laocoön sculpture but immobile in the perfection of their statuary balance. Yet even such dramatic gesturing does create some degree of emotional engagement. To counteract it, therefore, Poussin places on a raised structure to the left the Roman officer Romulus, calmly surveying the scene and lending a prevailing mood of restraint and order to the painting as a whole.

Browne's *Religio Medici*, composed during the very years that Poussin was working on these two paintings, reflects in literature that movement towards ra-

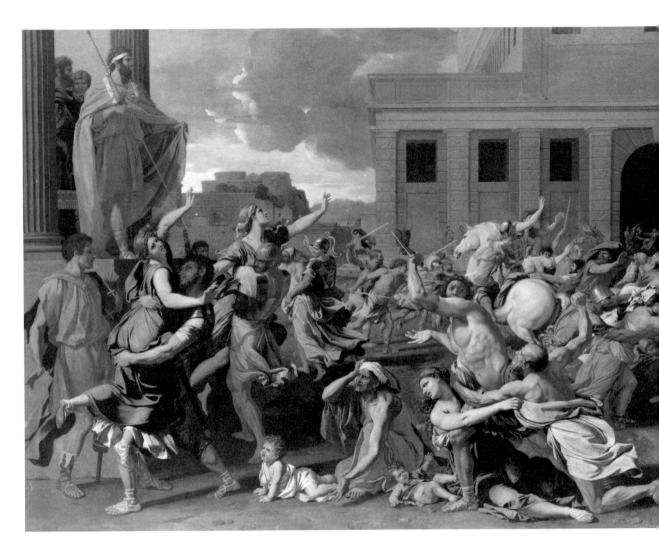

76. POUSSIN, *The Rape of the Sabine Women*

tional control which was to find its culmination in the dramas of the Restoration stage. There the swelling pride of martial ambition or the ardour of masculine love, while admired for their vigour and splendour, must eventually be modified by the cooler intellect. Even the impassioned characters themselves seem to possess divided personalities in this regard, standing, as it were, outside themselves at the moment of highest fervour, calmly measuring, almost as with a thermometer, the degree of anger or frustration to which their emotions have succumbed and commenting upon them, rather than offering any demonstration of passion itself:

> ABDELMELECH. She's gone; and now
> Methinks there is less glory in a crown;
> My boiling passions settle and go down.[22]

In Browne's writings the religious ardour he experiences is never condemned. On the contrary, it is validated as an integral part of Christian worship; but like Moses' wrath it is moved into the background; it is seen as belonging to the past or, indeed, to any period other than the moment of writing. He will allude to an *O altitudo!*, to his "untamed affections," to his abundant weeping at religious ceremonies, but we are never permitted to watch the author actually engaging in mystic or devotional meditation, nor see his soul struggling towards the realization of a truth.

At his most personal moments, therefore, with assurances that he speaks from his soul, he encourages us to believe that an act of intimate self-revelation is about to occur; but the potential confession is carefully dissipated into abstract terms such as "a mass of mercies," or "favour of affection," and the passage proceeds not towards a personal discovery which we may share, but to the promulgation of a universal religious truth, an assertion of the established tenet that "God is mercifull unto all":

> And to be true, and speake my soule, when I survey the occurrences of my life, and call into account the finger of God, I can perceive nothing but an abysse and masse of mercies, either in generall to mankind, or in particular to my selfe; and whether out of the prejudice of my affection, or an inverting and partiall conceit of his mercies, I know not, but those

which others terme crosses, afflictions, judgements, misfortunes, to me who enquire farther into them than their visible effects, they both appeare, and in event have ever proved the secret and dissembled favours of his affection. It is a singular piece of wisdom to apprehend truly, and without passion the workes of God, and so well to distinguish his justice from his mercy, as not to miscall those noble attributes. (p. 126)

The apparent fervency of the opening is, it transpires, only a lead-in for a reasoned theological statement; it is a "posed" passion which ultimately confirms the calm, controlling view.

On the other hand, despite that overall serenity, we remain persuaded of Browne's profound faith. His is not a theological treatise presented from the standpoint of a cold rationalist. It offers instead a touching self-portrait of a soul which has been plunged into doubts and fears, has joyed in mystery and paradox, and has meditated long on the nature of death. But it is a prose-poem of one no longer actively engaged in a disturbed search for spiritual truth, who is content instead with the religious philosophy he has evolved—rendering unto reason that which is reason's while yet rendering unto God that which is God's.

If definition requires not only a description of content but also the exclusion of whatever is alien to it, the removal of Sir Thomas Browne from his established position as the El Greco-like exemplar of mannerist prose in England may leave us freer to examine its truer representative, Donne, who in his prose no less than his poetry is so characteristic of the European mode. As in the passage briefly examined at the beginning of the chapter, with its disturbed rhythms reflecting the emotional anguish of the speaker—"when I shall need peace, because there is none but thou, O Lord, that shall stand for me"—it is in his religious writings, whether the sermons or the *Devotions Upon Emergent Occasions* that one finds in seventeenth-century English prose the qualities which Croll so sensitively discerned as an emergent European style, the abandonment of majestic Ciceronian rhetoric in favour of a more personal idiom less tolerant of logical progression, more immediate in its sudden tergiversations and, above all, in the sense it con-

veys of a process of discovery shared by author and reader. For as always, the emergent style was not mere fashion but symptomatic of a changing philosophical outlook. A distrust of reason was inherent in the scepticism of Montaigne and, within the religious sphere, in the Counter-Reformation cultivation of casuistry, the preference for Christian paradoxes denying the limitations of the earthly. Moreover—and no less significant for the new styles in art—such cultivation of paradox courted the technique of surprise. The revived meditative tradition sought imaginatively to wrest the worshipper out of his normal assumptions and shock him into faith; and part of that strategy was the process of misdirection, a leading of the unsuspecting meditator by rational steps into some fallacy or absurdity from which he is compelled logically to recoil, seeking a more satisfying alternative. That sequence of recoil, search, and eventual perception is intrinsic to the sense of personal discovery, of the reader's participation in a voyage of exploration which marked the new style in mannerist prose as it did in the painting of the time. Less interested than either Titian or Poussin in the humanist tradition, in the response of men and women to biblical events within their earthly setting, Tintoretto was drawn primarily to the wondrous elements in scriptural narrative. His *Miracle of the Brazen Serpent* (*fig. 77*) from 1575-76 presents that incident through the eyes not of a spectator but of a visionary, for whom it has become a turbulent transcendence of natural order, a manifestation of divine glory. In a chiaroscuro scene, with deep shadows contrasting with brilliant unworldly light, the Israelites on earth, like the angels in the thick clouds above, writhe and twist in mingled torment and ecstasy. Its purpose is not quietly to confirm faith but to excite into fervour by persuading the viewer to witness a moment of revelation, not vicariously but as an active participant in the drama itself. The spectator's eye, led into the canvas by the diagonal path in the foreground formed by the tangle of bodies, reaches the central patch of bright light, only to find there instead of the expected subject of the painting, a *Sprecher* figure dramatically directing him on towards Moses at the left and through the latter's outstretched arm upwards to the final focus of the painting, half-hidden against the glowering sky. The viewer has, in effect, by that devious path been compelled to travel his own circuitous route and to undergo thereby the same tortuous movement of discovery. When his eye does

297

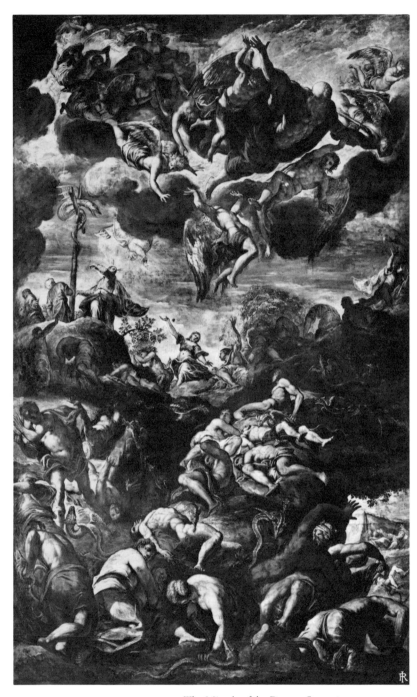

77. TINTORETTO, *The Miracle of the Brazen Serpent*

reach that focal point, it is to find far more than a scene of bodily healing. Curled about a cross, the serpent outreaches the limits of chronology to merge in symbolic paradox the major events of Christian history—the snake-entwined Tree of Eden from the past, the healing of the Israelites in the present, an adumbration of Christ's victory over the Serpent upon the Cross at Calvary and even, apocalyptically, the cessation of all sin and suffering at the end of days. Unlike a Poussin canvas or the *Religio Medici* in literature inviting interested, rational observation, this canvas, through the immediacy of its personal vision captures by its swirling lines the energy of a soul in agitation, the meditator's O *altitudo!* But again in contrast to Browne, that gasp of wonder is not recollected from some past occasion but vividly projected here at the instant of its being experienced.

Donne too, in a sermon he preached at the wedding of Margaret Washington in 1621 on the verse "And I will marry thee unto me for ever" (Hosea 2:19), climaxes his discourse with a vision, in this instance a vision of his soul's marriage to the Lamb in heaven. He offers there a scene like Tintoretto's which spurns the logic of temporal existence in favour of the miraculous inversion of all earthly norms. And the prose he employs deserts the philosophical, measured cadences of Renaissance writers in favour of rhythms and images generating the excitement and intensity of personal revelation:

> I shall see the Sunne black as sackcloth of hair, and the Moon become as blood, and the Starres fall as a Figge-tree casts her untimely Figges, and the heavens roll'd up together as a Scroll. I shall see a divorce between Princes and their Prerogatives, between nature and all her elements, between the spheres, and all their intelligences, between matter it self, and all her forms, and my marriage shall be, *in aeternum*, for ever. I shall see an end of faith, nothing to be beleeved that I doe not know; and an end of hope, nothing to be wisht that I doe not enjoy, but no end of that love in which I am maried to the Lamb for ever. Yea, I shall see an end of some of the offices of the Lamb himself; Christ himself shall be no longer a Mediator, an Intercessor, an Advocate, and yet shall continue a Husband to my soul for ever. Where I shall be rich enough without Joynture, for my Husband cannot die; and wise enough without experience, for no new thing can happen there; and healthy enough without Physick, for no sicknesse can enter; and (which is by much the highest of all) safe enough

without grace, for no tentation that needs particular grace, can attempt me. There, where the Angels, which cannot die, could not live, this very body, which cannot choose but die, shall live, and live as long as that God of life that made it.[23]

Here too the jolt of the unexpected awakens the audience from its conventional assumptions. The startling statements that on acceptance into heaven "I shall see an end of faith . . . an end of hope" just at the moment when faith might have been expected to be finally assured and hope ultimately asserted are, by their illuminatory resolutions, reminders that the soul has reached a sphere utterly different from the terrestrial, where all human needs, deficiencies, and desires will have disappeared forever. There is indeed true eloquence here, the incremental repetitions and rhythmic patterns of great rhetoric; however, it is not employed like the Ciceronian to win admiration for its elegance but to serve the urgent subject-matter of the discourse, the rhythms dictated by the throb of passionate engagement. Donne, when an idea needs to be modified or explained, does not hesitate to break up the flow of speech by interpolations or parentheses; and thereby he creates the "curtness" of natural speech movement:

> When I shall be rich enough without Joynture, *for my Husband cannot die*; and wise enough without experience, *for no new thing can happen there*; and healthy enough without Physick, *for no sicknesse can enter*; and (*which is by much the highest of all*) safe enough without grace . . .

Above all, despite the formality of the prose, appropriate in a sermon prepared for a ceremonial occasion and no doubt read aloud there from a written text, its power arises from the hearer's conviction that at the moment of its delivery, no less than at the moment of its composition, it was recapturing in words the immediacy of the preacher's own visionary experience—not universalizing the human condition into magniloquently abstract terms but, with all its significance for every Christian soul, focussing upon the compelling hopes, fears, and trust of the speaker's intimate self, his longing that there "where the Angels, which cannot die, could not live, this very body, which cannot choose but die, shall live, and live as long as that God of life that made it."

8

THE WORLD AS ANAGRAM:
THE POETRY OF GEORGE HERBERT

THE REHABILITATION OF GEORGE HERBERT IN THIS CENTURY
after so long a period of neglect and his eventual readmission into the antholo-
gies as a poet worthy of regard did not generate, as did the rediscovery of
Donne, a sense of excitement in the critical world, a conviction that here were
forgotten tones, themes, and experimental patterns of writing which might re-
shape our understanding of the very nature of poetry. Until recently, even the
warmest admirers of his art had drawn attention primarily to the serenity of his
faith, the gentle lyricism of his Christian teaching, and the quiet charm of his
verse, sometimes using him, as did Joseph Summers, as a counterbalance to the
predominant emphasis in New Criticism on the inner tensions, paradoxes and
ambiguities of poetry.[1] There was, after all, patent support for such a view in
Herbert's own declarations of purpose, when in both of his Jordan poems he re-
jects with scorn the abstruseness or "winding structures" of seventeenth-cen-
tury poetic wit, the "curling" metaphors whose sense could be caught only at
two removes, in favour of a directness of language and imagery which should
convey to his reader the uncomplicated faith of a genuine and humble belief. In
line with those statements, a leading study of his work could, as late as 1968, still
argue that his poems are to be understood essentially in the context of the plain
style, since by their eschewing ornament and convolution they lead to the vic-
tory of simple love and trust in their concluding lines.[2] From Rosemund Tuve,
it is true, we learned of the web of concealed liturgical allusions in his verse, for
the most part lost to the modern reader, which, by their subtle evocation of ideas

and phrases familiar from the Anglican service, had provided for the seventeenth century a poetic dimension unrecognized in our day. Yet if this more complex allusiveness seemed to question the previous assumption of Herbert's poetic directness, her study left unchanged the view that each individual poem was ultimately an ordered and integrated structure leading towards its Christianly reassuring conclusion.[3]

The structure, as was clear even then, was not undeviatingly linear. It employed surprise elements and emotional reversals; but such abrupt changes of direction to disqualify some false assumption on the part of the speaker or to check a dangerous tendency towards the sin of pride were seen as forming part of the conscious plan, as intended from the start to create the dramatic immediacy and often disarmingly colloquial realism of the verse. Thus, the speaker's confident assertion in "The Pearl" that he knows the way to God's love and is familiar with the price and rate for obtaining it is, at the word *Yet* when the poem moves into the past tense, suddenly swept aside by a retrospective, guilty realization of the lack of humility implicit in such self-assurance, the tone now changing in an abrupt *volte-face* to one of penitence and self-abasement for his "grovelling wit":

> with open eyes
> I fly to thee, and fully understand
> Both the main sale, and the commodities;
> And at what rate and price I have thy love;
> With all the circumstances that may move:
> Yet through these labyrinths, not my grovelling wit,
> But thy silk twist let down from heav'n to me.
> Did both conduct and teach me, how by it
> To climb to thee.[4]

In 1970, Helen Vendler proffered a suggestion disturbing to critical formalists accustomed to regard a poem as the finished product of the poet's art. Those twists and tergiversations were, she argued, not part of a didactically planned structure but a series of genuine "reinventions" on the poet's part as in the process of writing he restlessly redefines his experience, correcting an infelicitous

phrase, tempering a theological assumption, revising an inadequate formulation or dubious religious stance. Where other poets expunge their false starts and discard ineffective lines in order to replace the rejected passages by new ones so that none but the scholar laboriously editing the manuscript would ever know of the changes, Herbert, she maintains, preserves them intact in the final version of the poem as a record of his own tortuous path to the spiritual communion with the divine achieved only in the closing lines.[5] Such a reading, by indicating the provisional and shifting quality of his verse, posits an image of Herbert at once more complex spiritually and poetically than had previously been thought; not a preacher sure of the instruction he imparts but a dissatisfied searcher, forever tacking and veering to avoid the hidden sandbanks treacherous to faith.

Attractive as her theory may be in sensitizing us to the subtler movements of his verse, its weakness lies in the very complexity it assumes, a complexity which can scarcely accord with Herbert's own repeated avowal of the simplicity of true faith and the artlessness of the lessons he wishes to convey. "There is in love a sweetness ready penn'd: / Copy out only that."[6] In that same poem, he records how often he "blotted" what he had begun because it was not lively enough for his purpose; and to argue that he left the "blotted" sections of his poems undeleted as part of the final text would seem to contradict his own account of his customary process of composition.

With a similar respect for the thematic and structural subtleties of these poems and partly in response to Helen Vendler's theory, Stanley Fish has recently offered two variant interpretations of these sudden reversals of direction, the first as part of a larger study of seventeenth-century poetic and the second in a form more specifically related to *The Temple*. Within the broader study, his stimulating redirecting of critical attention from the text as finished work to the activity of reading itself, the changing responses which we experience as each consecutive line or phrase interacts with our own consciousness, led him to place Herbert's work in the category of the "self-consuming" artifact—exemplified on his book-jacket by Jean Tinguely's modern sculpture photographed at the moment of its planned self-destruction.[7] With the delicacy of a critic attuned to poetic modulations, Fish argues that there is to be perceived in Herbert's poems a gradual annihilation of the poet's or speaker's self. The perceptual and concep-

tual categories in which the human moves are slowly eroded until the poet him-
self ceases to exist as an independent being. The aim of the poems is thus seen to
be not a vindication of the plain style, as had been thought, but ultimately a val-
idation of poetic silence. Towards the close of his poems, Fish maintains, Her-
bert obliterates himself even as the author of the lines we are reading. The source
of the lines, the very creative act of their composition, is disclaimed by him and
attributed to God—not in some coy literary convention but with all the persua-
siveness of genuine belief. His well-known poem printed in the visual form of
an altar is offered by Herbert, we are told, not as an edifice constructed by the
poet's skill but as one framed directly by nature, which in accord with biblical
commandment no workman's tool has touched. If acceptable, its purpose will
be to serve henceforth as a substitute for the poet's words, becoming, as it really
is already, not Herbert's poem but God's. The ambivalence resonating in the fi-
nal word suggests, therefore, that it is not only dedicated to God but now His in
every sense of the term, including its origins:

> Oh let thy blessed S A C R I F I C E be mine,
> And sanctify this A L T A R to be thine.

Intriguing though that theory may be, Fish seems himself to have been dis-
satisfied with it, and, taking a leaf from Herbert's book, a few years later he also
reversed direction, offering in his recent volume, *The Living Temple*—a study
devoted exclusively to Herbert's verse—an alternative explanation for the sup-
posed "reinventions" of the poems. Although the reasons motivating his change
of view were never specified there, we may suspect where he felt the weaknesses
to lie. In "The Altar," for example, silence is not in fact espoused by the speaker
as Fish had suggested; it is merely mentioned as a casual possibility—"That if I
chance to hold my peace, / These stones to praise thee may not cease." Herbert,
as we know, did reject silence, continuing to write and to produce poem after
poem as part of an *opus* planned as a missionary endeavour to win others over to
his beliefs. Within that collection, so far from obliterating his personal identity,
he repeatedly employed his own easily recognizable self as the leading figure in
the drama of human communion with the divine, with scenes from his experi-
ence, whether fictionally devised or historically based, reenacted for the moral

edification of his readers. Presumably Fish sensed the contradiction inherent in his earlier view—the positing on the one hand of Herbert's denial of self and, on the other, of the self-confidence and assurance requisite in however minimal a form for the task of religious instruction, an assumption, at whatever level of humility, that the teacher possesses some experience or knowledge worthy of being imparted to others. At all events, in the revised theory he placed the poetic reversals within a new setting, not as rectifications of false starts by the poet but instead as part of a planned process of spiritual teaching.

Again focussing upon the reader as active participant in a dialogue with the text, Fish saw in the tradition of the catechism (of which Herbert was known to be a keen advocate) a strategy of spiritual pathfinding relevant to our understanding of his poems. In the chapter devoted to that educational device in his prose work *The Priest to the Temple: or the Country Parson, his Character and Rule of Holy Life*, Herbert had advocated not a simple teaching or testing by rote but, in its most effective form, a leading of the pupil towards self-discovery. The catechist, nudged towards some false conclusion, catches himself in error and by self-correction attains to the truth with a more fruitful sense of personal achievement than passive learning would have provided. So, in the poem "Love-joy," the reader is encouraged in the opening lines to make the easy identification of the initials "J.C." with the name Jesus Christ (a choice made even more likely by the typological association of the grapes, on which the initials appear, with the blood of the Passion). Momentarily confounded a few lines later when the speaker identifies the initials with Joy and Charity instead, he is comforted at the conclusion by the interlocutor's assurance that his own original answer had been correct:

> Sir, you have not miss'd,
> The man reply'd; it figures JESUS CHRIST.

By the temporary misdirection in the poem, Fish argues, the reader has not merely returned to his first assumption but has gained *en route* some valuable additional knowledge, the equation of Christ with the principles of joy and charity; and the process of perception is one in which the reader has been an active participant. Yet this theory too has its problems, for as Fish admits a little rue-

fully, the catechist situation is relevant only at times. The reader is not always addressed in the poems and the structural progression often does not accord with any sequence of question and answer. Fish must therefore resort finally to a vaguer framework, if not the catechism itself, then the broader process of the reader's self-discovery.

What emerges from this recent critical debate on the nature of Herbert's "reversals," divergent as the suggested solutions may be, is a heightened awareness of a puzzling discrepancy, the realization that his poetry seems at one and the same time to suggest both restlessness and security, a planned structural unity on the one hand and yet some indication of unpredicated, dissatisfied revision on the other, perhaps intended temporarily to mislead the reader. There is, I suspect, no magic formula to resolve these discrepancies. Herbert's verse, like all great poetry, will no doubt continue to provoke a wide and varied range of responses and to tease us with the subtleties of its content and form. Within this present study, however, it will come as no surprise if I propose that the problem should not be studied in isolation but as part of the changing aesthetic climate in European art. How precisely the techniques of his verse reflect the new modes manifesting themselves in painting and architecture will require more detailed examination, but even at this stage it will be apparent that this concept of the deliberate misdirection of the reader has a close affinity with the contrived illusionism of mannerist art—contrived in its less serious forms simply to surprise, but within religious mannerism with the earnest purpose of producing in the viewer a momentary sense of insecurity or instability, a distrust of the rational, spatially defined temporal world in which he stands as a preparation for his translation into the world of ecstasy or of meditative identification with martyr and saint. For that aspect, however, we shall need to review some of the more recent interpretations of the art form.

Mannerism, that most elusive and Protean of styles, has elicited a bewildering plethora of contradictory definitions from those attempting to define its characteristics. For those suspicious of the very existence of a *Zeitgeist* the debate has

provided an entertaining spectacle, reminiscent of the elephant and the blind men, one of whom, holding its tail, solemnly declares it to be very like a snake while another, grasping the animal's leg, insists on its amazing resemblance to a tree. Ernst Curtius, confining himself to the literary manifestations of that style, defined it as a phenomenon reappearing cyclically throughout history, generally towards the end of a period valuing the classical principles of order and restraint. Its main impulse he identified as a desire for liberation from imposed and even self-imposed restrictions. It is marked therefore by a wilful cultivation of eccentricity, of verbal pyrotechnics, and of complex, convoluted argument.[8] Among art historians there developed a similar conception which, in its application to the architecture and painting of the sixteenth and early seventeenth centuries, discerned in tandem a rejection of convention and a pursuit of visual incongruity, often for its own sake. There are, as in Parmigianino's *Madonna of the Long Neck* from about 1535, columns which inexplicably support nothing, deliberate distortions of linear or anatomical proportion, and a crowding of figures to disrupt the established harmony of High Renaissance form.[9]

On the other hand, John Shearman, in an influential address to a conference on mannerism in 1962 (later expanded into a book) challenged that view, seeing the distinguishing and unifying quality of the style not as a negative impulse, a fretful weariness with established modes, but rather as a new and lively pursuit of elegance and sophistication for their own sake. The term *maniera* from which the style, through Vasari, a member of the group, obtained its name, was, he pointed out, originally used at that time in a positive sense indicating artistic flair, and only later gained its pejorative connotation of idiosyncratic perverseness. Mannerist works, therefore, should not be judged according to the Renaissance criteria of volumetric realism or harmonious proportion but as deliberately stylized artifacts. A silver salt-cellar by Benvenuto Cellini or the attenuated figures by Primaticcio were, he argued, conscious demonstrations of virtuosity and craftsmanly skill, to be valued accordingly.[10]

One particularly welcome side-product of Shearman's reading has been its neat circumvention of the reasons for treating this style at best with condescension and more often with active dislike. For once elegance and bravura were seen to be the ideals endorsed by such artists, the attempt to condemn mannerist art-

ists by those very High Renaissance standards of verisimilitude or harmony which they were consciously rejecting was seen to be absurd. Accordingly, his validation of the style has, after the short-lived rise in its reputation during the twenties, again opened the way for a more appreciative reappraisal of their work.

Louis Martz, for example, has persuasively used that reading of the art form to separate Marvell from the metaphysical tradition and link him with Carew, Herrick, and Lovelace as consciously "stylish stylists" who, like the mannerist painters, recall the lessons of their masters and then proceed to use those lessons in a way that departs from the rational harmony and idealized beauty characteristic of the Renaissance. In these poets he identifies a joy in incongruity and virtuosity which predominates even when the subject-matter is overtly religious. The central conceit in Marvell's "On a Drop of Dew" is so coolly and deliberately developed that it seems attenuated by intellectual control, producing an effect of polish and wit rather than of Christian commitment. More recently, James V. Mirollo has used Shearman's reading of mannerism with equal effectiveness. Both in the Petrarchan love-sonnet, with its technique of variation on established literary conventions, as well as in such pastoral poems as Marlowe's "Come Live with me and be my love" with the sequence of "Replies" it evoked from Ralegh and others, he has recognized a mannerist delight in art commenting upon art, in the effect, as on a palimpsest, whereby the reader is simultaneously to view the text before him and to discern through the text the earlier versions to which it is offering a witty or sobering response.

At the conference in which Shearman presented his new approach, Frederick Hartt subsequently read a paper on mannerist art which might at first sight appear to be diametrically opposed in its interpretive stance. So far from elegance and wit, the main impetus of the movement was, he argued, a mystical fervour reflecting the intense piety of the new monastic orders then arising within the Church. The Theatines, founded by Gaetano in 1524, adopted regulations even stricter than those of their predecessors in banning for its wandering friars all forms of begging or requesting of alms. They were to accept only spontaneous offers of charity. At a time when the Church of Rome was under attack for its laxity of morals, the Capuchins in 1525 tightened their own self-imposed disci-

pline by insisting that members of their new order were to go barefoot at all times, and as the culmination of that outcrop of new ascetic orders, the Society of Jesus, founded in Rome in 1540, demanded the most far-reaching surrender of all, a total submission of intellect at a time when explorative enquiry and in-dividualism were at the height of secular fashion.

Paralleling this surge of piety within the Church, contemporary painting, Hartt notes, displays an intensified devotionalism. After a period at the begin-ning of the sixteenth century when the theme of the *Pietà* had rarely interested artists, from 1517 onwards there is a sudden focussing upon that subject, with paintings by Pontormo, Rosso, and many others, all conveying a deep sense of mystery and inwardness of vision. Pontormo's *Deposition* of 1525 (*fig. 78*), he points out, has no spatial setting, no cave, no cross, not even a tomb, but in the tradition of San Gaetano, who was known to spend many hours rapturously contemplating representations of holy scenes, it depicts that moment in Chris-tian history as the focus for a perpetual adoration of the sacrament. Its aim is to evoke in the spectator the mood of being *amore inflammatus abreptusque.*[11]

Contrasting as these readings of mannerism may seem, they should be re-garded, I would suggest, not as antagonistic but as complementary, as describ-ing two different facets of the art style—the secular and religious manifestations respectively. The secular form expressed its dissatisfaction with integrated and rationalized space in painting and architecture by resisting the newly discovered rules of perspective. The emphasis here, as Shearman has shown, is on a surface texture which discards depth-illusion, as in the pearly nudes of a Bronzino can-vas. Alternatively it offers an amusing display of wit and ingenuity, often mov-ing beyond verisimilitude into the realm of the chimerical, as in Arcimboldo's facial portraits, the features grotesquely composed of gnarled roots and fruit, or, in the portrait of *A Librarian*, of piled books. Even within the secular sphere there seems to have been some desire to undermine the spectator's sense of firm-ness and solidity. On the facade of the house Giulio Romano built for himself in Mantua, the half-windows along the base line create the strange impression that the entire building is sinking into the ground. And as part of the mannerist im-pulse to surprise, Shearman includes the fantastic grottoes and water-gardens at Castello, at the Villa d'Este, and at Pratolino, where Bernard Palissy and Buon-

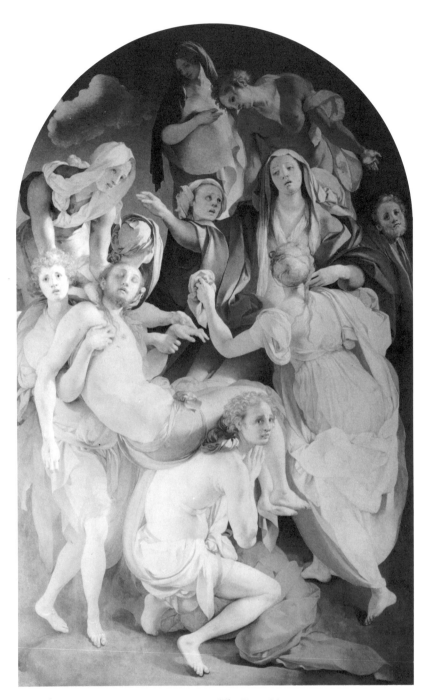

78. PONTORMO, *The Deposition*

talenti designed elaborate *tableaux* to be set in motion at the turn of a hidden tap, as well as practical jokes to tease the visitor, including a statue holding a vase in one hand and a text in the other which would empty the vase on the head of anyone stepping forward to read the text.[12]

There is, understandably, no such frivolity or casual wit in the forms of mannerist art employed by the religiously committed artist, although the latter does share, in a more serious mood, the questioning of rationalist authority and the reduced confidence in the physical world. When that same Buontalenti created in the church of S. Trinita (moved later to S. Stefano) the sensation of an altar disintegrating before the eyes of the entering worshipper, it is clear from his placing of the device in the most sacred section of a church that his purpose there is not to arouse the jocular response he hoped to obtain with his "wetting-stools," spraying unwary visitors who sat upon them at Pratolino. Its effect in that revered setting was to make the entering worshipper momentarily lose confidence in the substantiality of the building around him and hence in the ultimate authenticity of the temporal world in which he stood, and thereby to prepare him emotionally as he approached the altar for the spiritual prayer and meditation in which he was about to engage.

However different the secular mannerist may have been from the religious, particularly in the greater intensity and seriousness of the latter, this querying of structural solidity was a shared quality. We may note as one instance a fresco which Giacomo Zanguidi (known as Bertoia) painted in the Palazzo del Giardino in Parma between 1566 and 1571, depicting a crowded hall (*fig. 79*) in which the many columns supporting the ceiling are of pure glass through which all objects and figures behind them are clearly visible. The effect is especially disconcerting because of the traditional association of weight-bearing pillars with massivity and opaqueness. The scene may, I believe, have been inspired by the discovery in Venice at this time—a discovery of immense importance for the city's future trade and guarded by its laws with the greatest secrecy—of a method for manufacturing clear, colourless glass in place of the enamelled or gilt versions which its craftsmen had learned from Syria; but the idea in this fresco of applying the discovery to columns was an impracticality, whimsically devised by the artist to produce that momentary doubt beloved by the mannerist paint-

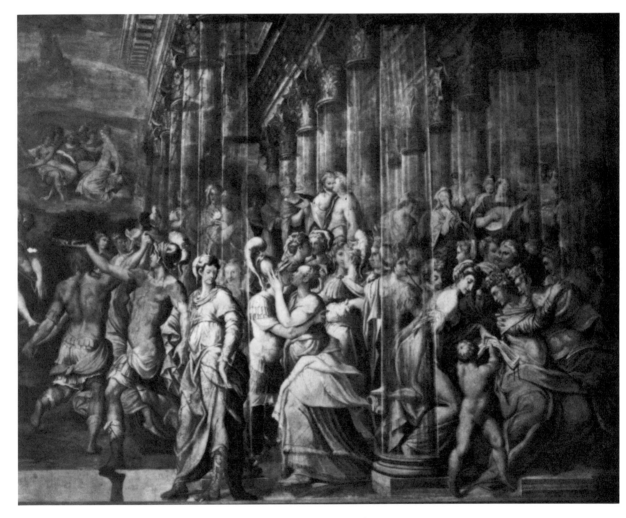

79. BERTOIA, Mural

ers, a feeling of temporary insecurity as the viewer gazed upon the diaphanous scene, peering through the insubstantial pillars to the figures beyond.[13]

There was in this mannerist encouragement of *contemptus mundi* a distinctly medieval quality. If Spengler was right in his theory of oscillatory movements in history, then a reaction to the High Renaissance would naturally possess affinities with the Middle Ages which had preceded it;[14] but as in all such instances, there could be no simple return to those earlier convictions. Nothing could erase the profound changes in philosophical and religious outlook which had occurred in the intervening years. During that time geographers and explorers had made their way to previously unknown areas of the earth, the cosmographers had mapped out the heavens with new accuracy, and the early empiricists had, through their varied enquiries, rooted in the contemporary consciousness a sense of the tangibility of terrestrial existence such as the Middle Ages had never known. The clock of history could not be set back. To recreate a conviction of *media vita in morte sumus* and a renewed susceptibility to spiritual contemplation akin to that of the past now demanded from the religious artist and teacher a forceful act of uprooting, a transportation out of the Renaissance consciousness of the physical such as had been superfluous for his medieval counterpart. The latter had accepted unquestioningly the contravention of measured time and place in the simultaneous presentation of the Fall and the Nativity; but by the time of mannerism, the spectator's inherent sense of spatial and temporal sequence needed to be undercut before he could be made to surrender to the fervour of divine visions transcending earthly limitations. Hence the emphasis upon ecstasy and rapture, the forcible snatching up of the soul from its bodily setting, the enthralling and ravishing in this period, not in the traditional Renaissance form of serene classical allegory, with a tranquil Europa settling herself comfortably on a quiescent bull, but both more intensely and more passionately as the worshipper, often with the shock of overt paradox, pleads for divine aid in releasing himself from the bonds of intellect and of the actual in order to enter the luminous world of religious paradox:

> Take mee to you, imprison mee, for I
> Except you 'enthrall mee, never shall be free,
> Nor ever chast, except you ravish mee.[15]

313

El Greco too must break through the rationalist assumptions of his era, violently transporting the viewer by means of hallucinatory figures defying anatomical proportion, as their souls seem to stretch them out of shape in longing for a more satisfying heavenly existence. The phosphorescent colours—the lurid greens, blues, and purples—create a dream-like setting in which forms lose their solidity, as in the visions induced by Ignatian meditation. His *Resurrection* (*fig. 74*, p. 290) deserts the quieter Renaissance tradition of Michelangelo's Vatican *Pietà* which had aimed at offering a holy scene for contemplation. Instead it depicts the impact of such a moment upon those privileged to witness the miraculous event, the shock of recognition. The canvas vibrates with the anguish, remorse, or religious awe of the human figures. One of them flung backwards to create an inverted reflection of Christ (symbolically representing the fallen Adam for whom the second Adam has risen) is thrust head over heels into, as it were, the very lap of the viewer, compelling in that viewer a sense of self-identification whereby he seems himself to undergo a similar process of "conversion" on both literal and figurative levels. And that emotional reversal is echoed in the people about Christ, revealing by their tormented postures and outstretched arms the agony of their own spiritual predicament.

The vividness of treatment is especially significant when we recall that there is no narrative source in the New Testament for such a scene.[16] In the Gospels the Resurrection has no witnesses, the soldiers only belatedly discovering the tomb to be empty. The canvas is intended, therefore, not as an evocation of an event in Christian history but as a stimulus for the fervent conjuring up of a meditative vision. Encouraged by Loyola's *Spiritual Exercises* and the other imitative religious programmes which began to proliferate at this time, the meditator was to visualize imaginatively some holy scene as if he were present in person, and to strive to experience afresh, as if on his own body, the martyrdom, bliss, or shock of revelation with the sharpness of actuality.[17] Hence it is that in such painting the spatial setting shimmers away into mistiness in a dream world beyond the tactile and the quotidian, where linear, vanishing-point perspective is no longer relevant. In the calmer but no less devotional art of Tintoretto, there is a similar rejection of Renaissance naturalism as he dramatizes the miraculous and the transfiguring. At a time when the Counter-Reformation was reaffirm-

ing the mystical sacrament of the Eucharist and resisting the more rational Prot-
estant disqualification of reliquaries, shrines, and hagiography, Tintoretto's se-
ries of paintings devoted to Saint Mark, including *The Finding of the Body of St.
Mark* (*fig. 80*) from about 1562, designedly carries the spectator out of the sub-
stantial world into the supernatural and the immaterial. The moment he chooses
is the visionary appearance of the haloed saint himself, dramatically halting the
search for his remains in the catacomb by announcing that the recently exhumed
body before which he stands is indeed his. The opened crypt from which the
body has been taken glows with a weird, unnatural light, whose greyish
emanations make the barrel-vaulting appear ghostly and evanescent. To the
right, an entranced figure writhes in the torment of the electrifying moment, a
smoke-like wisp issuing from his mouth as he is exorcised of some spirit within.
Moreover, the angle of the painting as a whole is disturbingly off-centre, the hall
receding sharply to a point towards the left, near the saint's hand. As Rudolf
Arnheim has remarked, the eccentricity of space in a Tintoretto painting indi-
cates that the law of this world has lost its absolute validity.[18] His scenes claim
their own centres and standards in defiance of traditional norms. This painting,
like the others in the series, is a canvas vibrant with religious faith, asserting the
primacy of the spiritual experience.

For devotional painting of this kind, the terms *caprice, elegance, virtuosity*, and
panache used so widely since the appearance of Shearman's paper to define man-
nerist art are singularly inappropriate. Such works possess a conviction of pur-
pose which makes trivial any concern with merely surface effects. If they do
share with the secular versions an anti-rationalist and anti-Renaissance impulse,
they express it in a context which demands profound seriousness from the artist
and a gravity of response from the viewer. Any attempt to define the mannerist
art style without distinguishing between its secular and religious manifestations
is liable to distort our perception both of its aims and its practices, and it is per-
haps that very tendency to treat them as a unified phenomenon which has caused
much of the confusion and discrepancy in the assessments which have been
made. For if these two variants move away from the ideals of harmony, propor-
tion, and naturalism to more disruptive, paradoxical, and even grotesque depic-
tions, the purpose at which they direct their energies are worlds apart. The sec-

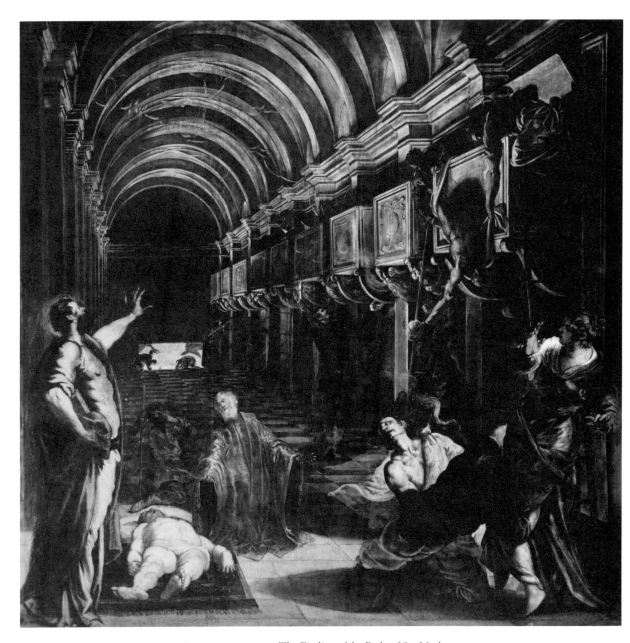

80. TINTORETTO, *The Finding of the Body of St. Mark*

ular artist aimed primarily at a display of personal skill, idiosyncrasy, or ingenuity, while the religious artist, reflecting the resurgent pietism of his time, exploited the art form as a medium for deeply serious ends, to express his dissatisfaction with the trammels of earthly existence and his yearning for the soul's release into eternity.

Although it has been a principle of this study that no direct contact need be posited between a writer and an artist nor any knowledge of each other's work be evidenced for them to be seen as sharing in certain ways the cultural expressions of their time, the insularity of England from aesthetic movements on the continent was, it may be noted, at this time drawing to a close, and works by leading European artists were becoming available for viewing in England, particularly by those with contacts at court. Charles I, a distinguished connoisseur in his own right, was assembling a magnificent collection of continental art whose hasty dispersal to foreign buyers under the Puritans was to prove an inestimable loss for subsequent generations. The King's agents scoured Italy, France, Germany, and the Low Countries for purchasable Titians, Mantegnas, Tintorettos, and Bronzinos, one of their most impressive achievements being their acquiring in Italy of the rich collection accumulated by the dukes of Mantua, which became available upon the failure of the Gonzaga dynasty. Within the royal entourage the Duke of Buckingham and the Earl of Arundel rivalled as collectors their monarch's enthusiasm as well as his cultivated taste, the Earl displaying an especial interest in sixteenth-century Italian mannerist paintings. The new aristocratic avocation reached such proportions as to evoke protests from two sources outside court circles—from the Company of Painters and Stainers who understandably resented the importation of foreign works and artists to the detriment of the underemployed English craftsman, and from religious circles, not only Puritan, which disapproved of the markedly Catholic treatment of Christian themes in the paintings now hanging in royal residences and in the homes of leading courtiers.[19]

With the increasing opportunity for continental travel on diplomatic and other missions, cross-fertilization of styles, as yet mainly one-directional, became feasible. Palladian architecture, admired and closely studied by Inigo Jones on his lengthy visits to Vicenza, received stately prominence in the new Ban-

queting House completed by 1621, where, on the ceiling of the main hall, the canvases commissioned from Rubens and executed by him in Antwerp were incorporated as intrinsic elements of the décor; while the latter's disciple Van Dyck, as official court painter, ensured that his English patrons were kept abreast of the latest continental innovations in portraiture. Art had at last become a fashionable interest in society. Sir Henry Wotton, with whom Donne maintained a warm and regular correspondence, published in 1624 while serving as ambassador in Venice an essay on *The Elements of Architecture* praising the proportions of contemporary Italian buildings; and Donne himself is known to have possessed his own considerable collection of paintings, some of Italian origin. In his will, he distributed them individually among his heirs, listing "the picture of the blessed Virgin Marye wch hanges in the little Dynynge Chamber . . . the picture of Adam and Eve wch hanges in the Greate Chamber . . . the picture of Marie Magdalene in my Chamber . . . the picture of the B. Virgin and Joseph wch hanges in my Studdy," while other beneficiaries were asked to select their own favourites from among those not specifically allocated. His reference to them by subject-matter rather than artist might suggest a devotional rather than an aesthetic interest on his part, but there is evidence to support the view that he was guided too by artistic discrimination. There are the lines in his poem "The Storme" praising Nicholas Hilliard as a miniaturist and the fact that his close friend Christopher Brooke, to whom that poem had been addressed and who may be assumed to have known Donne's predilections, bequeathed him in 1627 a painting of Apollo and the Muses assuring him that it was "an originall of an Italian Master's hand (as I haue bin made to Beleeue)."[20]

Whether Donne's contact with Italian art was in any way responsible or whether, as is more likely, his poetry arose organically out of the changing cultural conditions of sixteenth-century Europe, his devotional poetry constituted in its metaphysical reaching out towards eternity the literary equivalent of religious mannerist painting, stylistically as well as thematically. The swift tergiversations characteristic of his verse, the "buts" and "yets" which turn logic upon its head, the deliberate misdirection of the reader in order to surprise him into new ways of viewing his world, like St. Paul in Caravaggio's painting of his *Conversion*, cast backwards to the earth as he is suddenly blinded to the real

world by his dazzling vision of supernatural truth, all these have distinct rele-vance to the "reversals" in the poetry of Donne's admirer, George Herbert.

Herbert's verse may appear to have little in common with the passionate, vision-ary, and tortured quality of religious mannerist art. Outwardly his poetry is calmer, free from the rapturous longing, the brusque challenging of logic, or the violent inversions of perspective which distinguish an El Greco canvas or Donne's devotional verse. On the other hand, such poems as "The Flower" re-veal unquestionably the tension and anguish concealed behind that external calm, Herbert's need to wrestle with his own doubts and despair in order to achieve his brief interludes of inner peace. His turmoil rarely projects itself into the verse but, when he does become more passionate in his pleas, he can be hauntingly reminiscent of the tormented mannerist. Where Donne spurns the fixed measurements of empirical thought, subjectively contracting a universe into an eye or expanding one little room into an everywhere and El Greco stretches out his mortal figures in ecstasy as the soul's longings and fears distort their physical form, so Herbert, although concluding on a more submissive note, adopts a comparable elasticizing of space. In the first of his two poems en-titled "The Temper," he begs for divine remission of his suffering:

> O rack me not to such a vast extent;
> Those distances belong to thee:
> The world's too little for thy tent,
> A grave too big for me.
>
> Wilt thou meet arms with man, that thou dost stretch
> A crumb of dust from heav'n to hell?
> Will great God measure with a wretch?
> Shall he thy stature spell?
>
> ...
> Yet take thy way; for sure thy way is best:
> Stretch or contract me thy poor debtor:

This is but tuning of my breast,
 To make the music better.

Whether I fly with angels, fall with dust,
 Thy hands made both, and I am there:
Thy power and love, my love and trust
 Make one place ev'ry where.

In general, however, his connexion with mannerist art can be most profitably investigated in the context of the quieter strain, perhaps typified by Tintoretto, whose canvases, for all their commitment to the miraculous and the visionary, lead the viewer more gently into an acceptance of their religious assumptions. He employs, as I shall argue for Herbert, a more gradual process of conversion, persuading the viewer to question his conventional beliefs and more slowly to desert them in favour of the sacramental and mysterious. In his painting of *The Last Supper* in San Giorgio, Venice, for example, the diagonal positioning of the table disturbs, without shocking, those familiar with the standard frontal depictions of the scene in Renaissance art, and only after that difference has been absorbed do the luminescent elements of the scene, such as the angels swirling about the lamp, and the incandescent haloes begin to imprint themselves on our consciousness.

This strategy of seducing the viewer away from terrestrial criteria into a validation of the spiritual experience is particularly marked in Tintoretto's *Nativity* from the Scuola di Rocco (*fig. 81*). Since the viewpoint is from below, we first confront at eye-level an everyday scene within the ground floor of a barn, a group of peasants engaged in passing food from a basket, the scene only distinguished by the mysterious light cast upon it from above. In search of the source of that light, our gaze aided by the outstretched arms of the peasants is drawn upwards to the attic. There the Nativity scene is depicted from an unusual angle, as if elevated above earthly affairs, with its haloed Mary, a radiant Child, and a Joseph in adoration. But dominating that scene—and the element on which we are led to look last—is the mystic red glow of the heavens shining through the broken rafters to bathe the entire setting in the unearthly light of the miraculous, with a winged cherub hovering in blessing over the Birth. Instead of being dra-

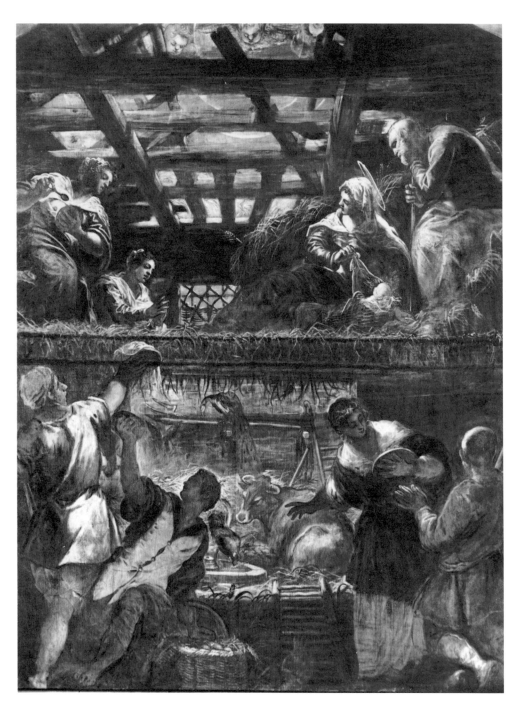

81. TINTORETTO, *Nativity*

matically projected into the supernatural in the manner employed by El Greco, we are here progressively enticed into an ascent, both literal and spiritual.

This gentler technique of elevation from the concrete world to the celestial, has, I believe, a particular relevance to the so-called "revisions" or "reversals" of Herbert's poetry which have been of such central concern to critics in recent years. In that context, the revisions need to be seen not as the poet's correction of his own false concepts or beliefs but as a stratagem whereby he invites the reader to accompany him from an initially terrestrial reading of his speaker's condition or situation towards the sacramental and transcendental viewpoint of Christian faith.

"Aaron" may serve as a paradigm of this poetic process. The despair in the opening stanzas is rooted in the world of actuality out of which the poet speaks, the awareness of his own human imperfection here on earth, his mortal unsuitability to the task of priesthood. That reciprocal integration of real and ideal in the Renaissance, the mutually enriching interplay of this world and the celestial which had formed so central a motif of its thought, no longer functions here. The poet's theme is the very opposite, the dreadful disparity between the ideal priest of harmony and perfection, serving in ancient times in the biblical sanctuary where he wore the divinely designed breastplate of Urim and Thumim described in Exodus 28,[21] and the unworthy priest of flesh and blood embodied in the speaker himself—frail, sinful, and unholy. Wearily he contrasts himself here on earth with the true Aarons:

> Holiness on the head,
> Light and perfections on the breast,
> Harmonious bells below, raising the dead
> To lead them unto life and rest,
> Thus are true Aarons drest.
>
> Profaneness in my head,
> Defects and darkness in my breast,
> A noise of passions ringing me for dead
> Unto a place where is no rest;
> Poor priest thus am I drest.

With that depressing contrast established, the first line of the next stanza now functions as the pivot for the entire poem, opening out new possibilities. Although expressed with a deceptive calm, it provides a mental and emotional jolt to the reader, a stimulus to reject the authenticity of the real and to move to "another" and more amenable world. If we adopt the modern critical method of focussing microscopically on the changing responses of the reader to each successive word or phrase, it becomes apparent that at the words "Only another head / I have" a grotesque anatomical image is momentarily conjured up, the picture of a two-headed speaker. It is an impression strengthened by the literal meaning of "head" in the two previous stanzas as the bodily member upon which the priestly mitre was placed and within which disturbing thoughts are experienced. The monstrous image it creates forces us at once to reject the anatomical meaning as absurd and to transfer with relief to the more acceptable figurative meaning—Christ's spiritual headship of the Church and hence the speaker's acceptance of Christ as being his own "head" too:[22]

> Only another head
> I have, another heart and breast,
> Another music, making live not dead,
> Without whom I could have no rest:
> In him I am well drest.

This is the true "meta-physical" wit of religious poetry, employing ambiguity or paradox not for purposes of humour but to redirect the reader from the physical world to an existence "beyond-the-physical," undermining his confidence in the logical processes of reason in favour of the impalpable principles of faith. In the continuation of this stanza, the diversion to the spiritual reading is extended from "head" to "heart" and "breast," no longer the localized anatomical organs upon which the ceremonial garments are to be laid or in which the speaker experiences his human passions and fears. They have taken on a supernatural force, like the luminescent figures of a Tintoretto painting, becoming the heart and breast of the risen Christ in which the believer is now mystically dressed.

With that change of focus from the corporeal to the immaterial comes a

surge of confidence to replace the despair at the opening of the poem. Where in the previous stanza the word *only* had meant no more than a mild *but*, its three-fold repetition, here buttressed by *alone*, expresses the growing certainty of the speaker, now dismissing as irrelevant the physical head, heart, and breast of his mortal self. The source of his security emanates from the realm of Christian faith. With that new trust, death, so dreaded earlier in the poem, has, in the mannerist tradition of an El Greco saint whose eyes gaze upward, away from this world to the next, become transformed into the longed-for release from the sinfulness of earthly existence, from the old Adam, which is soon joyfully to be cast off in preparation for the soul's union with its Redeemer:

> Christ is my only head,
> My alone only heart and breast,
> My only music, striking me ev'n dead;
> That to the old man I may rest,
> And be in him new drest.

To argue, as Helen Vendler does, that by the end of this poem the speaker's self-hatred "has turned to self-tenderness and the 'body of this death' has become a breast Herbert can love" is, I think, to miss the rich ambivalence achieved in that final stanza.[23] It is not his own breast which he has come to love in self-tenderness but the "dear" breast of Christ which, as in the earlier wordplay on *head*, has become the speaker's because by an act of faith he has made it his. His trust is thus not self-love but self-submergence in the divine love which now clothes him. On the same principle, this transfiguration of the mortal by its participation in the celestial is extended to his priestly teachings too, where again they are eventually seen by the speaker to be "his" only in the sense that he is the instrument by which the doctrine becomes audible, the harmony and perfection of that doctrine having been tuned above before reaching him:

> So holy in my head,
> Perfect and light in my dear breast,
> My doctrine tun'd by Christ (who is not dead,
> But lives in me while I do rest)
> Come people; Aaron's drest.

The techniques employed in this poem may suggest how Herbert's reputation for plain speech has arisen. There is indeed a deceptively simple facade, a tendency to use monosyllabic diction drawn from daily speech; but that should not mislead us into assuming that the poem itself is either plain or direct. As a learned scholar, past orator at Cambridge University, yet consciously aiming his verse at the wider Christian public, he disguises his subtleties in a form calculated to reassure the less sophisticated. Other exponents of seventeenth-century wit or religious paradox had, as Rosalie Colie has shown,[24] expressed in their verse even at their most serious moments a preference for the intellectually challenging or the riddlingly ambivalent. We may instance as part of this preference the pun implicit in Marvell's desire to "redress" the wrong of Christ's thorns by substituting a flowery garland, or, from another poet, the macrocosmic vision of Christ's hands spanning the "poles," the latter representing both the wooden spars of the Cross and at the same time the zenith and nadir of the created universe.[25] Herbert, however, conceals his paradoxes, here as elsewhere, in such utterly simple words as *his* and *my*. Such words comfortingly retain their outward form unchanged throughout the poem, but their implications and referents shift subtly, as we have seen, from stanza to stanza in a manner far removed from plain speaking. The structural form of the poem, too, may appear to have the simplistic repetitiousness of a nursery rhyme, with the same monosyllabic line-endings in the reiterated sequence *head, breast, dead, rest, drest*, as though to help a child memorize the order. Yet apart from the shifting implications of *head* and *breast*, the culminating word in each stanza, *drest*, undergoes a profound semiotic metamorphosis in the poem, moving from its uncomplicated meaning in the opening stanzas, the donning of the ceremonial robes for liturgical office, to the lambent force of its final appearance, representing the metaphysical clothing of the speaker's soul in the transfiguring perfection of Christ. It is a remarkable literary achievement; and the studied design of the poem, the careful exploitation of that preserved outer form, should warn us against any assumption of revisions and corrections spontaneously occurring in the course of its composition.

The gradual deflection of focus from the earthly realm to the visionary and meditational produced concomitantly in mannerist art as in metaphysical poetry a new treatment of the natural scene. In painting of this time, nature is often ab-

sorbed into the distorting surrealistic imagination of the dreamer where, as in El Greco's *Agony in the Garden*, rocks swirl upwards out of the earth like living creatures, hollows spin dizzyingly like maelstroms and, on another canvas, the landscape of Toledo shimmers in a ghostly light. The writer too spurns the material world as an intrusive physicality which the meditator must shun. Donne in a touching prose passage had bemoaned the distractions of reality, how even when on his knees in genuine prayer the noise of a fly, the rattling of a coach, the whining of a door would catch at his thoughts, drawing him away from that wholehearted devotion to God for which he yearned.[26] In that mannerist mood of ascetic withdrawal any response to the beauties of nature seemed a reprehensible indulgence in the vanities of mortal existence.

Yet the natural scene, as that passage had acknowledged, was not easily to be ignored. While the meditator, striving for divine communion within the darkened room or church, might temporarily withdraw his thoughts from the palpable world, on his emergence into the light of day, the variegated freshness of spring or the rich autumnal tones of meadow and garden awaited him in their full splendour, no less than they did in other eras, and a theological commitment to the affairs of the spirit could not blind poet and artist to such attractions. For the more anguished of the mannerists no compromise was possible, and the spiritual struggle of a figure on a canvas by Rosso Fiorentino or the tormented speaker in a holy sonnet unable to find peace on this earth nor reach the desired haven of the next endows these works with their compelling power. But to the Salesian-type meditator such as Herbert or Vaughan, calmer and more genial in their religious quest, an alternative response suggested itself at this time enabling them to justify their pleasure in nature without distracting them from their religious pursuits. It was the concept of nature as a source of moral edification, a storehouse of ethical teachings or, to use the popular term derived from the rediscovered Horapollo, a collection of hieroglyphs which the Christian was earnestly to decipher in order to extract from it the lessons concealed there by the Creator himself for man's use.[27] The Psalmist had spoken long ago of the heavens and the work of God's hand as silently declaring the glory of the Lord; but now it was not so much the glory of the Lord that was sought there, nor what the romantic poets would later see as the generalized impulses towards human

benevolence emanating from nature, but specific moral and religious instructions encoded there as guides to Christian behaviour. As Barbara Lewalski has convincingly demonstrated, a major motif of seventeenth-century Protestant poetic was its concern with "the Bible as word," its conviction that the text of the Scriptures could supply generic models and precepts for the religious lyricist.[28] But parallel to that veneration for the Book of Scriptures which was to be searched through and through for its poetic exemplars was the similar availability for exegesis of the Book of Nature, now seen as enshrining within its seasonal processes and within the individual details or activities of flower, bird, and shrub informative models for Christian living as well as anagrams for the Christian poet to solve.

In his *Religio Medici*, Sir Thomas Browne summarized this new concept of the existence of two complementary "texts." Moses, he informs us, having been educated in the Egyptian hieroglyphical system at the royal court, had composed the Pentateuch in an obscure and mystical form, which required decoding in order for it to be understood. That need for decoding, he argued, held true for that other "manuscript," the created world, lying open for commentary and elucidation but, he complained, rarely studied by the Christian with sufficient diligence:

> There are two bookes from whence I collect my Divinity; besides that written one of God, another of his servant Nature, that universall and publik manuscript, that lies expans'd unto the eyes of all. . . . [S]urely the Heathens knew better how to joyne and read these mysticall letters, than wee Christians, who cast a more carelesse eye on these common Hieroglyphicks, and disdain to suck Divinity from the flowers of nature.[29]

Few poets have been as sensitive as Herbert to the beauties of the natural scene, delighting as he does in the blossoming of tree and field after the winter snows, or the joy of a springtime "full of sweet dayes and roses" where sweets compacted lie. Yet he too saw as his primary task the diverting of such pleasure into morally productive channels. For one who stated his aims in such disarmingly simple terms it may be inappropriate to lay claim to a "poetic manifesto";

but in "The Flower" (perhaps the freshest and most spontaneous of his responses to the vegetative world, expressing the poet's wonder at the renewal of life from death), there appears a brief declaration which can be justifiably regarded as the cornerstone of his poetic creed. The poet's duty, he insists, is not to describe what is, but to go beyond. It is to spell out or interpret the cryptic message concealed within that visible text:

> We say amiss,
> This or that is;
> Thy word is all, if we could spell.

In the beginning was the Word, and that Word, he implies, was then implanted in the seasonal cycles of the earth to enlighten whoever is receptive to its teachings. From that change in response there emerges a new artistic perspective, and a recognition of this altered viewpoint is vital for an understanding of the painting and poetry it produced. The natural scene has, just as in mannerist painting, been dislodged from its commanding position as the authoritative reality which the painter must copy with fidelity. The fall of light on a rounded object, the eddying movement of water, the structure of a leaf which had so absorbed the attention of a Da Vinci or Dürer is dismissed here as merely what "is," as only a medium whereby more valuable perceptions may be attained. Indeed, the very metaphor whereby reality was conceived alters accordingly. The proponents of Albertian grid perspective had argued that the artist's framed canvas should be regarded as a window or glass pane through which reality could be both perceived and recorded. Now the focal point has moved beyond. The natural world, no longer the prime object of interest, has itself been demoted to the status of the window or glass through which higher truths may be discerned, and it is the latter which is now the concern of artist and poet. As Joseph Hall expressed it:

> I shall so admit of all material objects, as if they were so altogether transparent, that through them I might see the wonderful prospects of another world. And certainly, if we shall be able to withdraw our selves from our senses, we shall see, not what we see, but what we think . . .

and shall make earthly things, not as Lunets, to shut up our sight, but Spectacles to transmit to it spiritual objects.[30]

This concept of the "transparency" of the natural or physical world through whose ephemeral substance more lasting truths are to be perceived—we may recall the glass columns in Bertoia's painting (*fig. 79*, p. 312)—creates, as it had in the Middle Ages, a tendency to the reading of reality in terms of symbols or emblems, and the religious metaphysical lyric of the seventeenth century is patently linked in some way with the emblem poetry of the time, the combining of the verbal and visual arts in a manner which might be thought particularly relevant to this present study. However, the differences which separate the two genres may be more significant than the similarities. Both, it is true, would employ a scene or object as the symbolic starting-point for the poem, with the elaboration or elucidation of the symbol serving to yield its moral message. Thus Donne in "A Hymn to Christ: at the Author's last going into Germany" sees his immediate situation as a "type" or paradigm of his mood of world-weariness:

> In what torn ship soever I embark,
> That ship shall be my emblem of thy Ark;
> What sea soever swallow me, that flood
> Shall be to me an emblem of thy blood.[31]

and Herbert's "The Pulley," like so many of his poems in *The Temple*, evokes by its title the picture of some familiar object from the everyday world whose relevance to the poetic theme will be worked out in subsequent stanzas. Francis Quarles in the preface to his *Emblems* of 1635 subscribed at least ostensibly to the same paradigmatic technique derived from Horapollo, declaring "indeed what are the Heavens, the Earth nay every Creature, but Hieroglyphicks and Emblemmes of his Glory." By transplanting into the seemingly unpromising soil of Protestant England the Jesuit device of combining picture with poem to convey the Church's teachings, Quarles achieved in his day a popularity difficult to comprehend retrospectively, the first two editions of his poems selling over five thousand copies with many further editions to follow. It has indeed been claimed that he was the most popular poet of the seventeenth century, even Mil-

ton, according to Horace Walpole, needing to wait until the world had done admiring his predecessor before he could obtain his own due recognition.[32] From Quarles' statement within the preface, then, it would seem that he too had regarded the world as replete with morally enlightening symbols upon which he could draw for his own poetry.

On the other hand, critics have experienced an understandable discomfort at associating Herbert with this tradition. As Rosemary Freeman readily admitted, the quality of the verse produced not only by Quarles but by such other emblemists as Geoffrey Whitney, Christopher Harvey, John Hall, and Edmund Arwaker, was for the most part poor indeed and Mario Praz, who connects the genre with the ancient epigrammatist Martial and thereby with the contemporary wit of the metaphysical poets, acknowledges that in comparison with the latter it was, at the most "a cheap substitute" for the real thing.[33]

The question may be raised, however, whether the distinction between emblem poetry and metaphysical was merely one of poetic competence, with Herbert and his peers as the more gifted exponents of a technique handled only clumsily by the emblemists, or whether this qualitative difference resulted from a more fundamental contrast in artistic conception. For despite Quarles' claim that the heaven, the earth, and the living creatures within them will provide him with the paradigms he needs, a study of the pictures printed within his collection and the images elaborated in the text reveals that his paradigms have as much to do with the natural world as Grimm's *Fairy Tales*. The illustrations (all but ten of which were borrowed directly from two Catholic works—the *Pia Desideria* of Herman Hugo, appearing in Antwerp in 1624, and the *Typus Mundi* issued there four years later by the Jesuit College of Rhetoric) are peopled not by natural forms but by fork-tailed demons, skeletal figures of Death, ancient Father Times and, above all, by those strange conflations of children and adults which, unique to the emblem books, are presumably intended to suggest grown people acting with the innocence or foolishness of infants. The angels too, no longer the cherubic *putti* of Renaissance art with the charm of real children, are here incongruously depicted as sturdy toddlers in the maturer poses of adults. In consequence, the entire sequence of pictures, so far from constituting emblems drawn

from the natural world, is evocative of some remote realm of make-believe (*fig. 82*).

That sense of an invented, artificial setting is reinforced in both picture and poem by the convenient stage-props casually adopted to suit any particular local need, one instance being a globe representing this earth. It appears at one moment drawn by a chariot to indicate the swift movement of mankind towards hell, at another as the child's seat to indicate man's temporal abode, elsewhere placed upon a table for purposes of contemplation, or whipped like a top to denote the scourge of earthly lusts. Despite Quarles' claim, the impetus for such drawings and for the poems which follow is in no sense a reading of the moral messages encoded in nature but a reverse process—a turning away from reality to a fictitious world. The artistic weakness both of the illustrations and the accompanying verse is, moreover, their insistence upon spelling out the obvious, not least in terms of a prosaic literalizing of metaphor. Where the Psalmist pleads: "Turn away mine eyes from beholding vanity," the emblemist must concretize the image by the picture of a winged child-angel holding its hands over the eyes of a child-adult lest the latter see the female personification of Vanity standing nearby (Emblem IV, 5). No imaginative creativity is called for; and the result is poetry at three removes from the natural world, since the images are elaborations of drawings which are themselves intended to illustrate metaphors from literary texts. In *fig. 83*, the illustration to Emblem I, 12, for example, Isaiah's image "Ye may suck but will not be satisfied with the breast of her consolation"[34] is translated visually into a globular earth possessing the suggestion of breasts but (presumably for reasons of modesty) more obviously resembling balloons. One human figure milks a breast through a sieve into a leaking clay pipe while a second, his cheeks puffed with wind, vainly sucks the other breast for sustenance. Lest the reader still miss the message, Quarles laboriously restates it in verse form:

> Thou whose thriveless hands are ever straining
> Earth's fluent breasts into an empty sieve,
> That always hast, yet always art complaining,

82. Emblem II, 13, from Quarles' *Emblems*

83. Emblem I, 12, from Quarles' *Emblems*

And whin'st for more than earth has pow'r to give;
 Whose treasure flows, and flees away as fast;
That ever hast, and hast, yet hast not what thou hast.[35]

The qualitative difference between Quarles' *Emblems* and the metaphysical poetry of Donne and Herbert needs no comment; but the contrast in poetic strategy, which contributes in no small way to that qualitative difference, perhaps does. Where the emblemist, relying on the conventions of his literary source, with Latin captions, biblical quotations, and appended lists of epigrams to buttress the authoritative effect, ignores the original natural setting of the metaphors, the metaphysical poet, however he may stretch or contract the natural world in his meditative visions, remains intensely conscious of the visible reality he longs to transcend. Donne's brilliant evocation of the bracelet of

333

bright hair about the bone is a prelude for the aching movement of his thoughts beyond it to ponder the eternity separating the lovers. He perceives in the alchemist's study, in the movement of the planets, or the winter withdrawal of the sap into the tree's roots, evidence, often paradoxical, for his own faith in the immortality of the soul. For Herbert, too, whether he turns to the vegetative world or to the familiar structure of the country church or Temple, it is the actuality of the brittle glass window in the church at Bemerton through which the sun colourfully projects sacred stories for the congregants to see which symbolizes for him the task of the Christian preacher as a transmitter of heavenly lessons, and encourages him in the performance of his duties.[36] And Henry Vaughan, despite the unnatural emblem of a flinty heart striking out sparks which he placed as the preface to his *Silex Scintillans* and which would appear to ally him with the Quarles school of emblemists, within the religious poems themselves reverts to the sharp actualizing of metaphysical poetry in his vision of the cock crowing or the mistiness of an evening shower as symbols of religious truths.[37] In "The Tempest" Vaughan echoes Herbert's plea for the deciphering of the messages encoded within nature, praying for man

> that he would hear
> The world read to him! all the vast expense
> In the creation shed, and slav'd to sense
> Makes up but lectures for his eye and ear.
> ...
> All things here show him heaven: waters that fall
> Chide and fly up; mists of corruptest foam
> Quit their first beds and mount; trees, herbs, flowers all
> Strive upwards still, to point him the way home.[38]

The final lines here, with their vision of the hills pointing upward to heaven, although more gentle in their Salesian charm, offer a counterpart to the landscape of El Greco's *Mount Sinai* *(fig. 84)* where the hills in their more violent upward spiral symbolize man's own need to strive passionately heavenward.

In the emblem poetry which had been cultivated in England from at least as early as Geoffrey Whitney's collection of 1586, the illustration heading the poem was, as we have seen, largely self-explanatory, the appended verse merely elab-

84. EL GRECO, *Mount Sinai*

orating or confirming what could already have been grasped through the visual medium. In contrast, in Herbert's poetry the emblems of "Artillerie," "Love-joy," "The Church-Floore"—not offered as engravings but as verbal images in accordance with his interest in "spelling out" his hieroglyphs[39]—in themselves convey little to the reader. They are anagrams or riddles needing to be deciphered or explicated in the same way as the hieroglyphs derived from nature, and his process of decoding frequently employs, as in mannerist art, the exploration of a false trail, a designed nudging of the reader into incorrect assumptions based on rational, pragmatic, or conventional grounds, so that the eventual discovery of the spiritual truth should come with the force of revelation. Where Donne, particularly in his "Holy Sonnets," often delays that moment of discov-

335

ery until the final couplet in order to create the shock of a suddenly reversed perspective, Herbert for the most part places it, as in "Aaron," well before the end in order to allow for its more gradual absorption into the reader's sensibilities and to create that quieter mood of reconciliation for which his verse is recognized. Yet there are poems, such as "The Collar," in which the unveiling of the truth and the concomitant resolving of the enigmatic title are postponed until the conclusion in order to produce the more dramatic effect of newly acquired understanding.

Apart from an occasional more ingenious interpretation of this poem's title (as being, for example, a pun on *choler*), it has normally been accepted as an emblem of the chafing collar or yoke of discipline, with the possibility of an additional allusion to the clerical collar worn by the priest which the speaker in his rebellious mood longs to discard.[40] If that were so, the emblem would function here in a singularly limited sense, applying to the rebellious opening section of the poem but, in contrast to Herbert's usual practice, forgotten by the conclusion. Instead of returning us to the initial image with renewed understanding, he would in this reading seem here to have dismissed it as no longer relevant. From hints in the text of the poem, however, a more specific emblem emerges which fulfills all the requirements of the mannerist and metaphysical forms—the deliberate leading of the reader astray in order to surprise him into knowledge and, concurrently, the initial validation of worldly criteria until their sudden overthrow at the conclusion in favour of the transcendental.

Were the poem in the hands of a Whitney or a Quarles, the illustrative emblem, already revealing the conclusion, would no doubt have depicted a stag or hound racing headlong away from the stake to which it is loosely tethered, until the moment when the long rope suddenly snaps taut. The rope here is, of course, the speaker's spiritual commitment to his God, so that by that image the immediacy and totality of his submission in the final couplet is made infinitely more persuasive and compelling. In Herbert's hands, however, the nature and force of the true emblem is disclosed only at the end and then only allusively. By choosing a more ambiguous title than, for example, "The Leash" or "The Tether," he encourages the reader's incorrect interpretation of the collar as no

more than an irksome restriction, thereby creating an empathy with the rebel-
liousness of the speaker, his natural longing for freedom and the enjoyment of
life's pleasures. The basis for the true emblem of the leash, however, is already
being sketched in, as the speaker, unaware of his deeper commitment, boldly
claims that his "lines" are free and loose as wind, that the bond of his vocation is
a mere "rope of sands" which petty thoughts have made him foolishly regard as
"good cable" to enforce and draw. While the changing form of the emblem is as
yet only dimly perceived, at the same time the world of the flesh and of bodily
gratification begins, as in all mannerist art, to be haunted by the implications of
the ethereal world beyond, to which the speaker himself reveals a subconscious
responsiveness. On the surface level, his bitter lament for the waste of the year's
seasons, the forfeiting of poetic fame on earth, results in the sighs and tears
which have drowned whatever satisfaction he originally derived from his choice
of a sacred calling. Yet beneath that verbal protest can be sensed in the very im-
agery he employs his own continuing faith in the religious values he ostensibly
denies. The "fruit" he craves and the hands reaching out to pluck it recall the
forbidden fruit of Eden, his deeper recognition that his desires are indeed repre-
hensible; the wine and corn representing the carousal and banqueting of the
pleasure-seeker by their very juxtaposition carry at the same time unmistakable
allusions to the Eucharist; and the "thorn" which he protests has replaced the
desired crown of bays reveals to the sensitive reader the speaker's own, but as
yet unacknowledged consciousness that the suffering and self-denial of which he
so passionately complains in fact constitute the fulfilment of that very choice of
the ascetic path of *imitatio Dei* which had originally attracted him to and con-
firmed him in his priestly vocation:

> Have I no harvest but a thorn
> To let me blood, and not restore
> What I have lost with cordial fruit?
> Sure there was wine
> Before my sighs did dry it: there was corn
> Before my tears did drown it.
> Is the year only lost to me?

> Have I no bays to crown it?
> No flowers, no garlands gay? all blasted?
> All wasted?
> Not so, my heart: but there is fruit,
> And thou hast hands.

Despite the undertow created by these devotional hints, unacknowledged by the speaker and only dimly perceived by the reader, the speaker's eagerness to attain pleasure and freedom in the physical world, his angry defiance of the medieval death's head, and his apparently unbreakable determination are so dominant as to leave us largely unprepared for the abrupt change of mood at the conclusion—the evocation of the infant Samuel hearing a voice calling him to service, and of his unhesitating childlike acquiescence. That call from the spiritual world, however faintly it may sound—"Me thought I heard one calling, Child"—possesses, we discover then, the power not of a rope of sand but of the strongest cable to halt him instantly in his flight and to return him willingly and uncompromisingly to his God ("And I replied, *My Lord*"). It achieves its immediate acceptance on the part of the reader because of the carefully prepared, if subdued, emblem, the invisible thread of faith which by a mere twitch proves to the truly faithful stronger than all the counter-attractions of the visible world.

Such poetic strategy of reversal then, has, I think, less to do with the technique of priestly catechism suggested by Stanley Fish—there is no trace of any teacher-pupil relationship in this poem—than with the religious and aesthetic patterns of the European Counter-Reformation at large, whose ideas and methods were at this time filtering through into Anglican circles too, not least through the group of Herbert's friends at Little Gidding under the tutorship of Nicholas Ferrar. Within these patterns of thought, the shifting relationship between haptic and spiritual was of primary concern, the artist employing the techniques of misdirection, surprise, and reversal as means of enticing the viewer or reader away from his settled assumptions into an unconventional vantage-point, for which the rules of empirically fixed measurement or worldly logic were seen as no longer relevant. Such, we should recall, was not the normal practice of Christian poetry in other eras. Sir Walter Ralegh's "The Passionate Man's Pilgrimage," Browning's "Prospice," or Hopkins' "God's Grandeur" are

all poems of deep religious commitment accepting the dominance of the eternal over the temporal; but none possesses this mannerist quality of a disturbing interaction or conflict between the two entities, resolved only at the conclusion.

That dynamic is central to Herbert's poetry. His habitual reading of homely detail, of the church-porch, a flower, legal renewal of tenancy, or the action of a pulley in terms of divine anagrams and, conversely, as in "Aaron," his clothing of this reality in the garb of the celestial may convey on the surface the appearance of a settled and even simplistic Christian view. But the strains and tensions between the two worlds emerge not only in his own more passionate poems "Longing" and "Assurance" with their despairing pleas for divine aid, but in these apparently calmer poems too, where the reader is surprised or at times gently lured into deserting the sphere of the homely and familiar in which the poem begins in favour of the transcendent, the mystical, and the paradoxical. Herbert leads him into a Christian experience outreaching terrestrial limitations where, with echoes of Donne and of the surrealist landscapes of the mannerist artist:

> Thy will such a strange distance is,
> > As that to it
> East and West touch, the poles do kisse,
> > And parallels meet.[41]

That recurrent mannerist image of immense distances contracting or expanding before the infinite will of God, or shimmering away before the subjective yearnings of the Christian soul, has a particular relevance to the coordinating theme of this present study. For however enclosed the mannerist poet and artist may seem within the introspective world of religious experience, dreaming of the afterlife to come, the metaphors which he employed to describe his spiritual vision were drawn from that very physical reality, the scientifically measured universe, whose validity he was at such pains to deny. Medieval Christianity, for example, had also subscribed to the ephemerality of earthly existence and the infinity of God, but divine infinity in that earlier period had been an abstract

doctrinal tenet restricted to the theological discussions of the schoolmen and in no way impinging upon the cultural consciousness of the time. Medieval poetry and painting offer in their images no hint of the cosmic vastness which we have seen to be so central to mannerist verse—a cosmic vastness familiar to writers of the sixteenth and seventeenth centuries from the heliocentric theories of Copernicus and Bruno, and the proven discoveries of Galileo and Kepler.

The "perspective" of the creative artist in any era is, as I have argued throughout this book, not simply a way of viewing or representing the tactile world but an amalgam of current terrestrial and supraterrestrial concepts, interacting so intimately that any examination of either in isolation can be seriously misleading to the historian. When, as in the High Renaissance, the harmonious ratios derived from musical chords were acknowledgedly projected onto the celestial spheres and the proportions believed to exist in the ideal world beyond were designedly incorporated into the facade of a building, the interdependence of the two concepts was self-evident. The historian's contribution may at such time be directed to exploring the subtler, less obvious ramifications of the practice, such as identifying the dramatist's "green world" in Belmont or Arden as the representation of that ideal element, always eventually to interact with the mundane.

In mannerism, however, the integration of the two concepts is the more remarkable as their polarity might be thought to make them mutually exclusive; for the revived meditative tradition out of which religious mannerism grew had developed in large part as an attempt to nullify or circumvent the chilling authenticity of the new science, whose positing of a mechanistic universe in the sixteenth century had seemed to make God's continued presence superfluous and man himself miserably insignificant. The Church's response to the threat which the New Philosophy posed to traditional belief was not to disavow the discoveries themselves, whose empirical base became increasingly apparent towards the turn of the century,[42] but rather, in Ignatius Loyola's words, to cultivate in the worshipper at the moment of meditation an "indifference to all created things,"[43] a contempt for the phenomenal world as merely transitory, and a concentration instead upon the eternity beyond death for which he must prepare himself. Yet despite this derogation of the corporeal universe, the scientific ap-

prehension of the physical cosmos continued indirectly to mould the thought-processes of the religious poet. For his representation of the heavens, no longer relying on Ezekiel's vision of the divine chariot nor the apocalyptic Book of Revelations, draws its inspiration instead from the astronomer's panorama of whirling spheres, of which the truly celestial forms above are a serene and perfected version:

> I saw Eternity the other night
> Like a great Ring of pure and endless light,
> All calm, as it was bright,
> And round beneath it, Time in hours, days, years,
> Driven by the spheres
> Like a vast shadow moved, in which the world
> And all her train were hurled.[44]

These changing perspectives, created by each generation's altered conception of the relationship between the earthly and the transcendental, have modified and at times even predetermined their artistic interpretations of the natural scene, even in those periods when fidelity to nature and accuracy of representation were at a premium. Gozzoli's meticulous depiction of the gorgeous robes of the Magi or Chaucer's fascination with the *minutiae* of his pilgrim's apparel were hallmarks of their art; yet those details were presented, we recall, as only surface elements—engaging, amusing, informative, but ultimately two-dimensional and nugatory before the eternal truths sensed as existing beyond the facade of quotidian experience; and their very portrayal, as Chaucer admits, had left artist and writer feeling a little guilty at having spent time on mere "vanities." On the sixteenth-century stage, the growing tendency towards naturalism produced within the plays themselves a subtlety of characterization remarkable for its psychological credibility and realism, while the architectural stage-settings on the continent created a persuasive illusion of specific locality. Yet in both dramatic text and setting, as also in the paintings produced at that time, the most impressive achievement was less the verisimilitude of representation than the enlargement and elevation of the human image, the vistas evoking a heavenly magnificence above, in which man shares at the moments of his highest at-

tainment. And for mannerism too, although it moved in a direction opposed to naturalism in its scorn for fidelity to mere earthly forms and its anagrammatic interpretation of them as serving only as a window through which to perceive more lasting verities, the interdependence of temporal and eternal conceptions prevailed, with the newly revealed physical cosmos fashioning, however unobtrusively, the poet's religious images and celestial visions.

Periodization in its more sophisticated form does not presuppose the imposition of a fixed pattern upon an age to produce a dull uniformity among its writers, artists, and thinkers. It perceives rather, as the quality shared by each generation, the existence of a central complex of inherited assumptions and urgent contemporary concerns to which each creative artist responds in his own individual way. He may adopt those assumptions and priorities, he may challenge them, he may even deny them, but he may only at his peril ignore them. And even when he resists them most forcefully, they will, as matters of immediate pressure, continue to affect, often with no conscious awareness on his part, aspects of his own art, including the contextual terms for viewing the world about him and, at the same time, his own version of the imagined setting beyond. In that regard, the barriers between the literary and plastic arts in any era may prove less divisive than has been thought, and the comparative study of those arts, with all due care for their generic differences, emerge as a legitimate and fruitful pursuit.

NOTES

INTRODUCTION

[1] Roland M. Frye, *Milton's Imagery and the Visual Arts* (Princeton, 1978), and Ronald Paulson, *Book and Painting: Shakespeare, Milton, and the Bible: literary texts and the emergence of English painting* (Knoxville, 1982).

[2] Ferdinand de Saussure, *Cours de linguistique générale* (Paris, 1967), and Claude Lévi-Strauss, *Le Cru et le cuit* (Paris, 1964).

[3] Julia Kristeva, *Semiotiké: récherches pour une sémanalyse* (Paris, 1969), p. 146, developed by Harold Bloom in *A Map of Misreading* (New York, 1975); and Mary Ann Caws, *The Eye in the Text: essays on perception, mannerist to modern* (Princeton, 1981). The reference is to E. H. Gombrich, *Art and Illusion: a study in the psychology of pictorial representation* (Princeton, 1960), and Rudolf Arnheim, *Art and Visual Perception: a psychology of the creative eye* (Berkeley, 1966).

[4] Rosemund Tuve, "Baroque and Mannerist Milton," *Journal of English and Germanic Philology* 60 (1961):817, Alastair Fowler, "Periodization and Interart Analogies," *New Literary History* 3 (1972):488, and René Wellek, "The Parallelism between Literature and the Arts," *English Institute Annual 1941* (New York, 1942), p. 35.

[5] Wylie Sypher, *Four Stages of Renaissance Style: transformations in art and literature 1400-1700* (New York, 1955), p. 115. Fowler quotes the passage in a slightly abbreviated form, omitting a subordinate clause. As that may be thought unfair to Sypher, I have here quoted it in full. Cf. also Mario Praz, *Mnemosyne: the parallel between literature and the visual arts* (Oxford, 1970) as well as Frederick B. Artz, *From the Renaissance to Romanticism: trends in style in art, literature and music 1300-1800* (Chicago, 1962).

[6] These elements were examined in my *Milton and the Baroque* (London, 1980), chapters 2 and 4.

[7] On the literary implications see Earl Miner, "That Literature is a Kind of Knowledge," *Critical Inquiry* 2 (1976):501, and W.J.T. Mitchell, "Spatial Form in Literature: towards a general theory," *Critical Inquiry* 6 (1980):539 (which quotes Wayne Booth's comment without recording the source), as well as his new study *Iconology: image, text, ideology* (Chicago, 1986), which develops the theme. There is an account of the history of spatial concepts and their psychological implications in Max Jammer, *Concepts of Space* (New York, 1960), pp. 3-4, and of spatial metaphor in Rudolf Arnheim's essay "Space as an Image of Time," in *Images of Romanticism*, ed. K. Kroeber and W. Walling (New Haven, 1978), pp. 1-12.

CHAPTER I

[1] E. W. Tristam discusses this tradition in his *English Wall Painting of the Fourteenth Century* (London, 1955), pp. 9-10. There are, incidentally, counter-indications for this interpretation, such as the picture in the Holkham Bible Picture Book of a shepherd joyfully playing the bagpipes at the *Adoration*. See also Robert Boenig, "The Miller's Bagpipe," *English Language Notes* 21 (1983):1.

[2] D. W. Robertson, Jr., *A Preface to Chaucer: studies in medieval perspective* (Princeton, 1962), p. 243, and Edward A. Block, "Chaucer's Millers and their Bagpipes," *Speculum* 29 (1954):239.

[3] Ralph Baldwin, "The Unity of the *Canterbury Tales*," *Anglistica* 5 (1955):15. See also Edmund Reiss, "The Pilgrimage Narrative and *The Canterbury Tales*," *Studies in Philology* 67 (1970):295, and the reply of Siegfried Wenzel, "The Pilgrimage of Life as a Late Medieval Genre," *Medieval Studies* 35 (1973):370.

[4] Morton W. Bloomfield, "Symbolism in Medieval Literature," *Modern Philology* 56 (1958):73, and R. E. Kaske, "Chaucer and Medieval Allegory," *Journal of English Literary History* 30 (1963):175. There are more forthright attacks on the theory in F. E. Utley, *Romance Philology* 19 (1965):250, and R. S. Crane, "On Hypotheses in 'Historical Criticism,' " in his *The Idea of the Humanities and other Essays* (Chicago, 1967), 2:236, as well as Alfred David, *The Strumpet Muse* (Bloomington and London, 1976), especially pp. 138f. A useful summary of the critical dispute during its early years (in its relation to literature, not art) can be found in A. Leigh DeNeef, "Robertson and the Critics," *Chaucer Review* 2 (1968):205, and a well-balanced discussion of Chaucer's historical affinities in A. C. Spearing, *Medieval to Renaissance in English Poetry* (Cambridge, 1985), especially pp. 15-22.

[5] Cf. C. R. Morey, *Medieval Art* (New York, 1942), p. 303.

[6] While the ape was at times regarded as a *figura diaboli*, it was also a source of amusement and even an object of affection. Hugh of St. Victor records in a sermon that clerics liked to keep them in their homes as pets. H. W. Janson, who quotes this tradition, argues in his *Apes and Ape Lore in the Middle Ages and the Renaissance* (London, 1952) that the ape frequently served in medieval art not only as a means of parodying or vilifying human actions but also as an entertaining variation in depicting man's normal activities, in which latter category this scene of waggon-driving would seem to fall. For general surveys of medieval marginalia, see Nikolaus Pevsner, *The Englishness of English Art* (London, 1956); F. Harrison, *English Manuscripts of the Fourteenth Century* (London, 1937); Lilian M. C. Randall, *Images in the Margins of Gothic Manuscripts* (Berkeley, 1966); and Janet Backhouse, *The Illuminated Manuscript* (Oxford, 1979). Beverley Boyd, *Chaucer and the Medieval Book* (Huntington, 1973), discusses more specifically the relationship of the Ellesmere manuscript to medieval illuminations.

[7] Robertson, *Preface*, pp. 51 and 255, referring to *Gen. Prol.*, 183-85. Quotations from Chaucer throughout are from *The Poetical Works*, ed. F. N. Robinson (London, 1957).

[8] See Gertrud Schiller, *Iconography of Christian Art*, trans. Janet Seligman (Greenwich, Conn., 1971), 1:99. With reference to the Lambeth illumination (*fig. 9*), discussed below, the remoteness of the modern viewer from such typological reading of paintings can lead to strange results even among eminent art historians. In a volume prepared by F. Saxl and R. Wittkower of the Warburg Institute, *British Art in the Mediterranean* (Oxford,

1948), pp. 26-27, this illumination, described as representing *Jacob's Dream*, is reproduced with the announcement of Isaac's birth cropped from the top, revealing the authors' unawareness of the typological sequence represented. Not surprisingly, their commentary concludes: "The sacrifice of Abraham shown on the right has nothing to do with the main scene."

⁹ Bartolo di Fredi's *Adoration* has been variously dated by art historians to 1364, 1380, and, at the very latest, the 1390s; but 1380 is the most widely accepted attribution, as in Piero Torriti, *La Pinacoteca Nazionale di Siena* (Genoa, 1977), p. 165. Although he does not touch upon the aspects discussed here, Millard Meiss, *Painting in Florence and Siena After the Black Death: the arts, religion, and society in the mid-fourteenth century* (Princeton, 1951), offers some valuable discriminations between Sienese and Florentine art in that era, and, only too rare at the time of its publication, an interdisciplinary approach.

¹⁰ The legend that the Magi met at Calvary before proceeding to Bethlehem (for which reason there is no sign of the manger in the Limbourg version) first arose at this time. For the earliest known reference to this legend, by a Carmelite monk in the late fourteenth century, see *The Three Kings of Cologne: an early English translation of the "Historia Trium Regum" by John of Hildesheim*, ed. C. Horstmann (London, 1886), pp. 62f.

¹¹ Millard Meiss, *French Painting in the Time of Jean de Berry* (London, 1967) 1:6 and *passim*. Further details of the tradition can be found in John Hartham, *Books of Hours and their Owners* (London, 1977).

¹² Among the versions of *The Way to Calvary*, especially notable are those by Simone Martini (ca. 1342), by Andrea da Firenze (ca. 1367), and by Jacquemart de Hesdin from the circle of Jean de Berry (ca. 1390). For *The Flight from Egypt*, there is the version by the Brussels Master of the Initials and that by Melchior Broederlam, added to the wing of the *Maestà* altarpiece to be installed at the Chartreuse of Champmol in 1399. The funeral cortège of Charles VI is from *Chroniques de Charles VII*, a French fifteenth-century manuscript in the Bibliothèque Nationale of Paris (ms. fr. 2691, fol. 11r.).

¹³ Donald R. Howard, *The Three Temptations: medieval man in search of the world* (Princeton, 1966), pp. 55f., a theme extended to subsequent eras in Patrick Cullen, *Infernal Triad: the Flesh, the World, and the Devil in Spenser and Milton* (Princeton, 1974). See also Howard's valuable study, *The Idea of the Canterbury Tales* (Berkeley, 1976).

¹⁴ Arnold Hauser attributes the new sense of movement in art and the interest in detail to the growth of commerce in this era; but, as in so much of his otherwise excellent work, he restricts his attribution of cultural change to economic determinism when such phenomena are clearly much broader in scope. See his *Social History of Art*, trans. S. Godman (New York, 1951) 1:264.

¹⁵ Christian K. Zacher, *Curiosity and Pilgrimage: the literature of discovery in fourteenth-century England* (Baltimore, 1976), offers a stimulating account of the sense of exploration in this period.

¹⁶ Roberto Weiss, *The Renaissance Discovery of Classical Antiquity* (Oxford, 1969), p. 51.

¹⁷ The painting is reproduced in Derek Brewer, *Chaucer and his World* (London, 1978), p. 130.

¹⁸ Robertson, *Preface*, p. 374.

¹⁹ They are both reproduced in Margaret Rickert, *Painting in Britain in the Middle Ages* (London, 1954), pp. 154 and 179.

²⁰ J. A. Burrow, *Ricardian Poetry* (New Haven, 1971), examines interestingly the relationship of the poetry produced under Richard II to narrative techniques in the art contemporary to it. The realism entering late

medieval scenes is discussed in rather general terms in Derek Pearsall and Elizabeth Salter, *Landscapes and Seasons of the Medieval World* (Toronto, 1973).

[21] From the translation into modern English by Marie Borroff in the *Norton Anthology of English Literature*, 4th ed. (New York, 1979) 1:246.

[22] Significantly, the only other known instance of a pilgrimage used as the framework for a group of tales was by a contemporary of Chaucer. Giovanni Sercambi's *Novelle* (1374), which places his narrators on a pilgrimage from Lucca through parts of Italy, may have been known to Chaucer, but there is no firm evidence, as is noted by W. H. Clawson, "The Framework of *The Canterbury Tales*," *University of Toronto Quarterly* 20 (1951):137.

[23] Helen S. Corsa points out the effect in her *Chaucer: Poet of Mirth and Morality* (Notre Dame, 1964), p. 114. See also V. A. Kolve's absorbing study *Chaucer and the Imagery of Narrative* (Stanford, 1984), chapter 4, in which he reminds us that animal imagery was used in the Middle Ages not always with bestial connotations didactically relevant to man but often in a neutral way, free from moral or symbolic judgments, with Chaucer frequently resisting established image associations. I am grateful to him for having let me see the manuscript before its publication.

[24] Roman sarcophagal portraits of the second century A.D., preserved at Faiyum in Egypt, offer evidence that considerable subtlety in three-dimensional representation had been achieved prior to the Middle Ages, but was replaced by the more stylized forms of Byzantine art.

[25] The iconographical elements in this painting are examined in E. Panofsky, *Early Netherlandish Painting* (New York, 1971) 1:203.

[26] Chauncey Wood, "Chaucer's Use of Signs in his Portrait of the Prioress," in *Signs and Symbols in Chaucer's Poetry*, ed. J. P. Hermann and J. J. Burke, Jr. (Alabama, 1981), p. 81. On the equation of outward signs with inner character, Rodney Delasanta in "The Horsemen of *The Canterbury Tales*," *Chaucer Review* 3 (1968):29, has interestingly shown that there is an inverse relationship between the quality of each pilgrim's horse and its owner's moral worth. For the delicacy of the Prioress portrait and Chaucer's discarding of the conventional charge of concupiscence levelled against nuns, see Jill Mann, *Chaucer and the Medieval Estates Satire* (Cambridge, 1973), especially p. 130. The pagan source of the "*Amor*" quotation in Vergil's *Eclogues* makes any intention of religious love here highly dubious or, at the very least, comically ambiguous. See, for example, Arthur W. Hoffman, "Chaucer's Prologue to Pilgrimage: the Two Voices," *Journal of English Literary History* 21 (1954):1.

[27] E. Talbot Donaldson, "Chaucer the Pilgrim," in *Publications of the Modern Language Association* 69 (1954):928. The use of irony in this period as a means of coping with the disparities of fourteenth-century life is examined in Charles Muscatine, *Poetry and Crisis in the Age of Chaucer* (Notre Dame, 1972), while the abuses associated with fourteenth-century nuns are discussed in Eileen Power, *Medieval People* (London, 1924), pp. 59-84.

[28] Although still generally accepted, the identification of the youngest Magus with Lorenzo di Medici has been questioned in recent years on the grounds that he would only have been about eleven at the time the fresco was painted and that other portraits show him to have been dark-haired, at least in later years. However, as Rab Hatfield has pointed out in his "Five Early Renaissance Portraits," *Art Bulletin* 47 (1965):315, Florentine quattrocento artists did not feel bound to preserve the likenesses of their sitters—only an icono-

graphic allusiveness recognizable to contemporaries. In any case, portraits of other members of the family, including Piero di Medici have been firmly identified here, attesting to the contemporaneity with which the scriptural scene was viewed. On this point, see, for example, E. H. Gombrich, *Norm and Form: studies in the art of the Renaissance I* (London, 1978), p. 49. For another instance of Medici portraits believed to be incorporated in a Magi painting, see Rab Hatfield, *Botticelli's Uffizi "Adoration": a study in pictorial content* (Princeton, 1976), pp. 68-100, which discusses for Botticelli's version too the doubts which have recently arisen over the identification and the likelihood nonetheless that they are indeed portraits of the Medici.

[29] Techniques of narrative are discussed in Wayne C. Booth, *The Rhetoric of Fiction* (Chicago, 1961) and Robert E. Scholes and Robert Kellogg, *The Nature of Narrative* (New York, 1966), which have together helped us perceive the cumulative effect of detail in creating the illusions of fiction.

[30] The interpretation of the Wife of Bath portrait as essentially hostile, an exposure of her moral failings for didactic purposes, is reaffirmed by D. W. Robertson, Jr., in his recent article "Simple Signs for Everyday Life in Chaucer," in *Signs and Symbols*, ed. Hermann and Burke, especially p. 26. On the other hand, Lawrence Besserman, "*Glosyng is a Glorious Thyng*: Chaucer's Biblical Exegesis," in *Chaucer and Scriptural Tradition*, University of Ottowa Quarterly 53 (1983):327, has recently argued that the *Glossa Ordinaria* frequently quoted by Robertson to disqualify the Wife theologically seems to have been regarded with suspicion by Chaucer himself, who generally uses the term *glose* disparagingly.

[31] *The Wife of Bath's Prologue*, 557-64.

CHAPTER 2

[1] F. M. Salter, *Medieval Drama in Chester* (Toronto, 1955); Richard Southern, *The Medieval Theatre in the Round: a study of the staging of "The Castle of Perseverance" and related matters* (London, 1957), and Glynne Wickham, *Early English Stages, 1300-1600*, 3 vols. (London, 1959-81).

[2] W. L. Hildburgh, *English Alabaster Carvings as Records of the Medieval Religious Drama* (Oxford, 1949), and M. D. Anderson, *Drama and Imagery in English Medieval Churches* (Cambridge, 1963). The window from the church of St. Peter Mancroft in Norwich is reproduced in the latter volume as *ill. 22b*, and that of Noah and his wife (mentioned below) as *ill. 14a*. See also Emile Mâle, *Religious Art from the Twelfth to the Eighteenth Century* (New York, 1949), especially pp. 26-28.

[3] Cf. C. F. Tucker Brooke, *The Tudor Drama* (Cambridge, Mass., 1911), p. 13, with its praise for the clowning and fisticuffs as harbingers of Elizabethan drama.

[4] O. B. Hardison, Jr., *Christian Rite and Christian Drama in the Middle Ages: essays in the origin and early history of modern drama* (Baltimore, 1965) whose opening chapters discuss the evolutionary assumptions of critics from Chambers to Hardin Craig. Stanley J. Kahrl, *Traditions of Medieval English Drama* (Pittsburgh, 1975), examines some of the implications inherent in these assumptions.

[5] A. P. Rossiter, *English Drama from Early*

Times to the Elizabethans; its background, origins and development (London, 1950), p. 78.

⁶ Eleanor Prosser, *Drama and Religion in the English Mystery Plays* (Stanford, 1961), especially pp. 82–86.

⁷ V. A. Kolve, *The Play Called Corpus Christi* (Stanford, 1966), discusses Rossiter's view on pp. 134f. The quotation is from *The Chester Plays*, ed. H. Deimling (London, 1892), p. 7.

⁸ F. P. Pickering, *Literature and Art in the Middle Ages* (Coral Gables, 1970), pp. 272–73.

⁹ *The York Plays*, ed. L. Toulmin Smith (Oxford, 1885), p. 357, adapted here into modern English, as are subsequent quotations.

¹⁰ Rosemary Woolf, *The English Mystery Plays* (London, 1972), pp. 256–57. The quotation is from *The Towneley Plays*, ed. George England and Alfred W. Pollard (London, 1897), p. 233.

¹¹ The double perspective of this painting is discussed in the seventh edition of Helen Gardner, *Art Through the Ages*, revised by Horst de la Croix and Richard G. Tansey (New York, 1980), p. 589, a work which offers many valuable comments on the painting of the period and, at times, on its relationship to literature.

¹² That Antonio Pollaiuolo was interested in anatomical drawing before he painted this altarpiece and hence welcomed the opportunity it afforded is evidenced by his *Battle of the Naked Men*, an engraving he completed some ten years earlier, which compressed into its small area ten full-length nude male figures in various postures and viewed from different angles.

¹³ The sculpture is on a capital in the south transept of the cathedral, and is reproduced in the *Larousse Encyclopedia of Byzantine and Medieval Art*, ed. R. Huyghe (New York, 1963), *ill. 990*.

¹⁴ Grace Frank deduces from a stage direc-

tion in the *Jeu d'Adam* that early performances outside the cathedral took place near the church doors and, therefore, with ecclesiastical approval. See her "Genesis and Staging of the *Jeu d'Adam*," in *Publications of the Modern Language Association* 59 (1944):7, as well as her *Medieval French Drama* (Oxford, 1954), p. 74.

¹⁵ *Two Coventry Corpus Christi Plays*, ed. Hardin Craig (London, 1957), p. 27.

¹⁶ For reproductions, see M. D. Anderson, *Drama and Imagery* (*ill. 11b*), and Alan Shestack, *Fifteenth Century Engravings of Northern Europe* (New York, 1967), fig. 224. Also relevant is Miriam Ann Skay, "The Iconography of Herod the Great in Medieval Art," in *Early Drama, Art, and Music Newsletter* 3 (1980):4, published by Western Michigan University.

¹⁷ Cf. "in Pilates voys he gan to crie, / And swoor" (Chaucer's *Prologue to the Miller's tale*, 3124).

¹⁸ G. R. Owst, *Literature and Pulpit in Medieval England* (Oxford, 1961), pp. 388 and 342.

¹⁹ *Chester Plays*, p. 76.

²⁰ *York Plays*, p. 43.

²¹ Erwin Panofsky, *Early Netherlandish Painting* 1:142–43. Since its publication in 1953, others have searched for similar symbolism in the Joseph panel, seeing, for example, the axe there as alluding to "the axe is laid unto the root of the tree," Matt. 3:10. But there is a great difference between such strange items as a smoking candle displayed prominently on the table or the asymmetrical candle-brackets, one full, one empty which cry out for symbolic explication and the normal tools in the Joseph panel jumbled casually about the bench as he works, and in no way connected with the root of a tree. The one item which has justifiably attracted attention is the mousetrap on the window-shelf outside, which probably echoes Augustine's comment that Jesus was a mousetrap set to catch the devil. But that is merely to provide

some moral to the object being made, and has no effect on the marked realism of the scene itself. See Meyer Shapiro "Muscipula Diaboli," *Art Bulletin* 27 (1945), and I. L. Zupnik, "The Mystery of the Mérode Mousetrap," *Burlington Magazine* 108 (1966):126.

22 *Chester Plays*, pp. 44 and 45.

23 T. M. Parrott, "Mak and Archie Armstrang," *Modern Language Notes* 59 (1944):297.

24 Cf. Homer A. Watt, "The Dramatic Unity of the *Secunda Pastorum*," in *Essays and Studies in Honor of Carleton Brown* (New York, 1940), pp. 158-66. The argument for a parallel plot structure was presented by Margery M. Morgan in "High Fraud: Paradox and Double Plot in the English Shepherd Plays," *Speculum* 39 (1964):676, and the theory of an organic interconnexion between the two plots in Lawrence J. Ross, "Symbol and Structure in the *Secunda Pastorum*," *Comparative Drama* 7 (1967):122.

25 *Chester Plays*, p. 8.

26 For the sources, see H. J. Gardiner, *Mysteries' End* (New Haven, 1946), p. 96, n. 11.

27 W. W. Greg, *The Trial and Flagellation with Other Studies in the Chester Cycle* (Oxford, 1935), p. 159.

28 Murray Roston, *Biblical Drama in England: from the Middle Ages to the Present Day* (London, 1968), pp. 109-20. The theory of an inverse relationship between sanctity and dramatic humanization in the mystery plays was suggested there in an earlier form, but in the context of dramatic history and with only a brief side-glance at the visual arts.

29 A. P. Rossiter, *English Drama*, pp. 75-76 quotes this Bosch painting as evidence for his theory of Gothic ambivalence; but the fact that it was painted in 1510, almost a century after the composition of the York plays (a century in which styles in both art and literature changed so rapidly) makes it an invalid comparison. It should be seen rather as the culmination of the humanizing of the holy figures in the various arts, paralleling their gradual disappearance from the stage versions at the time of the Reformation.

30 Henry Crosse, *Virtue's Commonwealth: or the highway to honour* (1603,) cited in E. K. Chambers, *The Elizabethan Stage* (Oxford, 1923) 4:247, and Jean Luis Vives, *St. Augustine, of the city of god*, trans. J. H. Healey (London, 1610), p. 337.

CHAPTER 3

1 Jacob Burckhardt, *The Civilization of the Renaissance in Italy*, trans. S.G.C. Middlemore, 2 vols. (New York, 1958), the original German edition of which appeared in 1860; John Addington Symonds, *The Renaissance in Italy*, 7 vols. (London, 1875-86); and Herschel Baker, *The Image of Man* (New York, 1961), especially pp. 189 and 203. The changes in response, at least until the mid-century, are sensitively recorded in W. K. Ferguson, *The Renaissance in Historical Thought: Five Centuries of Interpretation* (Cambridge, Mass., 1948). The political background to the Renaissance in Italy is examined in Hans Baron, *The Crisis of the Early Italian Renaissance: civic humanism and republican liberty in an age of classicism and tyranny*, 2 vols. (Princeton, 1955).

2 E. Panofsky, *Renaissance and Renascences in Western Art* (New York, 1972). Its opening chapter offers a summary of the changes in attitude to the Renaissance continued beyond Ferguson's account.

[3] E.M.W. Tillyard, *The Elizabethan World Picture* (London, 1943), still heads the recommended reading list for the intellectual history of the period (a list compiled by leading modern scholars) in the most recent edition of the *Norton Anthology of English Literature* (New York, 1979) 1:2525. Tillyard's mild attempt to rectify this medieval emphasis in *The English Renaissance: Fact or Fiction?* (London, 1952) did little to change the general view.

[4] In Jacopo della Quercia's panel *The Creation of Adam* from about 1430 in S. Petronio, Bologna, which greatly influenced Michelangelo, Adam also has the muscular body of a Renaissance figure, although as yet none of the quiet confidence and intelligence. He is still presented in an inferior position, lying on the earth before the tall robed figure of God. In the Hamlet passage I follow the punctuation of the Folio, linking *apprehension* with *god*, as adopted by almost all modern editions of the play. For a discussion of that point, see the recent Arden edition by Harold Jenkins (London, 1982), pp. 468-70.

[5] Paul O. Kristeller, "Renaissance Platonism," in *Facets of the Renaissance*, ed. William H. Werkmeister (New York, 1963). The theme of man's enhanced dignity is examined in his *Renaissance Concepts of Man and Other Essays* (New York, 1972), notably in the opening chapter.

[6] M. Ficino, *Opera Omnia* (Basle, 1576), p. 805, the translation appearing in E. H. Gombrich, *Symbolic Images: studies in the art of the Renaissance ii* (London, 1978), p. 41.

[7] Machiavelli, *The Prince*, trans. and ed. Robert M. Adams (New York, 1977), p. 44.

[8] Hiram Haydn, *The Counter-Renaissance* (New York, 1950), especially pp. 139-66. Scepticism in this period is discussed in Margaret Wiley, *The Subtle Knot: creative scepticism in seventeenth-century England* (New York, 1968, originally 1952), in her later *Creative Sceptics* (London, 1966), as well as more recently in S. Chaudhuri, *Infirm Glory* (Oxford, 1981).

[9] Pico della Mirandola, *On the Dignity of Man* (the title of the essay added by a later editor), from the translation by Charles Glenn Wallis (Indianapolis, 1965), p. 7.

[10] Theodore Spencer, *Shakespeare and the Nature of Man* (New York, 1942), pp. 21-50.

[11] Roger Bacon, *The "Opus Maius,"* trans. Robert B. Burke (Philadephia, 1928) 2:420 and 580; and *The Notebooks of Leonardo da Vinci*, trans. and ed. Edward MacCurdy (London, 1954) 1:220.

[12] The Pythagorean influence in this period is examined in S. K. Heninger, Jr., *Touches of Sweet Harmony: Pythagorean cosmology and Renaissance poetics* (San Marino, 1974), and the musical harmony implicit in the philosophical system of that time in Gretchen L. Finney, *Musical Backgrounds for English Literature 1580-1650* (New Brunswick, 1952), and John Holloway, *The Untuning of the Sky* (Princeton, 1961). For a recent study moving beyond the Renaissance, see James A. Winn, *Unsuspected Eloquence: a history of the relations between poetry and music* (New Haven, 1981).

[13] Nicholas Cusanus, *De docta ignorantia* 1:21, and *Idiota* 3:5. Ernst Cassirer is generally thought to have overstated the latter's contribution to fifteenth-century thought in his *The Individual and the Cosmos in Renaissance Philosophy*, trans. M. Domandi (New York, 1963), but the basic elements of his account remain true. See the translator's introduction, p. xi.

[14] Da Vinci, *Notebooks*, ed. cit. 2:245. Also Erwin Panofsky, "Artist, Scientist, Genius," in *The Renaissance: Six Essays* (New York, 1962), and on the *Madonna of the Rocks*, Michael Levey, *The Early Renaissance* (Harmondsworth, 1977), p. 181.

[15] Art historians have recently argued for an anti-Albertian trend in the Renaissance, a theory of perspective based on a binocular rather

than a monocular system; but the indebtedness of such artists as Leonardo and Dürer to Alberti and the repeated quotation in that era of his famous passage on the work of art as an integrated entity testify to the extent of his influence. For details of the anti-Albertian theory, see Robert Klein, *Form and Meaning: essays in the Renaissance and modern art*, trans. M. Jay and L. Wieseltier (Princeton, 1981), pp. 129-40, and on Alberti's influence E. Panofsky, *Renaissance and Renascences*, p. 27.

[16] L. B. Alberti, *De pictura*, section 12, the translation based on Cecil Grayson's edition (London, 1972). John White, *The Birth and Rebirth of Pictorial Space* (London, 1958), and Samuel Y. Edgerton, Jr., *The Renaissance Rediscovery of Linear Perspective* (New York, 1975), provide important surveys of perspective theory and practice in this period.

[17] Rudolf Wittkower, *Architectural Principles in the Age of Humanism* (New York, 1971), pp. 101-23, emphasizes that Alberti advocated a scrupulous attention to Vitruvius's proportions in order to echo the harmonious ratios and forms visible in nature and believed to exist in the heavens.

[18] L. B. Alberti, *Ten Books on Architecture*, trans. in 1726 by James Leoni (London, 1955) I, ix and VI, ii, appearing here in modernised spelling.

[19] Erwin Panofsky, *Gothic Architecture and Scholasticism: an enquiry into the analogy of the arts, philosophy, and religion in the Middle Ages* (Cleveland, Ohio, 1970), especially pp. 31f. The circular-type churches or "temples" recommended by Alberti were based on nine geometrical figures, including the square, the hexagon, and the decagon, all of which could be circumscribed within a fixed radius. These centrally designed buildings became models for subsequent architects, as Rudolf Wittkower shows in the opening pages of his book on humanism, referred to above.

[20] John F. Danby, *Shakespeare's Doctrine of Nature: a study of "King Lear"* (London, 1961), pp. 15-53, examines the wider usage of the term in that period. The distinction has also been examined in Geoffrey Bush, *Shakespeare and the Natural Condition* (Cambridge, Mass., 1956).

[21] The diagram is reprinted in Edgar W. Tayler, *Nature and Art in Renaissance Literature* (New York, 1966), opposite p. 2.

[22] Erasmus, *Praise of Folly*, ed. P. S. Allen (Oxford, 1925), p. 67. For Calvin's view of the imagination, see James D. Boulger, *The Calvinist Temper in English Poetry* (The Hague, 1980), particularly p. 17.

[23] George Puttenham, *The Arte of English Poesie*, ed. G. D. Willcock and A. Walker (Cambridge, 1936), pp. 303-4.

[24] "The mind of the painter should be like a mirror which always takes the colour of the thing that it reflects, and which is filled by as many images as there are things placed before it. Know therefore that you cannot be a good master unless you have a universal power of representing by your art all the varieties of the forms which nature produces" (Da Vinci, *Notebooks*, ed. cit. 2:216).

[25] Sidney, "The Defence of Poesy," in *Prose Works*, ed. Albert Feuillerat (Cambridge, 1968) 3:7-8 and 11 with spelling modernised. The literary implications are examined in Virgil K. Whitaker, *The Mirror Up To Nature* (San Marino, 1965). The comparison of painting to poetry was, of course, a commonplace of Renaissance theory, derived from Plutarch's *Moralia* but with the authority of Horace's maxim *ut pictura poesis* behind it. See, for example, Rensselaer W. Lee, *Ut Pictura Poesis: the humanistic theory of painting* (New York, 1967). Sidney's possible allusions to Titian's paintings are discussed in Katherine Duncan-Jones' article "Sidney and Titian," in *English Renaissance Studies: presented to Dame Helen Gardner* (Oxford, 1980), pp. 1-11.

351

[26] The bust of Henry VII is in the Victoria and Albert Museum, London, and that of Henry VIII in the Metropolitan Museum, New York.

[27] E. H. Gombrich, "The Early Medici as Patrons of Art," reprinted in his *Norm and Form*, especially p. 52.

[28] John Lyly, *Complete Works*, ed. R. W. Bond (Oxford, 1902) 1:70-71.

[29] It may be noted that Henry Bolingbroke was the first king of England since the Norman conquest whose mother tongue was not French.

[30] Malory, *Morte Darthur* XXI, xi, ed. E. Strachey (London, 1931), p. 485.

[31] F. W. Bateson, quoted without reference by C. Barber, "The Later History of English," in W. F. Bolton, ed., *The English Language* (London, 1975), p. 301.

[32] Thomas Wilson, *The Art of Rhetoric* (London, 1553), bk. 3; Sir John Cheke in a letter to Thomas Hoby in 1557, reprinted in Hoby's translation of *The Courtier* (London, 1956), p. 7; and Thomas Elyot, *The Book Named Governor* (1531), bk. I, sec. xx, ed. S. E. Lehmberg (London, 1970), p. 98. The desire in this period for a more elegant, well-proportioned style is discussed in Elizabeth C. Traugott, *A History of English Syntax: a tranformational approach* (New York, 1972), especially p. 113.

[33] The preface (by an anonymous Scottish publisher) to the first translation of Ramus' *Logic* (London, 1574).

[34] Richard Sherry, *A Treatise of Schemes and Tropes* (London, 1550), p. 98.

[35] George Pettie, in the preface to his translation of Guazzo's *Civil Conversation* (London, 1581).

[36] Thomas Elyot, *The Book Named Governor*, bk. I, sect. i, in ed. cit., p. 6.

[37] Thomas Lodge, *Complete Works*, published for the Hunterian Club (New York, 1966) 1:26.

[38] Sidney, *The Prose Works*, ed. Albert Feuillerat, 1:216-17, the spelling again modernised. I have followed the 1593 edition in preferring *slip* to *stir*. Norman K. Farmer, Jr., *Poets and the Visual Arts in Renaissance England* (Austin, 1984), which examines pictorialism in the poetry of that period, draws attention (pp. 2-3) to Sidney's enquiry addressed to Nicholas Hilliard concerning techniques of depth-illusion in painting. Sidney's question on the method of distinguishing distant objects from near seems surprisingly naive, at least as Hilliard records it.

[39] That Veronese intended the painting to represent the Last Supper even though it seems doubtful from the Gospel account that the event took place in the house of Simon is evidenced by his own testimony at the trial, a record of which appears in *A Documentary History of Art*, ed. Elizabeth G. Holt (New York, 1957) 2:65-70.

[40] F. Bacon, "Of Death," in *Essays and New Atlantis*, ed. G. S. Haight (New York, 1942), p. 7.

[41] N. Pevsner, *The Englishness of English Art*, p. 26.

[42] Yvor Winters, "The Sixteenth-Century Lyric in England," in *Elizabethan Poetry: Modern Essays in Criticism*, ed. Paul Alpers (Oxford, 1967), p. 95.

[43] Wyatt's "Divers doth use as I have heard," 9-14.

[44] Sidney, *Astrophil and Stella*, Sonnet 81, in *Poems*, ed. William A. Ringler, Jr. (Oxford, 1962), p. 207.

[45] Shakespeare, *Sonnet 27*.

[46] Sidney, *Astrophil and Stella*, Sonnet 59, ed. cit., p. 194.

[47] *A Midsummer Night's Dream* 5.1.13-17. Theseus, of course, delivers these lines in condemnation of the poet but Hippolyta's reply corrects that judgment, confirming the validity of the poet's art in that regard.

CHAPTER 4

1 G. Boccaccio, *Lettere edite ed inedite*, ed. F. Corazzini (Florence, 1877), p. 189.

2 C. S. Lewis, *English Literature of the Sixteenth Century: excluding the drama* (Oxford, 1954), p. 2.

3 Jean Seznec, *The Survival of the Pagan Gods: the mythological tradition and its place in Renaissance humanism and art*, trans. Barbara Sessions (Princeton, 1972), pp. 149-83.

4 Spenser, *Fairie Queene* 1.12.23, in *Poetical Works*, ed. J. C. Smith and E. de Selincourt (Oxford, 1969), p. 65, which is the edition used for subsequent quotations.

5 Ghiberti, *Commentarii*, bk. 3, in Holt ed., *Documentary History of Art*, 1:165-66.

6 Panofsky, *Renaissance and Renascences*, pp. 184f.

7 The versions of the *Processus Prophetarum* from Rouen, Limoges, and Laon appear in Karl Young, *The Drama of the Medieval Church* (Oxford, 1933) 2:138-71.

8 Seznec, *Survival*, pp. 12f.

9 Nicholas of Cusa records his divine vision in his *De docta ignorantia* 3.12 and develops his universal theory of religion in his *De pace fidei* where he argues that all who have worshipped polytheistically have at the very least thereby acknowledged the existence of a divinity ("Omnes qui unquam plures deos coluerunt divinitatem esse praesupposuerunt"—*Ibid.*, p. 15). Cf. Ernst Cassirer, *Individual and Cosmos*, pp. 8 and 29-30.

10 Donne, "Goodfriday, 1613; Riding Westward," 11-12, in *Divine Poems*, ed. Helen Gardner (Oxford, 1978), p. 31. Such ingenious attempts to discover adumbrations of classical myths within the Bible may be exemplified by Jean Cousin's painting *Eva, Prima Pandora* (1538) in the Louvre.

11 Cf. Raphael's *Parnassus* in the Vatican's Stanza della Segnatura, which depicts Apollo and the Muses in a scene of musical harmony placed opposite a second lunette portraying the Christian Theological Virtues. Raphael, Giulio Romano's teacher, had also painted scenes from Psyche and Cupid on a ceiling of the Villa Farnesina, Rome, in 1517.

12 Panofsky, *Renaissance and Renascences*, p. 186.

13 In the preface to his translation of Ariosto's *Orlando Furioso* (London, 1591), Sir John Harington similarly justified his own reading of the classics on the basis of the time-honoured fourfold exegesis, pointing out that the ancient poets "have indeed wrapped as it were in their writings divers and sundry meanings." He contrasts the literal accounts there of the actions of heroes with the profitable moral sense concealed beneath, and the allegorical and mysterious significance to be further uncovered.

14 Ficino, *Opera Omnia*, ed. cit., p. 1370, translation from E. H. Gombrich, *Symbolic Images*, p. 59.

15 *The Oxford Book of Medieval Latin Verse*, ed. Stephen Gaselee (Oxford, 1937), p. 124. For the probable authorship of this poem, see Helen Waddell, *The Wandering Scholars* (London, 1968), pp. 161-76.

16 Bernard Silvestris, *Commentarium super sex libros Eneidos*, ed. G. Riedel (Greiswald, 1924), p. 9. Kenneth Clark, *The Nude: a study of ideal art* (Harmondsworth, 1960), pp. 64f., discusses the distinction between *Venus Coelestis* and *Venus Naturalis* in Renaissance art and her portrayal in increasingly sensuous terms.

17 Edgar Wind in his *Pagan Mysteries in the Renaissance* (London, 1968), pp. 141f., questions the authenticity of the late title to this painting, suggesting that it really represents not sacred and profane love but the two

higher forms of love, celestial and human—a view which I fully accept.

[18] Leslie A. Fiedler, *Love and Death in the American Novel* (New York, 1966), p. 54.

[19] *Paradise Lost* 1:533-36.

[20] Cf. Rashi's commentary on Exodus 25:18 that the cherubim possessed "the likeness of an infant's face."

[21] There is a record from as early as the thirteenth century of an abbot at St. Etienne in Caen having the words *Ecce mitto angelum meum* engraved around the figure of a Cupid. See Seznec, *Survival of the Pagan Gods*, p. 105.

[22] The large plasterwork frieze in the high chamber at Hardwick Hall, almost certainly the work of an Englishman, Abraham Smith, contains among other scenes Venus chastising Cupid, while the subjects selected by Bess of Hardwick for the cushion-covers embroidered by herself and her attendant ladies (still preserved there) include "Diana and Actaeon" and "Europa and the Bull."

[23] This and similar instances are recorded in J. Huizinga, *The Waning of the Middle Ages* (New York, 1954), pp. 315-16.

[24] Although the fourteenth-century anonymous *Ovid Moralisé* marked a new surge of interest in the "deciphering" of the classics, it had many antecedents in the Christian world, such as Fulgentius' sixth-century *Mythologiae*, which interpreted the Judgment of Paris metaphorically as a choice between the active, the contemplative, and the amorous life. But the burgeoning of this reading into a philosophical system was a fifteenth-century phenomenon. The Christian reading of Ovid is examined, in its literary, not its pictorial context, in Don Cameron Allen, *Mysteriously Meant: the rediscovery of pagan symbolism and allegorical interpretation in the Renaissance* (Baltimore, 1970), pp. 163-200.

[25] T. Nashe, *Works*, ed. R. B. McKerrow (London, 1910) 3:30-31.

[26] Cf. L. T. Golding, *An Elizabethan Puritan: Arthur Golding* (New York, 1937), pp. 194-95 and Gordon Braden, *The Classics and English Renaissance Poetry* (New Haven, 1978), chapter 1. The quotation is from *The Epistle to the Earl of Leicester*, lines 67-68, which Golding published with his translation. It appears in the edition of his *Metamorphoses* by J. F. Nims (New York, 1965), p. 407.

[27] The modern reader is not alone in his response. Rabelais in the prologue to his *Gargantua* asked incredulously: "Do you honestly believe that Homer penning his *Iliad* or *Odyssey* ever dreamed of the allegorical patchwork subsequently inflicted upon him? If you do, you are miles away from my opinion. For I hold that Homer no more dreamed of all this allegorical fustian than Ovid in his *Metamorphoses* dreamed of the Gospel." *The Five Books of Gargantua and Pantagruel*, trans. Jacques LeClercq (New York, 1944), p. 5.

[28] François de Sales, *An Introduction to a Devout Life*, trans. John Yakesley, 3d ed. (Rouen, 1614), p. 155. See also Richard Baxter, *The Saint's Everlasting Rest*, 4th ed. (London, 1653), pt. 4, pp. 216-21, which advocates the use of the physical senses to attain to spiritual understanding of the divine.

[29] The passage quoted appears only in the first edition of the poem.

[30] L. D. and Helen S. Ettlinger, *Botticelli* (New York, 1977), p. 138.

[31] Cf. John B. Bender, *Spenser and Literary Pictorialism* (Princeton, 1972), pp. 63-65.

[32] Perhaps the most interesting comparison other than to Botticelli is to Bronzino's *Venus, Cupid, Folly, and Time* (*fig. 52*) mentioned briefly by W.B.C. Watkins in his *Shakespeare and Spenser* (Princeton, 1950), p. 238, before he proceeds to his main comparison of Spenser with Giorgione and Titian. The Bronzino painting, discussed below in a more specific context, has a similar combination of sensuousness and moral didacticism, represented

by Time's angry tearing down of the curtain to reveal the licentiousness of the scene, which is itself depicted in its full erotic attractiveness. On the other hand, the aesthetic treatment is very different, with none of Spenser's deliberate artificiality.

[33] Leonardo devotes a lengthy section to waves and the movement of water in his *Notebooks*, ed. cit., 2:9-131, and numerous sketches of his have been preserved, studying the effects of eddies and currents. Although compiled in 1508, the *Notebooks* contain material on which the author had been engaged during earlier years. For his derogatory comment on Botticelli's painting of landscapes, see the book on him by the Ettlingers referred to above, p. 12.

[34] Alastair Fowler, in his study of numerology in verse, *Triumphant Form: structural patterns in Elizabethan poetry* (Cambridge, 1970), pp. 108-12, identifies the Spenserian stanza as mannerist on the doubtful principle that the distinguishing characteristic of that latter style is "complexity of design." That trait is, in fact, shared by almost all acknowledgedly Renaissance works of art, such as Raphael's Madonna paintings with their complex and subtly interrelated geometric substructures. My own view of the basic distinction between the two styles, notably the sense of instability which mannerism cultivates, will be developed in the following chapters.

[35] Cf. Spenser *Poetical Works*, ed. Smith and de Selincourt, p. 417.

[36] *Ibid.*, p. lii The more general identification of Error with Roman Catholicism is discussed in James Nohrnberg, *The Analogy of "The Fairie Queene"* (Princeton, 1976), p. 142; and the argument that Spenser's Neoplatonism was tinged with elements of Christian Kabbalah, in Francis A. Yates, *The Occult Philosophy in the Elizabethan Age* (London, 1979), pp. 96f.

[37] The theme of Elizabeth as goddess was, with less artistic delicacy than in Spenser's poem, depicted in Hans Eworth's canvas of 1569, *Queen Elizabeth Confounding Juno, Minerva, and Venus*. George Peele concluded a royal performance of his *Arraignment of Paris* by having Diana, the goddess of chastity, interrupt the contest to award the prize to the Queen herself. The compliment would seem to have found little favour with the Queen in that more blatant form, as Peele was never invited by her to prepare further stage offerings. See David Bevington, *Tudor Drama and Politics* (Cambridge, Mass., 1968), pp. 170-71.

[38] Cf. Burghley as the "sage old syre" in 5.9.43, Leicester's campaign in the Netherlands in 5.10.11, and Sidney presented as Sir Calidore in 6.1.2-3.

[39] Patrick Cullen, *Infernal Triad*, pp. 57f., examines the Red Cross Knight in terms of his Christian pilgrimage as he endeavours to conquer the flesh, the world, and the devil.

[40] Stephen Greenblatt, *Renaissance Self-Fashioning* (Chicago, 1980).

CHAPTER 5

[1] Marshall McLuhan, *The Gutenberg Galaxy: the making of typographic man* (London, 1962), pp. 241-43 and, less idiosyncratically, in his *Understanding Media* (London, 1968), p. 184.

[2] There is strong evidence that until the ap-

pearance of vernacular translations of the Bible, lay people generally relied on sermons and church readings for their knowledge of the scriptures. Cf. Beryl Smalley, *The Study of the Bible in the Middle Ages* (Oxford, 1952), p. xiv.

3 Erich Auerbach's seminal study of the contrast between sharply detailed realism in Homeric epic and the mysterious eternalization implicit in scriptural narrative has led to a widely held assumption that he was in this respect distinguishing classical from biblical literature. As he admits (if only in a brief aside), his distinction excludes, as it must, the large body of Greek and Roman tragedy which also aspires to the universal and the mysterious, and disdains particularization of detail. His disclaimer appears in *Mimesis: the representation of reality in Western literature*, trans. Willard Trask (New York, 1957), p. 19.

4 See Julius Wellhausen, *Prolegomena to the History of Ancient Israel* (New York, 1957), pp. 10-13, where he explains his methodology of identifying narrative repetition or digression in terms of additions to the text by later authors. The original German edition appeared in 1878.

5 *The Non-Cycle Mystery Plays*, ed. O. Waterhouse (London, 1909), p. 54.

6 Lorenzo Ghiberti, *Commentarii*, bk. ii, in Holt ed., *Documentary History* 1:161.

7 The technique goes back as far as the fourth century, and in early Renaissance art can be seen in some of the individual frames appearing on Duccio's *Maestà* altarpiece. There is a discussion of the possible interrelationship between the mystery cycles and such multiple scenes in the plastic arts in Gustave Cohen, *Histoire de la mise en scène dans le théâtre religieux français du Moyen Age* (Paris, 1926). For the development of this technique after Memlinc, cf. Lucas Cranach's *Garden of Eden* (1550), which relates the entire story within a single naturalistic setting.

8 George R. Kernodle, *From Art to Theatre: form and convention in the Renaissance* (Chicago, 1944), pp. 31f. The recognition of the Gothic frames in medieval painting as early forms of a proscenium arch was also suggested in Miriam S. Bunim, *Space in Medieval Painting* (New York, 1940), p. 111.

9 Instances are numerous. The eleventh-century bronze doors on the Church of St. Michael at Hildersheim, for example, paralleling scenes from Genesis with scenes from the life of Christ, place the Fall panel on the left door opposite the Crucifixion panel on the right. An illustration is available in John Beckwith, *Early Medieval Art, Carolingian, Ottonian, and Romanesque* (London, 1964), p. 145.

10 Giovanni Boccaccio, *The Decameron*, trans. Frances Winwar (New York, 1955), p. 16.

11 W. H. Clawson, "The Framework of *The Canterbury Tales*," *University of Toronto Quarterly* 20 (1951):137, provides a helpful comparison of the framing narratives in the two works, although he is, I believe, overly generous to the effectiveness of the device in *The Decameron*. There is an important essay on that topic by Robert A. Pratt and Karl Young in *Sources and Analogues of Chaucer's "Canterbury Tales,"* ed. W. F. Bryan and Germaine Dempster (New York, 1958), pp. 1-81. I have not discussed the possible debt to Sercambi as there is again no firm evidence that Chaucer had seen the *Novelle*, and in any case the latter appeared even in its earlier form so near in time to Chaucer's own work that it offers no indication of a developmental process.

12 See particularly the article by George L. Kitteridge, "Chaucer's Discussion of Marriage," *Modern Philology* 9 (1911-2):435, followed by a host of articles supporting and rebutting the thesis.

13 Such disruption of dramatic illusion is discussed in general terms in Jackson I. Cope,

The Theater and the Dream: from metaphor to form in Renaissance drama (Baltimore, 1957), and in David M. Bevington, *From Mankind to Marlowe: growth and structure in the popular drama of Tudor England* (Cambridge, Mass., 1962), pp. 50-51.

[14] *The Towneley Plays*, ed. cit., p. 313.

[15] See Ann Righter, *Shakespeare and the Idea of the Stage* (London, 1964), particularly the opening chapter.

[16] *A Refutation of the Apology for Actors*, by "I.G.," published in 1615 as a rebuttal to Thomas Heywood's *An Apology for Actors*. Both are available in the Scholar's Facsimile and Reprints series (New York, 1941).

[17] Karl Young, *The Drama of the Medieval Church* (Oxford, 1933), 2:14, 412. Kolve, in his *Play Called Corpus Christi*, p. 278, suggests that the Virgin Mary image may here be a remnant of the old *praesepe* tradition, the static model of the entire crib scene gradually being dramatized figure by figure. Yet even if that is so, the fact that she is the last to be replaced would itself indicate a reverential hesitation at dramatizing her by means of substituting a human actor for the image.

[18] Sidney, *Defence of Poesy*, in *Prose Works*, ed. Feuillerat, 3:8. The Renaissance idea of the world as theatre, in which the real king is seen as acting a part no less than the actor king upon the stage (an idea reinforced by the contemporary love of royal pageantry) served as a further means of justifying drama at this time. If all the world was a stage, then the stage was, in a sense, all the world. See Francis A. Yates, *The Theatre of the World* (London, 1969).

[19] Coleridge in his *Biographia Literaria*, chapter 14. The view offered here would, of course, be unacceptable to deconstructionists such as Derrida, P. D. Juhl, or Stanley Fish (in his most recent phase) who deny the text's direction and manipulation of reader response, placing instead the full weight on what the reader brings to the work. For an interesting reply to the deconstructionist view, see David H. Hirsch, "Penelope's Web," *Sewanee Review* (1982):119, as well, of course, as E. D. Hirsch, Jr., *Validity in Interpretation* (New Haven, 1967).

[20] In "Ways of Seeing in Shakespearean Drama and Elizabethan Painting," *Shakespeare Quarterly* 31 (1980):323, Roland M. Frye argues that both English painting and English drama at the time of Elizabeth ignored the continental demands for unity of time, place, and action, preferring multiple to single perspective. He therefore sees the *Henry V* prologue as a denial of fixed perspective. I would claim that it marks rather Shakespeare's sensitivity to the new pressures, and his frustration at the difficulties involved in implementing such realistic perspective on the stage.

[21] Serlio's detailed description of his own experiments in Vicenza and his advice to subsequent designers repeatedly drew attention to the contrast between the solid foreground and raked, illusionist background. On the front, level stage he recommends that five rows of equal-sized squares should be marked out; but from the line where the level stage ends, there should begin a diminishing perspective created by oblique orthogonals, leading to a low-placed vanishing-point beyond. His *Second Book of Architecture* (1545), which discusses this point, is translated by Allardyce Nicoll in *The Renaissance Stage; documents of Serlio, Sabbattini, and Furttenbach*, ed. Barnard Hewitt (Coral Gables, Fla., 1958), pp. 24-33.

[22] Stephen Orgel, *The Jonsonian Masque* (Cambridge, Mass., 1965) and *The Illusion of Power: political theatre in the English Renaissance* (Berkeley, 1975); Roy Strong, *Splendour at Court: Renaissance spectacle and the theatre of power* (Boston, 1973); and their jointly authored *Inigo Jones: the theatre of the Stuart Court*, 2 vols. (Berkeley, 1973). Also *A Book of Masques: in honour of Allardyce Nicoll* (Cambridge, 1967).

²³ Roy Strong, *Splendour at Court*, pp. 180-94. Gary Schmidgall, *Shakespeare and the Courtly Aesthetic* (Berkeley, 1981), provides a valuable examination of the artistic milieu of the masques, focussing upon *The Tempest* as part of that setting.

²⁴ The traditional assumption that the influence of Vitruvius was not felt in England until the early seventeenth century was questioned by Frances A. Yates in her *Theatre of the World*, pp. 20-41. Her claims are, perhaps, larger than her evidence warrants, particularly in relation to the structure of the Globe playhouse (see pp. 112-35); but her discovery that John Dee possessed a copy of Vitruvius's work in his library and that he quoted from it at length together with Alberti's theories does, at the very least, confirm that these works were known in England earlier than had previously been thought. For an account of books on art, perspective, and architecture recorded as held in English libraries in the late sixteenth and early seventeenth centuries, see Lucy Gent, *Picture and Poetry, 1560-1620* (Leamington, 1981), pp. 66-86.

²⁵ Cf. also Veronese's *The Marriage at Cana* from the Louvre, painted in 1563, which is even larger (over thirty feet long), and again sets a crowded and theatrical human scene against a vista of monumental buildings decorated with classical columns and opening up to the spacious heavens.

²⁶ Thomas Sackville and Thomas Norton, *Gorboduc: or Ferrex and Porrex* 2.2.52-56, ed. Irby B. Cauthen, Jr., Regents Renaissance drama series (Lincoln, Nebraska, 1970), p. 35.

²⁷ Marlowe, *I Tamburlaine* 1.2.190-201, in *Complete Works*, ed. Fredson Bowers (Cambridge, 1973) 2:91.

²⁸ Harry Levin, *Christopher Marlowe: the Overreacher* (London, 1965), p. 31.

²⁹ Leo Kirschbaum, "Marlowe's *Faustus*: a Reconsideration," *Review of English Studies* 19

(1943):229, was the first to argue convincingly that the play does not reluctantly succumb to traditional religious pressures in its concluding scene but, from the first, acknowledges the sin committed by Faustus in his pact with the devil. Such a view now generally accepted, must assume a shift in Marlowe's sensibility after the daring challenge offered by *Tamburlaine*.

³⁰ Madeleine Doran, *Endeavors of Art: a study of form in Elizabethan drama* (Madison, 1964), defines her policy on pp. 4-5 before embarking on her close analysis of the plays. The weakness inherent in Wölfflin's principles will be discussed in a later chapter.

³¹ Bevington, *From Mankind*, pp. 124-27. The hybrid genre which usually results from such contrasting elements is examined in Marvin T. Herrick, *Tragicomedy: its origin and development in Italy, France, and England* (Urbana, 1962).

³² Cf. G. G. Coulton, *Medieval Panorama* (New York, 1955), p. 311.

³³ The author of *Gammer Gurton's Needle*, described on the frontispiece simply as "Mr. S., Master of Arts" is generally believed to be William Stevenson. See Henry Bradley's introduction to the play in C. M. Gayley, *Representative English Comedies* (New York, 1907), which offers what is still the most persuasive attribution.

³⁴ Doran, *Endeavors*, pp. 277-78 and Bernard Weinberg, "Castelvetro's Theory of Poetics," in *Critics and Criticism*, ed. R. S. Crane (Chicago, 1957), 146. Richard Levin, *The Multiple Plot in English Renaissance Drama* (Chicago, 1971), provides a general survey, mainly devoted to Shakespeare's period.

³⁵ It is interesting to note as part of the growing sensitivity to chronological integrity in narrative that Alberti himself had advocated not only the window-like accuracy of a painted scene but also what he termed *historia*—a representation which implies the ante-

cedents of the scene as well as its future development. Cf. Cecil Grayson's edition of Alberti's *On Painting* (London, 1972), p. 13.

36 Andrea del Castagno's fresco in the refectory of S. Apollonia, Florence (1447), and Ghirlandaio's (1480) in Ognissanti, Florence, are examples of the earlier, less dramatic versions of the Last Supper.

37 The illustration is reproduced in W. Moelwyn Merchant, *Shakespeare and the Artist* (London, 1959), plate 1.

38 Cf. Barbara K. Lewalski, "Biblical Allusion and Allegory in *The Merchant of Venice*," *Shakespeare Quarterly* 13 (1962):327.

39 Although there can be no certainty of an allusion to Preston's play, it is generally accepted as such by modern editors, particularly as there seem to be verbal echoes in the text. The recent Arden edition by Harold F. Brooks (London, 1979), especially the footnotes on pp. 20 and 107, discusses the probability of the allusion.

40 *Hamlet* 3.2.47-48. Kempe, one of the original shareholders in the Globe playhouse in 1599, is known from the pamphlet *Kempe's Morris to Norwich* to have danced his way from London to Norwich in February 1600. That event would seem to date his departure from the company of the Chamberlain's Men to the time Shakepeare wrote these lines, the allusion to Kempe no doubt being intended to be caught by the audience.

41 John Case, *Praise of Musicke* (London, 1588), p. 44.

42 Thomas Morley, *A Plaine and Easie Intro-*

duction to Practical Musicke (London, 1597), p. 180. See also Hallett Smith, *Elizabethan Poetry: a study in conventions, meaning and expression* (Cambridge, Mass., 1966), especially pp. 257f.

43 B. Sprague Allen, *Tides in English Taste* (Cambridge, Mass., 1937) 1:8 examines certain aspects of the change.

44 There are, it is true, instances of such *E* buildings prior to Queen Elizabeth's reign but their existence does not preclude the possibility of an intended compliment when that letter was selected during a period when she was on the throne. The hieroglyphic attention paid to the overall shape of a building is indicated by John Thorpe's design in 1570 (never implemented) for a house forming the initials of his own name. For a discussion of the country-house poems and Ben Jonson's attack on their extravagance, see William S. McClung, *The Country House in English Renaissance Poetry* (Berkeley, 1977).

45 Bacon, "Of Building," in *Essays*, ed. cit., p. 186.

46 His plays were, of course, designed to be presented in longer or shortened form depending on the specific needs of the occasion, whether at court, in the playhouse, or on tour; but the principle holds true, and only those parts affecting the drama least would be sacrificed to such needs. The omission of Fortinbras from *Hamlet*, as Granville-Barker pointed out, does damage the play seriously, however peripheral he may seem.

CHAPTER 6

1 Shakespeare's *Comedy of Errors* in his earlier period and *The Tempest* in his later display a willingness to conform to unity of time and, to a limited extent, of place too, but such conformity was, of course, the exception in his plays rather than the rule.

[2] René Wellek's essay "The Concept of Baroque in Literary Scholarship," which appeared originally in 1946, is reprinted with his postscript of 1962 in his *Concepts of Criticism*, ed. S. G. Nichols, Jr. (New Haven, 1965). For interesting examinations of Shakespeare's response to iconographic elements in painting and sculpture as well as to the emblem tradition, see respectively W. S. Heckscher, "Shakespeare and his Relationship to the Visual Arts," and John M. Steadman, "Iconography and Renaissance Drama: ethical and mythological themes," both appearing in *Research Opportunities in Renaissance Drama* 13 (1972).

[3] Peter N. Skrine, *The Baroque: Literature and Culture in Seventeenth-Century Europe* (London, 1978), p. 71, and Arnold Hauser, *Mannerism: the Crisis of the Renaissance and the Origin of Modern Art*, trans. E. Mosbacher, 2 vols. (New York, 1965), 1:164. The transition from mannerism to baroque art is examined in S. J. Freedberg, *Circa 1600: a revolution of style in Italian painting* (Cambridge, Mass., 1983).

[4] Heinrich Wölfflin, *Renaissance and Baroque*, trans. K. Simon (Ithaca, New York, 1967), p. 59. Peter Murray's introduction to this translation offers some brief but pertinent observations on the weaknesses in Wölfflin's distinctions. Michelangelo's entrance to the Laurentian Library was first identified as mannerist in the pioneering essay by Nikolaus Pevsner, "The Architecture of Mannerism," appearing in the first volume of *The Mint* (1946).

[5] Walter Friedlaender's lecture on mannerism delivered in 1914 appeared in translation, together with his later essay of 1930, as *Mannerism and Anti-mannerism in Italian Painting* (New York, 1957). Werner Weisbach, "Der Manierismus," *Zeitschrift für Bildende Kunst* 30 (1919):161, remained generally antagonistic to mannerism but was followed by Max Dvo-

rak's lecture in 1920, "Über Greco und den Manierismus" published in *Kunstgeschichte als Geistesgeschichte* (Munich, 1924), appearing in English form as "El Greco and Mannerism" in *Magazine of Art* 46 (1953).

[6] William Empson's *Seven Types of Ambiguity* appeared in 1930, and Cleanth Brooks' essay "The Language of Paradox" in 1942, included later in his volume *The Well Wrought Urn* (New York, 1947), pp. 3-21.

[7] For the antipathy of many leading art historians to mannerist art during a period as late as the sixties, we may quote the respected scholar Germain Bazin's description of it in his *A Concise History of Art* (London, 1962) 2:273-74 as a "sickness of styles—a sort of neurosis, a symptom of their inability to define themselves which led second-rate artists, overwhelmed by the authority of the great masters, into an extravagance of gesture and expression."

[8] For John Shearman and Linda Murray, see chapter 8 below, where bibliographical references are provided.

[9] Wylie Sypher, *Four Stages*, pp. 110 and 139.

[10] Hauser, *Mannerism*, 1:112f.

[11] The overarching moral order prevailing in Shakespeare's plays has been examined, in many works, among them D. G. James, *The Dream of Learning* (Oxford, 1951); Arthur Sewall, *Character and Society in Shakespeare* (Oxford, 1951); Geoffrey Bush, *Shakespeare and the Natural Condition* (Cambridge, Mass., 1956); Irving Ribner, *Patterns in Shakespearean Tragedy* (London, 1960); Robert Ornstein, *The Moral Vision of Jacobean Tragedy* (Madison, 1965); and Alan Hobson, *Full Circle: Shakespeare and Moral Development* (London, 1972).

[12] Norman Rabkin, *Shakespeare and the Common Understanding* (New York, 1967); the theory of complementarity is discussed on pp. 1-29.

[13] Marino's poetry, for example, had achieved wide acclaim on the continent by 1590 when Shakespeare was at the beginning of his career. See James V. Mirollo, *The Poet of the Marvelous: Giambattista Marino* (New York, 1963), pp. 8-9.

[14] The dangers of such a course have been illustrated by Hauser's treatment of both figures. By reading back the later tendencies into the earliest phase, he concludes that Michelangelo had been mannerist from the first (1:148 and 164). David Summers, on the other hand, in his *Michelangelo and the Language of Art* (Princeton, 1981), p. 19, has noted more recently how his art was regarded by contemporaries as being in the grand manner of the High Renaissance itself, and not a break-away from it.

[15] Sypher, *Four Stages*, p. 60. The italics are his.

[16] Malory, *Morte Darthur* XIII, xx, ed. cit., p. 364.

[17] *Henry V* 3.1.7-11. Quotations from Shakespeare throughout this book are from *The Complete Works*, ed. Hardin Craig and David Bevington (Glenview, 1973).

[18] Ernest Kantorowicz, *The King's Two Bodies: a study in medieval political theology* (Princeton, 1957), examines the twin elements in the conception of kingship, namely the combination of divine and political qualities.

[19] On anamorphic painting, see J. Baltrusaitis, *Anamorphoses* (Paris, 1966), and F. Leeman, *Hidden Images: games of perception, anamorphic art and illusion from the Renaissance to the present*, trans. E. C. Allison and M. L. Kaplan (New York, 1976). The Piedmontese painter Gandenzio Ferrari, who lived from about 1475 to 1546, is also recorded as having produced a portrait of Christ which achieved its true proportions only when viewed through a peephole in the frame. G. P. Lomazzo, *Trattato dell'arte della pittura* of 1584

(Rome, 1844) 2:174-75, describes having seen the portrait.

[20] Ernest B. Gilman, *The Curious Perspective: literacy and pictorial wit in the seventeenth century* (New Haven, 1978). There is an earlier discussion of this passage from *Richard II* and its anamorphic connexions in Arthur H. R. Fairchild, *Shakespeare and the Arts of Design* (Columbia, 1937), p. 128, a study which conveniently gathers Shakespeare's references to contemporary art and architecture. See also Claudio Guillén, "On the Concept and Metaphor of Perspective," in *Comparatists at Work: studies in comparative literature*, ed. S. G. Nichols and R. B. Vowles (Waltham, 1968), pp. 28-90; and William S. Heckscher, "Shakespeare and his Relationship to the Visual Arts: a Study in Paradox," in *Research Opportunities in Renaissance Drama* 13-14 (1972): 5-71.

[21] Gilman also bases his theory upon an ingenious (perhaps over-ingenious) reading of "rightly" here as a pun on "at right angles" (p. 94), but that suggestion is not requisite for an acceptance of his major interpretation. Stephen Greenblatt, *Renaissance Self-Fashioning*, pp. 17-21, interestingly compares this duality in Holbein's painting to the complex personality of his patron Sir Thomas More, in part committed as Lord Chancellor to the affairs of this world while in part drawn to a life of asceticism and the Christian eternity beyond.

[22] Northrop Frye, *Anatomy of Criticism* (Princeton, 1971), originally delivered in 1954, especially pp. 163-86, and C. L. Barber, *Shakespeare's Festive Comedy* (Princeton, 1959).

[23] Serlio, *Second Book of Architecture*, in Barnard Hewitt, ed., *The Renaissance Stage*, p. 24. The *costruzione legittima* of Alberti (discussed in chapter 3 above, with its use of what later came to be called a fixed vanishing-point) was, of course, itself a form of *trompe l'oeil*, creating an illusion of depth on a flat surface; but in contrast to the mannerist art of

such painters as El Greco, its purpose was to reproduce optically the sense of reality which the eye receives when gazing upon a scene and thus to provide for the viewer a faithful re-creation of the original. There is a discussion of *trompe l'oeil* in Shakespeare's plays in Robert M. Adams, *Strains of Discord: studies in literary openness* (Ithaca, 1958), pp. 52-62.

[24] The pose of the figures is in fact copied from an engraving, by Marcantonio Raimondi, of Raphael's *Judgement of Paris* where all the figures are nude; but the idea of the scene as a whole is clearly indebted to the Giorgione painting. His friend Antonin Proust in his *Recollections of Edouard Manet* (Paris, 1913) records Manet's explicit statement that his own painting was to be based on the copy of Giorgione's painting of nudes— "the one with the musicians in it"—which he kept in his studio.

[25] "From Henry V to Hamlet," in *Studies in Shakespeare*, ed. Peter Alexander (London, 1964), p. 85.

[26] Da Vinci, *Notebooks*, ed. cit., 2:331-33 and 247.

[27] George T. Wright, "Hendiadys in Ham-

let," *Publications of the Modern Language Association* 96 (1981):168.

[28] Buontalenti's staircase in S. Stefano, Florence, will be discussed in a later chapter. For its indebtedness to Michelangelo's staircase in the Laurentian Library, see Rudolf Wittkower, *Idea and Image: studies in the Italian Renaissance* (London, 1978), pp. 42f.

[29] Andrew Marvell, "A Dialogue Between the Soul and the Body," 1-6, in *Poems and Letters*, ed. H. M. Margoliouth (Oxford, 1963) 1:20. The El Greco incident was recorded in a letter written in 1570 by his friend Giulio Clovio. See Peter Murray, *A Dictionary of Art and Artists* (Baltimore, 1963), pp. 139-40.

[30] Robert B. Heilman, *This Great Stage: image and structure in "King Lear"* (Baton Rouge, 1948), especially chapter 2.

[31] *Richard II* 3.2.160-63.

[32] Michelangelo's comment to his friend Sangallo, recorded in Michael Levey, *High Renaissance* (Harmondsworth, 1975), pp. 107-10, which discusses the Renaissance vogue for sepulchral magnificence.

[33] Shakespeare *Sonnet 55*, 1-4.

[34] *The Tempest* 5.1.49.

CHAPTER 7

[1] Montaigne, *Essays* 1:40. The translation, with a slight change to improve clarity, is from *The Complete Essays* by Donald M. Frame (Stanford, 1965), p. 185.

[2] Morris W. Croll, "Attic Prose: Lipsius, Montaigne, Bacon," in *The Schelling Anniversary Papers: by his former students* (New York, 1923), pp. 117-50, and "The Baroque Style in Prose," in *Studies in English Philology in Honor of Frederick Klaeber*, ed. K. Malone and M. B. Ruud (Minneapolis, 1929), pp. 427-56.

[3] S. E. Fish, ed., *Seventeenth-Century Prose:*

modern essays in criticism (New York, 1971), p. vii. Cf. George Williamson, *The Senecan Amble: a study in prose form from Bacon to Collier* (Chicago, 1951), which followed Croll's lead.

[4] René Wellek, *Concepts of Criticism*, p. 87, would seem to suggest that he was the very first English-speaking critic to use the word *baroque* for literature, although it was already well established by then in continental criticism.

[5] "There is a considerable affinity between baroque architecture and seventeenth-cen-

tury prose." Geoffrey Scott, *The Architecture of Humanism: a study in the history of taste* (London, 1961), p. 264.

⁶ Second Prebend Sermon delivered 29 January 1625, in *The Sermons of John Donne*, ed. George R. Potter and Evelyn M. Simpson (Berkeley, 1953-62), 7:57. M. M. Mahood has an illuminating chapter on "Donne: the Baroque Preacher" in her *Poetry and Humanism: a study of the great seventeenth-century English religious poets and their relation to Renaissance humanism* (New Haven, 1950), chapter 5, but its insights, as so often in that period, are spoilt by the attempt to make him at one and the same time part of the baroque Grand Style and of mannerist attenuation and unworldliness.

⁷ Joan Webber, *The Eloquent "I": style and self in seventeenth-century prose* (Madison, 1968), especially pp. 154f.

⁸ Quotations from the *Religio Medici* are from *Sir Thomas Browne: the major works*, ed. C. A. Patrides (Harmondsworth, 1977), with page references cited in the text.

⁹ Sir Kenelm Digby, *Observations Upon Religio Medici*, 3d ed. (London, 1659), p. 33.

¹⁰ Austin Warren, "The Styles of Sir Thomas Browne," *Kenyon Review* 13 (1951):674.

¹¹ D. C. Allen, "Style and Certitude," *Journal of English Literary History* 15 (1948):168.

¹² Margaret Wiley, *The Subtle Knot*, p. 137.

¹³ Austin Warren, in the essay cited above, declares that Browne has little originality in metaphor and almost no visual imagery.

¹⁴ Croll does acknowledge, as a variation, the statement of truth followed by a different aspect of it, but even there he sees the sequel as consisting of "new apprehensions" of that truth, like the successive flashes of a revolving jewel.

¹⁵ *The Spiritual Exercises of St. Ignatius*, trans. A. Mottola (New York, 1964), p. 56.

¹⁶ "And have you no pride in thinking you have no pride? St. Bernard makes twelve degrees of pride, of which bragging is one." Alexander Ross, *Medicus Medicatus: or the Physician's Religion cured by a lenitive or gentle potion. With some Animadversions upon Sir Kenelm Digby's Observations on Religio Medici* (London, 1645), p. 74. Such attacks on Browne are discussed in James N. Wise, *Sir Thomas Browne's "Religio Medici" and Two Seventeenth-Century Critics* (Columbia, Mo., 1972).

¹⁷ Luis de la Puente, *Meditations upon the Mysteries of our Holy Faith*, trans. John Heigham (St. Omer, 1619) 1:55, the original work dating from 1605. Browne's relationship to the meditative tradition in outlook rather than prose style is examined in Leonard Nathanson, *The Strategy of Truth: a study of Sir Thomas Browne* (Chicago, 1967), pp. 76-81 and 93-99, and in the chapter entitled "Sir Thomas Browne and Meditative Prose" in Laurence Stapleton, *Elected Circle: studies in the art of prose* (Princeton, 1973), as well as in Ann Drury, "Epistle, Meditation, and Sir Thomas Browne's *Religio Medici*," *Publications of the Modern Language Association of America* 94 (1979):234.

¹⁸ "The Bad Physician: the Case of Sir Thomas Browne," in Stanley E. Fish, *Self-Consuming Artifacts: the experience of seventeenth-century literature* (Berkeley, 1972), pp. 353-73. A provocative reply is offered by Frank J. Warnke, "A Hook for Amphibian: Some Reflections on Fish," in *Approaches to Sir Thomas Browne: the Ann Arbor Tercentenary Lectures and Essays*, ed. C. A. Patrides (Columbia, Mo., 1982), pp. 49-59.

¹⁹ From the "Chorus Sacerdotum" which Fulke Greville appended to his drama *Mustapha*, in *Poems and Dramas*, ed. Geoffrey Bullough (New York, 1945) 2:136.

²⁰ His *Bacchanalian Revel*, painted in 1637, in the National Gallery, London, employs the same technique.

[21] Quoted in Anthony Blunt, *Nicolas Poussin* (New York, 1967), p. 220. Blunt discusses at length the stoical elements which entered Poussin's work at about that period. The second quotation is from a letter to Paul de Fréart, Sieur de Chantelou, dated 24 November, 1647 and appearing in E. G. Holt, ed., *A Documentary History of Art*, 2:155.

[22] Dryden, *The Conquest of Granada*, 2.1.178-80.

[23] Sermon preached at the Church of St. Clement Danes 30 May 1621, in *Sermons*, ed. Potter and Simpson, 3:254-55.

CHAPTER 8

[1] Joseph H. Summers, *George Herbert: his religion and art* (Cambridge, Mass., 1954), pp. 26-27.

[2] Arnold Stein, *George Herbert's Lyrics* (Baltimore, 1968), especially the opening chapter on "The Art of Plainness."

[3] Rosemund Tuve, *A Reading of George Herbert* (Chicago, 1952), pp. 32-99.

[4] Herbert, "The Pearl," 32-40, in *Works*, ed. F. E. Hutchinson (Oxford, 1959), p. 89, which is the text used for quotations throughout this chapter.

[5] Helen Vendler, *The Poetry of George Herbert* (Cambridge, Mass., 1975) contains a chapter which originally appeared as "The Re-Invented Poem: George Herbert's Alternatives," in *Forms of Lyric: selected papers from the English Institute*, ed. Reuben Brower (New York, 1970).

[6] "Jordan II," 17-18; also "I often blotted what I had begun; / This was not quick enough, and that was dead" (9-10).

[7] S. E. Fish, *Self-Consuming Artifacts*, pp. 157-223. For the fuller discussion of Herbert, see Fish's *The Living Temple: George Herbert and catechizing* (Berkeley, 1978).

[8] Ernst R. Curtius, *European Literature and the Latin Middle Ages*, trans. Willard R. Trask (New York, 1963), pp. 273-301. The excellent summary of the controversy by James V.

Mirollo published in *The Meaning of Mannerism*, ed. F. W. Robinson and Stephen G. Nichols, Jr. (Hanover, N.H., 1972), pp. 7-20, has now been brought up to date and appears together with a lengthy bibliography as the opening chapter of his recent *Mannerism and Renaissance Poetry: concept, mode, inner design* (New Haven, 1984).

[9] S. J. Freedberg's study of *Parmigianino: his works in painting* (Cambridge, Mass., 1950) discusses the artist's place in the larger movement, and is at the same time a valuable critique of mannerism itself.

[10] John Shearman, "*Maniera* as an Aesthetic Ideal," in *Renaissance and Mannerism: studies in Western Art*, Acts of the Twentieth International Congress of the History of Art, vol. 2 (Princeton, 1963), p. 200. The lecture was later expanded into a book entitled *Mannerism* (Harmondsworth, 1967). Also Louis L. Martz "Marvell and Herrick: the masks of Mannerism," in C. A. Patrides, ed., *Approaches to Marvell: the York Tercentenary Lectures* (London, 1978), pp. 194-215, and James V. Mirollo, *Mannerism and Renaissance Poetry*, particularly chapters 3 to 5.

[11] Frederick Hartt, "Power and the Individual in Mannerist Art," in *Renaissance and Mannerism*, p. 222.

[13] For details see Shearman, *Mannerism*, pp.

126-33. There is a useful collection illustrating mannerist works in F. Würtenberger, *Mannerism* (New York, 1963), and a discussion of humour in Mannerist art in Paul Barolsky, *Infinite Jest: wit and humor in Italian Renaissance Art* (Columbia, Mo., 1978).

[13] For a helpful general discussion of such illusionism, see Linda Murray, *The Late Renaissance and Mannerism* (London, 1967), especially pp. 34-78.

[14] Oswald Spengler, *The Decline of the West*, trans. C. F. Atkinson (London, 1932).

[15] *Holy Sonnet xiv*, 12-14, in *Divine Poems*, ed. Helen Gardner (Oxford, 1978), p. 11. The relevance of Donne's poetry to this movement is, of course, central. I have refrained as far as possible from discussing it here as the connexion of his poetry with mannerist art formed the main theme of my book *The Soul of Wit: a study of John Donne* (Oxford, 1974). The theme of ecstasy in this period in both art and literature is examined in Robert T. Petersson, *The Art of Ecstasy: Saint Teresa, Bernini, and Crashaw* (London, 1970).

[16] Although there was no scriptural source for the scene, meditators desiring to conjure it up in their minds as a hypothetical experience could find some assistance in Matt. 28:2-4 describing the supernatural disturbances occurring when the tomb was discovered to be empty.

[17] Louis L. Martz, *The Poetry of Meditation* (New Haven, 1954) has sensitized our own generation to the importance of the Catholic meditative tradition in seventeenth-century poetry, while Barbara K. Lewalski's more recent *Protestant Poetics and the Seventeenth-Century Religious Lyric* (Princeton, 1979) has argued persuasively for a parallel Protestant phenomenon.

[18] Rudolf Arnheim, *Art and Visual Perception*, p. 283.

[19] For further details, see Margaret Whinney and Oliver Millar, *English Art, 1626-1714* (Oxford, 1957), pp. 1-14, and J. H. Plumb and Huw Wheldon, *Royal Heritage: the treasures of the British Crown* (New York, 1977), pp. 94-126, the latter interestingly tracing the acquisitions and changing tastes of the successive English monarchs. Also Philipp P. Fehl, "Poetry and the Entry of the Fine Arts into England," in *The Age of Milton*, ed. C. A. Patrides and Raymond B. Waddington (Manchester, 1980), pp. 273-306.

[20] ". . . a hand or eye / By Hilliard drawn, is worth an history / By a worse painter made," from "The Storme: a verse letter addressed to Mr. Christopher Brooke," 3-6, in *The Satires, Epigrams, and Verse Letters*, ed. W. Milgate (Oxford, 1967), p. 55. Details of Donne's bequests are recorded in R. C. Bald, *John Donne: a Life* (Oxford, 1970), pp. 501 and 563.

[21] It is interesting to note in these lines the rejection of classical humanism as a source for poetry in favour of scriptural sources, a rejection which Herbert shares with the religious painters of the Counter-Reformation. Here the traditional harmony and perfection of the Renaissance ideal is diverted from Neoplatonism to the biblical Urim and Thumim. Although biblical commentators have never identified the real significance of the two words in Exodus 28:30—"And thou shalt put in the breast-plate of judgement the Urim and Thumim; and they shall be upon Aaron's heart when he goeth in before the Lord"—the literal meaning of the Hebrew words, namely, "lights and perfections," were sufficient to serve Herbert as valued substitutes for the pagan ideals of perfect concord, usually represented in Renaissance literature by the Platonic sphere.

[22] Donne, from whom Herbert may have borrowed the idea, uses the same wordplay to achieve a similar sense of anatomical monstrosity in his Meditation on the tolling of the bell (*Devotions Upon Emergent Occasions* xvii)

where he argues that a child upon baptism "is thereby connected to that Body which is my head too, and engrafted into that body, whereof I am a member."

[23] Vendler, *The Poetry of George Herbert*, p. 119.

[24] Rosalie L. Colie, *Paradoxia Epidemica: the Renaissance tradition of paradox* (Princeton, 1966), notably pp. 103-41 and 204.

[25] Marvell, "The Coronet," line 4, ed. cit., 1:14, and Donne "Goodfriday," line 21, in *Divine Poems*, ed. Gardner, p. 31.

[26] See the sermon preached at the funeral of Sir William Cockayne on 12 December 1626 in *Sermons*, ed. Potter and Simpson, 7:264-65.

[27] *Hieroglyphica*, the work of the fifth-century Greek grammarian from Egypt, Horapollo, rediscovered in 1419 and published in Venice in 1505, was a primary source for the earliest emblem book produced by Andrea Alciati in 1531. See Mario Praz, *Studies in Seventeenth-Century Imagery*, rev. ed. (Rome, 1964), pp. 22-25. On hieroglyphics in Herbert, see Summers, *George Herbert*, pp. 123-46.

[28] Lewalski, *Protestant Poetics*, especially the opening chapter.

[29] Sir Thomas Browne, *Religio Medici*, 1:16, with the Moses reference from 1:34, in *Major Works*, ed. C. A. Patrides, pp. 78-79 and 104.

[30] Joseph Hall, *The Invisible World: discovered to spiritual eyes and reduced to useful meditation* (London, 1652), pp. 335-36.

[31] Donne, *Divine Poems*, ed. cit., p. 48.

[32] Helen Gardner comments in her edition of *The Metaphysical Poets* (Harmondsworth, 1980), p. 317, that Quarles' *Emblems* was "far the most popular book of verse in the century." Walpole's remark appears without source in the Gilman article cited in the following footnote.

[33] Rosemary Freeman, *English Emblem Books* (London, 1948), pp. 126-27, and Mario Praz, *Studies in Seventeenth-Century Imagery*, p. 163. Ernest B. Gilman, "Word and Image in Quarles' *Emblemes*" *Critical Enquiry* 6 (1980):385, marks a brave attempt to perceive some degree of literary and thematic subtlety in certain of the poems; but the subtlety is, I think, Gilman's and not Quarles'. For a general study of the poet's life and work see Karl Josef Holtgen, *Francis Quarles* (Tübingen, 1978), of which chapter 6 discusses the emblem poems.

[34] This is, in fact, a deliberate misquotation. Isaiah 66:11 refers in the original to the rebuilt Jerusalem and the joy of its returning inhabitants restored, as it were, to the maternal breast. Quarles, wishing to use the verse with entirely different application related to man's misuse of earth's bounty, casually inserts a negative into the biblical verse.

[35] Francis Quarles, *Emblems: Divine and Moral* (London, 1825), p. 59.

[36] The references are to Donne's "The Relique" and "Hymne to God my God, in my Sicknesse" and to Herbert's "The Windows."

[37] James D. Simmonds, *Masques of God: form and theme in the poetry of Henry Vaughan* (Pittsburgh, 1972) discusses the poet's search for a knowledge of God through the created world.

[38] Henry Vaughan, "The Tempest," 17-20 and 25-28, in *Works*, ed. L. C. Martin (Oxford, 1968), p. 461.

[39] Cf. Earl Miner, *The Metaphysical Mode from Donne to Cowley* (Princeton, 1969), p. 132.

[40] D. S. Norton, "Herbert's 'The Collar,' " *Explicator* 2 (1944), no. 41. The normal reading is summarized in Mary Ellen Rickey, *Utmost Art: complexity in the verse of George Herbert* (Kentucky, 1966), pp. 99-101, and in C. A. Patrides, ed., *The English Poems of George Herbert* (London, 1974), p. 161. From a passing hint in S. Fish's *Self-Consuming Artifacts*, p. 221, I suspect that his reading of this

emblem may be close to my own. Richard Strier, *Love Known: theology and experience in George Herbert's poetry* (Chicago, 1983) provides a perceptive examination of the doctrinal background to the poems.

⁴¹ Herbert, "The Search," 43-44.

⁴² While the Church was, understandably, not eager to welcome the new cosmological theories, the popular view that Bruno and Galileo were mercilessly hounded for their unorthodoxies needs to be modified. Frances A. Yates has shown in her *Giordano Bruno and the Hermetic Tradition* (London, 1971), pp. 355-56, that Bruno was really condemned by the Inquisition for heresies unconnected with astronomical theory, his unconventional view of the heavens being added simply as extra weight to the charge. Galileo, it should be recalled, received no less than four official *imprimaturs* from the Church censors before the publication of his *Dialogue on the Ptolemaic and Copernican Systems* (1632), and it was only later that internal pressures forced the Pope to call him to trial, a trial made particularly awkward for the Church because of its previous approval of the work.

⁴³ Loyola, *Spiritual Exercises*, ed. cit., p. 47.

⁴⁴ Henry Vaughan, "The World," 1-7, in ed. cit., p. 466.

INDEX

369

LIBRARY OF CONGRESS CATALOGING-IN-
PUBLICATION DATA

ROSTON, MURRAY.
RENAISSANCE PERSPECTIVES IN LITERATURE AND THE
VISUAL ARTS.
INCLUDES INDEX.
I. ENGLISH LITERATURE—EARLY MODERN, I500-I700—
HISTORY AND CRITICISM. 2. ENGLISH LITERATURE—
MIDDLE ENGLISH, I100-I500—HISTORY AND CRITICISM. 3. ART
AND LITERATURE—EUROPE. 4. RENAISSANCE. 5. PERSPECTIVE.
6. CREATION (LITERARY, ARTISTIC, ETC.) I. TITLE.
PR428.A76R67 1986 820'.9'357 86-18681
ISBN 0-691-06683-3 (ALK. PAPER)

Murray Roston is Professor of English at
Bar Ilan University, Israel